AMERICAN SHOWCASE
OF PHOTOGRAPHY ILLUSTRATION AND GRAPHIC DESIGN

AMERICAN SHOWCASE
OF PHOTOGRAPHY ILLUSTRATION AND GRAPHIC DESIGN

American Showcase, Inc.
New York

We're proud of this book, and it is a reflection of the craft, dedication and personal pride of the professionals who were involved. Thank you to:

the Showcase staff — Bonnie Boxer for her unwavering and tireless dedication to perfection; Fiona L'Estrange for her coolness and commitment under fire; Barbara Lee for epitomizing efficiency; Jan Trainor, Carol Collamer, Bonnie Jay and Wayne Hallowell for their enthusiastic support and belief in the book.

Lubalin Associates for Herb's pointed insights and striking design, and for Michael Aron's admirable grace under pressure.

Offset Separations for Abby Sundell's personal supervision in tandem with Paolo Riposio and his universally acclaimed craftsmen.

Mondadori — Gino Brocato for his encouragement and trust; Gianpaolo Malapelle for his patient and charming responses to our never-ending questions; and to Pierluigi Campagnari, Cesare Cucati, and all the people in Verona who share our desire for fine-quality reproduction.

For additional information, contact:

AMERICAN SHOWCASE, INC.
Suite 1929
30 Rockefeller Plaza
New York, New York 10020
(212) 245-0981

Book Design by Herb Lubalin and Michael Aron, Herb Lubalin Associates, Inc., New York City.

All color separations produced in Italy by Offset Separations Corp., New York City.

Printed and bound by A. Mondadori Editore, Verona, Italy.

Typesetting by M.J. Baumwell Typography, New York City.

Typesetting of Phone Listings by Pastore, DePamphilis, Rampone, Inc.

ISBN 0-931144-03-5 (soft bound)

ISBN 0-931144-04-3 (cloth bound)

ISSN 0163-3309

741.6

5

8001 DR/ART

CONTENTS

INTRODUCTION

"How can you charge $450 a day when you've only been shooting two years? For $500 I can hire one of the best photographers in your field who has 16 years experience."

"That's why I charge $50 less, and I get it."

—A conversation in the marketplace, 1972

14 years for $50! I was outraged.

By now I've mellowed a bit. If you can get more than you're worth, in any situation, more power to you. Who am I to be upset with a photographer who hoodwinks an unknowing client? We all remember the times we were underpaid or exploited with a smile.

Nevertheless, the idea of fairness and rewards to the good guys remains appealing, however idealistic. So I feel content momentarily as Volume Two comes together.

This second Showcase is larger, offers more images on over 200 color pages, and represents many additional visual communicators. There's a new section of work by graphic designers that should enable corporate clients to conveniently survey the best talent in that field. And hundreds of other graphic designers are identified in what we think is the most comprehensive list of designers ever published. Furthermore, we have included the phone numbers of over 4000 photographers and illustrators, their representatives, and stock photo companies.

Our initial vision for Showcase was to provide the finest reference for introducing the better commercial images and talents to those who do the hiring — and for reminding buyers about top artists they'd heard of or worked with earlier.

It's satisfying to know that Volume One has brought many people together for the first time. Or for the first time in a long time. Some are separated by a few blocks; others by states and oceans. And they've benefited from a meshing of talents, services and needs.

We also wanted to increase the visibility of fine pictures to help improve the quality of commercial imagery. We're pleased to hear that some less sophisticated clients saw images their competitors used and gave more innovative assignments. Other clients pointed to specific photographs in Volume One and said, "Make mine just like

Several weeks ago I was backpacking in the Jersey meadows when a thick, impenetrable fog settled in about me. I lost my bearings and tried to retrace my steps. I walked for hours and finally at nightfall I gave in to the realization that I, an experienced Alpine swamp fox, was lost. With the coming of night, panic began to take possession of me. Suddenly I heard a voice, thin and shrill, asking me, "Lost, sonny?" Startled at first, I was then overcome with relief. My eyes pursued the voice. It was a little old lady in a large black hat tapering to a point. I explained my plight. Her wizened face broke into a tight smile. Her voice wavered. "I can grant you three wishes, sonny. But first, you must grant my wish." She whispered in my ear. Wearily, I complied.

She arranged herself. "Now," she asked, "what are your three wishes?" I relate them to you now.

Number one, I wish I never will have to look at a formula picture or design again — and that artists and art directors henceforth shall have enough intelligence and guts never to make another "son of" ad. Every brilliant and innovative ad is followed by a battalion of imitators. Why does every two-bit baritone have to sing "Impossible Dream"? Thirty years ago we held in contempt those who took American ideas and copied them. Back then the Japanese came up with inferior imitations of American products. The phrase "Japanese copy" became part of our lexicon. But that was years ago. Today, we have great and deserved admiration for Japanese ingenuity and creativity. The sad irony is that it is we who have become the imitators. We have become so inured to mediocrity about us that we can no longer recognize it.

that!" Countless people saw the book — or publicized excerpts from it — and possibly altered, perhaps improved, their own picture-taking and visual sensitivity.

During the last few years, <u>Showcase</u> has brought me a lot closer to the photographers, illustrators, and graphic designers in our field. I feel closer to their work and also to their problems. Two things in particular seem a bit unjust. If the communicators who use this book — professionals whose messages influence the buying decisions and attitudes of millions of people — would focus their efforts in two specific areas, we could make a significant difference. However slowly.

First, where's the sense of fair play when multi-billion dollar companies hire multi-million dollar ad agencies that hire a multi-thousand dollar photographer... and then force him or her to advance $10-40,000 for props, sets, models, or plane tickets and wait three to six months for reimbursement! This cash flow obstacle drowns too many talents. Can invoices be signed more quickly? Or advances be given by the agencies?

Second, there are thousands of new photography and art graduates who are totally naive about their ability to make a living. They crash blindly into the reality of the post-academic world. And no one's told them there are far more graduates than jobs. To minimize their shock and disillusionment, let's describe more of our business lives to the students and teachers we meet. It's not all picture-making and glamorous travel.

I admit that many people think visual communicators are crazy! Impossible to deal with and hardly worth assisting. Most of the ones I know strive constantly to create their best. The survivors are very competitive, necessarily aggressive, and extremely profit-oriented. A few are damn obnoxious, even arrogant. Still our jungle is lush with creative people who are sensitive, reflective and somehow optimistic.

And when they take a picture or make a design that excites me, it's a rare taste of honey in a world of bitter pills. So I'm hooked. And I love it. And I want to make it all better. Truly.

IRA SHAPIRO
November 13, 1978

Ripping off the design or visual idea of a winner is easy and safe...but it is also intellectually degrading and artistically sterile. Too many "creative people" aren't creative at all. They know the technique of their craft, but the heart and the daring is often in someone else's storyboard. They should spend a lot more time looking at the work of the masters, not only in their own fields but in those of architecture, painting, photography, sculpture, film, you name it. One must develop an eye, a feel, a sensitivity, and then <u>use</u> it.

My second wish is that advertisers and account people will have the savvy and courage to give artists and art directors the freedom to experiment and to fail. Creative growth demands the license to explore and to take an idea a step beyond the conventional. Certainly there are risks, but that's the price of distinction. The rewards are infinitely greater.

My third wish is that the graphic arts will eschew the lowest common denominator. The graphic arts, the most pervasive and influential art form, are, many complain, unjustifiably held in contempt by the fine arts. Well, what we see from day to day seems to justify that contempt. But it also is true that the best in graphic arts today reaches the highest level of creative expression. That work should be recognized and celebrated. But if the graphic arts are to be on the cutting edge of visual creativity, we must all expect and demand far more from artists, art directors, account people, advertisers...and ourselves.

After I finished recounting my three wishes, the witch looked at me with bemusement. "Sonny," she asked, "aren't you a little old to believe in witches?" I hope not.

TENNYSON SCHAD
November, 1978

P.S. For reasons he will surely understand, I dedicate at least my half of this book to my friend, Malcolm Forbes.

PHOTOGRAPHY/N.Y. METROPOLITAN AREA

BILL ASHE
11 East 17th Street
New York, New York 10003
(212) 924-5393

Specialties: Still life, advertising, corporate, jewelry and food.

Some of our clients include: Almay, American Can Corporation, Art Direction Magazine, Borden, Bundy Corporation, CNA Financial Corporation, Danos, Ltd., Federated Department Stores, Fuji Photo Film USA, High Fidelity Trade News, IMS Systems Corporation, J & B Scotch, Japan Air Lines, Lorillard Tobacco, Loews Corporation, Matthew Bender & Company, Sacramento Tomato Plus, Sansui Electronics, Scholastic Magazines, Snow's Chowders, Sony Corporation of America, Stonehenge Restaurant, Tandberg of America, Tetley, Timex Watches, Tribuno Vermouth, Uher HiFi, Union Carbide, U. S. Department of Transportation, Waldorf-Astoria Hotel.

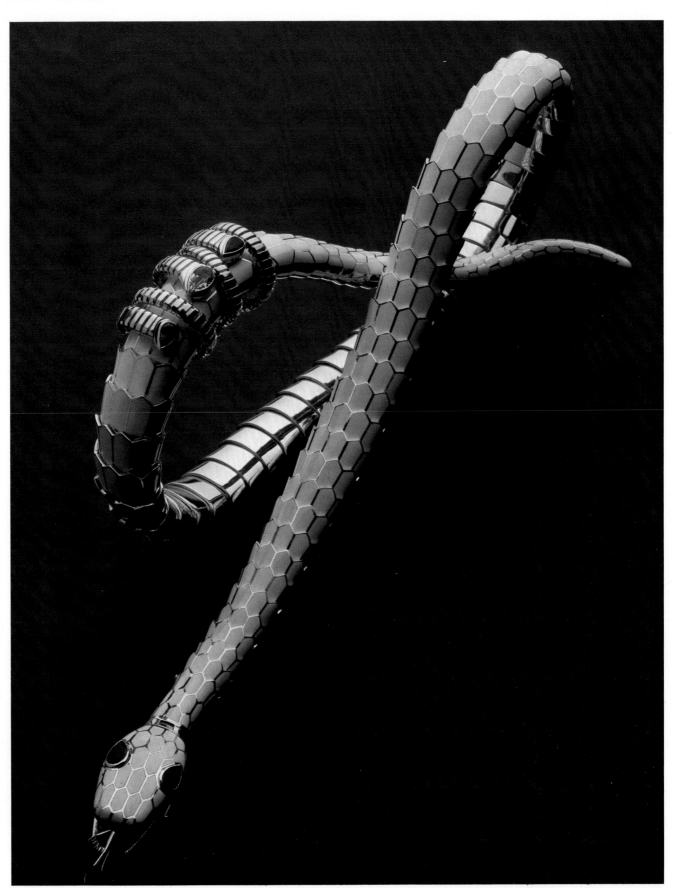

PHILIP BENNETT
1181 Broadway
New York, New York 10001

Representatives: Laurence and Nob Hovde
(212) 753-0462

Australian-born Philip Bennett has been making photographs over the past eleven years for almost every major international advertising agency, as well as many editorial clients. He has been instrumental in developing successful innovative approaches for the many accounts on which he has worked. He enjoys the challenge of creating fresh graphic concepts.

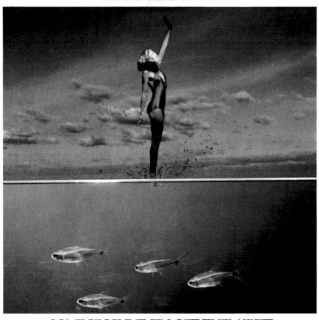

BERLEI SEABODIES.

SOME PEOPLE EVEN GET THEM WET.

LEE PASTELS
American jeans with a European accent

I'm a whole new me – with Clairol® Nice 'n Easy Colour

Put on Real Silk
for the Sheer Sensational effect...
Silk Fashion

Helena Rubinstein/the science of beauty.

ALAN BERNSTEIN
209 West 38th Street
New York, New York 10018
(212) 221-6631

Representative: Joan Schifrin
(212) 686-0907

BURGESS BLEVINS
103 East Read Street
Baltimore, Maryland 21202
(301) 685-0740

Representative: Cory Taylor
(301) 385-1716

Minnesota was so cold that the pigs had trouble keeping the back end moving with the front end. We needed pigs from pig level which means you know where I was. The smell...?
Every time the strobe fired, the Nikon felt like it was on the end of Franklin's kite. Pigs were eating power packs, sync cords and things were crawling in my finder like it was home.
In walks the lady of the farm with fresh deep-fried doughnuts and coffee and just sets the tray down in all of this. John looks at me, Gary looks at John, Doug...Doug rolled his eyes and went on catching pigs. There was no way....

BURGESS BLEVINS
103 East Read Street
Baltimore, Maryland 21202
(301) 685-0740

Representative: Cory Taylor
(301) 385-1716

Sapin & Tolle Inc. wanted the day. TRW Inc. wanted the ad. Bud the bulldog wanted gone. The Winton wanted back in the museum and two models wanted space from forty or so very real buffalo. I wanted one more frame...when the herd bull, all twelve hundred pounds of him, decided he wanted in the next county and all buffalo types were to go with him. Now, between him and there was me and wants being subject to whims, what I wanted now was a tree...one that was a lot closer than that one over there....

BARBARA BORDNICK
Photographer/Director
39 East 19th Street
New York, New York 10003
(212) 533-1180

Print and film.
Fashion/beauty advertising, editorial and illustration.
Corporate and celebrity portraiture.
Also specializes in 8x10 Polaroid portraiture.
First one-person exhibition of 8x10 Polacolor portraits.
ASMP member.

MATHEW BRADY FILMS INC.
31 West 27th Street
New York, New York 10001
(212) 982-2700

Representative: Maria Giordano

JAMES BRODERICK
9 Ridge Road
Tuxedo Park, New York 10987
(914) 351-2725
(212) 972-0959

Just a word of thanks to all those with whom I have worked: Saul Bass, Tom Carnase, Ivan Chermayeff, Ted Colangelo, Louis Dorfsman, Bruce Gelb, Tom Geismar, Kit Hinrichs, Mel Johnson, Sheldon Levison, Dick Lopez, Herb Lubalin, Peter McGuggart, John Milligan, Bob Newman, Bob Paganucci, Tony Palladino, Dick Rogers, Bob Salpeter, Ernie Smith, and Russ Tatro.

Stock photography available.

And to all the corporate, industrial, advertising, publications and annual reports for which I have worked: American Airlines, American Tobacco, Allied Chemical, AT&T, Bethlehem Steel, Burnup & Sims, Celanese, Chase Manhattan Bank, CIBA-Geigy, Columbia Gas & Oil, Cunard Lines, du Pont, Exxon, First National Bank, Hoover, IBM, ITT, Lederle Labs, Penick Labs, Pepsico, Polychrome, Sandoz Labs, Seaman's Computer, Superior Oil, UBAF American Bank, Western Electric.

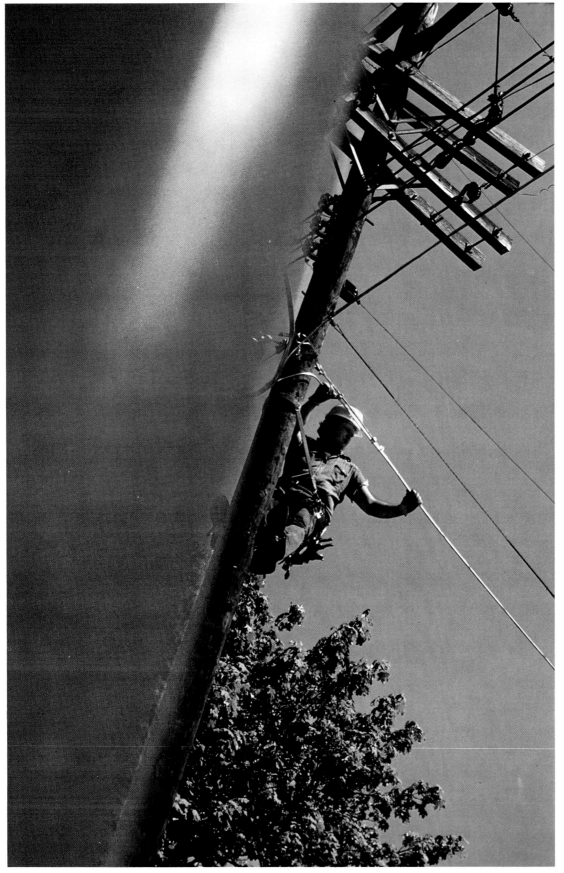

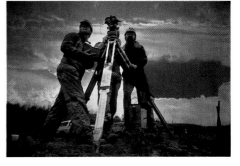

"**B**e original." "Break new ground." "Find new ways of doing things." "Creativity." That's what advertising is all about. It's what people with big reputations preach. It's what people with small reputations torture. It's what people in stiff agencies avoid.

Yet it's ironic, I know of no other business that produces so much sameness, but embraces creativity so passionately as advertising.

The word bothers me.

Creative is a pretentious word. Not by itself, but how it applies to advertising generally.

I've been the Creative Director of the agency I helped co-found since we started. That was in 1962. Although that title serves the purpose of describing a long established agency function, it nevertheless makes me feel uncomfortable at times. Particularly when I meet people who know little or nothing of advertising. Can you imagine certain job titles if the situations were reversed? "Hello, I'm Stella, Creative Anthropologist." Or "Hi, my name's Ralph, Creative Proctology."

The advertising business is a business of communicating information. The wasteful part of advertising occurs when good solid information is taken and then so distorted no one understands what's being communicated. This is frequently referred to as the Creative Process.

Creativity is too heavy a burden to place on creative people. It's unfair. Think of all the undue anxiety it causes us. I'm not even sure how you describe it.

I'll settle for information. It's what I can understand. It's what people want. To be told something that's important to them about goods and services – specific, detailed, factual. For example: is the construction of your radial tire different from other radials? Does it hold the road better or last longer? What's its performance like on wet surfaces versus biased ply tires? Is the extra cost worth the investment in terms of value, safety, peace of mind? If the departure and return of your vacation is in mid-week, will the air fare be cheaper? Where is the gas tank positioned in your car in the event of a rear-end collision? What's the nutritional value of your breakfast cereal?

Dig for information. Ask questions. Become as expert on the product and the category as you can. Absorb. Tell the truth. If a product has been around for any length of time, it must have some virtue. Find it. Explain it. Demonstrate it. If a product is new, why is it being introduced? To imitate other products previously launched with no particular advantage, or to produce its own special reason for being? Believe in what you do. If you don't believe it, how can you get other people to believe it?

I'd be foolish to deny the creativity of this business. It exists certainly. In small measure certainly.

But to my mind the real creative challenge of advertising begins <u>before</u> the ad is written. It's in the search, examination, and discovery of new information. Confronting the <u>reality</u> of things. Dealing with the controversy of things. Dismissing the inappropriate. Answering the most pertinent questions. And finally, deciding on what is the most persuasive and substantive statement you can make about whatever it is you're about to sell somebody.

AMIL GARGANO
President/Creative Director
Ally & Gargano, Inc.
New York City

WALTER CHANDOHA
R.D. 1, P.O. Box 287
Annandale, New Jersey 08801
(201) 782-3666

Representative: Sam Chandoha

Animal and horticulture/nature specialist Walter Chandoha makes custom photographs to layout or concept. Or for his clients-in-a-hurry, he has a stock file of over 100,000 Chandoha-made photographs on hand for instant use.

Since expression and pose are so important in animal photography, using pictures from existing stock makes a lot of sense. The required photographs can be selected from many choices—and they're available immediately!

Who uses Chandoha photography? Eclectic art directors and editors who require outstanding photographs of flora and fauna. Many of the animal photographs seen in text books and encyclopedias, calendars and greeting cards, posters and jig-saw puzzles are Chandoha's work. His photographs are on pet food packages, they've illustrated 2000 ads and have appeared on over 200 magazine covers.

He's even made the cat and dog photographs sometimes featured on the giant Eastman Kodak Colorama in New York's Grand Central Station.

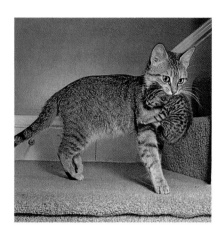

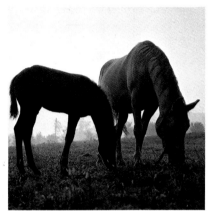

WALTER CHANDOHA
R.D. 1, P.O. Box 287
Annandale, New Jersey 08801
(201) 782-3666

Representative: Sam Chandoha

Chandoha's knowledge of plants and their taxonomy is one of the reasons his horticultural photographs are outstanding.

He has written and/or illustrated articles for text books and encyclopedias —including Britannica. The N.Y. Times frequently features his illustrated garden articles. Ad agencies and magazines—National Geographic, Family Circle, Ladies' Home Journal, Boy's Life, Woman's Day, Horticulture—use his photography.

If time precludes shooting to layout, or if botanical photographs are needed out of season, use Chandoha's file of stock photographs. Matched four seasons sets, growing vegetables, herbs and fruits, trees and leaves, skies and sunsets are some of the subjects in his nature file.

His fauna file contains thousands of photographs of dogs, cats and other domestic animals plus African animals made on location in Kenya. All of the stock photographs are Chandoha-made and are of the same high quality as those he makes for his clients who require custom photography to layout.

GEORGE M. COCHRAN
381 Park Avenue South
New York, New York 10016
(212) 689-9054

12

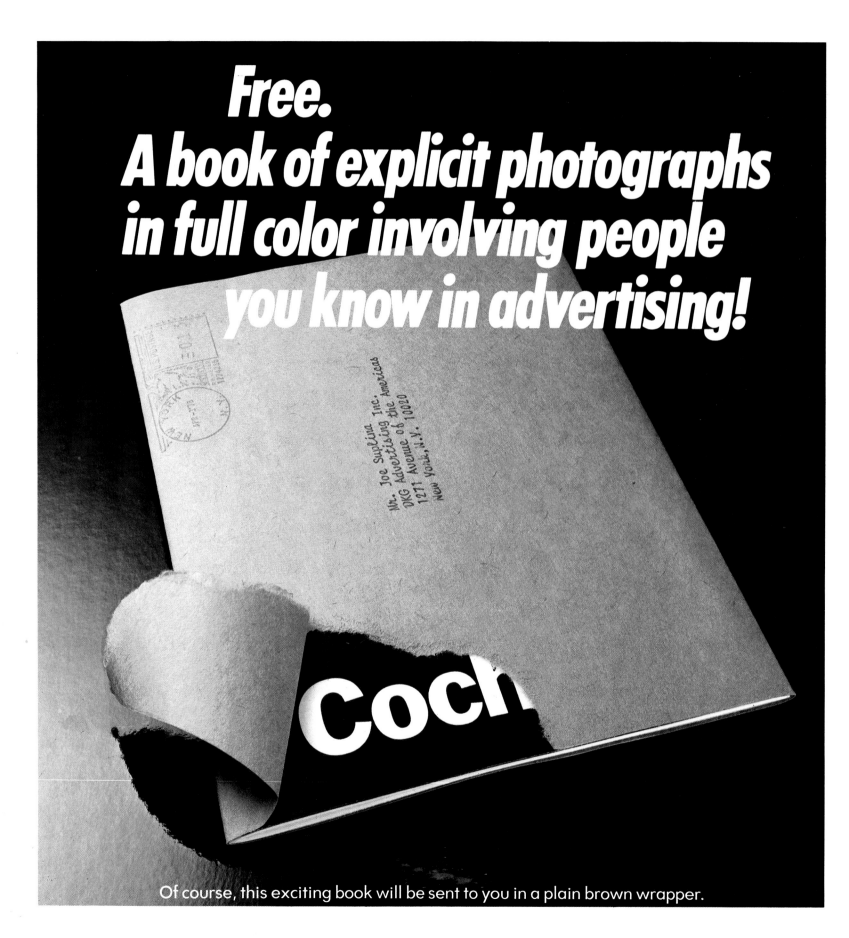

Free.
A book of explicit photographs in full color involving people you know in advertising!

Of course, this exciting book will be sent to you in a plain brown wrapper.

ROBERT COLTON
New York, New York
(212) 831-3953
(212) 581-6470 service

I've been all over the world photographing everything from automobile racing to farming, business machines to fashion. Clients include: Allied Stores, Champion International, CIBA-Geigy, Colt Industries, Continental Baking, Dravo, General Electric, General Foods, IBM, Louisiana Land and Exploration, Mobil. My work is divided equally between advertising and corporate projects that are reportorial or require elaborate lighting and production. You can see my work in Photographis as well as the AIGA, Mead, and NYADC shows.

CONTINENTAL GROUP (ARNOLD SAKS)

POLYCHROME CORP. (LOPEZ SALPETER)

COLT INDUSTRIES (ARNOLD SAKS)

PRATT & WHITNEY DIV. UNITED TECHNOLOGIES (CUNNINGHAM & WALSH)

IBM (GEER, DuBOIS)

COSIMO
35 West 36th Street
New York, New York 10018
(212) 563-2730

Representative: Frank Marino
(212) 563-2730

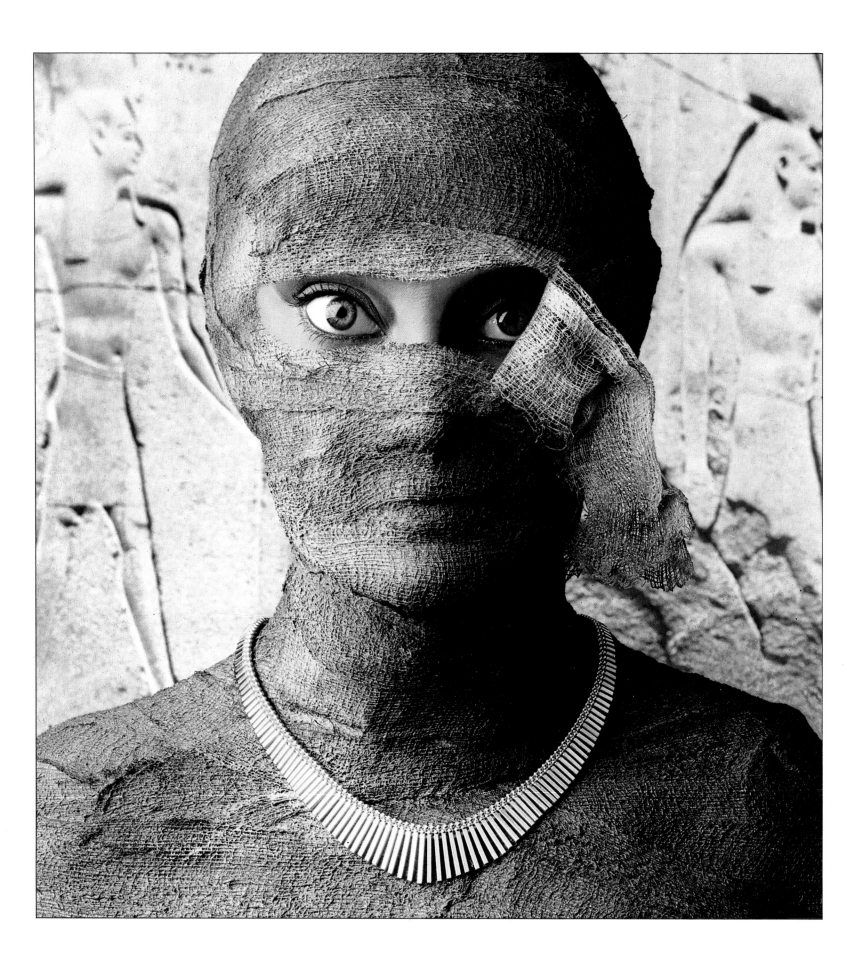

CROSS/FRANCESCA
502 East 88th Street
New York, New York 10028
(212) 988-8516

William Cross
Carole Francesca

...night and day...(Heraclitus)

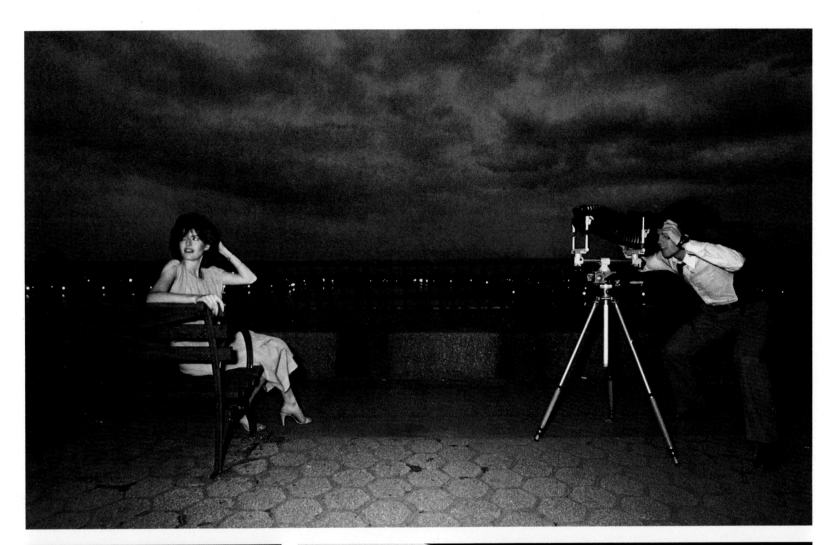

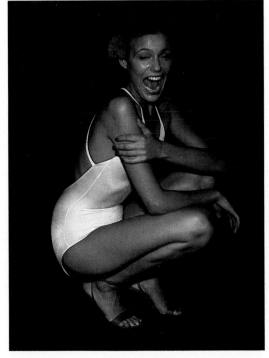

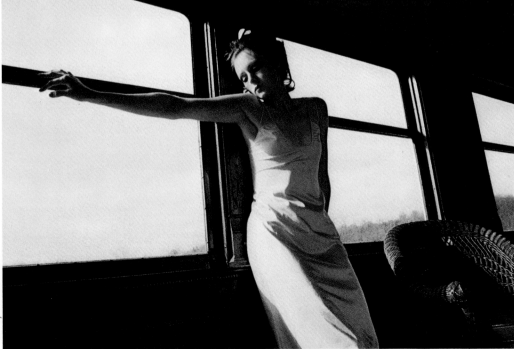

PHOTOGRAPHY: HENRI DAUMAN
136 East 76th Street
New York, New York 10021
(212) 737-1434

World-wide corporate, advertising
and editorial assignments.

Extensive color and b/w stock file:
Travel, cities and countries including New
York, Washington, San Francisco, Miami,
Paris, Versailles and France, Italy,
England, Greece, Israel, Egypt, the
Scandinavian countries, Portugal and
Vietnam.

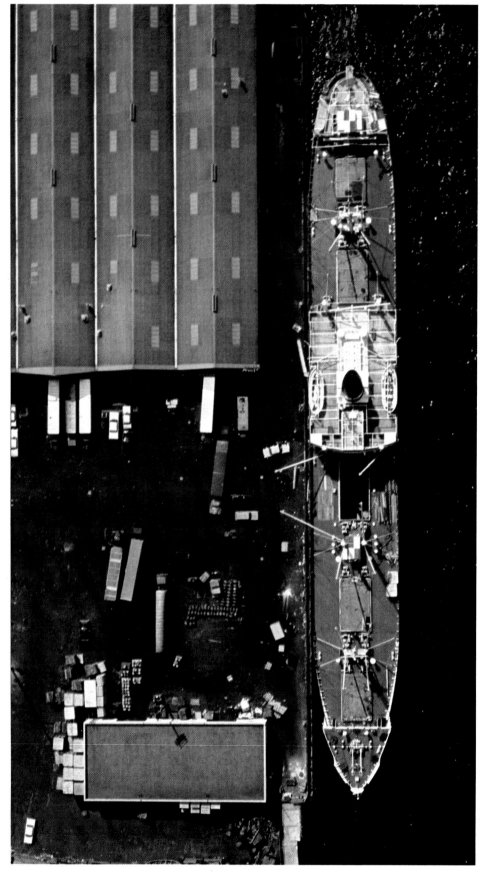

© HENRI DAUMAN 1979

DARWIN K. DAVIDSON
32 Bank Street
New York, New York 10014
(212) 242-0095

Location photography of home furnishings and
residential and contract installations for
advertising, editorial, publicity and catalogue use.

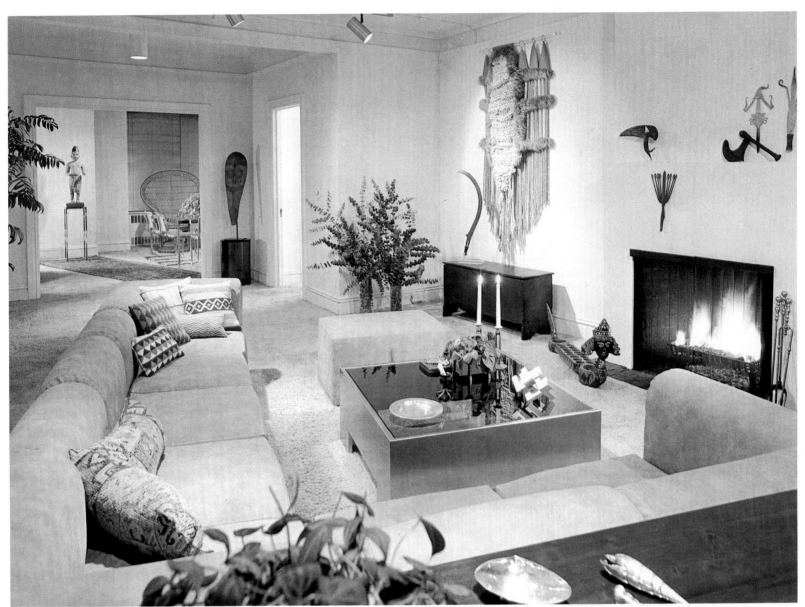

RICHARD DAVIS STUDIO
17 East 16th Street
New York, New York 10003
(212) 675-2428

Fashion, beauty, illustration.
Clients include: Revlon, Danskin,
Glamour, Seventeen, Town and Country,
Maximilian Furs, Sylvania, Gucci, Piz
Buin, Butterick, Bill Blass, Avon,
J. P. Stevens, Bonne Bell.

DANSKIN

SEVENTEEN

YVES ST. TROPEZ

EXPERIMENTAL

NICHOLAS DE SCIOSE
3292 South Magnolia
Denver, Colorado 80224
(303) 455-6315 studio
(303) 756-0317

Chicago Representative: Vincent J. Kamin Associates
(312) 787-8834
42 East Superior Street
Chicago, Illinois 60611

New York City Answering Service:
663 Fifth Avenue
New York, New York 10022
(212) 757-6454

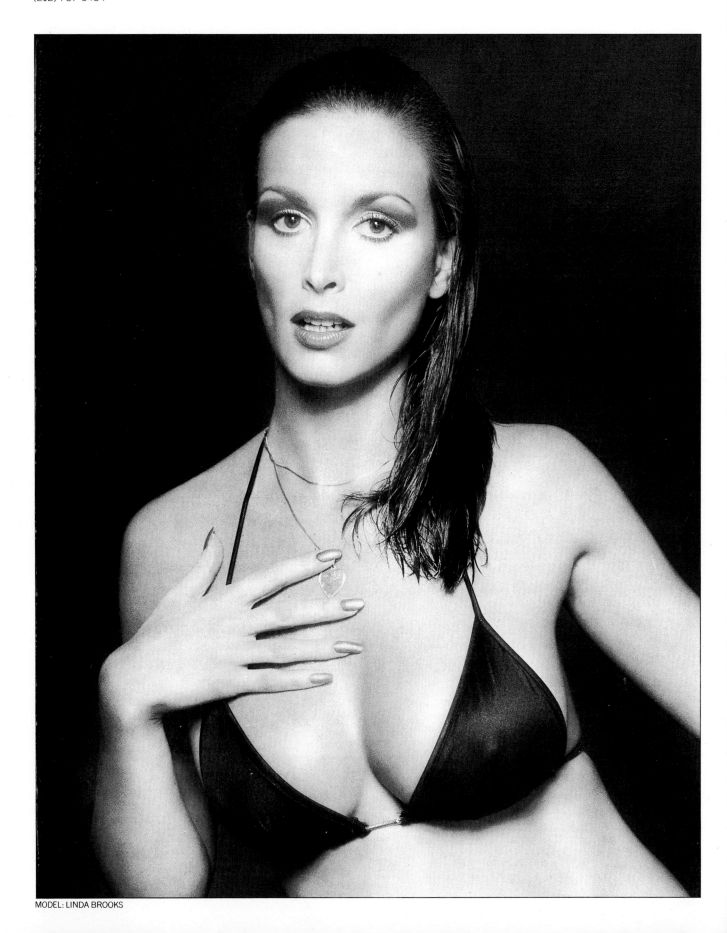

MODEL: LINDA BROOKS

LEO de WYS, INC.
Photo Agency
60 East 42nd Street
New York, New York 10017
(212) 986-3190

Black & white and color.

Picture Editor for Sports and Recreation: Victoria Brown

Write or call for our free sample catalogue showing pictures
from our files on travel, industry, the environment, human
beings and their emotions.

ROCKY WELDON

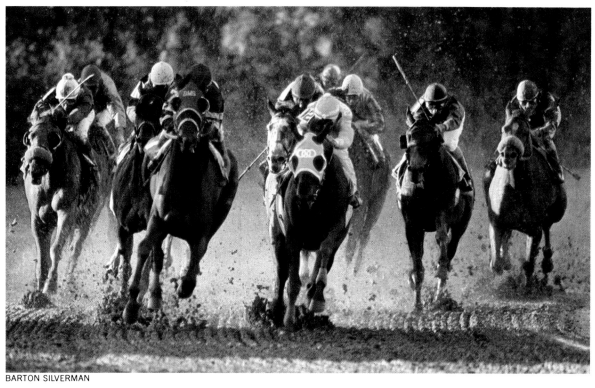

BARTON SILVERMAN

E. M. BORDIS

ROCKY WELDON

WILLI OSTGATHE

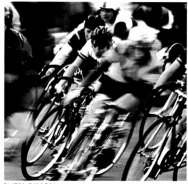

SVEN SIMON

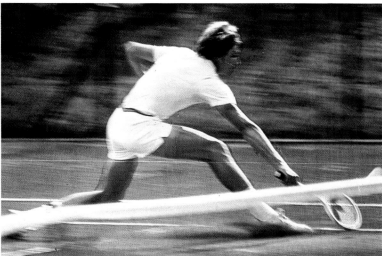

WILLI OSTGATHE

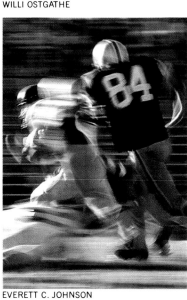

EVERETT C. JOHNSON

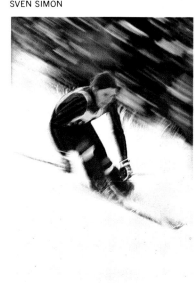

E. M. BORDIS

MEL DIXON
29 East 19th Street
New York, New York 10003
(212) 677-5450

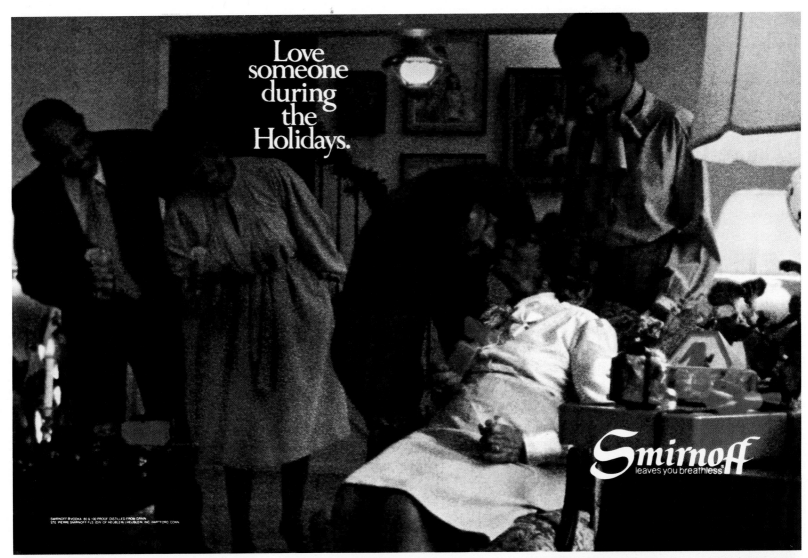

Love someone during the Holidays.

Smirnoff
leaves you breathless

It lets me be me!

"Sometimes I'm cool and laid back. Sometimes I'm young and goofy. The point is, I'm myself. And, I deserve my own look. That's why I like Nice 'n Easy. The conditioners are great. And, the highlights aren't just pretty. They're me."

Nice 'n Easy haircolor. It sells the most.

PHOEBE DUNN
20 Silvermine Road
New Canaan, Connecticut 06840

Representative: Tris Dunn
(203) 966-9791

"Phoebe and Tris Dunn are internationally known for their sensitive pictures of babies, young people, children and families...their work for magazine and TV advertisers appears regularly throughout the world." U.S. Camera World Annual.

Fairfield County studio plus wide range of suburban and country locations. Team has mastered the delicate psychology of working with babies and children.

Clients include: Avon Products, Campbell Soup, Eastman Kodak, General Foods, Gerber, Hasselblad Cameras, Eli Lilly, Procter & Gamble, Sierra Club, Sterling Drug, Union Carbide, Redbook, 3M Company, Woman's Day.

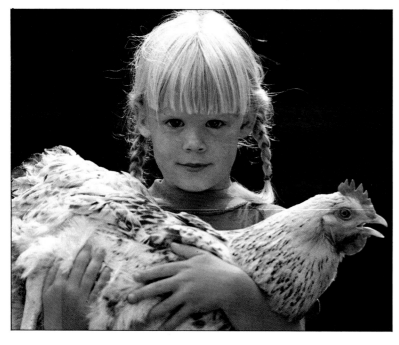

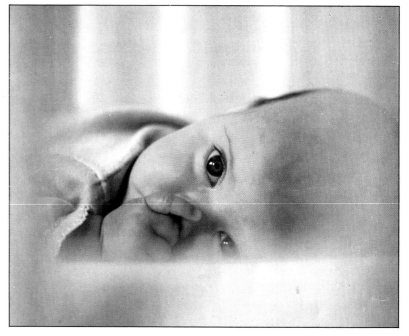

ROBERT FARBER
232 East 58th Street
New York, New York 10022
(212) 752-5171

Representative: Marc Renard
1 West 30th Street
New York, New York 10001
(212) 736-3266

Existing photography: The Image Bank

Author of Images of Woman and
Professional Fashion Photography.

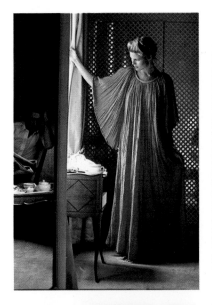
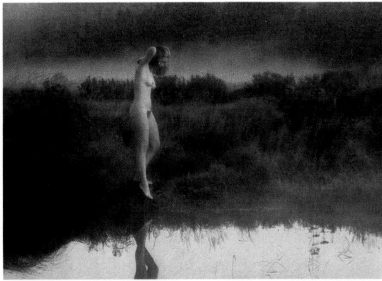

BILL FARRELL
343 East 30th Street
New York, New York 10016
(212) 683-1425

Representative: Ursula G. Kreis
63 Adrian Avenue
Bronx, New York 10463
(212) 562-8931

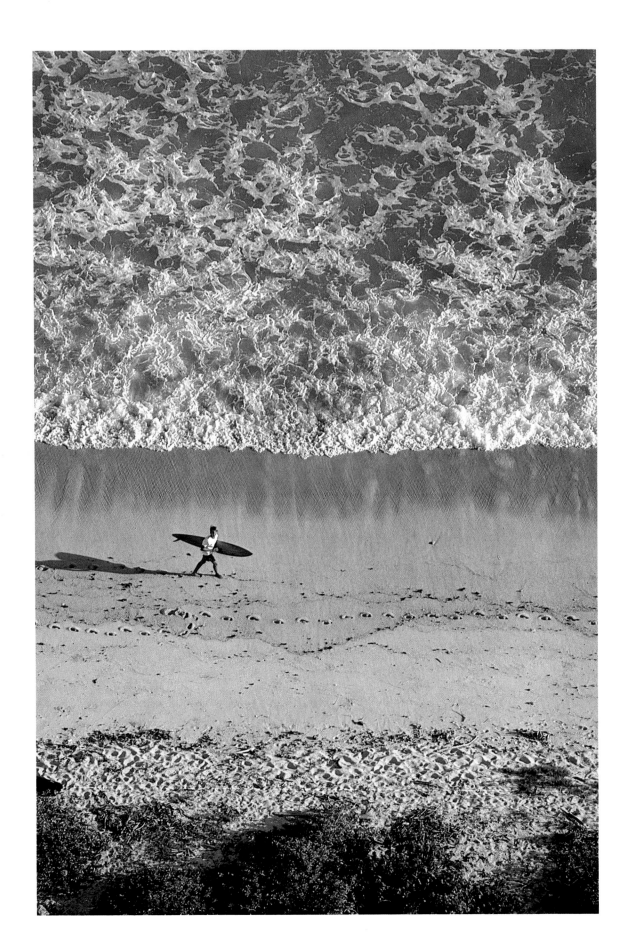

JAN W. FAUL
1011 Arlington Boulevard, Suite 1625
Arlington, Virginia 22209
(703) 522-0150

New York Representative: Ellen Klein
(212) 243-0069

For seven years Jan Faul has been polishing an image. He has traveled to locations as varied as the ideas of man. He is a master of light both in and out of the studio. And now he has moved to a new studio where he still puts ideas on film, is free to travel for the right pictures and is ready to perform his marvels for you. Member ASMP.

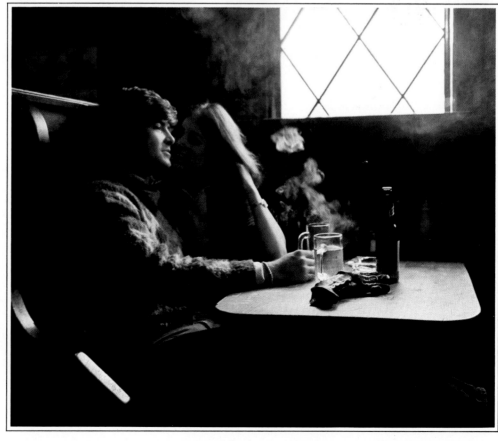

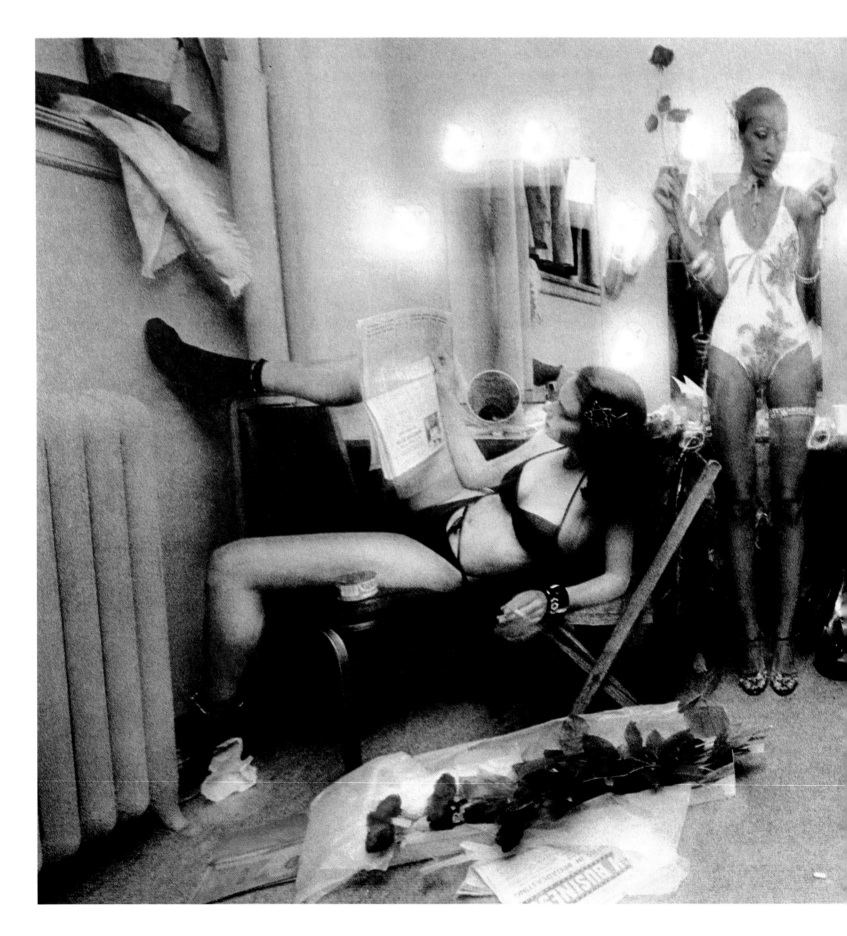

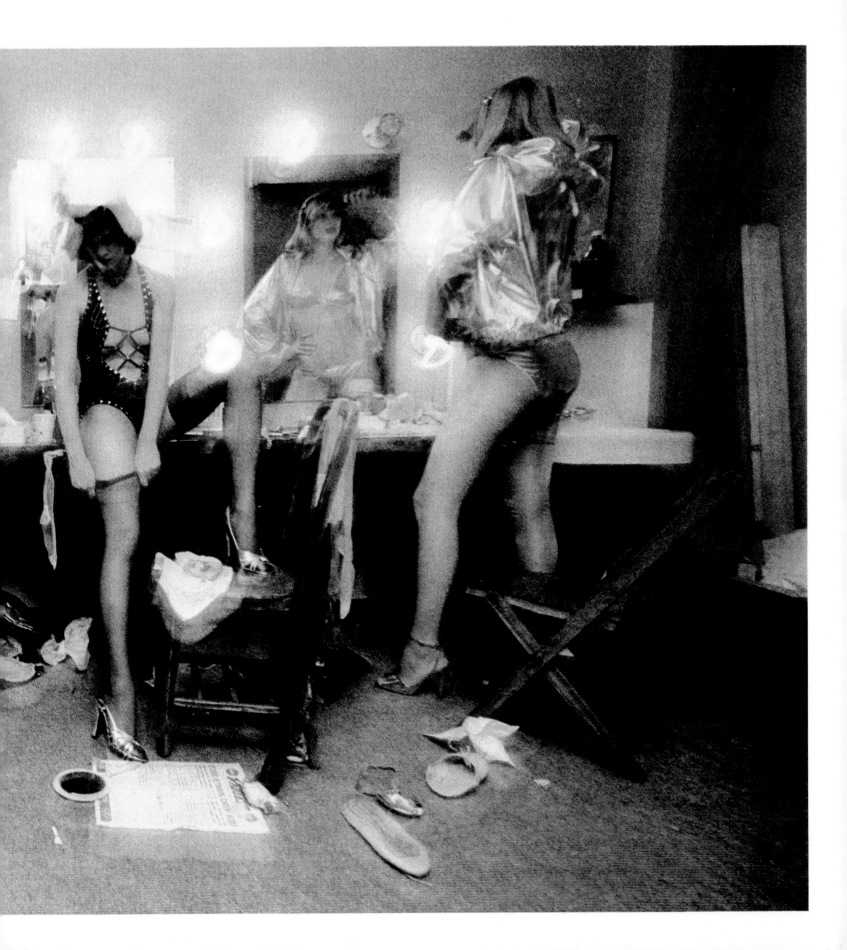

ROBIN FORBES
118 Spring Street
New York, New York 10012
(212) 431-4178

Stock photography: The Image Bank
(212) 371-3636

Advertising and editorial illustration,
specializing in children and people,
both location and studio.

Clients include: Ogilvy & Mather, Rolf Werner Rosenthal,
Sudler and Hennessey, William Douglas McAdams,
Redbook Magazine, Woman's Day Magazine,
Harcourt Brace Jovanovich, Macmillan Publishing
Company, Ziff-Davis Publishing Company.

AL FRANCEKEVICH
381 Park Avenue South
New York, New York 10016
(212) 689-0580

If you're an art director doing ads that are beyond the
"straight" approach, chances are that Al Francekevich should
be your photographer. To make really sure, call Al and ask
him to show you the rest of his samples.

© Al Francekevich 1979

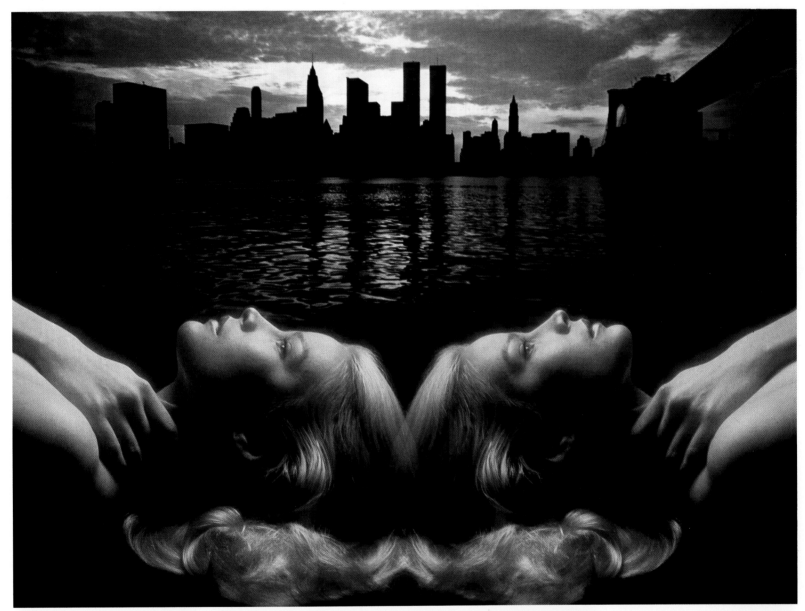

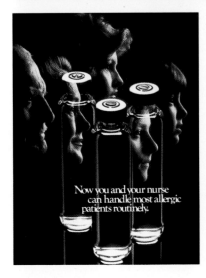

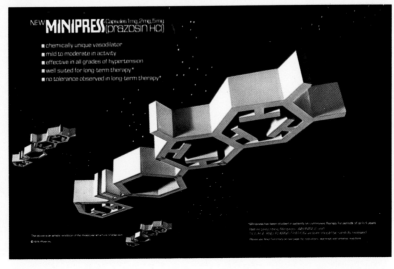

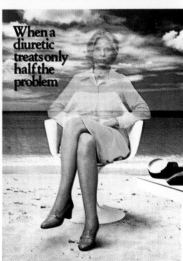

JERRY FRIEDMAN STUDIOS, INC.
873 Broadway
New York, New York 10003
(212) 533-1960

New York Representative: Rinaldo Frattolillo
(212) 486-1901

Chicago Representative: Dan O'Brien
(312) 856-0007

Pepsi-Cola, Maxwell House Coffee, Weaver Chicken, Smuckers, Post Cereals, Beck's
Beer, Anheuser-Busch, Suntory Ltd., Nestle's, Borden, General Foods, Finlandia,
Teachers, Johnnie Walker Red/Black, Tanqueray, Seagram, Dewars, Esquire, Redbook,
Ladies' Home Journal, Reader's Digest, Cosmopolitan, Seventeen, Elizabeth Arden,
Estée Lauder, Revlon, KLM, Pioneer, Omega, Singer.

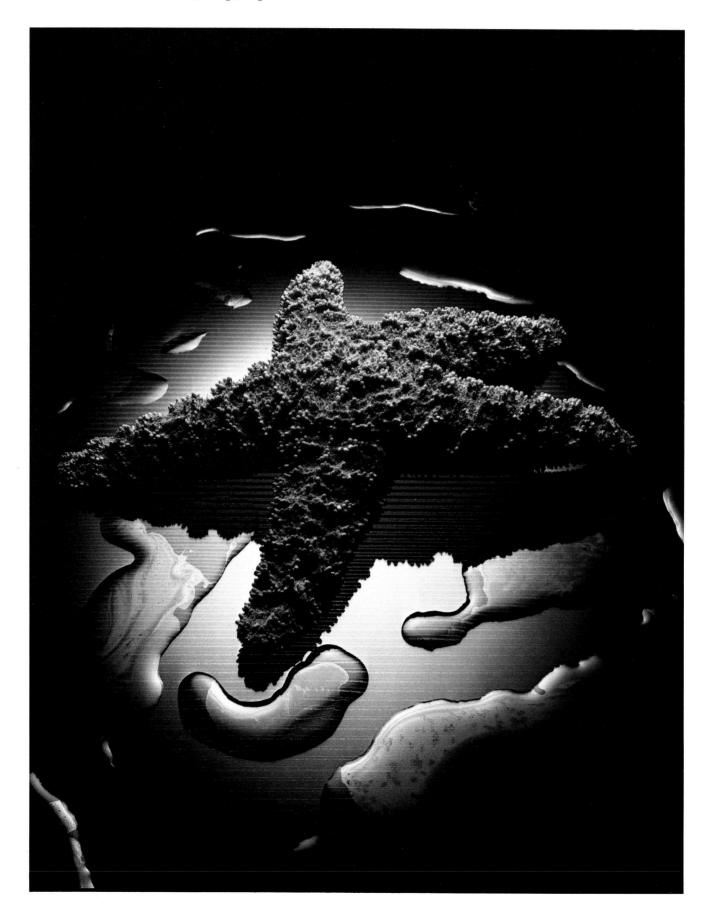

MICHAEL FURMAN PHOTOGRAPHER, LTD.
113 Arch Street
Philadelphia, Pennsylvania 19106
(215) 925-4233

FUR·MAN, MICH·AEL, fŭr'man, mīk'el; noun. Philadelphia photographer noted for still lifes. A little strange. Mustache, dark hair and sloppy dresser. (See Mike, Mikie, Furmie, Furman. See Portfolio.).

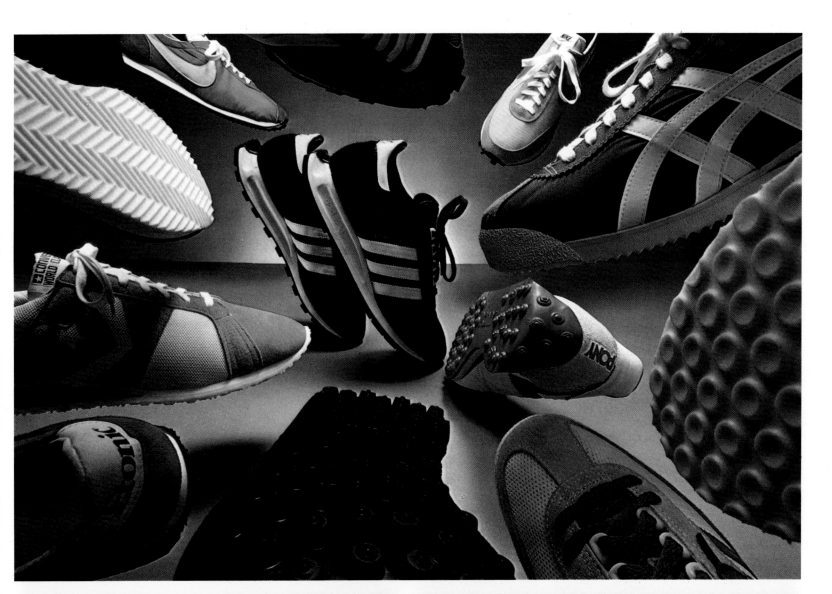

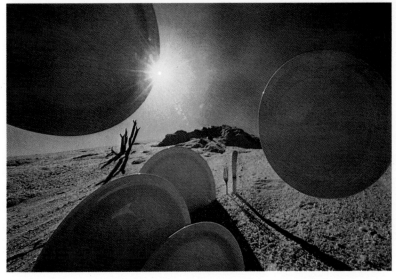

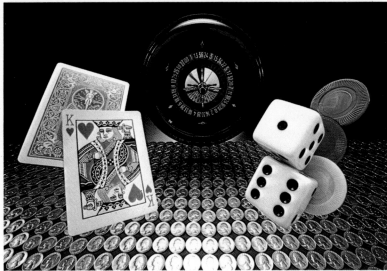

ED GALLUCCI
381 Park Avenue South
New York, New York 10016
(212) 532-2720

Asta, Astra, Ayerst, Bio-Essence, Burroughs' Wellcome,
Butterick, CIBA-Geigy, Emergency Medicine, E.P. Dutton,
IBM, Johnson & Johnson, T.J. Lipton, McGraw-Hill,
Penthouse, Playboy, WestPoint-Pepperell.

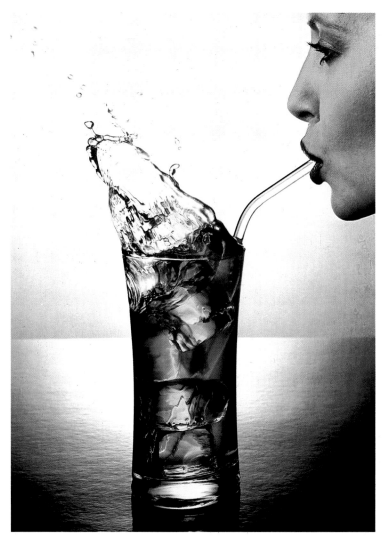

AL GIESE
119 Fifth Avenue
New York, New York 10003
(212) 477-3096

Representative: Mary Hottelet

My work ranges over many fields: advertising, editorial,
corporate/annual report, fashion/beauty and travel.

Clients (partial) have been: American Airlines, AT&T, Avon,
Burlington Mills, Clairol, Coke Foods, du Pont, Fieldcrest,
Heublein Liquors, IBM, Johnson & Johnson, Litton Industries,
Micar, New York Telephone, Olin Chemical, Playtex,
J.P. Stevens, Saks Fifth Ave., Seligman & Latz, Texaco, etc.
© Al Giese 1978.

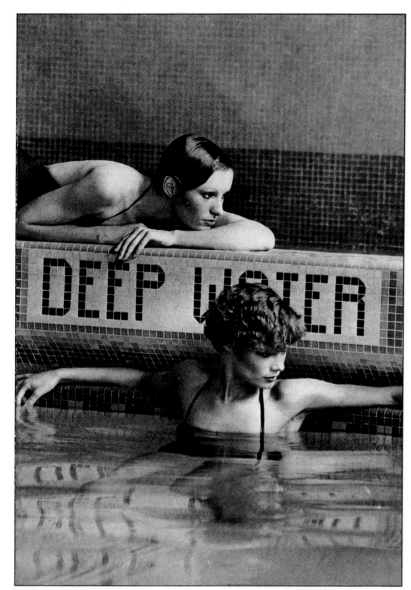

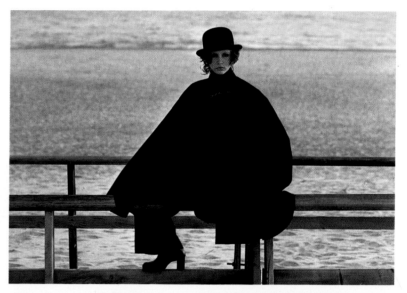

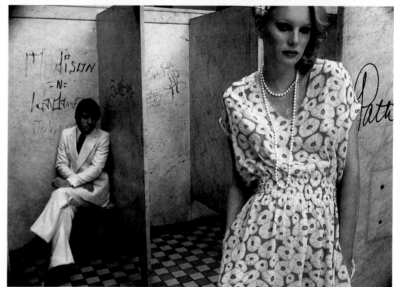

ANDRÉ GILLARDIN
5 East 19th Street
New York, New York 10003
(212) 673-9020

Representative: Robin Feld
(212) 249-7231

ANDRÉ GILLARDIN
5 East 19th Street
New York, New York 10003
(212) 673-9020

Representative: Robin Feld
(212) 249-7231

GARY GLADSTONE
The Gladstone Studio, Ltd.
237 East 20th Street
New York, New York 10003
(212) 982-3333

Stock photography: The Image Bank

Annual reports, capability books, business & industry—strong executive portraiture, financial community, aviation, college. Author of juvenile books and craft books (major publishers). Very strong design emphasis in all phases of work-people, places and things. Has graphic design background and enjoys working as a team with designer. Among clients are: AMAX, American Can, Business Week, Celanese, Cerro, Chesebrough-Ponds, C.I.T., Fortune, General Electric, International Paper, Johnson & Johnson, Kraft, Inc., Merrill Lynch, Moore McCormack, Nabisco, St. Joe, Sperry Rand, Time Inc., United Merchants, U.S. Industries, United Technologies, Xerox.

Awards and all that stuff.

BURT GLINN
41 Central Park West
New York, New York 10023
(212) 877-2210

New York Representative: Magnum Photos, Inc.
15 West 46th Street
New York, New York 10036
(212) 541-7570 Telex 420339

European Representative: Magnum Photos
2 rue Christine
75006 Paris, France
325·90·09 Telex 200254

Advertising, editorial and industrial assignments.
Extensive stock photography archives.
©Burt Glinn 1978, 1979

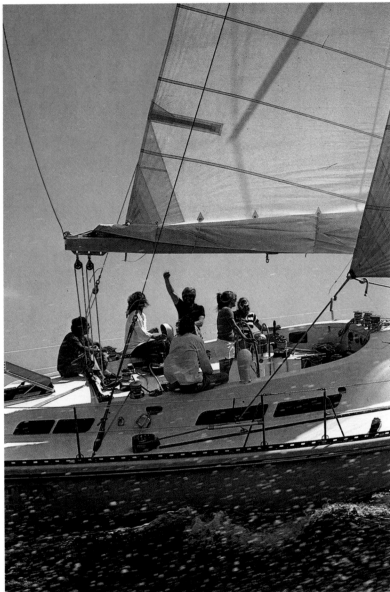

SEAGRAM

SEAGRAM

TOWN & COUNTRY

ESQUIRE

ESQUIRE

MITCHEL GRAY
169 East 86th Street
New York, New York 10028
(212) 427-2287

Representative: Marc Renard
1 West 30th Street
New York, New York 10001
(212) 736-3266

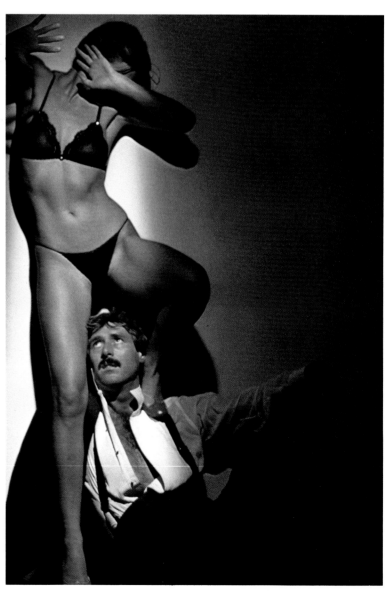

STEPHEN GREEN-ARMYTAGE
171 West 57th Street
New York, New York 10019
(212) 247-6314

HAVILAND PHOTOGRAPHY
34 East 23rd Street
New York, New York 10010
(212) 260-3670

Brian Haviland
Associate: Richard Lerner

Rebecca for **CRISTINA'S HANDBAGS INC.**
320 Fifth Avenue N.Y.C. 10001 Penthouse Suite (212) 279-5417

DANGEROUS . . .

STEPHAN ADRIAN LTD

H. SCOTT HEIST/FILE: 17 GROUP
616 Walnut Street
Emmaus, Pennsylvania 18049
(215) 965-5479

While you are reading this, it is not at all unlikely that we are driving through the night on Route 53 in Wisconsin (50 mph is tops due to the deer crossings) to make a 6:30 A.M. flight out of Minneapolis or enjoying the excellent sunset and bouillabaisse at Skipper's along Highway 1 in California. Or maybe something less exciting like arranging for a special processing run at Kodak so 2500 slides can be edited at 4 A.M. to make an 11 o'clock deadline in New York. The next time you've got a travel job, from coal mines to resorts, with problems in need of special solutions…check with us in Emmaus, Pennsylvania. We're always on location. Just two hours outside New York. © H. Scott Heist 1978.

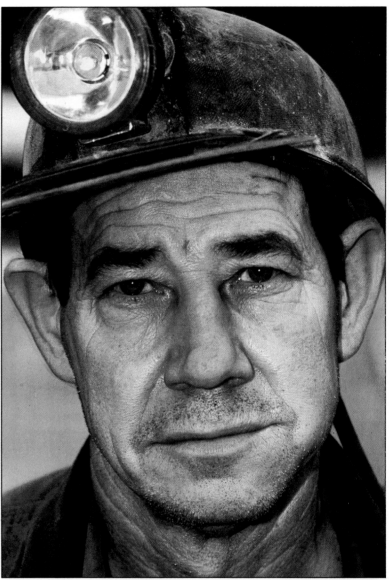

BILL HELMS, INC.
1175 York Avenue
New York, New York 10021
(212) 759-2079

Representative: Jennifer Sims
Yellowbox, Inc. (New York)
(212) 532-4010

To communicate effectively is the sole objective of my photography. Form follows function (communication).

Photography on these pages from "A Touch of Glass."
Design Coordination: June Manton

BILL HELMS, INC.
1175 York Avenue
New York, New York 10021
(212) 759-2079

Representative: Jennifer Sims
Yellowbox, Inc. (New York)
(212) 532-4010

Photography on these pages from "A Touch of Glass."
Design Coordination: June Manton

CORSON HIRSCHFELD
316 West Fourth Street
Cincinnati, Ohio 45202
(513) 241-0550

RYSZARD HOROWITZ
103 Fifth Avenue
New York, New York 10003
(212) 243-6440

Eyes. Dior.

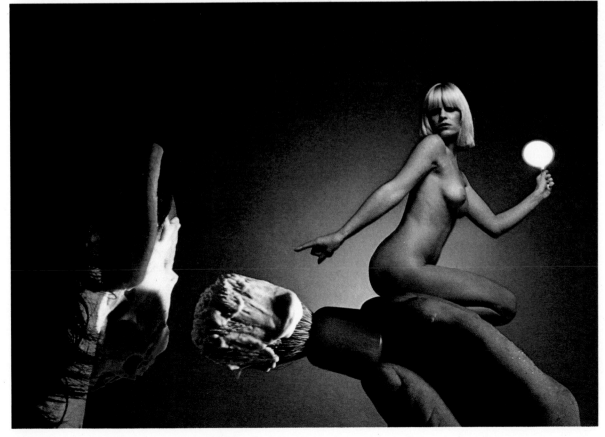

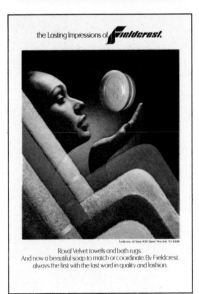

the Lasting Impressions of *Fieldcrest.*

Royal Velvet towels and bath rugs.
And now a beautiful soap to match or coordinate. By Fieldcrest,
always the first with the last word in quality and fashion.

TED HOROWITZ
8 West 75th Street
New York, New York 10023
(212) 595-0040

Photographing the Fortune 500 for advertisements and annual reports, Ted Horowitz has a list of clients that reads like the Who's Who of Megabusiness: AT&T, IBM, ARCO, ALCOA, Bank of America, Union Carbide, US Steel, Westvāco, Celanese, and Continental Grain. Whether in steel or oil, aluminum or agriculture, research or refining, chemicals, computers or commerce, Ted Horowitz photographs each project with enthusiasm and insight, bringing to the assignment the experience of extensive travel and location work, a strong sense of color and design, and a skillful eye for the unexpected.

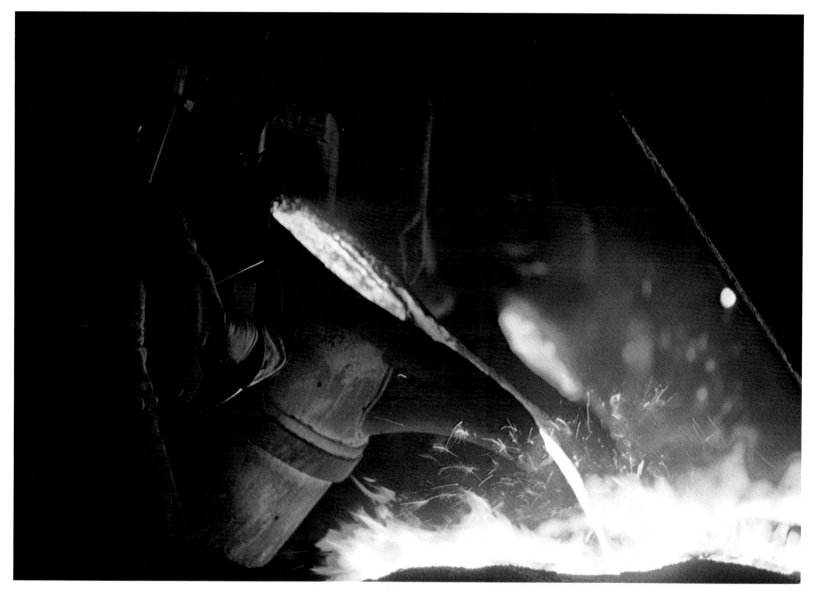

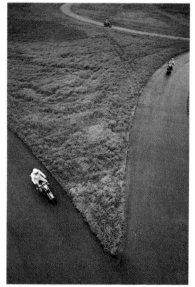

TED HOROWITZ
8 West 75th Street
New York, New York 10023
(212) 595-0040

From Brooklyn to Bangkok, from Bombay to his own
backyard, Ted Horowitz covers a wide range of advertis-
ing, corporate, editorial, and illustration assignments
for such clients as AT&T, Bank of America, Continental
Grain, Union Carbide and Time Inc. To each assignment
he brings skill, insight, and spirit. With a genuine
enthusiasm for his subjects, a strong feeling for color
and light, and a graphic sense of design, Ted Horowitz
photographs our world beautifully.

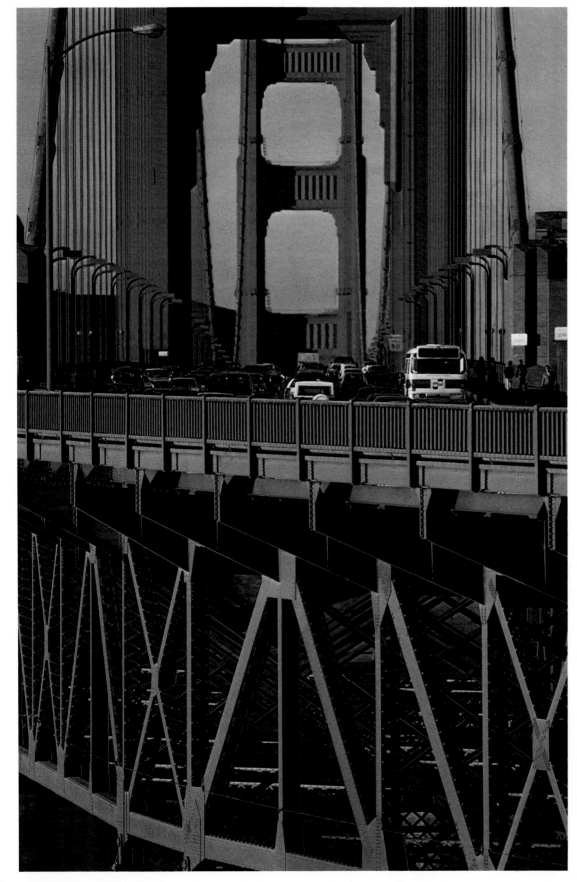

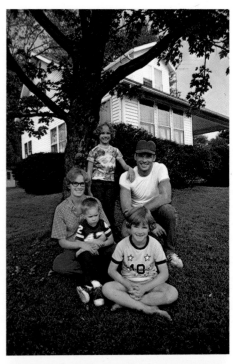

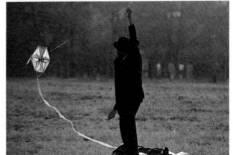

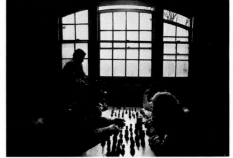

ROSEMARY HOWARD
902 Broadway
New York, New York 10010
(212) 473-5552

ROBERT HUNTZINGER
3 West 18th Street
New York, New York 10011
(212) 675-1710

For years Robert Huntzinger has been one of the best location photographers in the business....

The photographs on this page were done in his studio at 3 West 18th Street in New York. The same meticulous approach to casting, propping, lighting and set design, will be given your job— on location or in the studio.

SHIG IKEDA INC.
119 West 22nd Street
New York, New York 10011
(212) 924-4744

Representative: Joe Cahill
(212) 751-0529

Advertising and editorial for:

Mobil Oil, Texaco Oil, Courvoisier, Drambuie, Peter
Heering, Black Velvet, Colt 45, Labatt Beer, Christian
Dior, Coty, Bausch & Lomb, Hasselblad, Pentax, Procter
& Gamble, General Foods, CIBA-Geigy, Monsanto,
Scovill, American Tourister, Spiegel, L'Eggs, CBS
Records, Atlantic Records, Arista Records, Fortune,
VIVA, Esquire, Playboy.

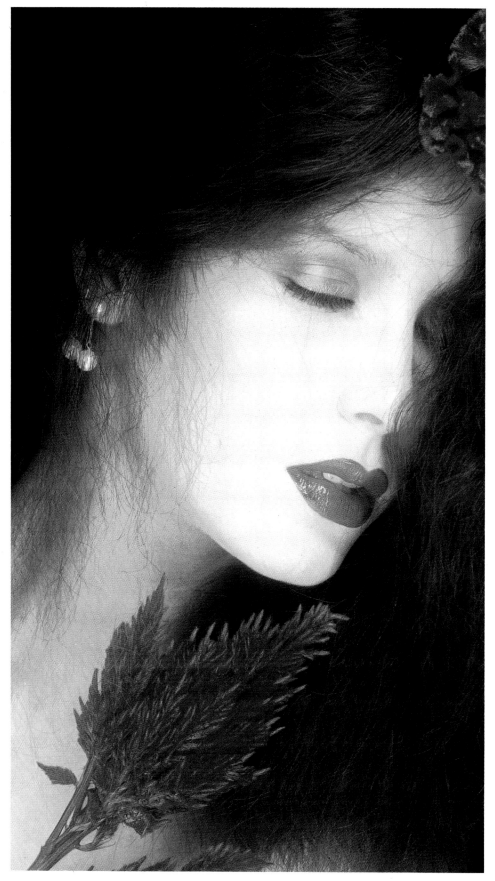

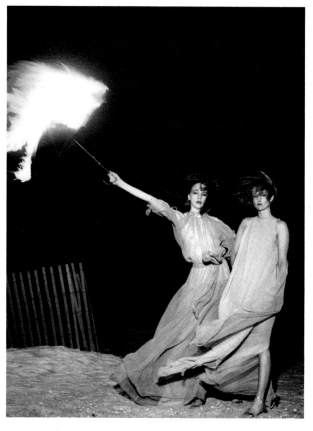

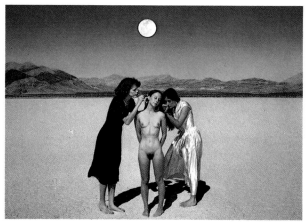

34 East 23rd Street
New York, New York 10010
(212) 475-1160

Representative: Edward Sun

Fuji, American Express, Orlane,
American Airlines, Mobil, A.M.C.,
Polaroid, Sussex, Golden Vee, Nik Nik,
Quantum, Drummond, Kaynee, Big
Smith, Western Union, Doubleday,
Vogue, Time-Life, J&B Scotch, Pall Mall,
Benson & Hedges.

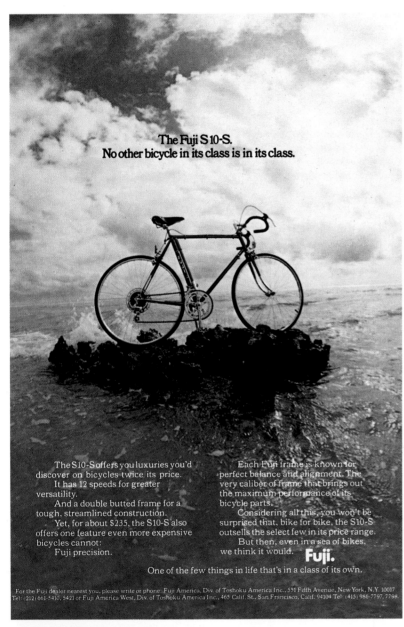

The Fuji S10-S.
No other bicycle in its class is in its class.

The S10-S offers you luxuries you'd discover on bicycles twice its price.
It has 12 speeds for greater versatility.
And a double butted frame for a tough, streamlined construction.
Yet, for about $235, the S10-S also offers one feature even more expensive bicycles cannot:
Fuji precision.

Each Fuji frame is known for perfect balance and alignment. The very caliber of frame that brings out the maximum performance of its bicycle parts.
Considering all this, you won't be surprised that, bike for bike, the S10-S outsells the select few in its price range.
But then, even in a sea of bikes, we think it would. **Fuji.**

One of the few things in life that's in a class of its own.

For the Fuji dealer nearest you, please write or phone: Fuji America, Div. of Toshoku America Inc., 551 Fifth Avenue, New York, N.Y. 10017 Tel: (212) 661-5410, 5421 or Fuji America West, Div. of Toshoku America Inc., 465 Calif. St., San Francisco, Calif. 94104 Tel: (415) 986-7797, 7798.

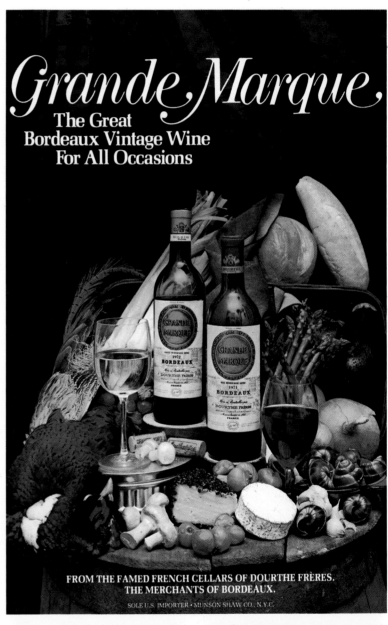

Grande Marque
The Great
Bordeaux Vintage Wine
For All Occasions

FROM THE FAMED FRENCH CELLARS OF DOURTHE FRÈRES.
THE MERCHANTS OF BORDEAUX.

SOLE U.S. IMPORTER • MUNSON SHAW CO., N.Y.C.

The boy by Mrs. Carlson.
The boy's shirt by Kaynee.

KAYNEE
Creating apparel for boys carefully and lovingly for over 80 years.

For a limited time only, our distinctly French purse organizer, the Maqui Pochette, and three very exclusive double-ended eye pencils (all told a $16.00 value) are yours for only $5.00 with any $6.00 Orlane purchase.
You'll find the Maqui Pochette a most clever accessory. For within this pure white leatherette envelope, sporting our Paris address, there's enough room for all the cosmetics you'd need to refresh your face during the day or before a colorful evening.
And since most memorable occasions are those in which much is said though little is spoken, our new eye pencils provide a vocabulary all

their own. Each comes with two subtle yet expressive colors. In the new Fall shades of Silver and Smoke, Moonglo and Blue Dawn, Shell and Woodrose that color so smoothly, so expertly, at first touch it is clear an art has been mastered.
Discover the Maqui Pochette, the new Fall eye pencil collection, and our world-renowned beauty treatments and cosmetics at finer stores everywhere.

ORLANE An advantage shared by the world's most beautiful women.

Orlane announces
an important bonus for the woman
who wishes to master
the art of self-expression.

ART KANE
1181 Broadway
New York, New York 10001
(212) 679-2016

New York Representative: Michele Saunders
235 West 75th Street
New York, New York 10023
(212) 580-3845

London Representative: Julian Seddon
Chelsea Cottage 183 Kings Road
London SW35EB England
(01) 935-0702

Chicago Representative: Bill Rabin & Assoc.
600 North McClurg Court
Chicago, Illinois 60611
(312) 944-6655

PALMA KOLANSKY
24 East 21st Street
New York, New York 10010
(212) 673-3553

Clients: Revlon, Coty, Avon, Elizabeth
Arden, Cosmopolitan, GQ, Menswear,
Essence, Cue Magazine, Beauty Digest,
Crawdaddy, A & S, B. Altmans, Pierre
Cardin, Clovis Ruffin, Raphael,
Alexander Julian, Sal Cesarani, Lee
Wright, Charlotte Ford, Micar Commu-
nications, Kayser Roth, J.P. Stevens,
Excello Shirts, Fiorucci, American
Optical.

STYLED BY JANE HEILES

MARK KOZLOWSKI
24 East 21st Street
New York, New York 10010
(212) 475-7133

Representative: Jane Mautner
(212) 777-9024

Advertising and editorial photography.
Photograph below: 57th Annual Art Directors Club Award.
Client: Psychology Today Magazine.
Article Title: The Battle Over Children's Rights.
Art Director: Neil Shakery.

GILLES LARRAIN
95 Grand Street
New York, New York 10013
(212) 925-8494

Advertising, travel, cars, still-life,
architecture, editorial, annual reports.
Clients include: Club Med, American Express, Renault USA,
Lankor, Pierre Cardin Eyewear, Facets, Scully & Scully,
Time, New York Times, Vogue, Rolling Stone, Oui, Stern,
Elle, Zoom, L'Express, Atlas, Architecture d'Intérieur, Crée,
Marvel Publications.

Extensive file of stock photographs.
Exhibitions. Books.

DAVID J. LEVEILLE
Northlight Studios Inc.
671 Panorama Trail West
Rochester, New York 14625
(716) 381-5341

Advertising, industrial, editorial photography.
Location or studio.

Partial list of clients includes: Anchor Hocking, BankAmericard,
Bausch & Lomb, Corning Glass, Hammermill Bond, Hooker Chemical,
Eastman Kodak, Raybestos-Manhattan, Xerox, etc., etc.

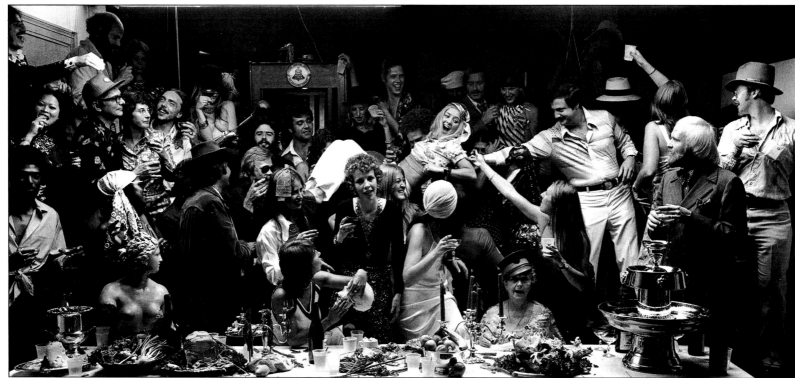

ALLEN H. LIEBERMAN
126 West 22nd Street
New York, New York 10011
(212) AL 5-4646

Still life photographer,
specializing in food, liquor,
and film production.
Procter & Gamble, Seagram, Fleischmann's, National Distillers, Heinz, Betty
Crocker, Nabisco, Purina, Rohm and Haas, American Express, Quaker State, General
Mills, General Foods, Kraft, American Motors, Dow Chemical, American Tobacco,
R. J. Reynolds, Liggett & Myers, Bell Systems, IBM, du Pont, Pepsi, Canada Dry,
Coca-Cola, Schaefer, Piels, Air France, TWA.

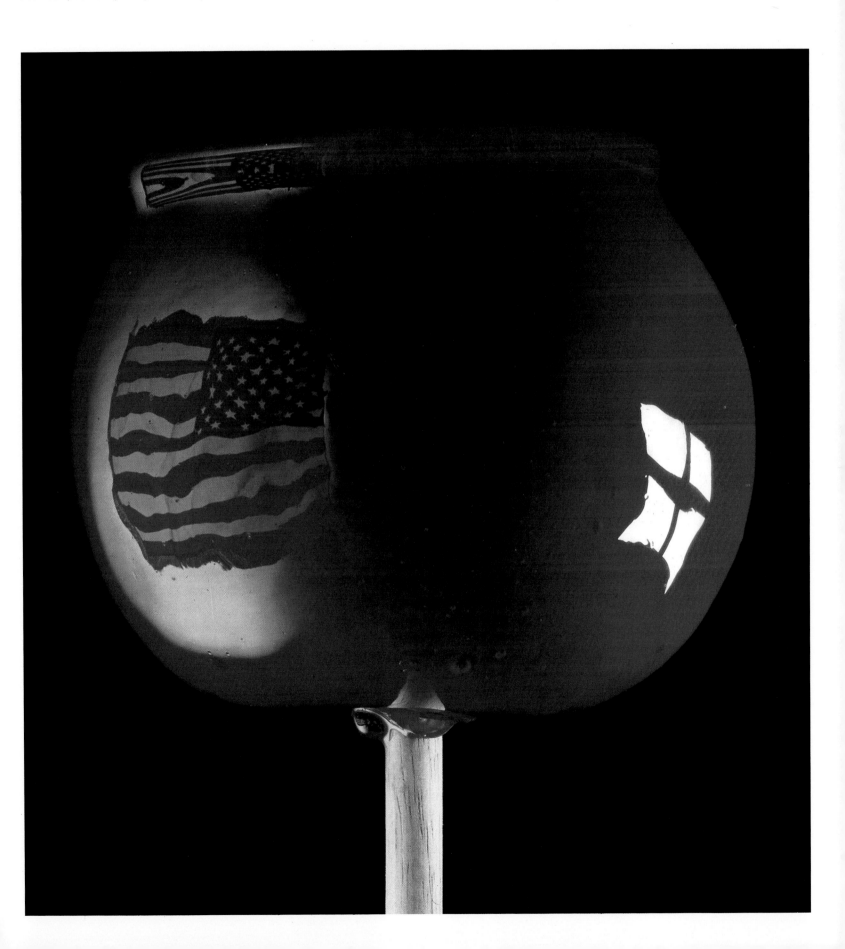

CHRISTOPHER LITTLE
New York, New York
(212) 691-1024

People.
For advertising. In editorial. On location.
In photojournalism. For fashion and beauty.
Personalities and problem-solving world-wide.

TV GUIDE

US MAGAZINE

AMERICAN AIRLINES

FABERGÉ

KLAUS LUCKA
35 West 31st Street
New York, New York 10001
(212) 594-5910

Representatives in New York, Chicago, Detroit, Europe and Japan.

Benson and Hedges, General Motors, Revlon, New York Times, Monet, Noxema, Max Factor, Secret, Clairol, Canadian Club Whiskey, Levis, Wrangler, Trevira, Parliament Cigarettes, Helena Rubinstein, Anheuser-Busch, Maxi Pads, Lord Extra Cigarettes, Europe, New York Telephone, American Standard, Harper's Bazaar, Ladies' Home Journal, Bausch & Lomb, Johnson & Johnson, Q-Tips, Amaretto, More Cigarettes, Colt 45, Sealy, Excedrin, L'Eggs, Hiram Walker, Fieldcrest, Texaco, Heinz, Chrysler, Maybelline, Motorola, Gentlemen's Quarterly, Hart Schaffner & Marx, Haggar, Volkswagen, American Optical, Swiss Air, VIVA, L'Uomo Vogue, Coca-Cola, Rolls Royce, United Brands, Town and Country, Procter & Gamble, etc.

DICK LURIA PHOTOGRAPHY, INC.
5 East 16th Street
New York, New York 10003
(212) 929-7575

"I believe a photographer must listen to his clients—focus in on their needs and give them what they want (even if they don't ask for it directly). In addition, he should bring an extra-special excitement and enthusiasm to his work. I do."

Corporate and industrial advertising and annual reports for over forty of the "Fortune 500": Allied Chemical, American Airlines, Babcock & Wilcox, Bear Stearns, Braniff International, Burroughs Corporation, Chemical Bank, E.F. Hutton, Eastern Airlines, Engelhard Minerals & Chemicals, Entenmann's Inc., Fortune, General Electric, General Signal, Getty Refining, IBM, ITT, Ingersol-Rand, International Paper, Lever Brothers, Merrill Lynch, North American Philips, Pratt & Whitney, Savin, Sperry & Hutchinson, Teltronics, Texasgulf, Toshiba, TWA, U.S. Steel, U.S. Surgical, Warner-Lambert, W.R. Grace.

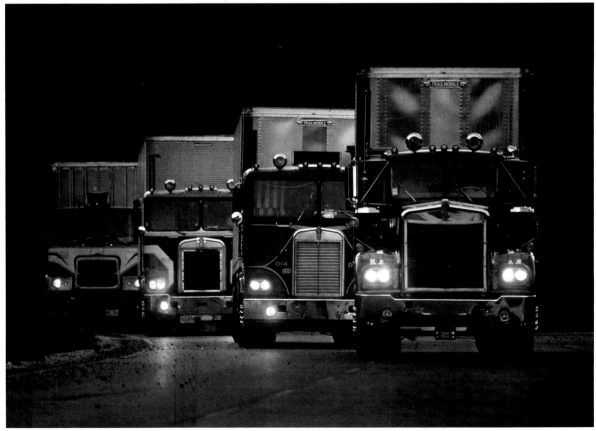

HOW TO INCREASE READERSHIP

Sometime ago, I was preparing a photograph of an elegant chair for reproduction. I had ordered the usual "range of prints," selected the best one for finished art and pushed the inferior prints off to the side of my desk. One of these rejects was badly overexposed and thoroughly unacceptable.

Simply because it was handy, I used this reject as a color palette, a coffee mat, and a backing for applying rubber cement. Finally, I crumpled it up tightly and threw it into my waste-paper basket.

When sometime later I had difficulty in opening a tube of paint, I lit a match, held the tube over it as I had done many times before and eased the cap off the tube. I then discarded the match and was dismayed when the rejected photo caught fire. I hurriedly extracted the burning photo, stomped the fire out with my feet and put it down where it would cause no further damage.

During the remainder of that day, several people entered my room and each without exception was enthusiastic about the artistic qualities of my overdeveloped, soiled, damaged, burnt photo. All agreed that it was very exciting as an example of expressionistic art. I tacked it to my wall where it continued to receive interest and praise.

Obviously, the way to capture the viewer's interest these days is to be obscure, sloppy, illogical, unbelievable and destructive.

IRVING D. MILLER

Do you know what one ulcer said to the other ulcer? "Oh my God, I think I'm coming down with a photographer!"

NICHOLAS DE SCIOSE

A FEW WORDS ABOUT SIMPLICITY

A few words about simplicity: it's not. Simplicity is a misnomer. To do something simple is in fact a very complex discipline exercising judgements of both restraints and releases. As a result, the semantics of the word "simple" suffer from much misinterpretation and misunderstanding. Sometimes a profusely propped set or background, in an attempt to create an attractive image, is more distractive and can confuse and even destroy an otherwise wonderful idea.

A successful graphic visual is one in which simplicity of light, composition, and overall design allows nothing to get in the way of the idea you wish to impart. The first serious portfolio I put together contained a battery of ideas and concepts, simply designed and lit. Today, 18 years later, I still light simply. The only difference is that I have begun to learn how to maintain that simplicity of light and design through a myriad of almost any given conditions.

Although today I enjoy the kudos of my expertise as a craftsman, to me, my photographic technique has always been of secondary importance to my interest and role as a visual communicator. Long before I ever held a camera, I was very seriously involved in the pursuit of painting as a career. My initial contact with photography occurred around this time as well, but my involvement was primarily assisting a photographer, and doing small photographic jobs as a way of paying for my loft rent and painting supplies. I also used the camera as a photographic notebook of ideas for future paintings.

Painting finally gave way to my growing interest in photography. What was one of the most determining factors was the speed with which the photographic medium could efficaciously record and communicate ideas. I was also in awe of what is probably one of photography's most salient and unique attributes — its credibility. A person looks at a photograph, and accepts as incontrovertible truth that what he sees does, in fact, exist. A photographic image, even when manipulated, can still hold a degree of credibility because of our natural propensity to accept it as truth. A case in point is "Star Wars," or even the fascination of "King Kong." Though it's nothing more than a large, overstuffed animal, the credibility of the medium carries the suspense, interest, and intrigue, regardless, because the viewer instinctively accepts photography as a mirror image of reality.

Personally, I am now at a very exciting crossroad of my career. One path is leading my print imagery in a gallery and museum direction, while the other is involving me in television commercials and film. What is even more interesting, is that I am following both paths simultaneously, and I am genuinely equally enthusiastic about each. Although the final outcome remains to be seen, when you are through changing, you are through, and that being the case, I am just beginning.

The metamorphosis of photography from its genesis is also very intriguing. What began as a crude apparatus used by painters as a drawing aid, has evolved into one of man's most eloquent and powerful tools of communication. Today, photography expands man's realm of consciousness and expression; it saves and illuminates our lives; explores our inner and outer space on a daily basis. It has ceased to crawl and begins to walk with ever increasing speed. Cinema and print abound in our concert halls and museums. Some of photography's aesthetic critics have accused it of being too mechanical. And in truth perhaps it is, and maybe more so than other implements of expression. However, to equate or evaluate one mode of expression over another is absurd, and an exercise in futility. In the final analysis, what really matters is not one medium or another in and of itself, but the individual expression of a human being, whether he or she chooses to manipulate a camera or a brush.

PHIL MARCO

PHIL MARCO PRODUCTIONS
104 Fifth Avenue
New York, New York 10011
(212) 929-8082

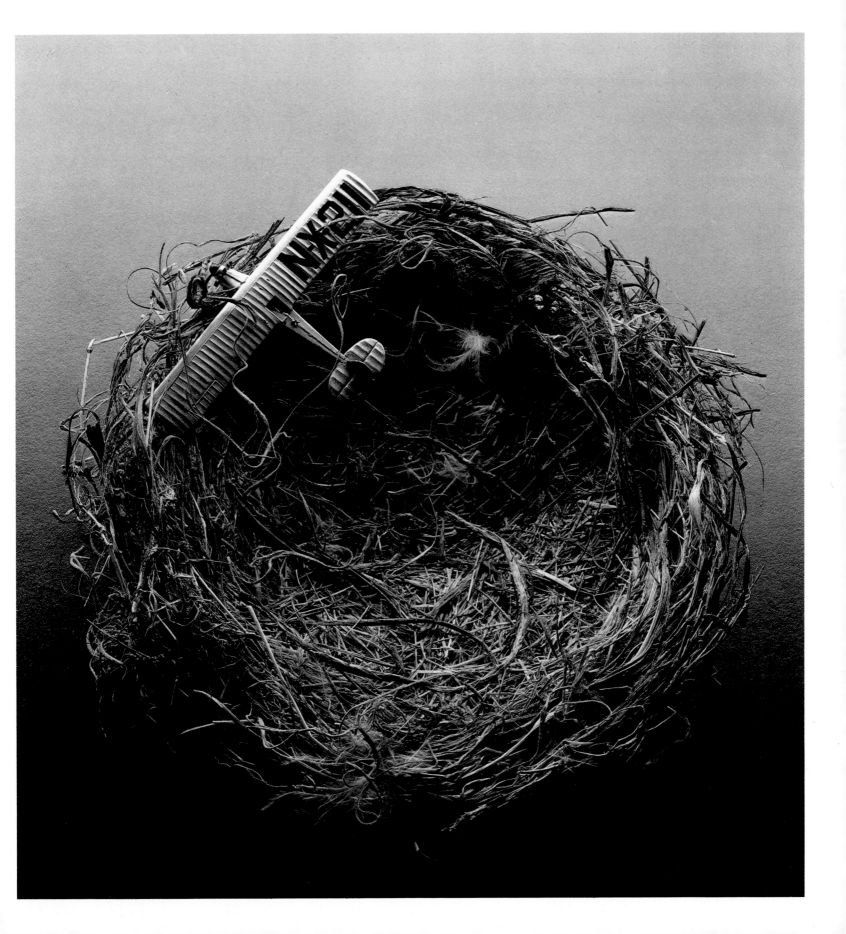

JOHN MARMARAS
235 Seventh Avenue
New York, New York 10011
(212) 741-0212

Representative: Woody Camp
(212) 355-1855

Clients include: Fortune, Business Week,
IBM, Xerox, Citibank.

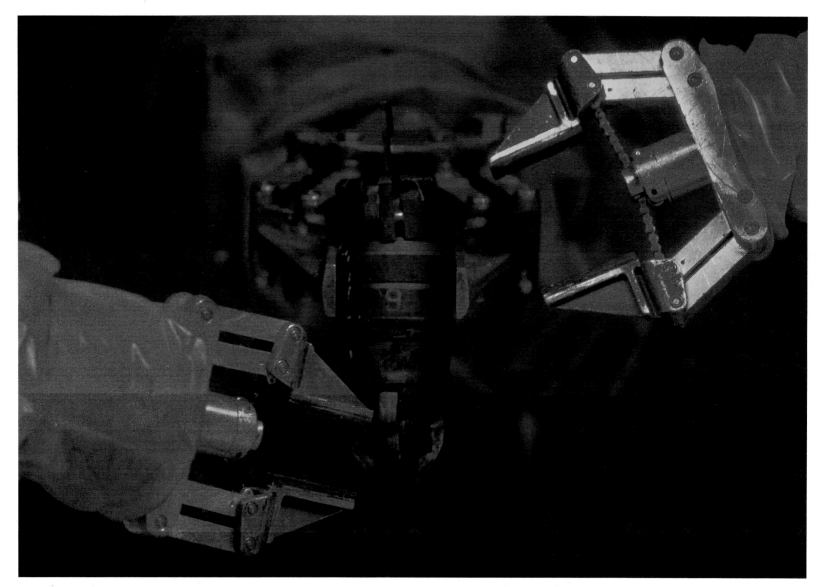

TOSH MATSUMOTO
30 East 23rd Street
New York, New York 10010
(212) 673-8100

Representative: Joan Jedell
(212) 861-7861

SUSAN McCARTNEY

Studio:
Room 1608
902 Broadway
New York, New York 10010
(212) 868-3330

Representative: Suzanne Goldstein
Photo Researchers Inc.
60 East 56th Street
New York, New York 10022
(212) 758-3420

Home:
P.O. Box 166
Wallkill, New York 12589
(914) 895-3122

Susan is an editorial and advertising photographer specializing in people, travel and tourism. Her work combines a strong feeling for color and graphic design with a real sensitivity to people all over the world. She has worked in over 100 countries and her pictures have appeared in most national magazines.

LOUIS MERVAR
29 West 38th Street—16th floor
New York, New York 10018
(212) 354-8024

Representative: Lillian Studer
(212) 687-2272

J. BARRY O'ROURKE
1181 Broadway
New York, New York 10001
(212) 686-4224

Chicago Representative: Clay Timon
(312) 641-0934

CHARLES J. ORRICO
72 Barry Lane
Syosset, New York 11791
(516) 364-2257 home
(212) 490-0980 office

Photography offering a variety in style and approach for agency, publication, and corporate needs. After attending Pratt Institute, Charles Orrico worked as an art director, later focusing his efforts totally toward photography. Visual communication, both competent and creative, has led to a variety of awards and an expanding list of clients.
Location and studio photography for advertising, editorial, beauty, still life and annual reports. Nature/environmental stock photos.
Member ASMP.

National
Geographic
goes
where the money is
...and here are the numbers that prove it.

A House of Many Styles

Light streams down 50 feet from skylight, left, nurturing exotic plants in the vast, balconied family room. Above, Susan and Michael Santangelo rest on wicker settee on grass-green carpeted balcony after hanging his portrait of her over fireplace to replace painting shown in view of the room at right. Despite the room's spaciousness, it has an intimate feeling created by splashes of color and ordinary furnishings contrasted with objects from around the world.

By Elaine Salkala *Photos by Charles Orrico*

Susan Phipps Santangelo loves to travel. She has explored sunken ships while deep-sea diving off Bora-Bora in the South Seas; she's been on safaris in Africa. Even as a child, she routinely went between school in Switzerland and her parents' two houses, one in Old Westbury, the other in Palm Beach. She finds it exciting.

That's why her magnificent mansard-roofed home on the water in Centre Island is such an exciting combination of so many different styles. The house where she and her husband, artist Michael Santangelo, live with her three small children and his teenage daughter is like a collage of vivid memories.

A remembered Normandy-style restored barn at Fontainebleau provided the inspiration for the basic structure of the U-

ONOFRIO PACCIONE
Paccione Photography Inc.
115 East 36 Street
New York, New York 10016

Representation: National and international
(212) 532-2701

Clients include: Eastern Airlines, General Electric, Seagram, Smirnoff, Gordon's Gin, Harry Winston, Bain de Soleil, Coca-Cola, Coty, Revlon, Gillette, R.J. Reynold's, Puerto Rican Board of Tourism, Dansk Design's, Ladies Home Journal, Travel & Leisure, Esquire, Viva, L'Oreal, Gucci, Oleg Cassini, Clairol, Foster Grant, Johnson & Johnson, Mennen, International Gold, Wamsutta, Colgate-Palmolive, Fleischmann's Gin, United Negro Fund, Shulton, Pioneer, Lark, Avon, CBS TV, McCalls, Collier Graphic Services, Norton-Simon, Monsanto, McGraw-Hill, Fieldcrest, Macy's, Neiman-Marcus, Barney's, American Express, American Home Products.

ONOFRIO PACCIONE
Paccione Photography Inc.
115 East 36 Street
New York, New York 10016

Representation: National and international
(212) 532-2701

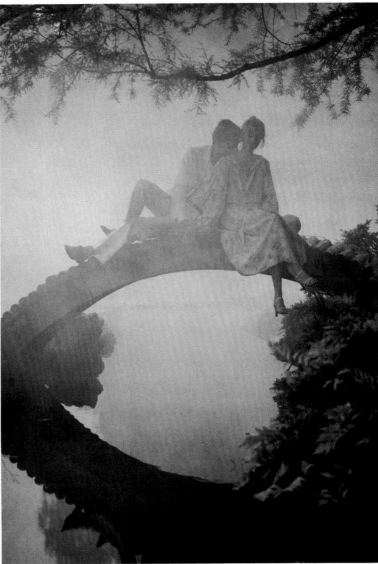

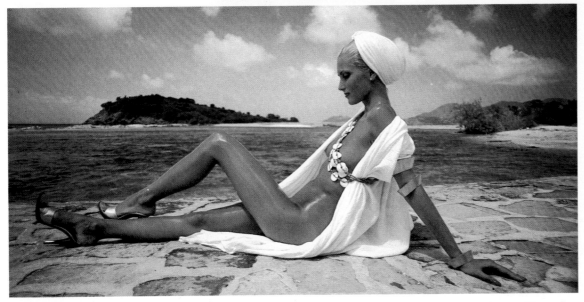
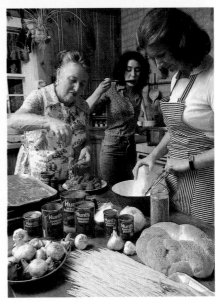

PETER PAPADOPOLOUS
78 Fifth Avenue
New York, New York 10011
(212) 675-8830

Representative: Ed Susse
(212) 477-0674

BRUCE PENDLETON
485 Fifth Avenue
New York, New York 10017
(212) 986-7381

Representative: Ursula G. Kreis
63 Adrian Avenue
Bronx, New York 10463
(212) 562-8931

Design problem: Show amphora shape, subdue ugly screw top and show type of wine.
Solution: Below.

Other design problems: Put German brewmaster into stein of beer—show your product on
the dark side of the spectrum—Reflect a group of executives in a car bumper....
Solution: Call for samples.

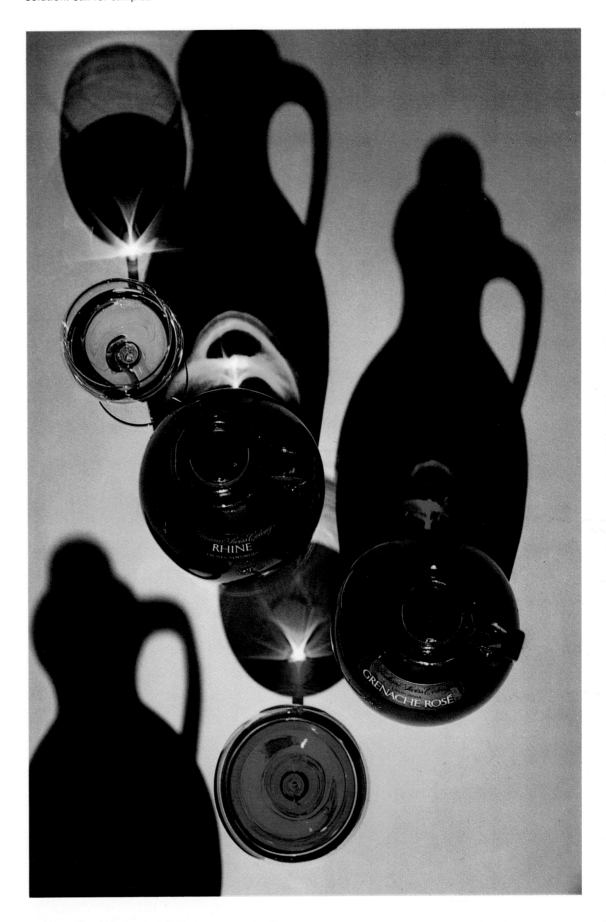

HENRY RIES
204 East 35th Street
New York, New York 10016
(212) 689-3794

HELIOPTIX© is a unique photographic concept.
Controlled motion of light and lens creates
designs of imaginative shapes and colors
around words, logos, products and symbols.

WILLIAM RIVELLI
24 East 21st Street
New York, New York 10010
(212) 254-0990
Cables: Rivelfoto

Representative: Cynthia Rivelli
(212) 254-0990

William Rivelli is a designer with a camera. For the past nine of his nineteen year career as a professional photographer, he has specialized in corporate and industrial subjects. He has photographed over one hundred annual reports as well as numerous advertisements and brochures. His clients include a host of financial institutions and major corporations, among them: Allied Chemical, The Bank of New York, The City of New York, Champion International, Conrac, The May Company, Westinghouse.
© William Rivelli 1979

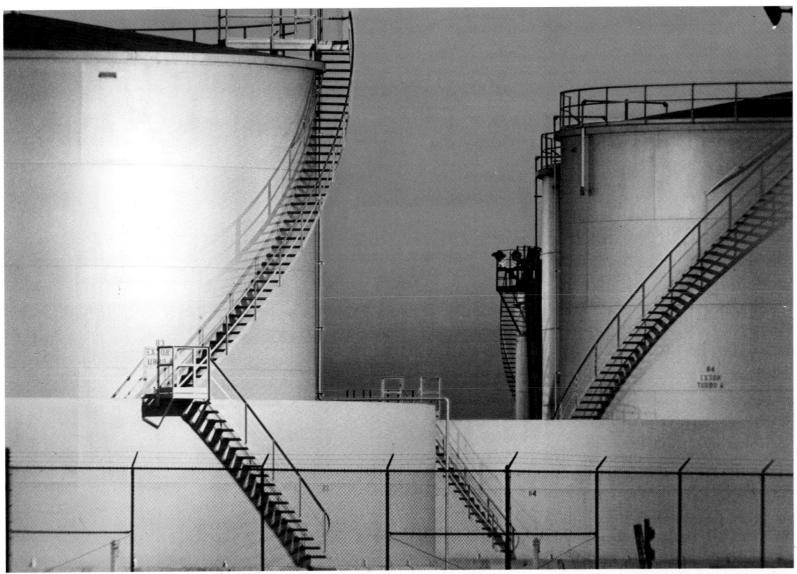

LAWRENCE ROBINS
Robins Studio Limited
5 East 19th Street
New York, New York 10003

New York Representative: Louise Marino
(212) 677-6310

California Representative: M. B. Weilage
(213) 651-2878

Chicago Representative: Owen Pulver
(312) 332-5325

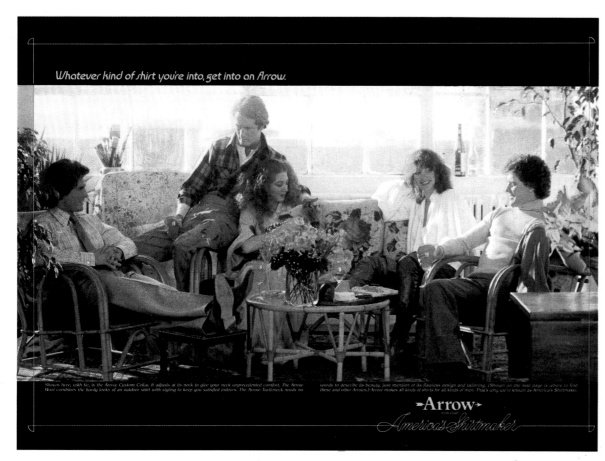

Whatever kind of shirt you're into, get into an Arrow.

>Arrow>
America's Shirtmaker

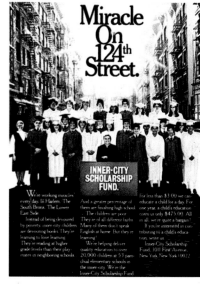

Miracle On 124th Street.

INNER-CITY SCHOLARSHIP FUND.

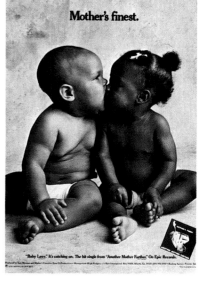

Mother's finest.

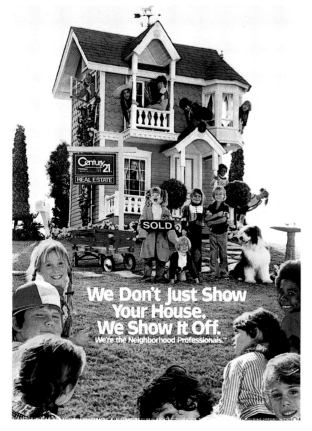

We Don't Just Show Your House, We Show It Off.
We're the Neighborhood Professionals.™

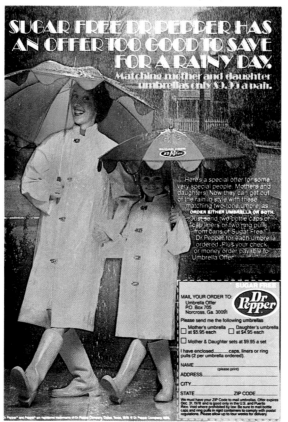

SUGAR FREE DR PEPPER HAS AN OFFER TOO GOOD TO SAVE FOR A RAINY DAY.

Matching mother and daughter umbrellas only $9.95 a pair.

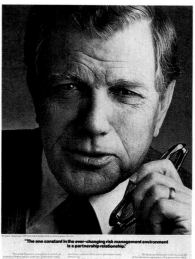

BEN ROSE
91 Fifth Avenue
New York, New York 10003
(212) 691-5270

Representative: Sol Shamilzadeh
1155 Broadway
New York, New York 10001
(212) 532-1977

Multiple imaging. Space, time motion studies. Stroboscopy. Image programming techniques. Time selection in micro seconds. Freezing short events —sports. Logos in motion. Sophisticated electronics in photography. Outer space events. Illusions.

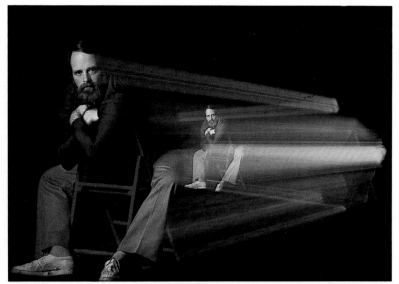

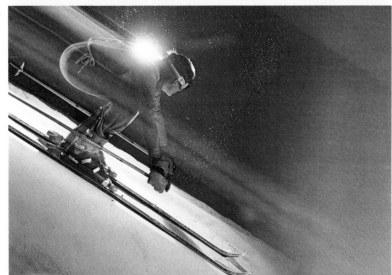

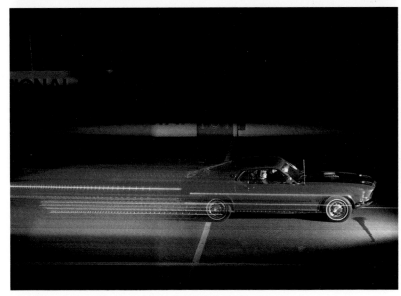

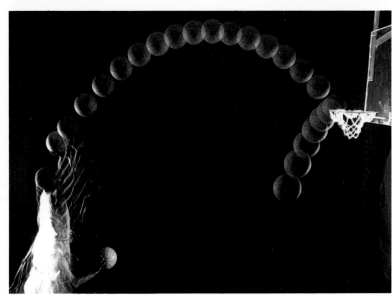

STEWART ROTH
23 East 21st Street
New York, New York 10010
(212) 673-8370

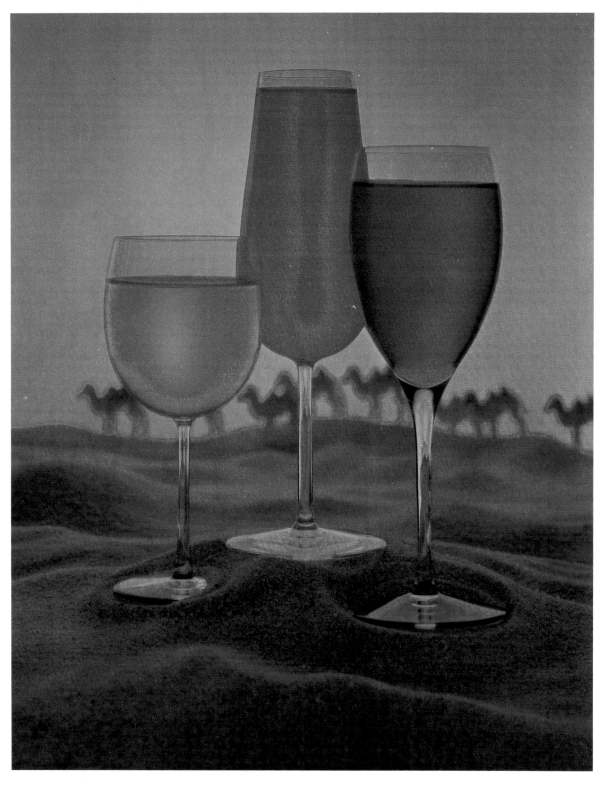

FRED SCHULZE
163 West 23rd Street
New York, New York 10011
(212) 242-0930, 242-0480

Representative: William Broderick
(212) 242-0930

Advertising, still life, annual reports.
Clients: Coty, Avon, Revlon, Estée Lauder,
Borghese, General Foods, Weight Watchers,
Seagram, ITT, IBM, CIBA-Geigy, Van Heusen,
Nikon, Johnson & Johnson, S.C.M., U.S. Steel,
Woman's Day, Ladies' Home Journal, Parent's
Magazine, Redbook.

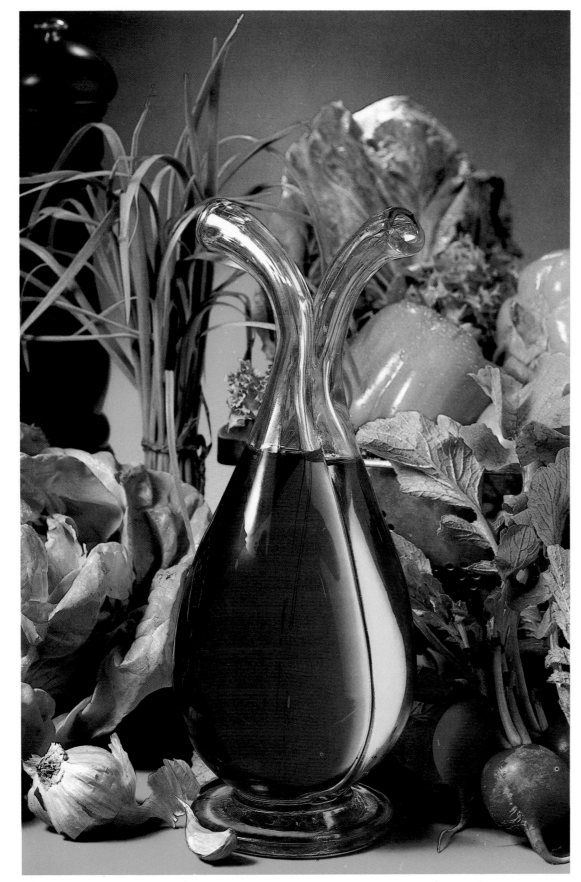

**AN OPEN MESSAGE TO THE
BEST EX-CREATIVE PEOPLE
IN OUR BUSINESS
And To Those Headed in
That Direction**

"Nothing great was ever achieved without enthusiasm." **Ralph Waldo Emerson**

I believe in Emerson's quote from the bottom of my heart. The joy of coming up with a big idea — the thrill of selecting the right picture — the fun of making the type work — and then that marvelous sense of anticipation in waiting for the first proof to come in. For me, these are still the most thrilling parts of this whole damn business.

I still love to see the work I personally created appear in magazines, newspapers and on the air. I still love being an advertising art director even though I don't have to be one anymore.

And that's the point of this message. My agency, Rosenfeld, Sirowitz & Lawson, Inc., in seven short years has grown to over $50 million in billings and is staffed with lots of very talented admakers. It would be so easy for me to tell myself that I have more than I can handle in running the company with my two partners, Ron and Tom. On top of that, there's supervising others, spending time with the clients and pitching new business. If I wanted to stop making ads myself, I could easily justify it.

But I won't stop. My partner, Ron Rosenfeld, won't stop. We love it too much. For us it's a way of life.

To me, the saddest thing about this business is what ultimately happens to the best art directors and copywriters in the giant ad agencies. They do such a good job of making ads — they get promoted out of it. Fulltime. They start running big departments, signing expense reports, going to meetings, seeing the client and are forced to play the odious game of office politics that they were not put on this earth to tangle with.

The management of those agencies, sensing their valued employees' frustrations, will tell them their sacrifice is for the good of the shop. It's the mature approach. While at the same time, the management of those agencies is privately thinking they were really more valuable when they were creating those ads that used to attract clients to their agency.

So sad. That raw and rare talent, that got them where they are today, soon fades. Their creative fires go out. They no longer can inspire others. Their enthusiasm for the whole business wanes. The jobs they were promoted into sour. They become lost souls.

Listen to me, men and women who are creative no longer. Listen, before it's too late. Move heaven and earth to get back to making ads again. Even if it's only part-time. Jog your mind again! Let the juices flow again! Inspire by example again. Earn respect again. Grow through working with talented photographers, illustrators and filmmakers again. Thrill to the joy of seeing your first proofs come off the press again. Become more valuable to your company again. And to yourself again.

**LEN SIROWITZ
Executive Vice President, Partner, Co-Creative Director
(Working art director and feeling good.)
Rosenfeld, Sirowitz & Lawson, Inc.
New York City**

HERB SCULNICK
133 Fifth Avenue
New York, New York 10003
(212) 777-3232

Bringing life to still life, with more than
fifteen years experience with food, liquor,
and product photography. Past and present
clients include: Somerset Importers, Taylor
Wines, Bacardi, McCall's Magazine and Johnson
& Johnson. Fifth Avenue studio with complete
kitchen facilities.

*An idea so advanced, it has changed the face
of marine instrumentation for all time.*

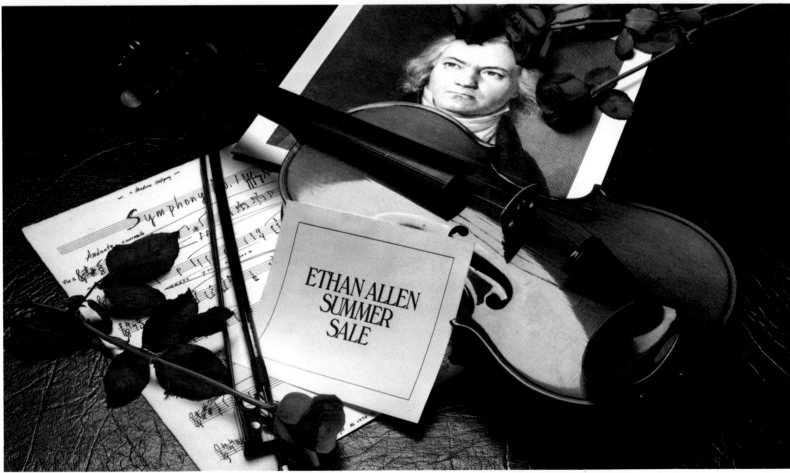

HARRY SEAWELL
Seawell Multimedia Corporation
Suite 3, 215 Eleventh Street
Parkersburg, West Virginia 26101
(304) 485-4481

Washington, D.C. Representative: Shari Hall
(202) 244-7823
New York Representative: Margery Andrews
(212) 777-3770
New Orleans Representative: First National Productions
(504) 897-1592
Denver Representative: Henry Associates, Inc.
(303) 756-4811

When you can't afford to miss the action, you need a damn good location photographer.

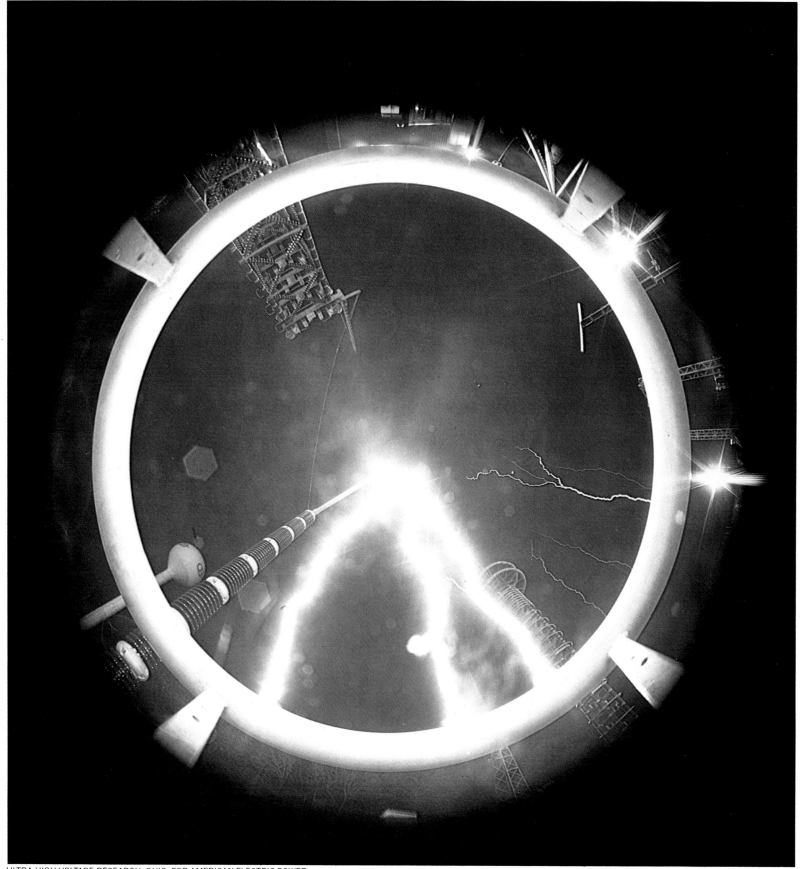

ULTRA HIGH VOLTAGE RESEARCH, OHIO, FOR AMERICAN ELECTRIC POWER

HARRY SEAWELL
(304) 485-4481

Fuller & Smith & Ross, Ketchum MacLeod & Grove, Ogilvy & Mather, J. Walter Thompson, Edward Weiss, Viewpoint, Young & Rubicam, Business Week, Fortune, Ladies' Home Journal, Life, Paris Match, Reader's Digest, Sports Illustrated, Stern. Aluminum Ltd., American Electric Power, Armco Steel, Ashland Oil, AT&T, Borg Warner, Columbia Gas, Douglas Aircraft, Federal Express, Florida Rock, Gulf Oil, Inland Steel, Kaiser Aluminum, L·O·F, McGraw-Hill Books, Missouri Pacific, M.I.T., National Steel, PPG Industries, Shell Chemical, Time-Life Books, Union Camp, Union Carbide, Vulcan Materials, Westinghouse.

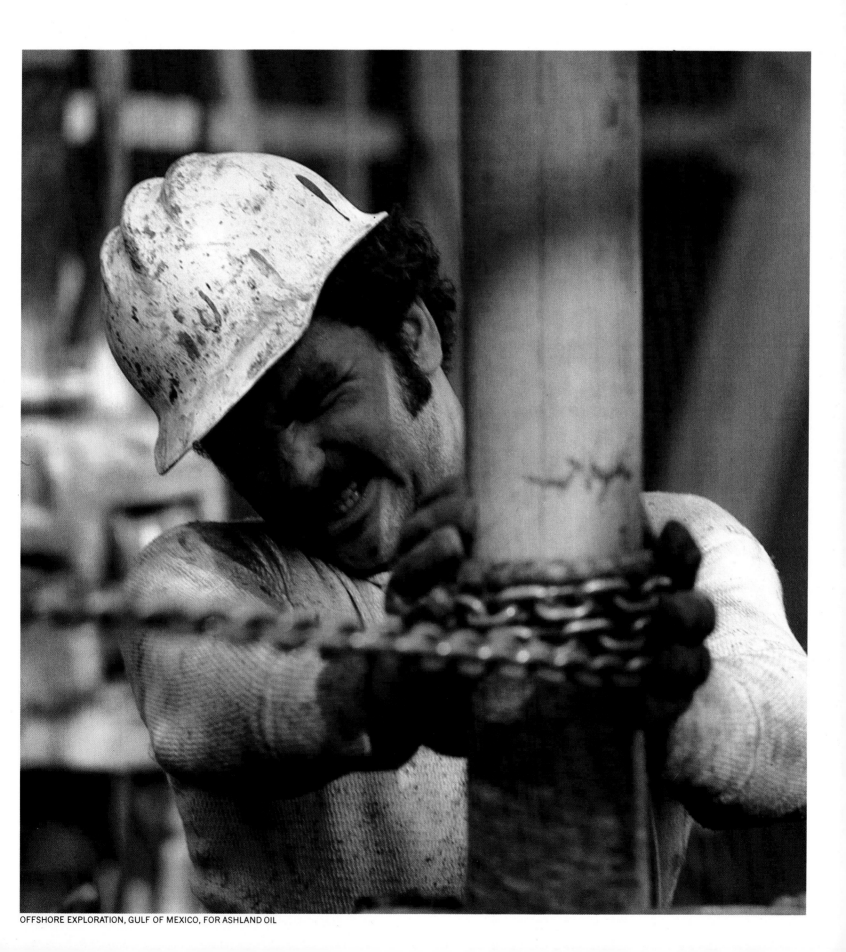

OFFSHORE EXPLORATION, GULF OF MEXICO, FOR ASHLAND OIL

BARRY SEIDMAN
119 Fifth Avenue
New York, New York 10003

Representative: Judith Shepherd
(212) 838-3214

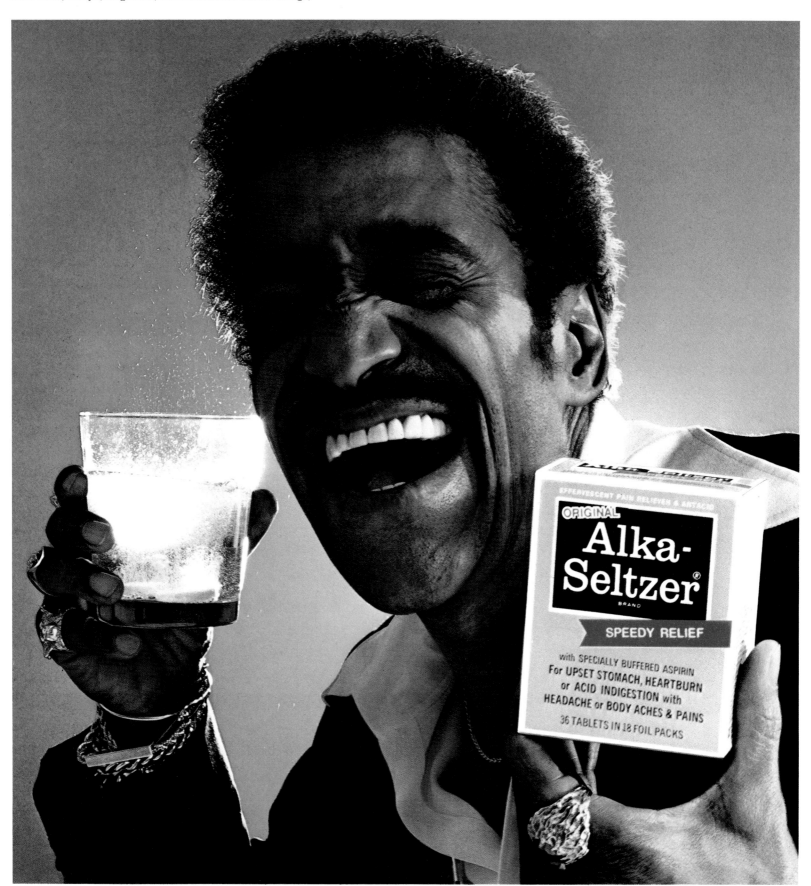

SEPP SEITZ
381 Park Avenue South
Room 1216
New York, New York 10016
(212) 683-5588
(516) 367-9675

Clients: American Express; Anglo;
AT&T; Cummins; Esquire; IBM; Main,
Lafrentz; Peat, Marwick, Mitchell;
Price, Waterhouse; SCM; Schlumberger;
U.S. Steel; Ziff-Davis.

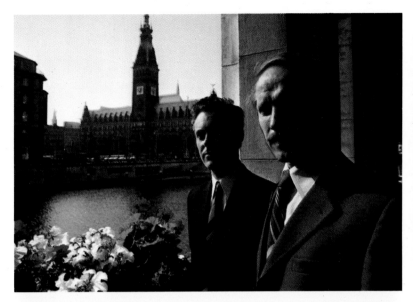

GUY J. SHERMAN
581 Avenue of the Americas
New York, New York 10011
(212) 675-4983

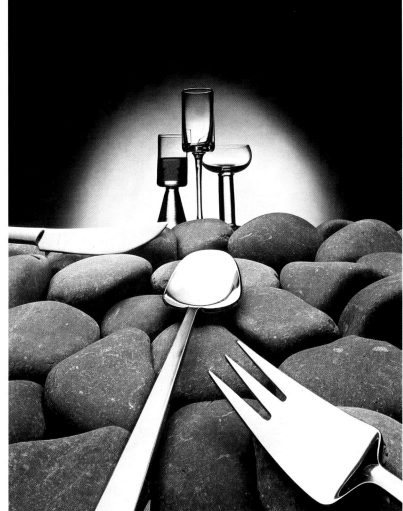

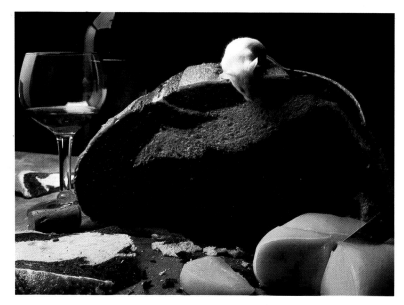

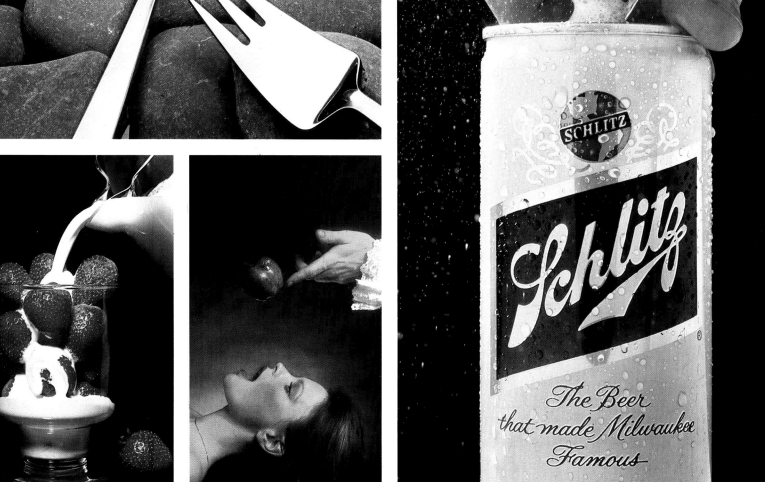

GUY J. SHERMAN
581 Avenue of the Americas
New York, New York 10011
(212) 675-4983

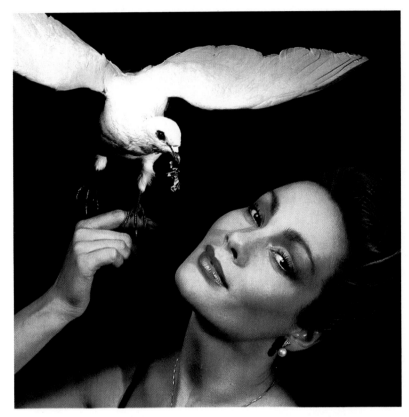

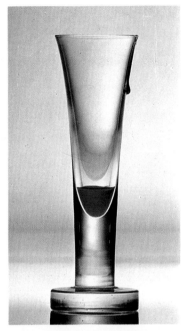

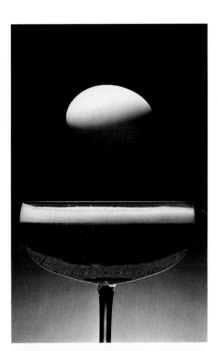

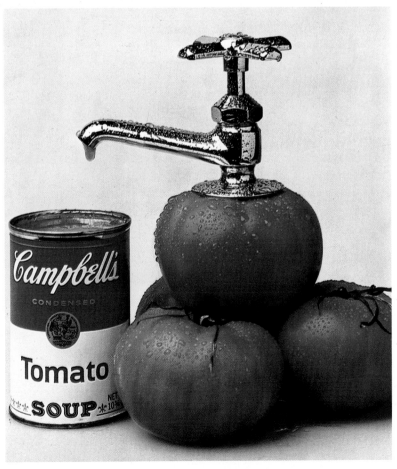

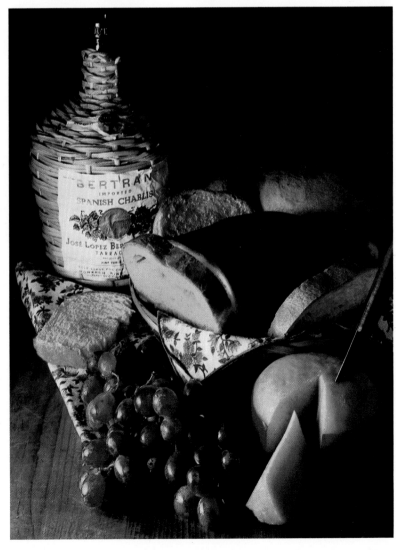

CARL SHIRAISHI
137 East 25th Street
New York, New York 10010
(212) 679-5628

Representative: Kim
(212) 679-5628

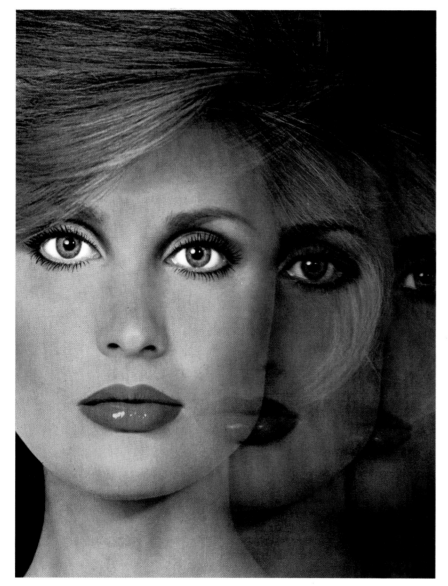

GORDON E. SMITH
134 East 28th Street
New York, New York 10016
(212) 679-2350
(203) 655-9226

Over 15 years dedicated professional photography for major ad agencies, corporations and national magazines.

Numerous awards: New York Art Directors Club, Society of Publication Designers, Creativity Show, Tucson Art Directors Club and others. Graduate of Art Center College of Design.

Heavy experience foods (location and studio); food and people; beverages, interiors and all types of still-life. 35mm to 8x10. Enjoys travel.

HOWARD SOCHUREK
680 Fifth Avenue
New York, New York 10019
(212) 582-1860 office
(914) 337-5014 home

Electronic imaging, color conversion and image enhancement.
Medical illustration, ultrasound, thermography, X-ray color.
Photojournalism for advertising, capabilities books,
and corporate reports.

Clients: IBM, SCM, AVCO, Revlon, Eastman Kodak, Squibb,
Time-Life, Pfizer, Gillette, Merrill Lynch, Pan Am, Carrier,
G.M., Western Electric, Newsweek, Boeringer-Ingelheim,
Forbes, Wheelabrator-Frye, Rockwell, Cameron Iron,
Belco Petroleum, McDonnell Douglas, Kimberly-Clark,
and many many more.

SPORTS ILLUSTRATED PICTURE SALES DEPARTMENT
Room 1919
Time & Life Building
New York, New York 10020
(212) 841-3663
(212) 841-2803
(212) 841-2898

Manager: Karen B. Loucks

SPORTS ILLUSTRATED photography—a tradition of excellence.

Stock photography and assignments now available for editorial, advertising, and a full range of related promotional uses.

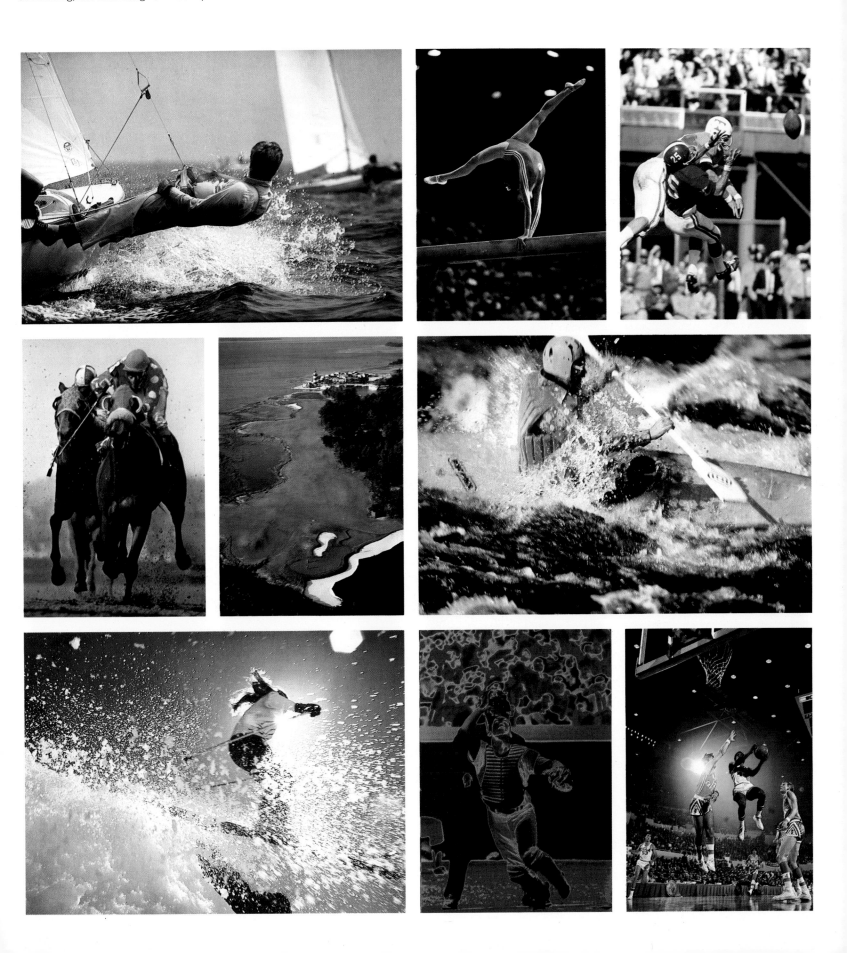

JOE STANDART
377 Park Avenue South
New York, New York 10016
(212) 532-8268

An excitingly different talent—use it. They did: Ambiance, American Express, AT&T, Baron, Costello & Fine, Inc., Bessen & Tully, Bundy Corporation, Camera 5, Cosmopolitan, Glamour, House and Garden, Intercontinental Hotels, Pan Am, Travel and Leisure, Us, and many others.

Joe does corporate, location, foreign travel, industrial, still life, interiors, food, editorial illustration. To each job he brings the special spark and warmth that is the mark of his photographs.

PAN AM DID IN SCOTLAND

YOU CAN ANYWHERE

HILTON DID IN COLOMBIA

AVIANCA DID IN PERU

CHARLES STEINER
61 Second Avenue
New York, New York 10003
(212) 777-0813

Representative: John Henry
(212) 686-6883

Corporate/industrial, architecture, portraiture.

Photograph:	Client:	Art Direction:
Space shuttle assembly building	STV, Inc.	Vance Jonson
Design Research Store	Progressive Architecture	Sharon Ryder
Chairman and president	American Maize-Products	John Waters
Programmer and supervisor	Supermarkets General	Fujita Design
Diagnostic test serum	Flow General, Inc.	James Cross
Welder	Theobald Industries	Theobald Industries

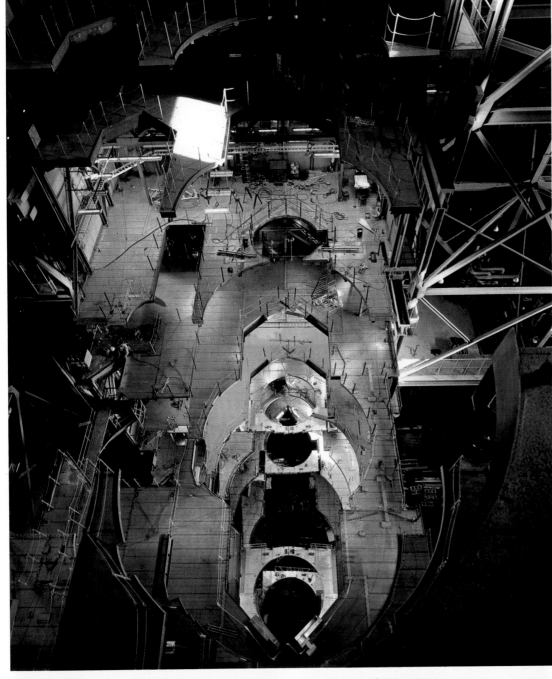

BOB STERN
39 West 38th Street
New York, New York 10018
(212) 354-4916

Corporate/industrial	—	Tenneco
Editorial/brochures	—	AT & T
Advertising	—	Minolta
Still life	—	Oscar de la Renta
Beauty	—	Coty
Products	—	Avon
People	—	Dewars
Fashion	—	Cotton Incorporated
Photo-animatics	—	General Foods

BEN SWEDOWSKY
381 Park Avenue South
New York, New York 10016
(212) 684-1454

Still-life photography for advertising, editorial, corporate brochures and annual reports.

Wide range of clients from liquor, food, cosmetics, jewelry, cigarettes to interiors.

Exploration of creative lighting, surfaces and effects; the tools of a still-life photographer.

Portfolio available upon request.

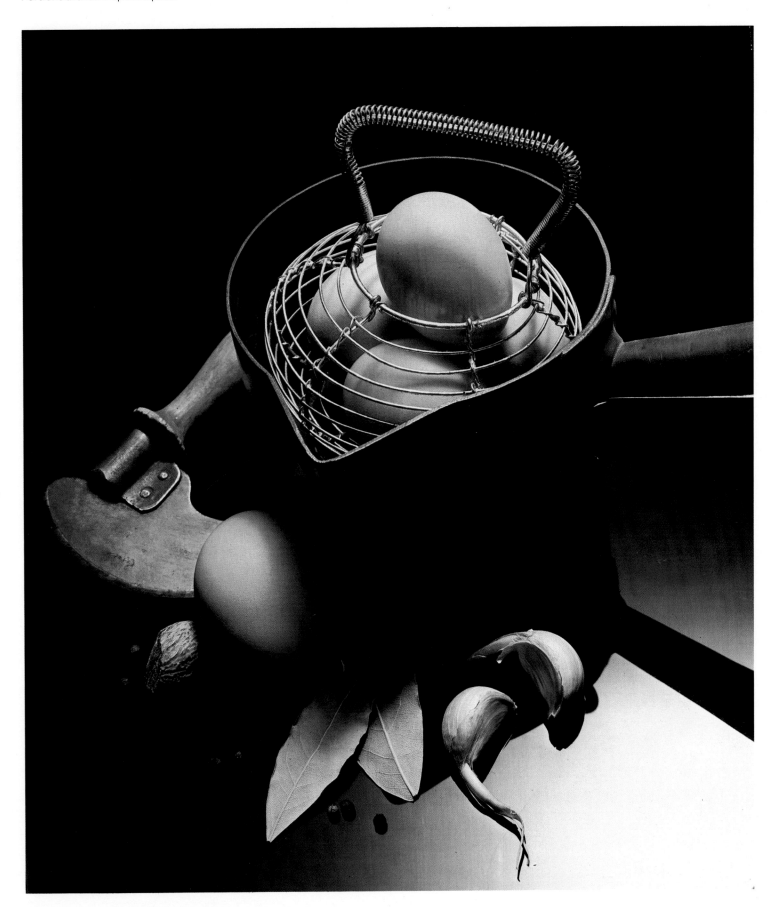

KEN TANNENBAUM INC.
306 Fifth Avenue
New York, New York 10001
(212) 947-5065

Representative: Camille Daniels

Classic elegance. Pure and simple.

96

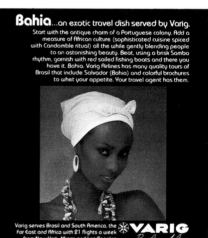

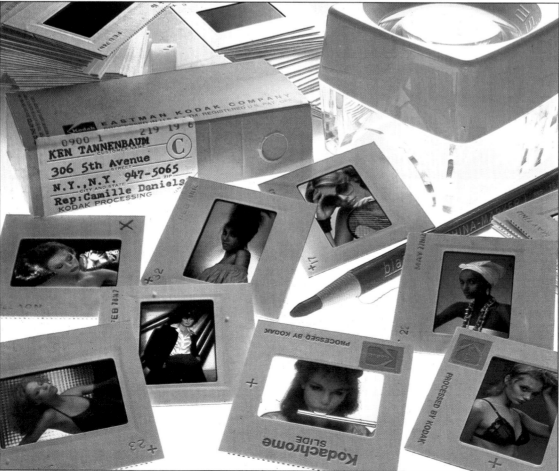

MICHEL TCHEREVKOFF
873 Broadway
New York, New York 10003
(212) 228-0540

Representative: Nob Hovde and Laurence
(212) 753-0462

Michel Tcherevkoff designs the strong graphic
image that makes commercial photography an
art form. Technically and conceptually inno-
vative, Michel has photographed a range of
subjects including food, liquor, cosmetics,
jewelry, cars and interiors. He has worked for
almost every major advertising agency, advertiser
and magazine in the United States. His work has
been produced and exhibited world-wide.

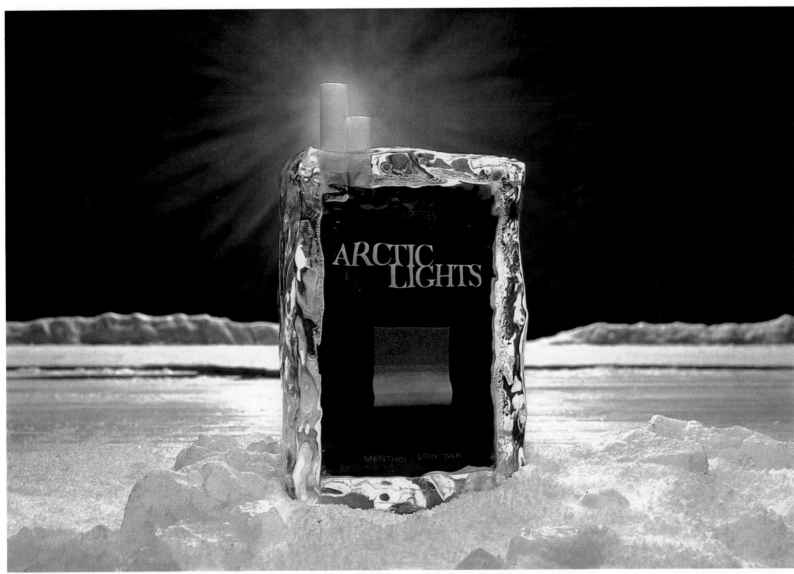

PETE TURNER
154 West 57th Street
New York, New York 1001
(212) 245-0981

Chicago Representative: Bill Rabin
(312) 944-6655

Up to now, when you wanted to show an altered reality your choice was limited to nonphotographic art. Now you can combine commercial photography with inner, normal or outer space events. We do mat work and complicated multiple element combinations. This plus laser technology in real or sidereal time. It's just possible that we can take you on the ultimate trip. These photographs are unretouched.

Stock photography: The Image Bank

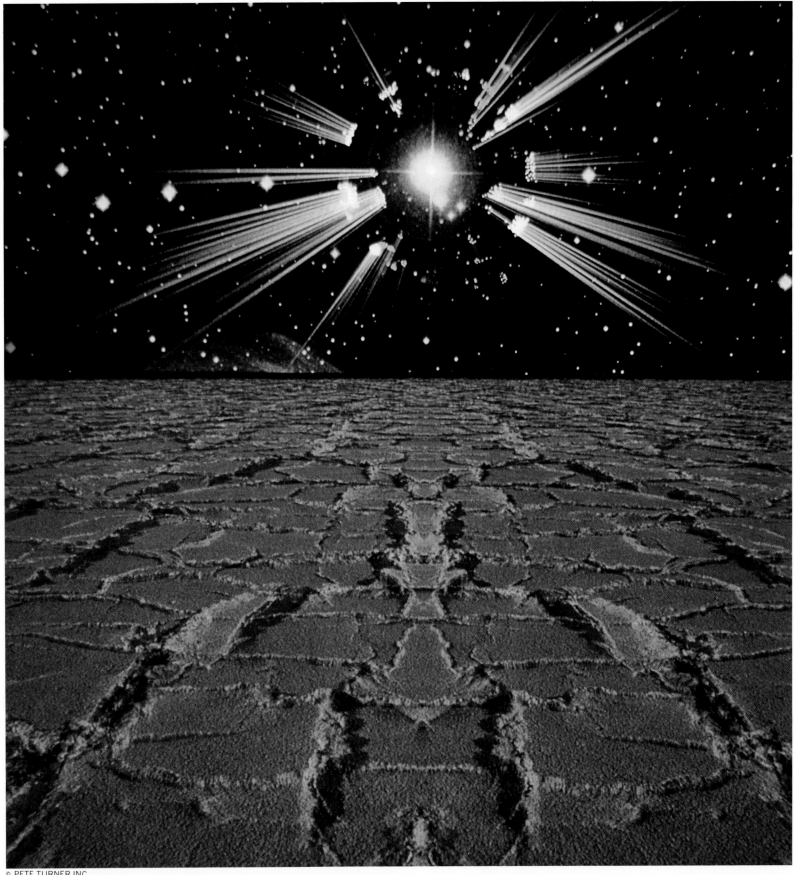

PETER VAETH
Carnegie Hall
New York, New York 10019

Representative: Stogo & Bernstein Assoc., Inc.
60 East 42nd Street
New York, New York 10017
(212) 697-5252

JAMES A. VICARI
8 East 12th Street
New York, New York 10003
(212) 675-3745

Specializing in advertising and editorial still life, industrial, travel and people illustration.

Clients: Lenox China and Crystal, J&B Scotch, Seagram's VO, Schaefer Beer, Julius Wile, Dr. Pepper, Pentax, Smith-Corona, GAF, International Silver, General Foods, Avon, Monsanto, CBS Records, Bulgari Jewelry, Bonne Bell Cosmetics, Helena Rubinstein, Clairol, Revlon, Vidal Sassoon, Bottega Veneta, Mark Cross, Food & Wine Magazine.

Portfolio available upon request.

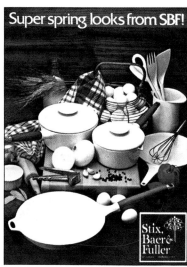

FRANK WHITE
Time-Life Building
Room 2850
Rockefeller Center
New York, New York 10020
(212) 581-8338

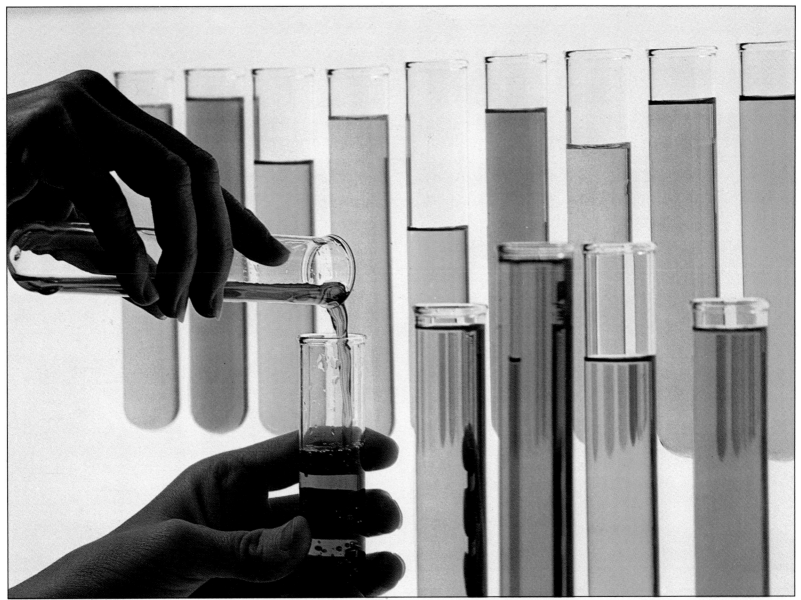

WOODFIN CAMP AND ASSOCIATES
415 Madison Avenue
New York, New York 10017
(212) 355-1855
Cable: Campfoto, New York

Woodfin Camp, Incorporated
1816 Jefferson Place, N.W.
Washington, D.C. 20036
(202) 466-3830
Cable: Campfoto, Washington, D.C.

Associate offices in London, Paris, Hamburg and Tokyo.

We represent 25 major photographers around the world.
Contact us for comprehensive stock files or original
assignment work.

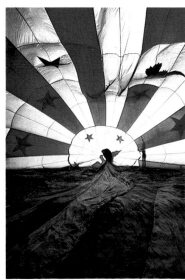

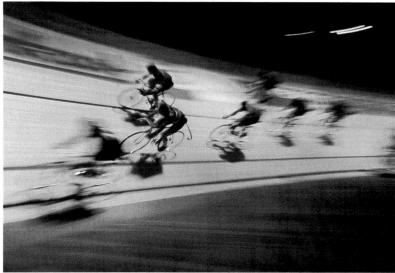

© DAILY TELEGRAPH MAGAZINE 1978 © CRAIG AURNESS 1978 © G&J FOTOSERVICE 1978

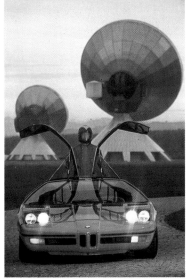

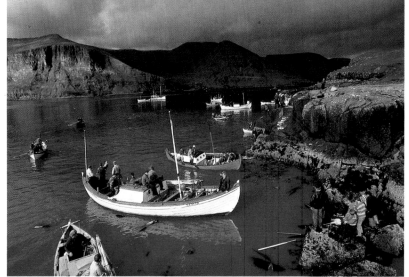

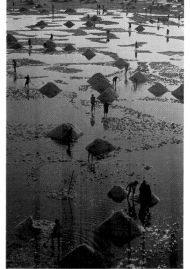

© THOMAS HOPKER 1978 © ADAM WOOLFITT 1978 © LOREN McINTYRE 1978

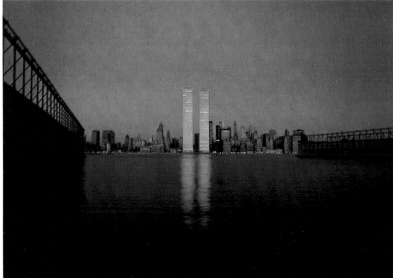

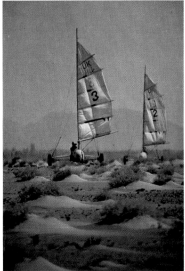

© TIMOTHY EAGAN 1978 © ADAM WOOLFITT 1978 © THOMAS HOPKER 1978

HERBERT WOODWARD
555 Third Avenue
New York, New York 10016
(212) 685-4385

Clients include: N. W. Ayer, Benton &
Bowles, Bozell & Jacobs, CBS Pub-
lishing, Grey Advertising, Good
Housekeeping Magazine, Kenyon &
Eckhardt, Marschalk, J. M. Mathis,
McCann-Erickson, Ogilvy & Mather,
Seventeen Magazine, S S C & B,
J. Walter Thompson, Young &
Rubicam.

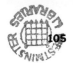

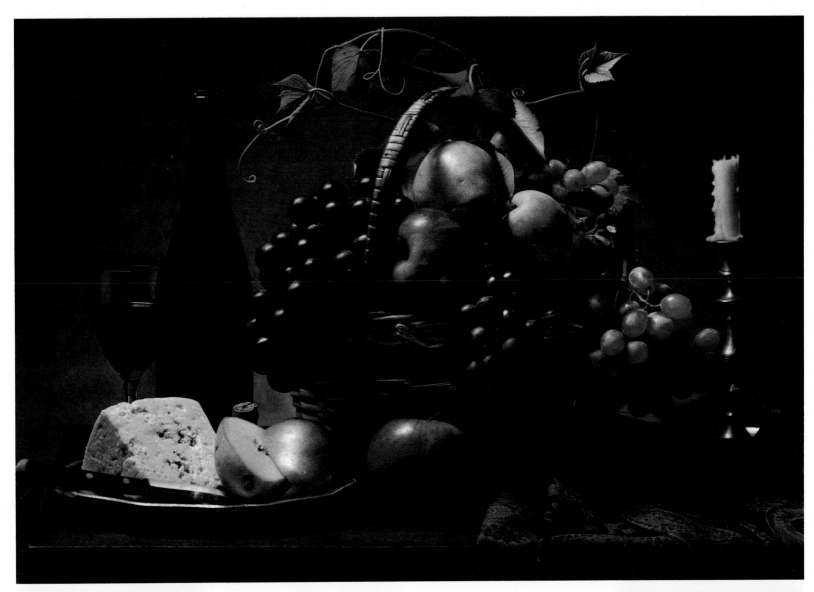

Multiply her by *Seventeen* and
you're into a $20 billion market.

YAMAOKA STUDIO
35 West 31st Street
New York, New York 10001
(212) 736-8292

Mike Yamaoka specializes in: advertising and editorial illustration, still life, travel, industrial, food, people and film.

Partial list of clients: American Express, Audio Video Magazine, Black and Decker, Caloric, Campbell Soup, Chiquita Banana, Citibank, Clairol, Dean Witter, Family Health Magazine, General Electric, Gillette, Greenwood Mills, Gabriel Industries, Geo. A. Hormel, Lever Brothers, Minolta Camera, People Magazine, PGA Golf Equipment, Pitney Bowes, Radio Relay, Sheraton Hotel, Sterling Drug, St. Regis, Taylor Wine, Time-Life, Wall Street Journal, Bonate, Drexel Heritage Furnishing, International Commodities Export and Avon.

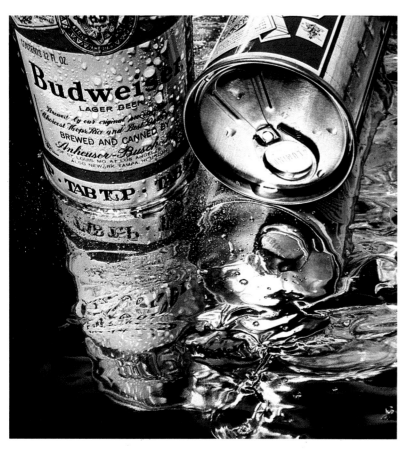

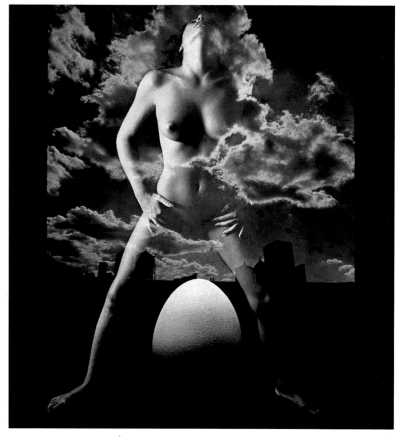

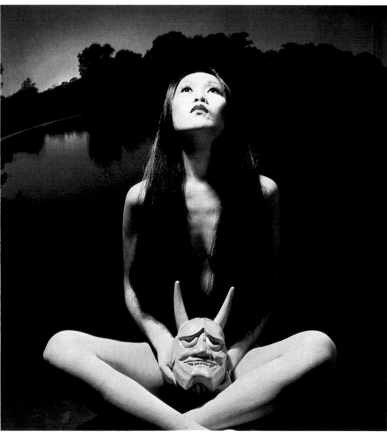

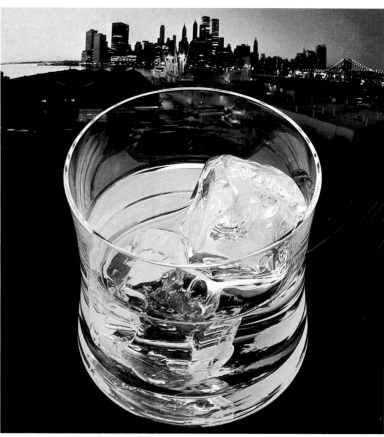

TONY ZAPPA
28 East 29th Street
New York, New York 10016
(212) 532-3476

JOHN G. ZIMMERMAN
Girard Studio Group, Ltd.
9135 Hazen Drive
Beverly Hills, California 90210

Representative: Delores Zimmerman
(213) 273-2642
Chicago Representative: Bill Rabin & Associates
(312) 944-6655

Innovative illustrations.
People, action, fashion, travel, sports, etc.

See West Coast Section,
Page 198.

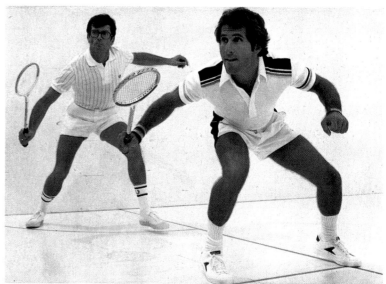

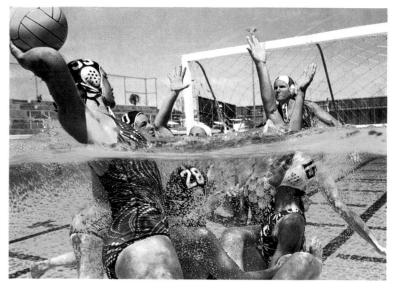

There has been tremendous growth in the use and appreciation of photography by corporations in recent years, accompanied by a deepened recognition that photography is a vital tool in corporate communications.

In addition to its practical advantages, there is also a special element of personal pleasure involved. Contact with a photographer is one of the few remaining examples of a creative, one-to-one relationship in business, and the sparks and excitement that result are tremendously gratifying.

Advertising is still the largest outlet for corporate photography, but that's a bit out of my bailiwick. I'm more involved with a documentary style of photography that attempts to capture, realistically and artistically, the day-to-day life and work of a corporation. There's little overlap between photographers working in the two areas; many of the photographers doing the news-style documentary work are former staffers of Life magazine whose background and training were in photojournalism.

The annual report is the main user of this real-life corporate photography, but companies are developing the medium in other ways, such as internal publications, descriptive booklets, and special projects. At Squibb our commitment to photography has manifested itself in new dimensions: the walls of our world headquarters in Princeton are decorated with several hundred dye transfer prints of nature photographs, and a photography exhibit was one of the most popular shows ever at the Squibb Gallery, which itself is one of the first corporate fine art galleries in the country. That photography exhibit, "Eye of the Beholder," displayed 57 photographs selected from the finest work of 21 international photographers.

With all this increased demand, however, the number of independent photographers whose services are regularly used by corporations remains surprisingly small. There is no shortage of people who claim operative knowledge of a camera, and it isn't hard to compile a fair-to-middling portfolio. It's even possible to pull off an adequate shot of autumn-leaves-and-ducks-by-the-pond. But that's not what I look for, and it's not what I need. The edge comes when you find the few photographers who can intuitively grasp a concept or a theme, and enhance it, expand it and develop it. These are the experts who walk into a warehouse and come out with a composition that has balance, beauty tension and counterpoint.

Most photographers and designers I deal with are thorough professionals, gentlemen, and capable businessmen. There are a few whose billing procedures might be charitably described as imaginative, and there are other personality traits to account for. An excellent photographer I know invariably returns from company locations with fine shots — but only of women. No men, just women. It's obvious where his interest lies.

continued on page 122

CHUCK BELL
818 Liberty Avenue
Pittsburgh, Pennsylvania 15222
(412) 261-2022

Representative: Michael Murphy

Consumer and industrial
photography that clicks.
At our studio. Your location.
Or anywhere else.

Conceptual catalogues.

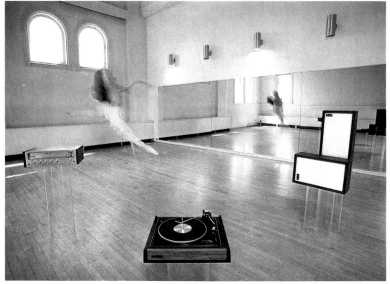

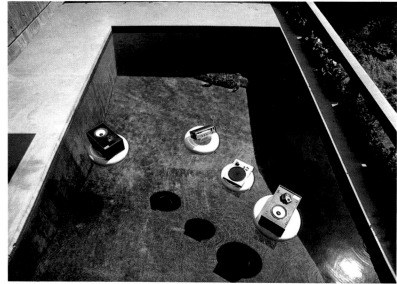

STEVE GROHE STUDIO
186 South Street
Boston, Massachusetts 02111
(617) 523-6655

Pictorial technology for industrial enhancement,
otherwise known as:
"Neat stuff for gee whiz companies."

Polaroid Corporation; Data General Corporation; Digital
Equipment Corporation; Harvard Collection of
Historical Scientific Instruments; Bose Corporation;
Sybron Corporation, Barnstead Division; Nashua
Corporation; Modcomp Computers; Ortho Division of
Johnson & Johnson; Parker Brothers; Unitrode
Corporation; Techops Corporation.

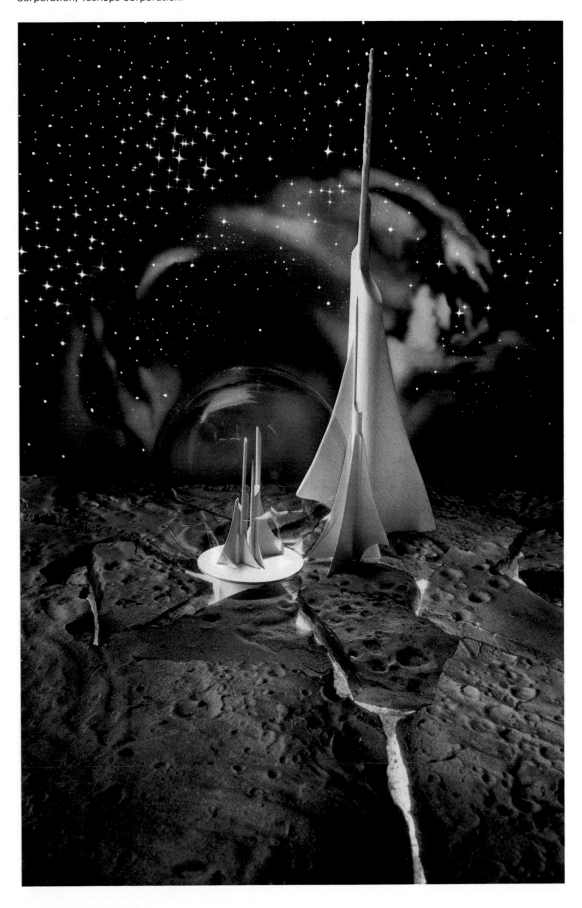

JOHN HOLT
129 South Street
Boston, Massachusetts 02111
(617) 426-7262

Clients include: Sheraton Corporation, Polaroid, Howard Johnson's, Dunkin' Donuts, GTE Sylvania, Itek, Kidder Peabody & Co., Trak Skis, Zipfer Beer, Matlaw's Seafoods, Dresser Industries, Gillette, Algonquin Gas, Sears Roebuck, Reed & Barton Silver, Oxford Foods, Atlantic Steel, Acushnet, Little Brown & Co., Norton Safety Products Division, Liberty Mutual Insurance.

Awards: The One Show, Francis W. Hatch.

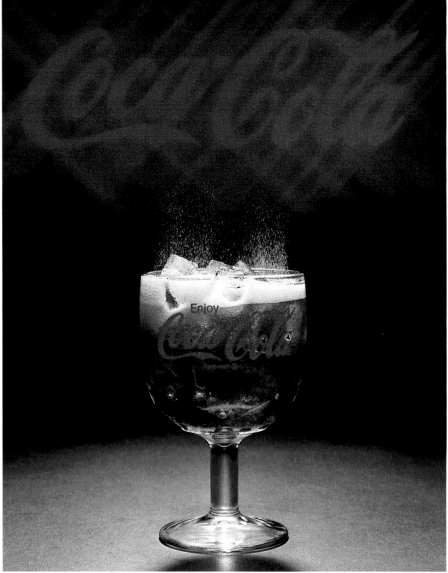

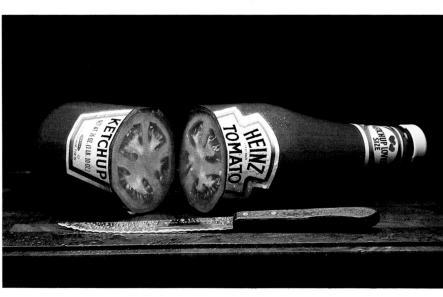

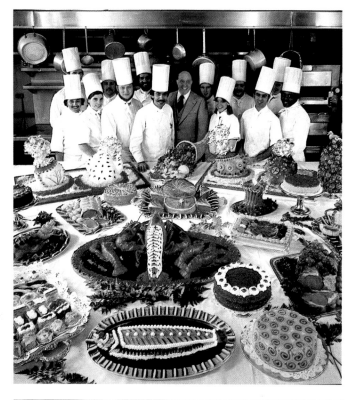

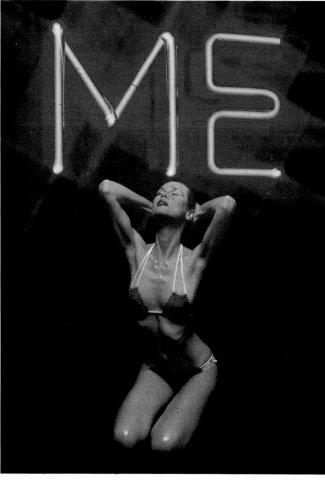

RALPH KING
King Studio
103 Broad Street
Boston, Massachusetts 02110

Representative: Ella
(617) 426-3565

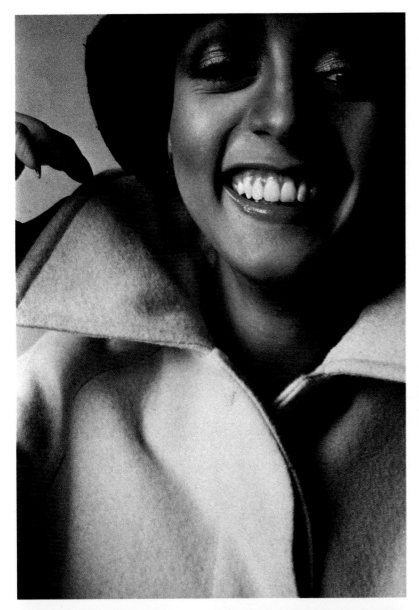

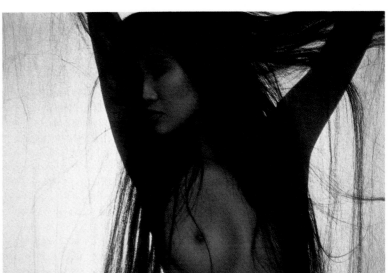

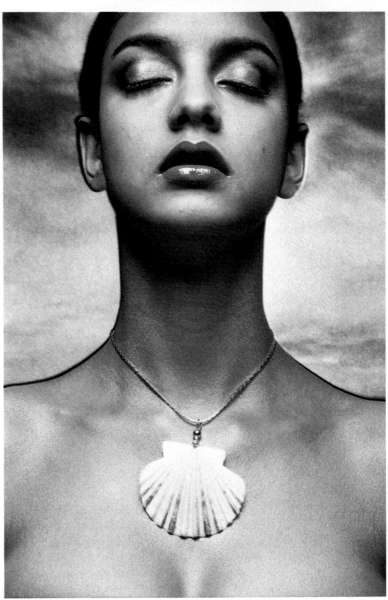

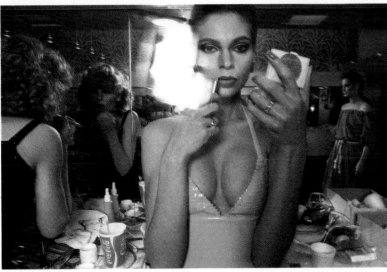

WEAVER LILLEY
125 South 18th Street
Philadelphia, Pennsylvania 19103
(215) 567-2881

"Yes, Weaver Lilley is his real name. And no, I'm not being paid to write this endorsement. It's just that I want you to know Weaver is as professional as he is talented. As reliable as he is resourceful. And as sensitive to client limitations and marketing objectives as he is sensitive."

"Try him on your next shot. If you're not 100% satisfied you can curse me out loud and stick pins in your Victor Sonder doll."
Victor Sonder
Creative Director
Sonder Levitt Advertising

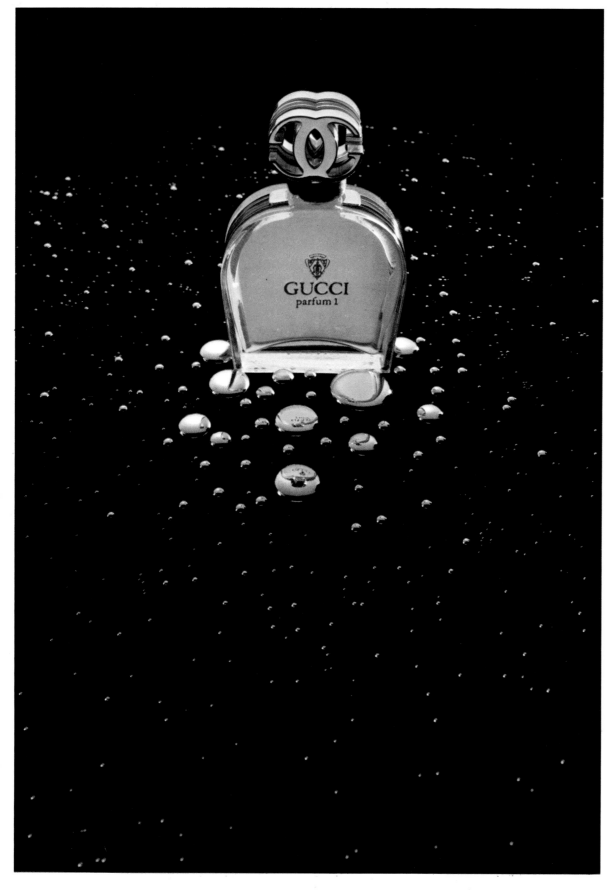

JOHN NEUBAUER
Washington, D.C.

Studio:
1525 South Arlington Ridge Road
Arlington, Virginia 22202
(703) 920-5994

Stock Representative: Sharon Sencindiver

Advertising, editorial illustration, still-life, travel,
industrial, architecture/interiors, people, annual reports.

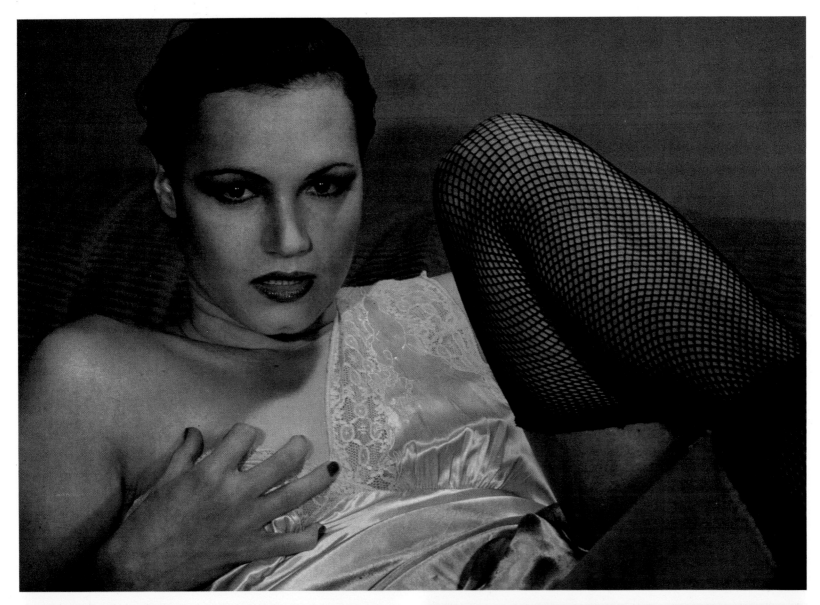

DON NICHOLS
1241 University Avenue
Rochester, New York 14607
(716) 275-9666

Representative: Eva Nichols, Don Nichols

Advertising illustration, people, still life,
industrial, annual reports, landscape/
nature.

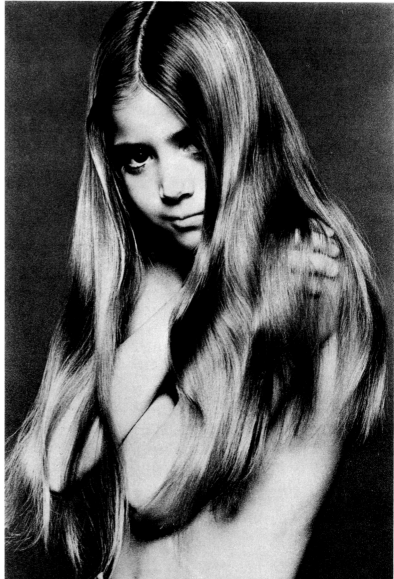

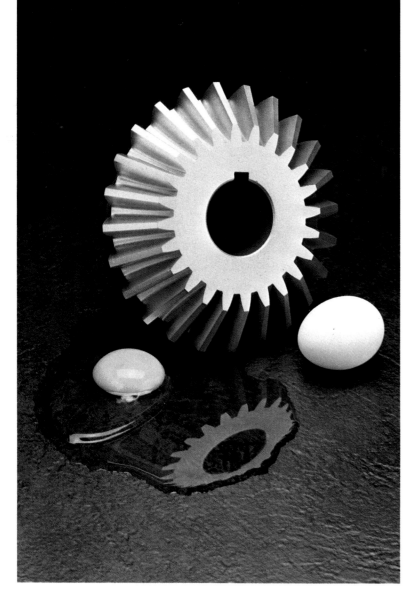

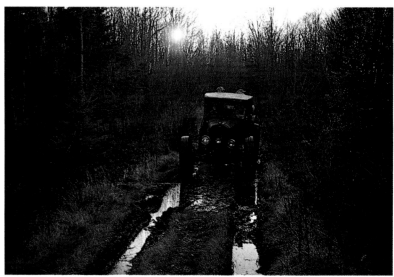

NORTHLIGHT VISUAL COMMUNICATIONS GROUP
45 Academy Street
Newark, New Jersey 07102
(201) 624-3990
Samuel Calello/Thomas Francisco

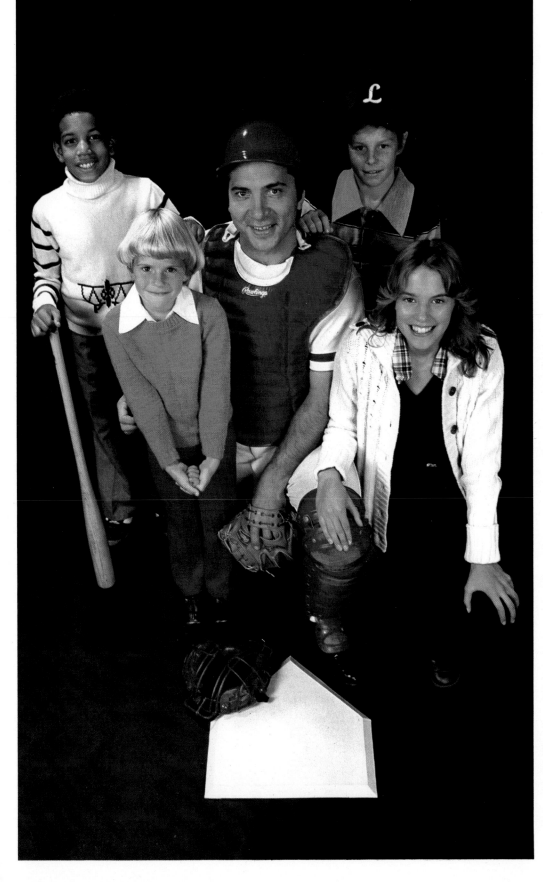

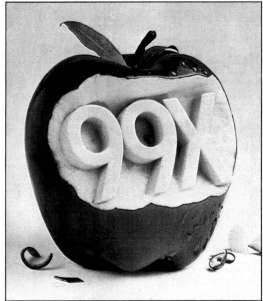

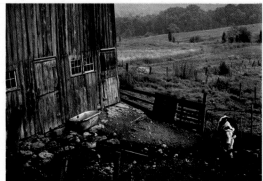

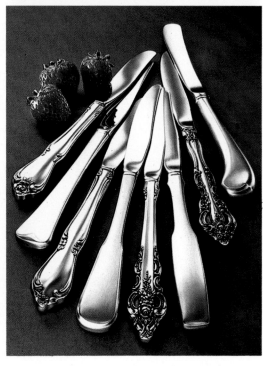

TED POLUMBAUM
Laurel Drive
Lincoln (Boston), Massachusetts 01773
(617) 259-8723

AT&T, Arthur D. Little, Badger, Baybanks,
Cabot Corporation, Damon, W. R. Grace,
Harvard Business School, IBM, Itek, Ken-
dall, New England Telephone, Norton, Ray-
theon, Stone & Webster, Textron, Esquire,
Forbes, Fortune, Life, Money, New York
Times Magazine, People, Time-Life Books,
Us, etc.

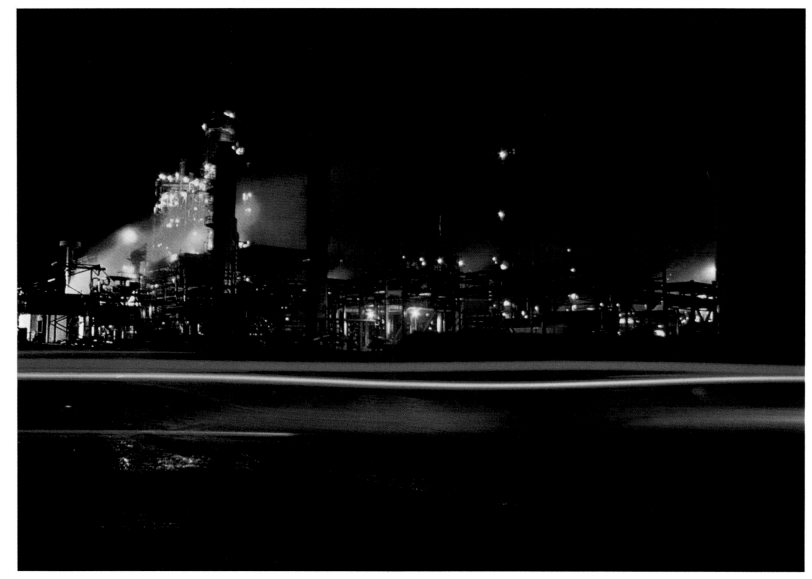

DAVID SHARPE
930 "F" Street, N.W.
Washington, D.C. 20004
(202) 638-0482

Specializes in catalogue, retail, and advertising photography.

Clients include: C & P Telephone; Garfinckel, Brooks Brothers, Miller & Rhoads, Inc.; General Electric; National Geographic Society; National Park Service; The Smithsonian Catalogue; Thalhimer's; Time-Life Books; Woodward/Lothrop.

David Sharpe is reasonable.

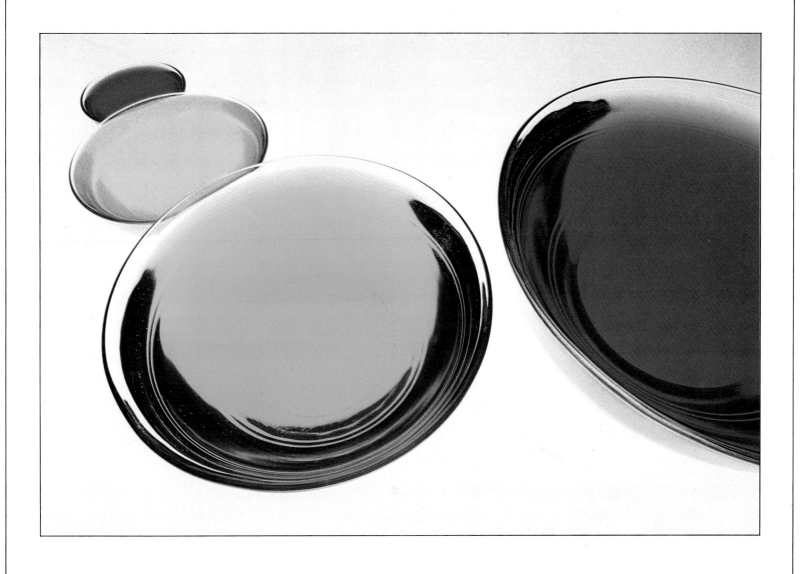

continued from page 110

It must be remembered that the photographer sent out on assignment becomes an emissary for the home office, for better or for worse. I still hear snarls around the office about a freelancer who was dispatched, sight unseen, to a foreign location for several days of shooting. He treated his subjects as if they were just that, displaying all the tact, decorum and good will of a Mongol emperor. (His work, by the way, was satisfactory, but we haven't called him again.)

I also feel that photographers are hurting themselves when they insist on payment for each corporate use of a photograph. I believe that once a corporation pays for a photographer's work, the company owns it and has the right to use it again as it wishes. This ability to get many uses out of one photograph, or group of photographs, is what spurred investment in corporate photography in the first place. It would be impossible to get approval for lavish photography budgets if the result was a one-shot deal, and photographers are limiting their own use if they don't realize this.

A similar category is when photographers insist on shooting the entire annual report themselves. While this might be desirable pictorially, it doesn't always suit corporate financial requirements or deadlines, and the total effect of these non-visual differences is to cloud what has traditionally been a very warm, low-key, and mutually rewarding relationship between the photographer and his corporate client.

The independent photographer is just one member of the team that produces corporate photography. The person who really runs the creative show is the designer, whose importance cannot be overstated. The designer is rightfully the person who has responsibility for coordinating the entire project, and his ability to work effectively with the photographer is crucial.

In addition, the in-house photography staff handles much of the daily, meat-and-potatoes corporate phototaking. These staffs are growing in size and ability, and at Squibb the house staff has been responsible for some innovative, remarkable camera work. However, it remains a fact of life that the glamorous, challenging assignments usually go to outsiders brought in for the occasion, and this is always a potential cause for friction.

But the trend to greater use, and better quality, of corporate photography is here, and I welcome the excitement it has brought to this field of communication. The field is now at a juncture that combines elements of art, advertising, public relations, and graphic design, and its creative potential has hardly been scratched. I believe the best days for corporate photography are just beginning.

GRANT WOLFKILL
Vice President, Public Affairs
Squibb Corporation
New York City

There was a time in the Fifties when illustration went out of style. That's because illustrators were doing what photographers do. And the camera was much better than the brush or the pen.

Even Norman Rockwell was thought of as a part of our past. After all, he was an illustrator doing realistic pictures. At that time the technology of camera lenses was just beginning to explode. The exciting things were happening only in the world of photography.

Then people like Push Pin Studios showed us how illustrators could be designers. And illustration has been growing ever since. Instead of competing with the camera, illustrators created their own place in the world.

Now we're about to see another rebirth in the world of photography.

With the advent of television, great showcases for photography went out of business. True there were magazines for photography buffs. But for general audiences, there was no longer a Life or a Look. And all the specialty magazines that appeared recently were roughly 8½" x 11¼." Not exactly showcase size. And with the price of paper going up, even old established publications such as Esquire, McCalls, and even Vogue came down in size.

Recently it was announced that Life magazine will be published again on a regular monthly basis. Not just specialty issues. And even more importantly, Life will be its old familiar size. Roughly 10" x 13." And with that, there is even talk of Look magazine coming back also.

So photographers will have new outlets. And creative teams can be excited again about having an ad in Life. And portfolios will be big again.

There's talk about rising TV costs making the 30-second commercial as outmoded as the 60. Well 10-second spots go by pretty fast. And I for one am grateful that there will soon be new showcases for photography that we can hold in our hands and take our time enjoying.

NORMAN GREY
Creative Director
Bozell & Jacobs, Inc.
Atlanta

FAUSTINO
P.O. Box 1252
Coral Gables, Florida 33134
(305) 854-4275

New York Representative: Noel Becker
150 West 55th Street
New York, New York 10019
(212) 757-8987

Motion picture director/Cinematographer.
Stock photos available New York and Miami.

Worldwide shooting assignments for the past 12 years. Extensive experience in travel and resort location work, underwater, aerials, all types of outdoor location photography. Well versed in outdoor lighting techniques for fashion and products.
Clients include: Gulf + Western, National Airlines, Jamaica Tourist Board, Eastern Airlines, Revlon, Nabisco,

Shell Oil, Boeing Aircraft, Hilton Hotels, Holiday Inns International, ITT, Pan Am, Costa Rica Institute of Tourism, Dominican Republic, du Pont-Italy, British Leyland Motors, Pepsi Cola, Lums, Boise Cascade, Wine Institute-California, Holiday Inns of America, Bank of America, Paradise Island Bahamas, McDonalds, Ferrari Motors-Modena Italy, Bacardi Rum.

BILL HYMAN STUDIOS
689 Antone Street, N.W.
Atlanta, Georgia 30318
(404) 355-8069

Some of our clients and friends include:
ARA, Holland; BBDO; BDA; Burrell Advertising; Cargill and
Associates; Case Hoyt-Atlanta; Coca-Cola, USA; Continental
Telephone; D'Arcy-MacManus & Masius; Delta Airlines; Dixie
Crystal; Evans, Lowe and Stevens; Fletcher/Mayo Associates;
Gold Kist; Grumman American; IBM; Ike Leonard; Kaiser
Chemicals; Kex Industries; Kinder Care; Lanier Business
Products; Lawry's; Liller, Neal, Weltin; McCann-Erickson;
R. J. Reynolds; Richway; Saunders Leasing Systems; Sheraton
Hotels; STP; Techsonic Industries; The Creative Department;
Union Carbide; Waffle House; W. B. Doner (Hi Tricia!).

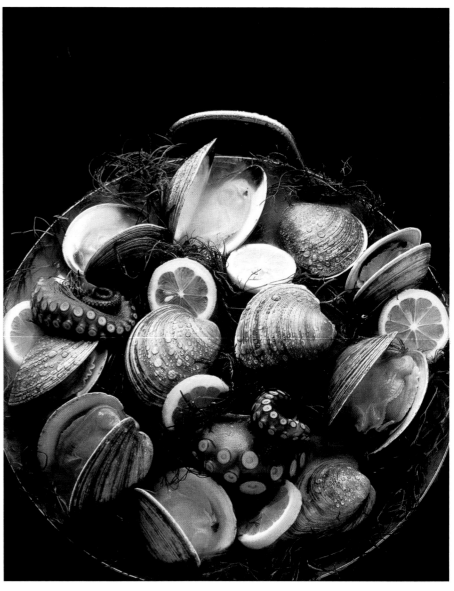

PARISH KOHANIM
10 Biltmore Place, N. W.
Atlanta, Georgia 30308
(404) 892-0099

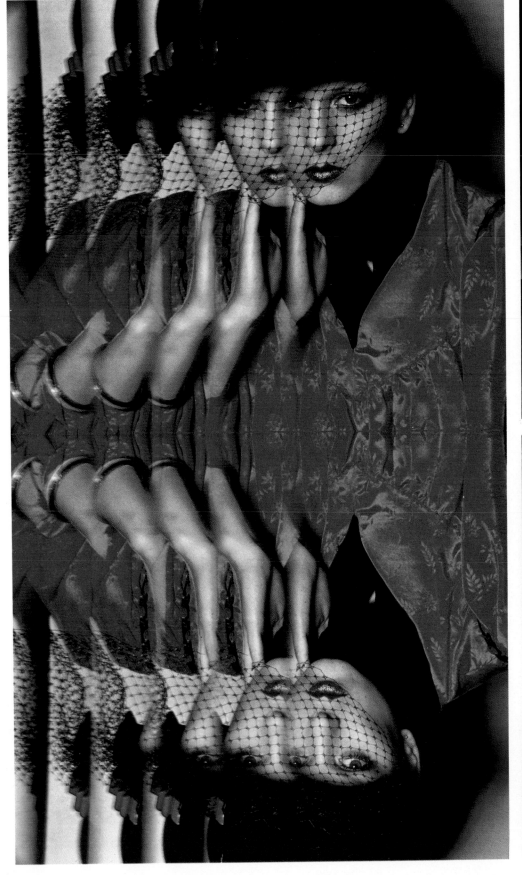

RANDY MILLER
6100 Southwest 92nd Street
Miami, Florida 33156
(305) 667-5765

Clients through New York agencies:
IBM, Coca-Cola, Eastern Airlines, Kodak,
Sears, Marriott Hotels, Ford, Chevrolet,
United Airlines, Bertram Yachts,
Johnnie Walker Scotch, J. C. Penney,
American Express.

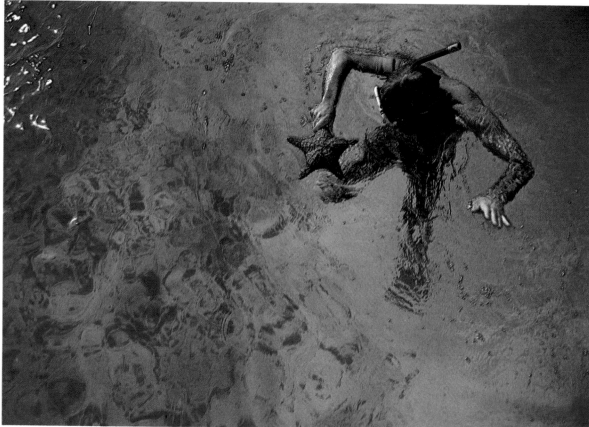

TIM OLIVE
Atlanta
(404) 872-0500

Representative: Bobbi Olive

A thinking photographer. Strongly oriented toward
concept development and visual problem-solving. Emphasis
on simple and effective communication, in both studio
and outdoor situations.

ROBERT T. PANUSKA
Representative: Al Forsyth
521 Madison Avenue
New York, New York 10022
(212) 752-3930

Graduate of L. A. Art Center. Awards include: Andy, Clio, One Show, Addys, C. A., Print, etc. Extensive experience in travel and resort work, including aerial, underwater, and other specialized types of outdoor photography. Clients include: National, Eastern, American, and Northwest Orient Airlines, Bertram Yachts, Kodak, Jamaican Hotel Association, Norwegian Caribbean Lines, Monarch Cruise Lines, Playboy Magazine, Dunhill Cigarettes, Tiffany's, Burger King, Coca-Cola, Ryder Trucks. Stock available.

The commercial art and advertising community recently lost a very special man: a master painter of western scenes; a master painter whose work is in galleries and homes all across this country; but more importantly, a man who devoted 47 of his 76 years to his kids.

Jackson Grey Storey, better known to his students as "Pop," directed a small commercial art school in Cincinnati, Ohio. He started teaching in the basement of his house and many years later built a small, but beautiful, building behind his house. Pop believed that the only way for you to develop as an artist was hard work and discipline, his and yours. And he taught it in such a unique way that his place became "that great little art school in Cincinnati with the three-year waiting list."

Pop didn't have any kids of his own. But if you were lucky enough to get into his school, you became one of Pop's kids; and you were to behave as one of Pop's kids.

Pop taught commercial art the way Vince Lombardi coached football. First you must learn the basics: drawing, lettering, perspective, design, painting, etc. – "for they are your tools," Pop would say, "and a craftsman without a tool box isn't good to anybody." But to get your tool box Pop would not accept anything that was "almost" right.

Oh how Pop loved type faces, and was a master when it came to lettering them. One of our assignments was to letter the Caslon 540 alphabet, each character perfectly, twenty-five times. Then Pop would measure each character with a piece of tracing paper. If one character didn't measure up you started over...from the beginning. It really hurt a lot to hear him say, "start over" after being up until 3 a.m. thinking you finally mastered that damn Caslon 540! But what a great feeling when Pop would finally smile and say, "Nice job, now you got it, kid."

Most of us in Pop's first-year class thought there had to be something wrong with the old man, because of the way he drove us, and drove us. But I'm sure that every person who spent time with Pop Storey has sat at their drawing board or desk and said to himself at one time or another, "Thanks, Pop, now I know what you meant."

Though tough, strong, and demanding, Pop Storey never lost his gentleness or sensitivity toward a struggling art student. He always found extra time for someone who needed it. He was always proud of those who started with less ability, those who struggled and worked harder than those with God-given talent. He knew who to push and when. He knew his kids like a parent knows his kids. If you weren't interested in building a good tool box, you were asked to give up your place in Pop's school to someone who was. It was that simple.

Unlike a lot of art schools where you "pay and play" or "come and go" as you please, Pop made sure that – if you were willing to work hard – you would walk out the door of his school as a Craftsman with your own tool box.

Pop Storey influenced so many students with his simple approach to doing things right, that many a new graduate from his school was asked, "How many years have you been working?" What a surprise when they were told "I haven't been – I just got out of school."

There will never be another like Pop Storey; but if I know Pop, every time one of his graduates has to make a young art director do something over and over until it's right, Pop will look down and smile and say, "Nice job. Now you got it, kid!"

One of the last things Pop Storey asked his wife was, "How are my kids?" If I may speak for all the "kids" who have had the pleasure, over those 47 years, to know and share some of Pop Storey, I will answer his last question: We're all doing just fine, Pop...thanks to you.

BOB EBEL
Creative Director
J. Walter Thompson Company
Chicago

JON BRUTON
3838 West Pine
St. Louis, Missouri 63108
(314) 533-6665

Representative: Judie Drewel

JOHN CASCARANO
230 West Huron
Chicago, Illinois 60610
(312) 266-1606

Representative: Wendy Brawar

RALPH COWAN
869 North Dearborn Street
Chicago, Illinois 60610
(312) 787-1316

Advertisements for Abbott Labs, Amana, Armour-
Dial, American Can, American Oil, Bang &
Olufsen, Chemetron, Continental Can, Cramer
Furniture, Cummins Diesels, Eastman Kodak,
FTD Florists, Greyhound, S.C. Johnson, Kellogg,
Kimberly Clark, Massey-Ferguson, Montgomery
Ward, Pullman, Ralston-Purina, Sears, Skil,
Spaulding, Star Kist, Stow-Davis, Uniroyal,
Victor Comptometer & others.

RICHARD EPPERSON INC.
230 East Ohio
Chicago, Illinios 60611
(312) 337-2138

Agencies: JWT, Burnett, FCB, Y&R, NHS, TLK, Creamer/FSR, Marsteller, Proctor & Gardner, Campbell-Mithun, Nader-Lief, Weber, Cohn & Riley, Burrell, G.M. Feldman, Meyerhoff, Mandabach & Simms.

Accounts: Brown's Chicken, Sexton Foods, Viceroy Cigarettes, Jewel Foods, Port Industry Group, GTE, Karoll's, Northern Electric, Nestlé, Pillsbury, Jacobsen Mowers, McDonald's, Peter Pan Peanut Butter, Betty Crocker, Kentucky Fried Chicken, United Airlines, Kellogg's Country Morning (packages and ads), Abbott Labs, Eureka Vacuum Cleaners, 3M Scotchgard, Evenflo (infant care), Sealtest, Twin Sister Vodka, RC Cola, Elco Industries, V-8 Juice, Campbell Soup. A video tape food reel is available.

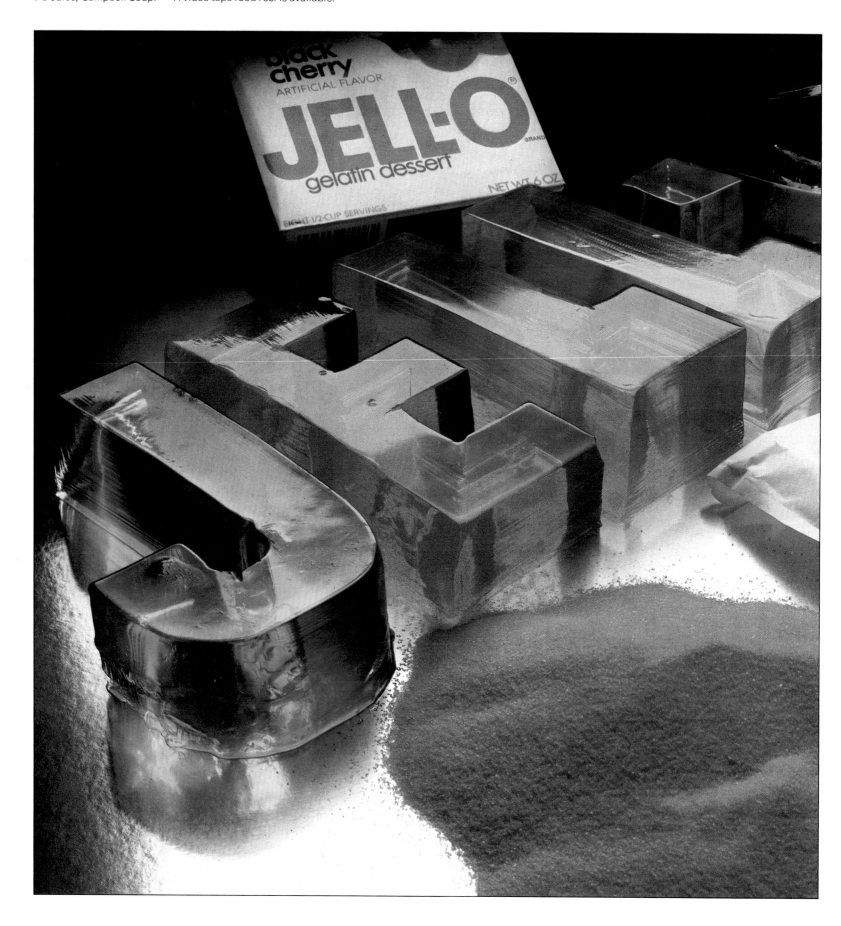

GABRIEL
160 East Illinois
Chicago, Illinois 60611
(312) 787-2915

Representative: Cathy Crawford

Specializing in everything except
weddings, babies, portraits—and
if it's legal.

Upper left, Jovan; center left, self
promotion; lower left, exercise in
antigravitation; upper right, Leo
Burnett 42nd anniversary poster;
center right, Bubble Yum; lower
right, studio table-top setting.

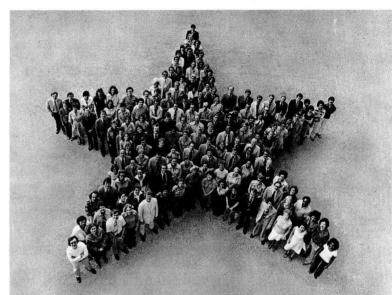

GETSUG/ANDERSON
127 North Seventh Street
Minneapolis, Minnesota 55403
(612) 332-7007

Chicago Representative: Walter Howze
(312) DE2-5700, page #072893

Unique still production company
specializing in people in the
studio and on location.

CASSETTE DECK SINGS. TRUTH COMES OUT.

When your cassette deck starts singing, you want the truth—true, pure sound. That's exactly what you get with Scotch® Master™ Cassettes.

Scotch Master Cassettes are an exciting development in sound quality. And they're the line of cassettes with a tape engineered for each bias switch position. Master I is for normal bias recording. Master II is for chrome bias recording (70 microsecond equalization). And Master III is for ferri-chrome recording. So no matter what switch position you like, Scotch Cassettes will sing your song the way you want it sung.

Scotch Recording Tape has always stood for sound quality. Maybe that's why most recording studios use it.

But don't take their word for it. Let a Scotch Master Cassette sing for you. You'll hear the truth, the whole truth and nothing but the truth.

SCOTCH RECORDING TAPE. THE TRUTH COMES OUT. 3M COMPANY

GETSUG ANDERSON

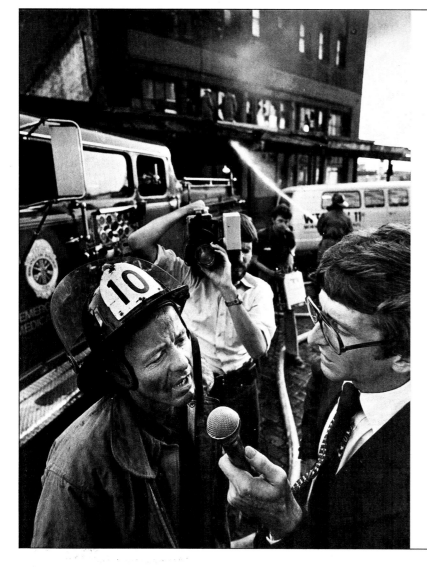

ONE THING ABOUT THE NEWS BUSINESS: YOU NEVER GET A SECOND TAKE.

Here's a videocassette made for the people who make the news.

It's the new "Scotch"® Brand Master Broadcast U-Matic videocassette. MBU for short. The first ¾" videocassette designed specifically for tough ENG recording and the repetitive stress of editing.

We took the same high energy oxide videotape you've used for years and fused it to an incredibly strong backing. The result is a videotape that won't twist, tear or jam in the field. An unyielding videotape that won't stretch under the strain of tape editing's shuttling modes or degrade in extended stop motion.

And to protect it even under the worst conditions, "Scotch" MBU videotape comes packed inside a high impact cartridge.

Of course, "Scotch" MBU videocassettes have the same high signal-to-noise ratio and low headwear and dropout rates of our superb quad tapes.

So if you've ever worried about a good story and a videocassette breaking at the same time, record on "Scotch" Master Broadcast U-Matic videocassettes. They'll always back you up.

"Scotch" MBU Videocassettes.

"Scotch" is a registered trademark of 3M Company, St. Paul, Mn. 55101. © 1977, 3M Co.

EXPECTATIONS...

What can an art director reasonably expect from a photographer? And conversely, what should a photographer expect from an art director?

For openers, the art director has a right to expect a quality of work at least equal to that in the photographer's portfolio. If it's a new relationship, there's no sure way to predict how the chemistry or personalities will mix. But being prepared can go a long way toward at least a mutual respect of each other's professional capabilities.

It's reasonable to expect that the photographer has his stuff together. He had darn well better have his homework done before the session begins. Equipment should be in top shape and organized, ready to go. If it's a studio shot, the studio should be neat and orderly. No one wants to come in and wade through yesterday's garbage, then wait for it all to be cleaned up before any signs of his shot emerge. Hopefully, there's been a pre-production meeting or discussion, so a selection of props is at hand. Backgrounds are in stock. Home-Ec is ready. Maybe a rough-in is already set up. Film is loaded. Everything's in place, and the team is ready to make a beautiful picture.

With even amateurs sporting SLR's with automatic everything, it's certainly reasonable to expect something more than technical expertise from a professional photographer.

There should be a willingness and eagerness to do more than just make a satisfactory picture. A photographer should attempt to reach out to new dimensions, to create more involvement, get more thought, more feeling into everything he does. And he shouldn't be afraid to use a little extra film – to walk that extra mile. It's surprising how many times that "just-right" shot was done <u>after</u> we thought it was done satisfactorily, but maybe we'd just try a couple more ideas.

But expectations are a two-way street. The photographer should really be buttoned up, but the art director had better be all-together, too. He or she had better know the product. And exactly what the ad is trying to accomplish. There should be plenty of product on hand. If some of the props are the art director's responsibility, they should be ready. The ad should be prepared to give the photographer assistance and direction in establishing the mood and character of the shot; with an open mind for adjustments as necessary. In fact, if everyone enters the project with an open mind and the fortitude to accept a little give-and-take, all parties concerned, even the client, will be better off for it. And you'll end up with a hard-working, beautiful picture – maybe even a great one!

KEN MORRISON
V.P./Executive Art Director
Martin/Williams Advertising, Inc.
Minneapolis

HICKSON-BENDER PHOTOGRAPHY
Box 201
281 Klingel Road
Waldo, Ohio 43356
(614) 726-2470

Waldo? Where the hell is Waldo? Then again, who cares?

Whirlpool cares. And Borden Inc., and Sheller-Globe, the state of Ohio, G.E., McDonald's, Peabody-Galion, Westinghouse, Exxon, Johns-Manville, Cooper Energy Services, Jim Walter, Charles E. Merrill Publishing, Philips Ind., Bob Evans Foods, and many more.

Our experienced strengths are in corporate/annual reports, advertising illustration, people and scenics, travel, agricultural and macro graphics, and photography for audio-visual productions.

Whether on location, in plant, or in the studio, from 35mm to 8x10, perfume to garbage trucks, we try for the simple, strong statement to capture the essence.

By the way, Waldo is 20 miles from Chesterville. We are looking forward to working with you.

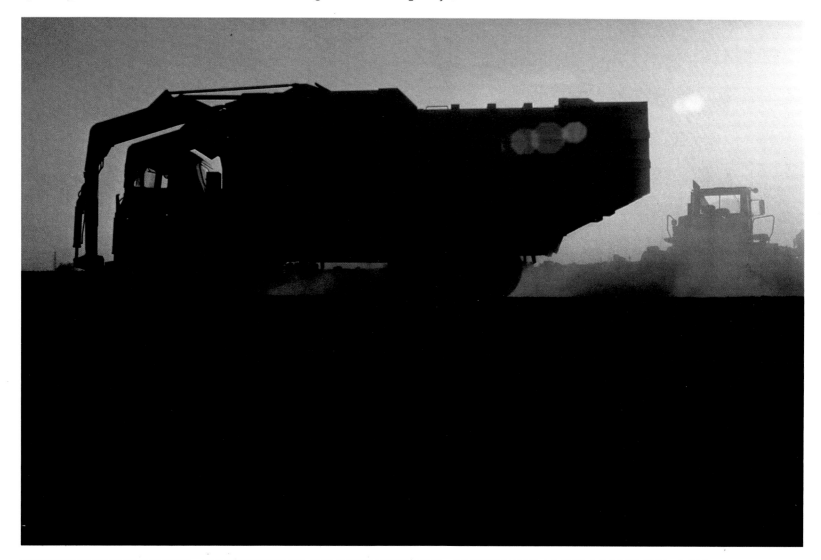

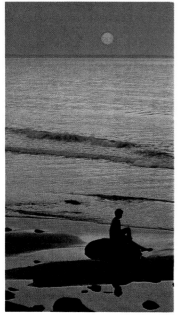

HICKSON-BENDER PHOTOGRAPHY
Box 201
281 Klingel Road
Waldo, Ohio 43356
(614) 726-2470

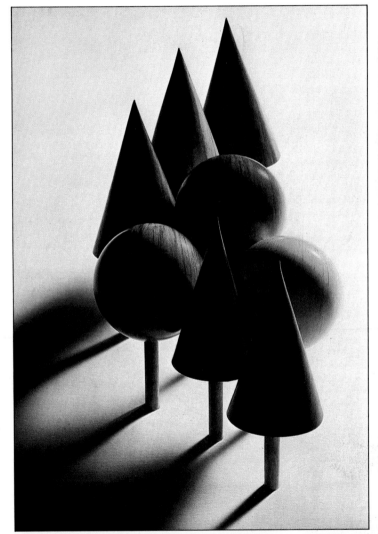

DICK JONES
325 West Huron Street
Chicago, Illinois 60610
(312) 642-0242

Representative: Bob Witmer

MEL KASPAR LTD.
2033 North Orleans
Chicago, Illinois 60614

Midwest Representative: Nancy Wilde
(312) 528-7711

West Coast Representative: (Movie Pitchers Only) Richard Goldstone Prod.
(213) 931-1305

What kind of a man is Mel Kaspar?
Education: Half-versed in English.
Favorite Wine: The expensive kind with the twist-off
 metal tops ("'Cause you can re-seal 'em.").
Favorite Lens: Len Bernstein, Len Bruce, Len DaVinci
Professional Goal: Hopes someday to be able to read
 without moving his lips.
Professional Attitude: "You and whose army?"
Advice to Art Directors: "If we shoot the food in

black and white, we can save two or three bucks on
the Photomat processing alone."
All-Time Favorite TV Personality: Pinky Lee.
All-Time Favorite Film: "I especially admired the
 subtlety of The Texas Chain Saw Massacre."
Favorite Food Shot: Liver & onions Jello mold.
Favorite Fruit: Tomato.
Notable Achievement: He is the only person alive who
 knows a word that rhymes with "orange."

Closing Remarks:
This is my reel
And this is my book.
They're bote real good
And so is my cook.

MANNING STUDIOS, INC.

2115 Chester Avenue
Cleveland, Ohio 44114
(216) 861-1525

307 East Fourth
Cincinnati, Ohio 45202
(513) 621-6959

348 Washington, N.E.
Warren, Ohio 44483
(216) 399-8725

Manning Studios is an organization of 55 highly skilled professionals who specialize in analyzing and solving your total marketing communications objectives.
Manning is a complete communications and collateral center of amazing versatility and productivity, confidently accepting the creative challenges of design, illustration, photography and multi-media (AV).

Photo Group

Photographers: Carl Fowler, Bob Bender, Ladd Trepal, Jiro Miyoshi
Coordinator: Roseanne Strelka
Assistants: Joe Theriot, Keith Berr, Alan Bennington
Lab: Dottie Stevens, Herb Schwartz, Jerry Sansavera

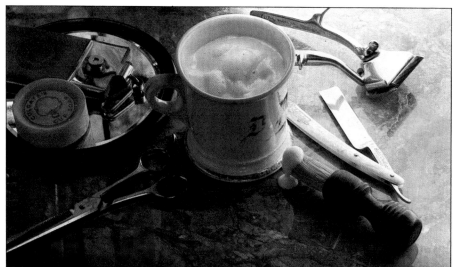

DISPATCH PRINTING/HOUSE COMMUNICATIONS

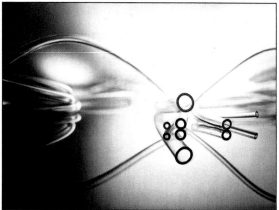

TYGON TUBING/NORTHLICH STOLLEY

TYGON TUBING/NORTHLICH STOLLEY

SHARON STEEL/WATTS-LAMB

SHARON STEEL/WATTS-LAMB

UNIROYAL/ROSS ROY

JIM MARVY
Marvy! Advertising Photography, Inc.
41 Twelfth Avenue North
Hopkins (Minneapolis), Minnesota 55343
(612) 935-0307

Photographic illustration.

Clients include: Miller Brewing Company, Hormel, Honeywell, 3M, Tonka Toys, Cargill, Ski Doo, Winnebago Industries, National Distillers, Litton Industries, Land O'Lakes, Peavey, Hart Skis, Valspar, Anheuser Busch, Green Giant, International Multifoods, Burlington Northern, Kimberly-Clark, Pillsbury, General Mills, E. F. Johnson, Arctic Cat, Northwestern Bell Telephone Company, Fiskars, Thermo-Serv.

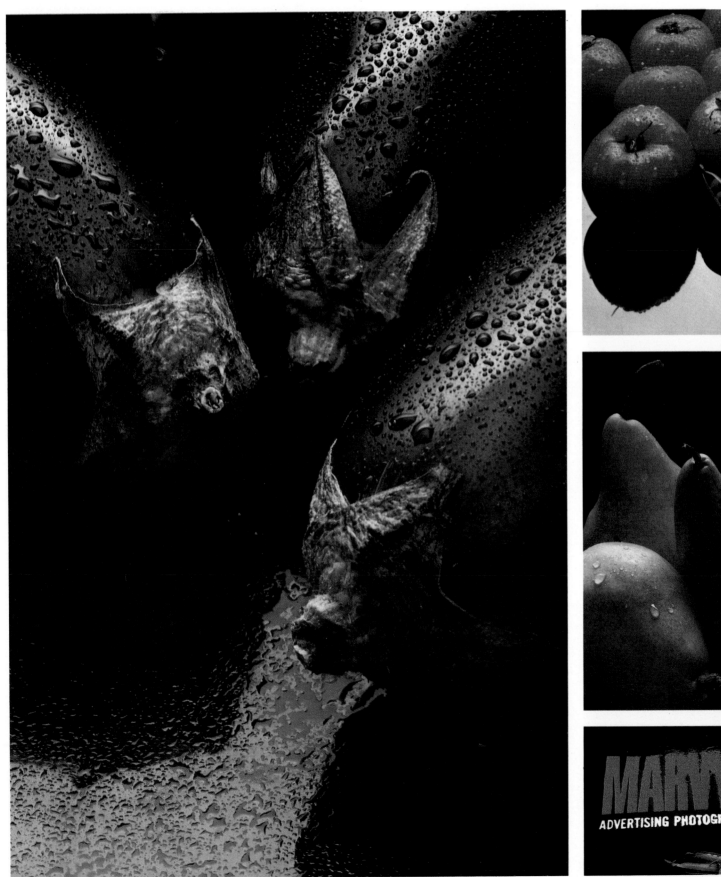

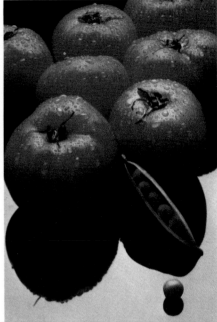

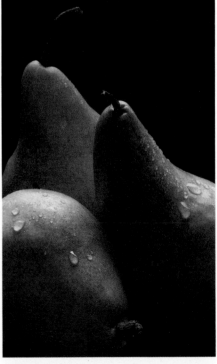

MERLE MORRIS PHOTOGRAPHERS, INC.
614 5th Avenue South
Minneapolis, Minnesota 55415
(612) 338-7829

Representative: John Schuck
(612) 338-7829

It's an age of specialists, <u>but</u> we don't specialize. People, products
and food in our fully equipped studio, <u>but</u> we do photography
on location worldwide. National and international clients, <u>but</u> also
a long list of local and regional accounts.
Twenty-six years in business, <u>but</u> young in attitude and energy. Strict
attention to the client's wishes, <u>but</u> enough integrity to take the picture
that's gotta be taken. Still photography, <u>but</u> we have film capability.
Excellent work — No <u>buts</u>.

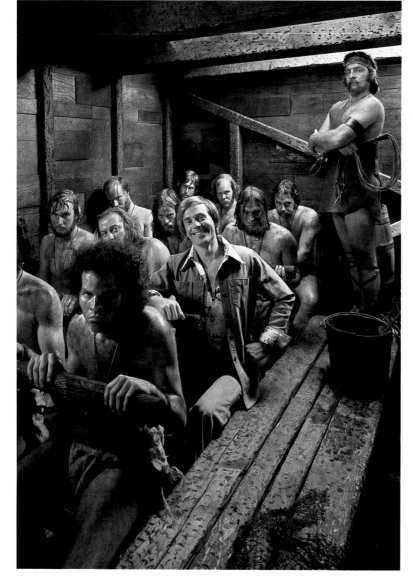

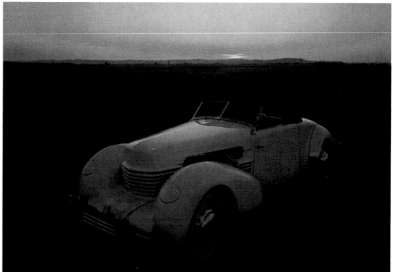

THE PICTURE PLACE
689 Craig Road
St. Louis, Missouri 63141
(314) 872-7506
Jim Clarke

Lately we have been getting a lot of calls to do projects that have been assumed photographically insolvable. Well, we do solve them, and generally have fun in the process, in spite of some minor hair-pulling and teeth gnashing. But this last call...

"Listen, Jim, in this next shot we use these half million trained ants, see, and then there's this naked lady, see, and.."

I hung up on that one, the trained ants were no problem, but a naked lady...???

Some of the people for whom we have had fun solving problems are Budweiser, International Shoe, 7UP, Gulf Oil, Kelly-Springfield, Buster Brown, Carter Carburetors, et cetera. If you'd like the et cetera itemized, give us a call.

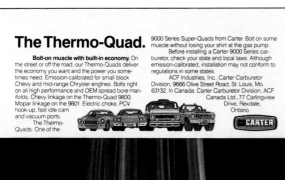

CHARLES SCHRIDDE
600 Ajax Drive
Madison Heights (Detroit), Michigan 48071
(313) 589-0111

One
Charlie Schridde
is worth a
thousand words.
Unfortunately, we haven't got room for a thousand words. So we can only give highlights of the Charlie Schridde Legend. His childhood abduction by a crazed film salesman. His lifelong fear of sanity. His successful fight to have his name changed (to Schridde). And above all, his great eye (it's four inches across).

But his pictures say it all. See? They speak of light and mood and tight deadlines. They speak of everything from movie stars to sexy cars. And they whisper TRUTH. Listen. Closely. There!

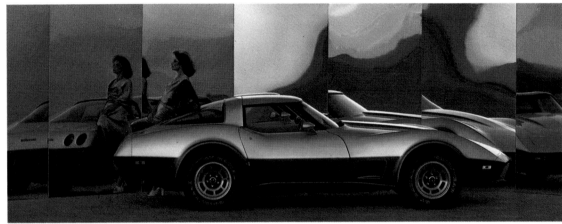

BOB FORLENZA, GENE BUTERA/CHEVROLET

DON BURZYNSKI/OSMUN'S

JIM TALIANA/CADILLAC

JIM FASCI/WIDMER

TOM RICKEY/OLDSMOBILE

T.J. NIEME/OSMUN'S

JOHN WELZENBACH
368 West Huron Street
Chicago, Illinois 60610
(312) 337-3611

Representative: Joni Tuke
(312) 664-4235

My clients think I'm ingenious,*
My woman thinks I'm cute,
My dog thinks I'm a benevolent master,
And my mom thinks I should get a decent job....

Oh well, 3 out of 4 aint bad.

*In case you're wondering who they may be,...Amoco, International
Harvester, Morton Salt, Reynolds Aluminum, Dow, Cummins, Chemetron,
GTE, Stewart-Warner, Searle Labs, and S. C. Johnson are among them...
as well as Dial, Gillette, Alpha Keri, Nivea, Neutrogena, Yardley, Gerber, and
the Girl Scouts...and of course TAD Davis Rackets, Dacor Diving, Victor
Sports, Nixdorf Computers, Zenith, Mercury Records, Barton Brands,
Campari, Brown & Williamson, Stroh, RC Cola, Sears, Anco, Kimberly-
Clark, Simmons, and The United States Navy...(to mention just a few).

STU WEST
Photogenesis
430 Oak Grove
Minneapolis, Minnesota 55403
(612) 871-0333

Advertising.
Annual report.
Architecture.
Editorial.
Concept, consulting, design and film.
People, places and things.
A decade of experience.
38 countries, two provisional
governments and one territory.
Any format, any place, any time.

Richard Litwin got a call on a Friday afternoon to shoot a lingerie ad that would run in a major fashion magazine. The client needed the transparencies first thing Monday morning, in time for the target issue. The ad would have to be shot late Saturday night, allowing enough time to build a special set. Models were hired at double rate for the underwear, plus <u>double</u> double rate for weekend night work. The lab was kept open by paying overtime charges, and a messenger was hired just to sit and wait for the film.

The shooting began at 8 p.m. and ended at 1 a.m. The 8x10 film holders were handed to the messenger to take to the lab, and everyone was sent home. Dick collapsed with a drink and waited to hear that all was well. The lab called shortly: nothing was coming up on the film. In the end, not one usable picture appeared. After the careful preparation and testing, there was nothing to show for the evening's work, and worse, no explanation.

A week passed, and all avenues of possible error had been checked. Finally, the messenger was asked to describe his exact movements from the time he left the studio to the time he arrived at the lab. He told this story: he had waited in the studio, out of view of the shooting area, for four hours, watching half-naked models moving to and from the set. He couldn't see exactly what was being shot, but he was sure it was pretty sexy. On the way to the lab he decided to take a peek at the shots of the naked ladies, so he stopped in a brightly-lit hallway and, one by one, opened each film holder. He couldn't understand why there were no pictures.

GARY GLADSTONE

CONSTANCE ASHLEY
2024 Farrington
Dallas, Texas 75207
(214) 747-2501
(212) 228-0900

A good client is worth a thousand words.

Fortunately, we have some very nice ones.

They understand the need to communicate—clients, art directors, models, stylists—all of us. I like people. I work <u>with</u> them. I ask a lot of questions. I tune-in to the fantasies they want to get on film. I immediately start seeing pictures and lighting them.

I work with models and subjects the same way. I give them permission to be at their best in front of the camera—perform and act out the concept. I light, they respond and I shoot. We have fun.

Words, motions and emotions flow and change during a shoot. But the most satisfying communication is when the client says, "Thanks. That's exactly what I wanted."

Beauty, fashion, illustration, advertising, personality studies, retail, catalogue, editorial, video tape.

"Do it in Dallas."

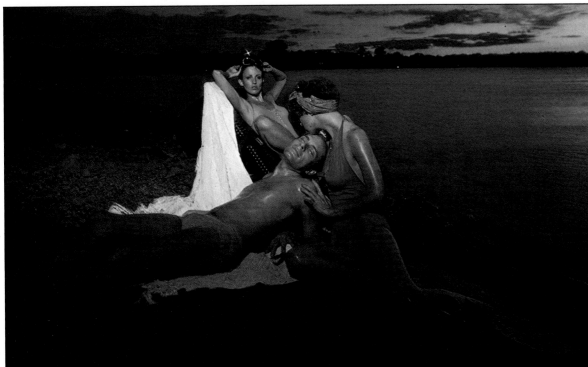

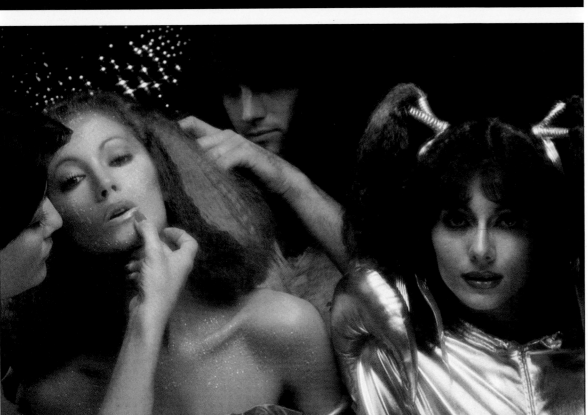

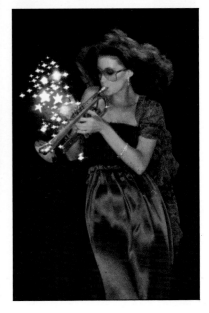

GERALD BYBEE
918 East 900 South
Salt Lake City, Utah 84105
(801) 363-1061

Recently relocated from the West Coast, Bybee
specializes in people, food and product illustration,
and location photography.

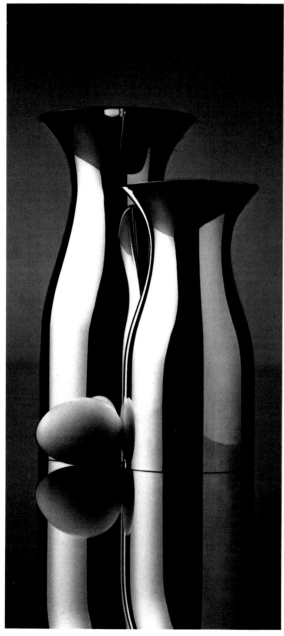

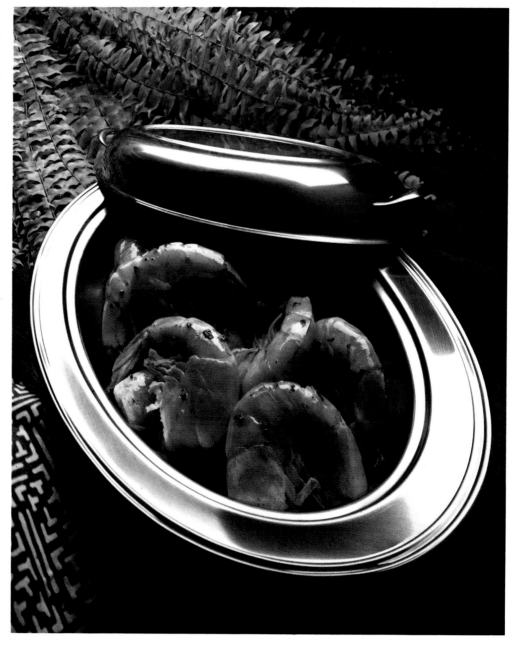

NICHOLAS DE SCIOSE
3292 South Magnolia
Denver, Colorado 80224
(303) 455-6315 studio
(303) 756-0317

Chicago Representative: Vincent J. Kamin Associates
(312) 787-8834
42 East Superior Street
Chicago, Illinois 60611

New York City Answering Service:
663 Fifth Avenue
New York, New York 10022
(212) 757-6454

MODEL: DEB TABKE, VANNOY AGENCY, DENVER

KIRKLEY PHOTOGRAPHY
1112 Ross Avenue
Dallas, Texas 75202
(214) 651-9701

Kent Kirkley
Andy Vracin
Jeremy Green

Representative: Linda Smith

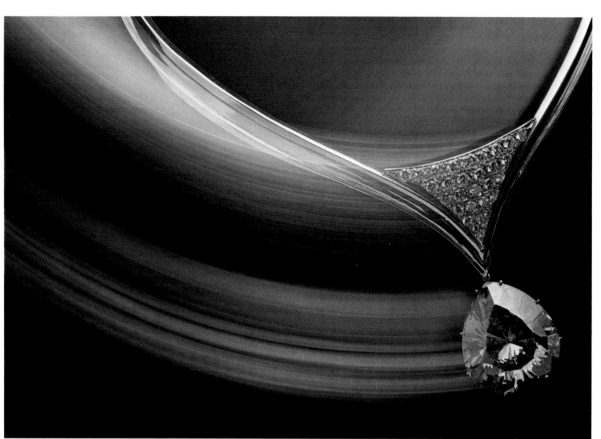
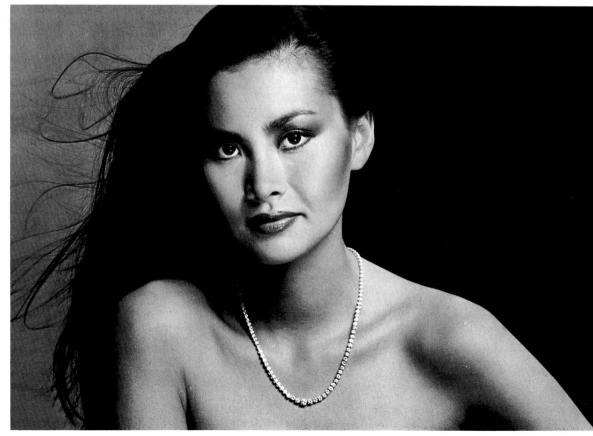

MICHAL UTTERBACK
918 East 900 South
Salt Lake City, Utah 84105
(801) 531-7767

San Francisco Representative: George Brown
(415) 495-7175

Director: Films and commercials.
Advertising and editorial photography.

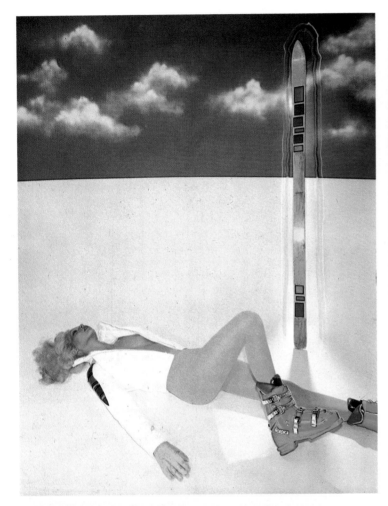

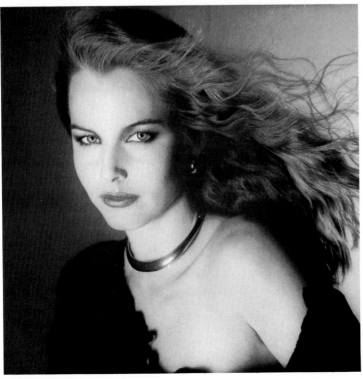

SHORTY WILCOX
Post Office Box 718
Breckenridge, Colorado 80424
(303) 453-2511 or 893-5275

New York Representative: Ron Basile
(212) 986-6710
Toronto Representative: Bob McPartlin
(416) 964-2391
Chicago Representative: Roy Skillicorn
(312) 321-1193
Los Angeles Representative: Laird Fleming
(213) 784-5814
Existing photography: The Image Bank
(212) 371-3636

In print, his talent appears as strong color with equally strong composition, always fresh. On assignment, his most unique talents appear: insight and energy.

He's surprisingly quick at recognizing the problem. Intuitively understanding the possibilities; feeling and seeing solutions that are natural, but not often apparent.

If it's there, he'll get it. If it's not there, he'll find it. From action to agriculture and industry, outdoor and indoor locations. From magazine covers to in-depth spreads to ads and annual reports.

There's no one more professional and harder-working. And at 7'1," no one can come close to Shorty's flexibility.

Prints by Pallas Photo, Chicago. ©Shorty Wilcox 1978

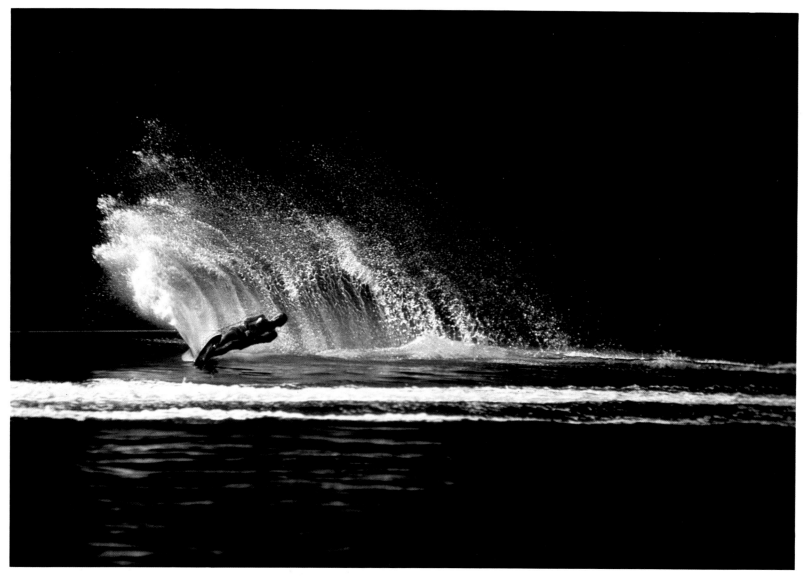

SHORTY WILCOX
Post Office Box 718
Breckenridge, Colorado 80424
(303) 453-2511 or 893-5275

New York Representative: Ron Basile
(212) 986-6710
Toronto Representative: Bob McPartlin
(416) 964-2391
Chicago Representative: Roy Skillicorn
(312) 321-1193
Los Angeles Representative: Laird Fleming
(213) 784-5814
Existing photography: The Image Bank
(212) 371-3636

Clients include: American Express, ABC Wide World of Sports, BASF, CertainTeed, Diamond Shamrock, Farm Journal, GATX, Georgia-Pacific, Hammermill, Hart Skis, International Harvester, IBM, Kodak, Mercury Marine, Mobil, Money Magazine, Newsweek, Nikon, Olympia Brewing, Pioneer Seed, Phillips Petroleum, Rossignol USA, Safeco, SAS Airlines, Schlitz Brewing, Smithsonian Magazine, Spalding, Stauffer Chemical, State of Alaska, State of New York, TWA, United Airlines, U.S. Gypsum, Valley Industries, Weyerhaeuser, Xerox.

Advertising agencies include: BBDO; Benton & Bowles; Bozell & Jacobs; Chenault Associates; Cole & Weber; Creamer/FSR; D'Arcy-MacManus & Masius; Doremus & Company; Dentsu Corp.; Foote, Cone & Belding; Fletcher/Mayo Associates; Gardner Advertising; Gray & Rogers; Horton, Church & Goff; Leo Burnett USA; Lewis & Gilman; Kraft Smith; McCann-Erickson; Tracy-Locke; Wells, Rich, Greene; Wilson, Haight & Welch. Design firms & designers include: Mandala; Newcomb House; Michael Reid; Schumaker/Deur; Robert Riger; Van Dyke, McCarthy & Tavernor; Unigraphics.
Prints by Pallas Photo, Chicago. ©Shorty Wilcox 1978

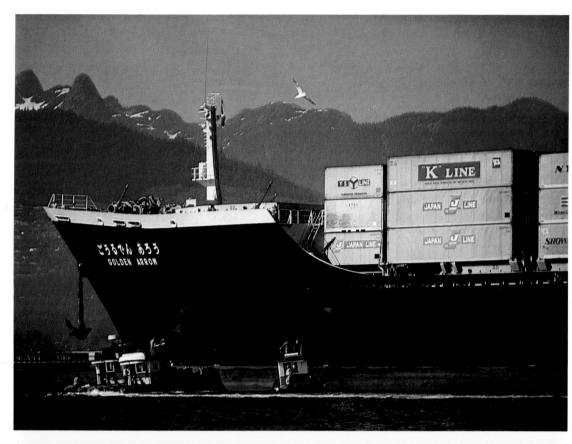

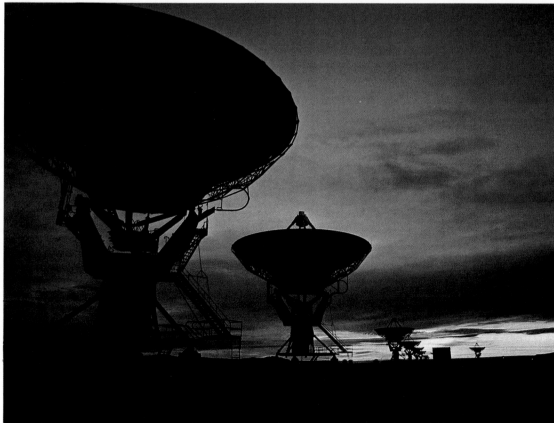

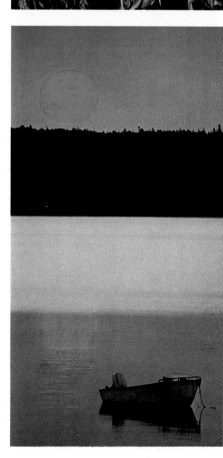

**THIS BOOK
MIGHT JUST PUT
A FEW CREATIVE PEOPLE
BACK TO WORK**

No more staring at toenails.

No more who did what to who talk in the halls.

No more pinching in the aisles.

No more mornings staring at light bulbs.

No more watering plants.

No more wondering where your next free lunch is coming from.

No more crossword puzzles.

No more girlie books.

Now, there's something really meaty to look at. Right here.

Now, you can see what this business is all about. Right here.

Now, there's something to goose a nerve. Right here.

**PAUL W. HODGES
Senior Vice President
F. William Free & Co., Inc.
New York City**

It is Thursday.
Today, I feel deliciously smug about us.
There are 18 projects going on
 one car in the auto club
 two cases of the flu
 one dog romping around.
And tomorrow there is a summit meeting with
a key account.
And everything is moving, humming, flowing, careening
correctly,
creatively
and on-time.
And people are laughing.
This is such a terrific sound. I mean, over the phones ringing and the
computer humming,
and the shouting, laughter is the most terrific sound.
And I think it is because…I know it is because
of the people.
I really must be feeling deliciously smug today.
Or I wouldn't have written such a setup into the fact that we are
21 women
and four men.
But it is who and what the women are that is most important.
Besides the executives, we hire for our reception desk women
who are deeply interested in advertising. Women who would never
normally take reception desk jobs. Women frequently with Masters' degrees.
And rarely has a woman spent more than six months at the reception desk.
One is currently a junior buyer.
Two are currently account coordinators.
One is currently my secretary. (Alas, soon to be moved to the creative
department.)
And it is the meshing of all the people that is so singularly beautiful.
No job is beneath anyone.
Even hiding the dog when the building people come in.
Even bringing coffee, tea or Perrier without being asked.
Even pinning my ticket to my jacket because I lose everything.
Sometimes I deliberately avoid the word "liberated" because it
is a "cringe" or a "clang" word.
But these are the most liberated women because they are liberated
from the need to be liberated.
They are women.
They are capable women.
They are warm, real, beautiful women.
Our four men?
Ah, they are giants, too.
It's just that they don't know how to hide the dog, where to find the
coffee, the Perrier,
answer the phone, or pin tickets on lost people's jackets.
I wonder
if that's why they don't laugh as much.

JANET MARIE CARLSON
President
Carlson/Liebowitz
Los Angeles

ERIK ARNESEN
11 Zoe Street
San Francisco, California 94107
(415) 495-5366

Representative: Peg Hamik
(415) 421-3422

People, location, destination photography for advertising, corporate communications, editorial illustration.
Best Foods, Coca-Cola, Crown Zellerbach, Dole, FMC, Kenner Toys, Kingsford Charcoal, Levi Strauss, Oroweat Foods, Marriott's Great America, Wells Fargo Bank.
Publishers: Apartment Life Magazine, Harcourt Brace Jovanovich, Human Nature Magazine, Macmillan, Scott Foresman.
Agencies: Dancer Fitzgerald Sample, deGarmo, Foote Cone Belding/Honig, McCann Erickson, Wells Rich Greene.

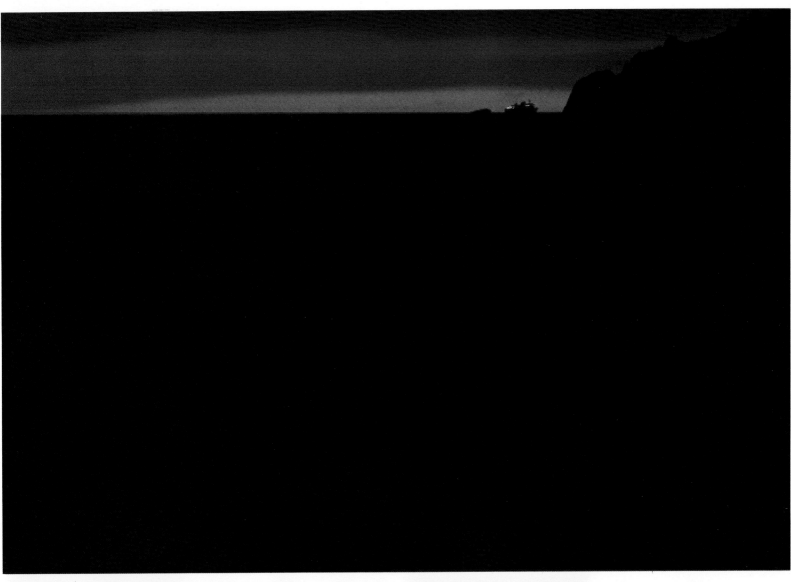

DAVID BARNES
500 Northeast 70th Street, #306
Seattle, Washington 98115
(206) 525-1965

The business of America is business…The business of
Dave Barnes is humanizing your world with strongly designed imagery.
Worldwide experience photographing for business, sports
and travel promotion, agriculture and publishing.

JIM BLAKELEY
520 Bryant Street
San Francisco, California 94107
(415) 495-5100

Los Angeles Representative: Eisenrauch & Fink
(213) 652-4183

Purex: Candid photo taken through keyhole of adjoining apartment.
Chevron USA: Each piece was meticulously placed by two men and a crane to resemble a pile of junk.
San Miguel Beer: Probably one of my pourest shots.
Peterbilt: Biggest problem was getting tire marks out of 3 inch thick carpeting.

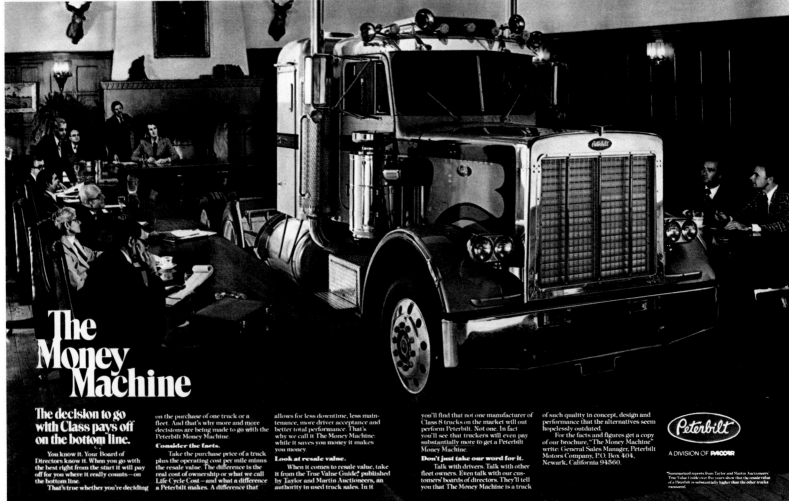

GO FOR THE THROAT

Just like anything else, 90% of everything stinks. This goes for photographers, too. I search for that elusive thing, excellence. It's everywhere, but you must bust your ass to find it.

The best photographers are walking the streets. I see anyone who calls me. I'm surprised nine times out of ten. Even the tenth one knocks me out; yes, even the terrible ones. I like them, too. Insulation from the outside world is creative death.

When I hire a photographer, I get a package: photographer, stylist, makeup artist, etc. I rely on them heavily. We usually like each other — chemistry is all-important. One person's ego or attitude can weaken or destroy a shot. Any photographer who follows my layout exactly I'll knock out. I expect my ideas to improve drastically, for the better, with the input of the photographer and his staff.

You must have a strong idea to start with first, not just photography with type added later. Then I look for an artist behind the camera, a thinking photographer.

I love futuristic photographers, people who stretch to the point of failure. In that stretch there's the fine line between good and great. (I'll take the great in large quantities, please.) You don't get anywhere being safe. I was once hired for a big job not only because of my work, but because the boss remembered the day in Chicago when I walked around a building ten stories up on a four-inch ledge and knocked on his window, "Hi. How are you today."

Futuristic photographers have a hard time selling their work. I worked for a medium-sized record company. Now you'd think nothing can be more futuristic than music, film, dance, etc. Absolutely not true. They were mediocre businessmen — nickel and dimed me to death. They didn't understand the fine line between good and great. The fine team of people I worked with, however, produced great ads with minimal time and money.

So go for the throat, you can always come back.

BRADLEY H. OLSEN-ECKER
President & Creative Director,
Olsen-Ecker, Inc.
New York City

R. CHANDLER STUDIO, INC.
1111 North Tamarind
Los Angeles, California 90038
(213) 469-6205

Representative: Mary Kathleen Fellows
(213) 469-6205

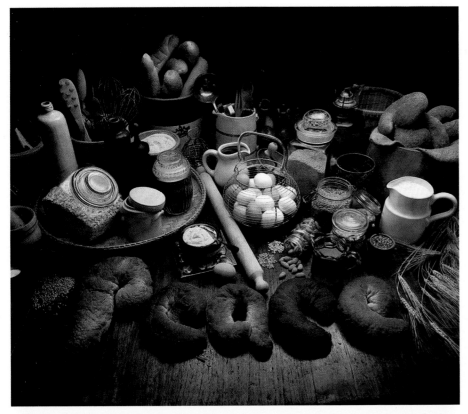

WHY ART DIRECTORS ARE A PAIN IN THE ASS

Even before an art director puts pencil to paper, he puts people through hell. He gives the account executive a hard time about the advertising strategy and the writer conniptions over the copy.

After the usual birth pains with attendant grunts, groans and primal screams by the art director and writer as procreating mates, there sometimes emerges an extraordinary piece of advertising. Then the battle begins to keep their creation from being violated.

First, the exposure to the Creative Supervisor, the Creative Group Head and the Executive Creative Director. One of them might take aim at the headline copy, another, the content of the main illustration and still another (heaven forbid) the basic concept. All of these things and more might occur or none of them. It all depends on how well the idea and execution work for these sharpshooters. If the advertisement survives these intramural attacks intact, it's a telling victory.

Second, the ad has to pass muster with the Account Assistants, the Account Executive, the Account Supervisor, the Account Director and the Account Management Representative. Some of them might take potshots at the text copy, others might stab at the visual technique and (again heaven forbid) one of them might seriously question if the ad is "on strategy." If the ad survives all the agency internal onslaughts intact, it's a minor miracle.

Finally, this extraordinary creation must withstand the external challenges of the client. Shots are fired by the Assistant Brand Manager, the Brand Manager, the Brand Group Manager, the Advertising Director and the Marketing Director, in rapid succession. All the questions asked back at the agency and more are leveled at this piece of advertising. If the ad encounters unusual resistance, the art director may, like Don Quixote, continue to battle against all odds to defend it. He risks ridicule, reprimand and possible retribution. But if the art director (and the ad) achieves the final victory unscathed, it's a major miracle.

Which means by the time the photographer, illustrator, designer, typographer, retoucher, film director, cameraman, editor, et al. get involved in the production of the ad, the art director has been to hell and back.

So if he's a pain in the ass about sticking to the basic concept, preserving the clarity of the communication and paying the utmost attention to detail, don't complain. If he demands every ounce of your energy and all the concentration you can bring to bear on the realization of the idea, don't complain. He's protecting the most precious commodity an advertising agency has to offer: the extraordinary advertisement. If you help him pull off another miracle when you're getting a hard time from him, don't complain. Because you may be getting an Andy or a Clio, too.

CARMINE J. BALLARINO
Senior Art Director/Producer
Dancer Fitzgerald Sample, Inc.
New York City

GEORGE de GENNARO STUDIOS
902 South Norton Avenue
Los Angeles, California 90019
(213) 935-5179

Photographic illustration, food, still life.

TOM ENGLER
968 North Vermont Avenue
Hollywood, California 90029
(213) 666-4640

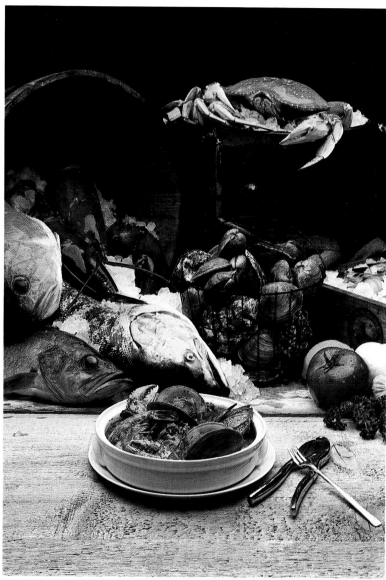

MARC FELDMAN STUDIO, INC.
6442 Santa Monica Boulevard
Los Angeles, California 90038
(213) 463-4829

Representative: Ashley Bowler

RICHARD YUTAKA FUKUHARA
3267 Grant Street
Signal Hill, California 90804
(213) 597-4497

Corporate, editorial and advertising illustration.
Images (clockwise):
"We can put your office anywhere in the world"
Flying Tiger Airlines;
"Make it a double...please"
Baskin Robbins;
"Salad special"
Party Magazine;
"Melon, a natural package of pure pleasure"
Los Angeles Times Home Magazine.

Other clients: Cox Hobbies, Datsun, Foremost-McKesson, General Telephone, Health Valley Natural Foods, Hunt-Wesson Foods, Inc., Tenneco West, Toyota, Trojan Distributing for Ice House Wine Cocktails and Gaetano Cocktails, Wham-O, Yamaha....

ROBERT GARDNER
800 South Citrus Avenue
Los Angeles, California 90036
(213) 931-1108

Representative: Gail

After studying under Melvin Sokolsky, I began my career on New York's East Side thirteen years ago.

Presently located in Los Angeles and specializing in fashion and beauty, still life and food illustration, I have worked on both coasts for clients such as:

Avon, Chanel, Clairol, Jhirmack, Helena Rubenstein, Jean Naté, Revlon, Vidal Sassoon, Viviane Woodard, Dipper's Swimwear, Poppy Swimwear, Sandcastle, Inamori Jewels,

Rolex, Benson & Hedges, Continental Airlines, Volkswagen, Esquire, Modern Bride, Bazaar, Seagram, Gaetano, Canadian Lord Calvert, Boodle's, Pepsi Cola, Coca-Cola, Olga, Vassarette, Rogers, Maidenform, Marantz, 20th Century Fox, General Foods, Nestea, Carnation, Silverwoods, Harris, J.C. Penney, Bullock's, du Pont Qiana, Montgomery Ward, Neiman-Marcus, Glenoit, IBM.

Stock photography also available.

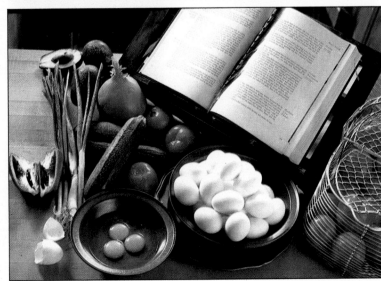

ARTIE GOLDSTEIN
1021½ North La Brea
Los Angeles, California 90038
(213) 874-6322

One of the Best is in the West.

Background:
Twelve years of advertising photography in N.Y.
Eight years of advertising photography on the West Coast.
Complete knowledge of locations, suppliers, labs, prop houses, and talent agencies from Vancouver, Canada, to Mazatlan, Mexico.

A completely equipped studio in Los Angeles.

Clients: Squirt, Master Charge, Memorex, Hewlett-Packard, PGE, Standard Oil, Arco, Tenneco, Gulf Oil, Wendy's, Sizzler, Jeep Int., Volkswagen, Toyota, Crocker Bank, Bank of America, Lloyds Bank, Johnston Yogurt, IBM, Rusco Security, NEC Pagers, International Paper, Paul Masson, Mumm, Gallo, LA Times, 7 Up, NBC, Pacific Stereo, Playgirl, Playboy, Arista Records, Occidental Insurance and others.

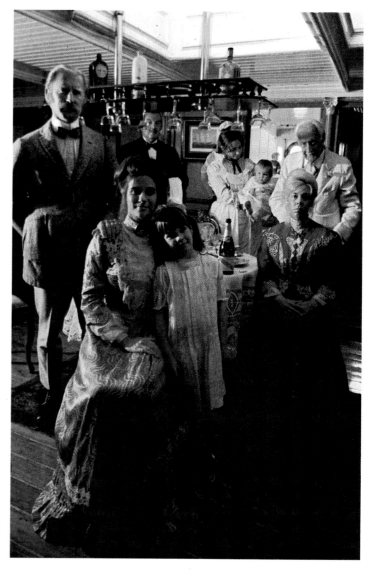

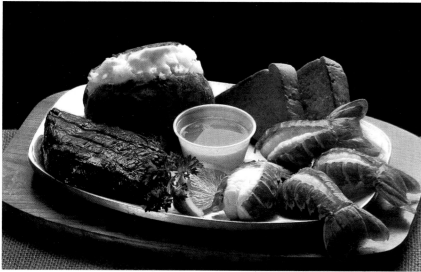

It's just nature and us Johnstons.

LARRY DALE GORDON
2047 Castilian Drive
Los Angeles, California 90068
(213) 874-6318

New York Representative: Nob Hovde & Laurence
(212) 753-0462

Chicago Representative: Clay Timon & Associates
(312) 641-0934

Paris Representative: John Dunnicliff/Blink Photography
256-8000

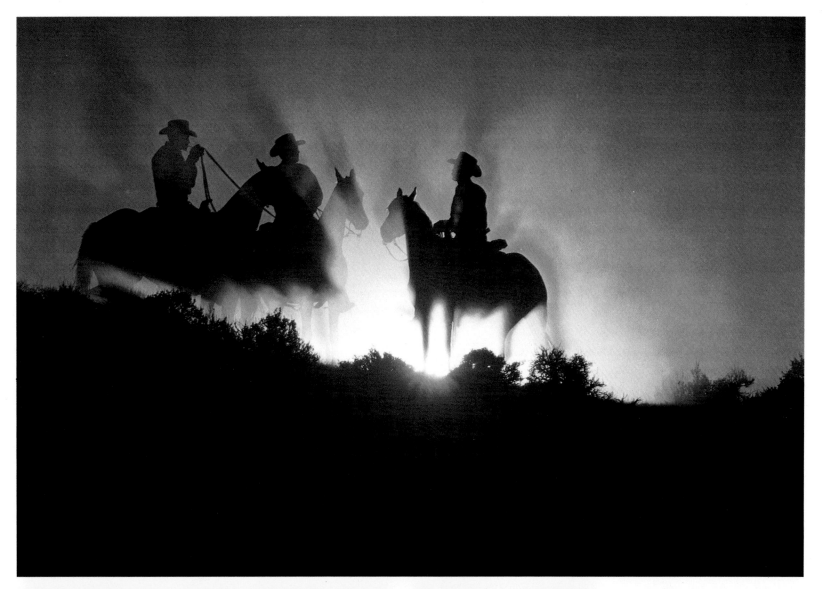

BRUCE HARLOW
2214 Second Avenue
Seattle, Washington 98121
(206) 622-4843

Recent assignments for:
Boeing Commercial Airplane Co.,
Crescent Foods,
Uniflite,
California Redwood Assoc.,
Tree Top.

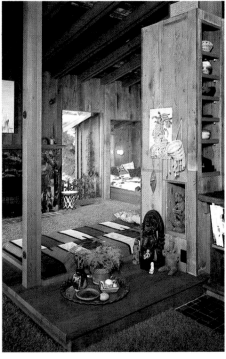

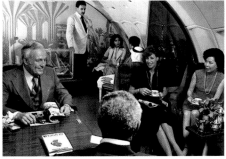

CHARLES KEMPER PHOTOGRAPHY
74 Tehama Street
San Francisco, California 94105
(415) 495-6468

Representative: Peg Hamik
(415) 421-3422

Almaden Vineyards, Armour, Bechtel, Blitz Beer,
Castle & Cooke Foods, CBS, Charter Bank of
London, Chevron, Cutter Laboratories, F.M.C.,
Kimberly-Clark, Knudsen, Pacific Telephone,
Paul Masson, Pillsbury, Saga Foods, Shaklee
Corporation, Smirnoff, Straw Hat Pizza, Syntex,
Teledyne....

ALAN KROSNICK
215 Second Street
San Francisco, California 94105
(415) 957-1520

Working for major agencies for
the last ten years.

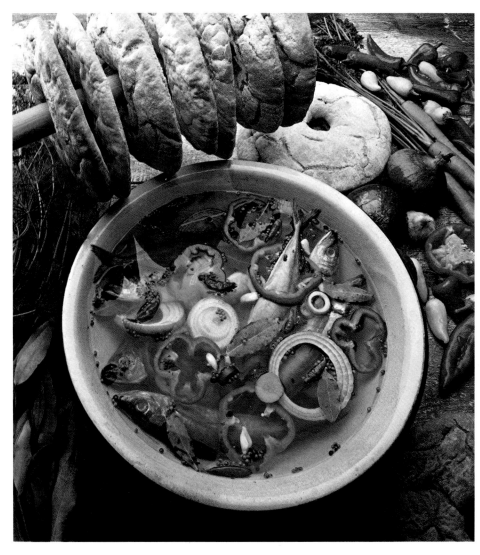

MARV LYONS
7900 Woodrow Wilson Drive
Los Angeles, California 90046
(213) 650-8100

Advertising illustration.
Creative consultant.

Space age fantafiction reflecting on contemporary
fashion, people and products.

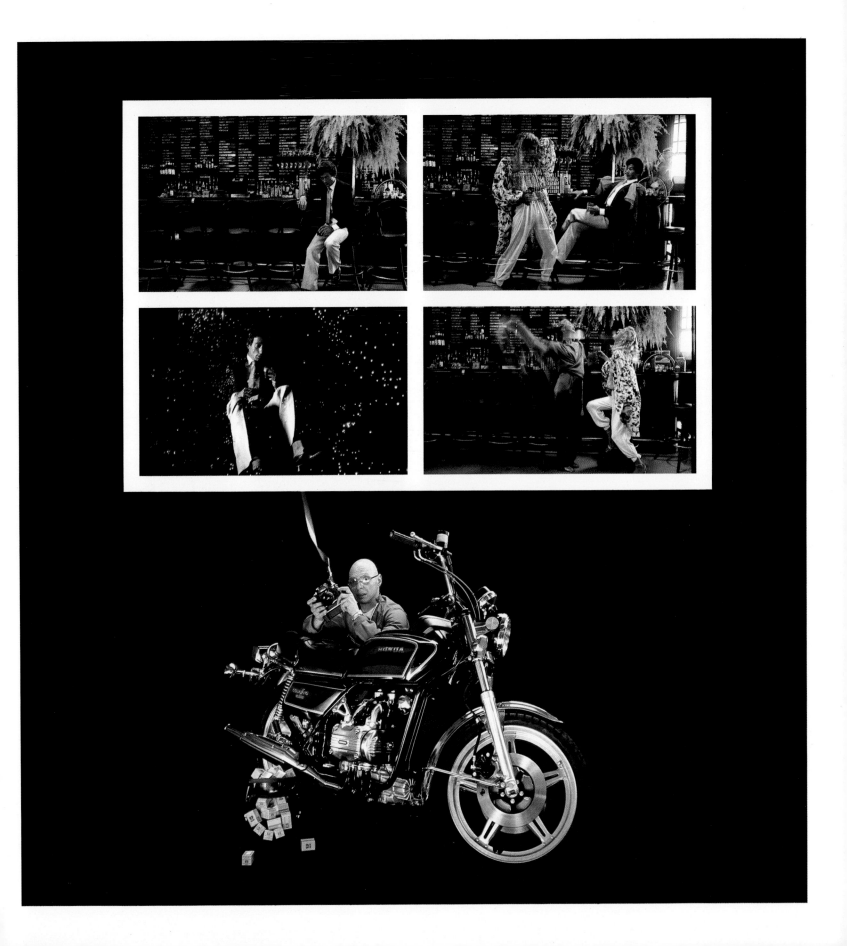

MADDOCKS/ALLAN PHOTOGRAPHY
4766 Melrose Avenue
Los Angeles, California 90029
(213) 660-1321
J. H. Maddocks
David Allan

A new team, with over 25 years of experience in product illustration, corporate photography and annual reports, ads and brochures, both on location and in a well equipped studio. They offer a wide variety of creative solutions to photographic problems, as well as TV lighting and location consulting. Client list and portfolio on request.

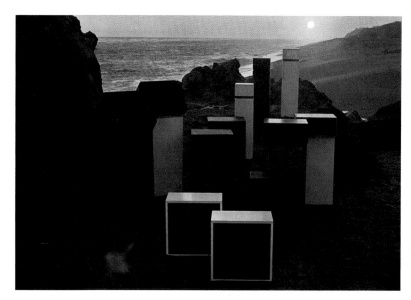

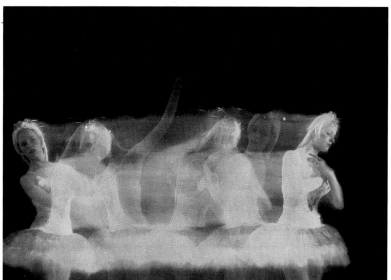

Two things that I hold near and dear in the rapidly expanding world of visual arts are: pig pictures and scenic souvenir bubbles.

Pig pictures are easy enough to explain. It all started in 1976, the year that the Muppet Show introduced Miss Piggy to the airways. Her bio very much duplicates my own perception of my life; Miss Piggy and I resemble each other in most ways with two exceptions: she's shorter, and my nose is straight.

Busby Berkeley had his dancing ladies, Elizabeth Taylor has her diamonds, Robert Louis Stevenson had his toy soldiers, and I have my bubbles. You see, I'm employed by a company that publishes ten in-flight airline magazines. The planes go everywhere, but they fly without me. Sure, I get to read about Bali. And I get to see pictures of Bora Bora, but do I get to go? Need you ask? So I visit vicariously, through my bubbles, those three-dimensional scenes in liquid, and enclosed in glass, that shower snowflakes and glitter when you shake them.

There are pluses and minuses in every part of our lives. If you're a photographer, the minuses would be showing me photographs of ham sandwiches or footballs, the plus would be to present me with a souvenir bubble of Hong Kong, made in Hong Kong.

Admittedly, I see countless portfolios, but as it turns out I see very little photography. Excellence in photography — that's the real plus.

If a photograph evokes feeling within me — if it makes my mouth water upon seeing a dish of luscious strawberries and cream, or if I feel Ali's fist as if I were punched in the jaw, or if I just want to know more about the subject in the photo — I'm hooked. A good photographer can show me any type of photography, I don't have to like the subject, but I do have to get something from the content and quality.

Mediocrity is selling. America is buying. It's easy. It's reliable. You can always find it. We all settle. I settle if I pick a picture with the knowledge that "it will do." But that shouldn't be good enough for the photographer. Being in the right place at the right time is important, but forsaking quality for just plain luck won't do. If the choices presented were limited to favorites instead of seconds and thirds, we would have quality. Less is more.

If you don't love it, leave it home.

FRAN BLACK
Picture Editor
East/West Network
New York City

GEORGE MEINZINGER
968 North Vermont
Los Angeles, California 90029
(213) 666-4640

Clients include: Allergan, A&M Records, American Express International Banking,
American Telecommunications, ASTECH, Alza, Beringer Vineyards, Collins Foods,
Coca-Cola, Carnation, Computing & Software, Craig Stereo, Clorox, Egyptian
American Bank, Flour, Getty Oil, Home Savings & Loan, Hughes Tool, Hughes Laser,
Hallmark Cards, Host International, Hi-Shear, Hyatt, HMO, Hilton, Handy Dan, House of
Fabrics, ICN, ITEL, Ingram Paper, Kaufman & Broad, Lockheed, Levi Strauss, Lear
Siegler, Litton, MCA, Magicam, Mattel, Northrop, Petrolane, Phillips Petroleum,
PERTEC, Paramount, Quotron Systems, Republic Corporation, Registry Hotels,
Shapell Industries, Saga, Signal Oil, Sargent Industries, Shaklee, Sitmar Cruises, Tele-
dyne, Union Bank, United California Bank, Varian, Warner Bros., Whittaker, Yamaha.

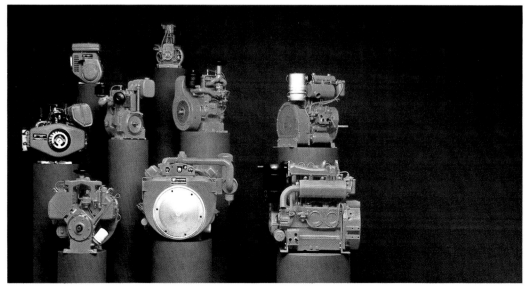

GEORGE MEINZINGER
968 North Vermont
Los Angeles, California 90029
(213) 666-4640

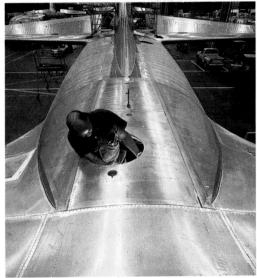

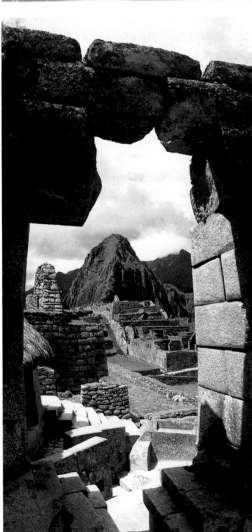

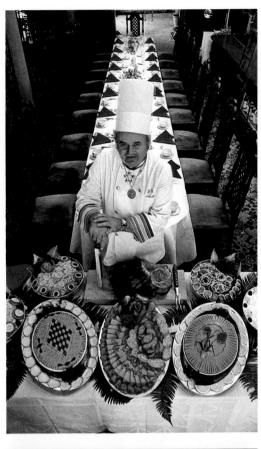

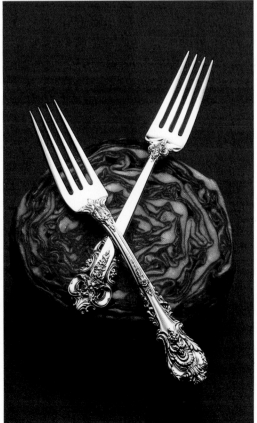

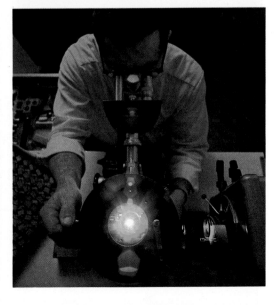

GRANT MUDFORD
5619 West 4th Street, #2
Los Angeles, California 90036
(213) 936-9145
New York: (212) 799-8572

Beauty, fashion, advertising, travel.

Clients range from J. Walter Thompson to Time-Life Books, from English Vogue to Campbell-Ewald, Toyota to New West Magazine.

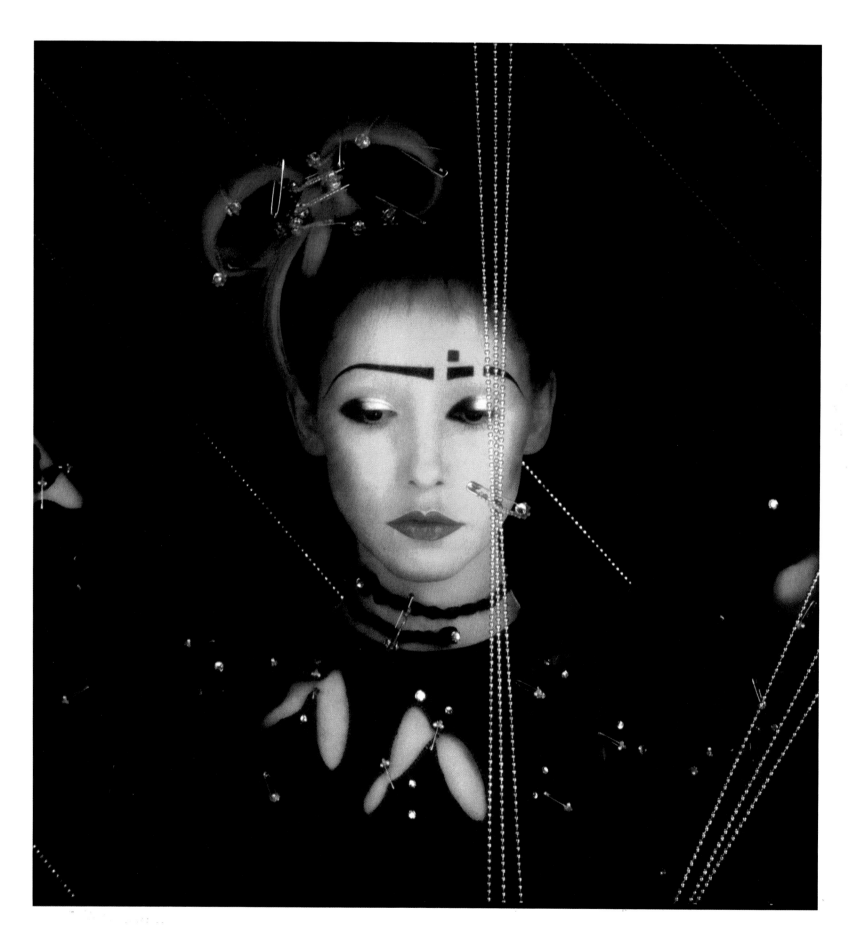

DAVID MUENCH
P.O. Box 30500
Santa Barbara, California 93105
(805) 967-4488

Landscape, nature, environmental, wilderness—its beauty. For advertising, books, editorial and travel.

Innovative seeing with large format and 35mm stock. The landscape, its natural rhythms and pulse, light, spatial forms—the mysterious. Personally illustrated over fifteen exhibit format nature books. Images from all regions of the United States.

SUZANNE M. NYERGES
413 South Fairfax Avenue
Los Angeles, California 90036
(213) 938-0151

...when a thousand pictures scintillating in the night
walk the walls of my vivid memory...
M.A.

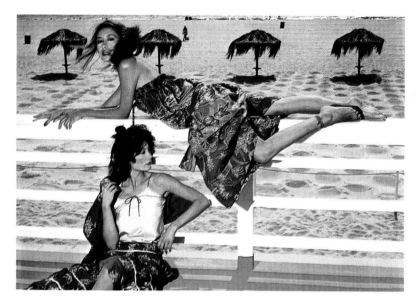

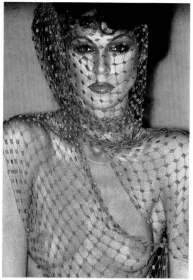

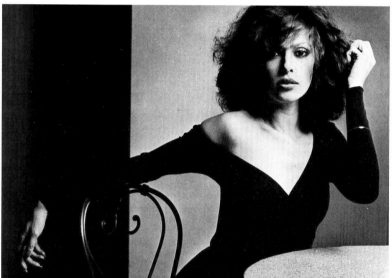

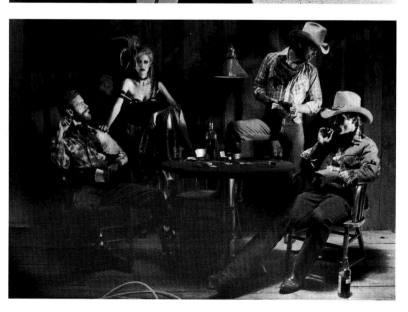

TOMAS O'BRIEN
450 South La Brea
Los Angeles, California 90036
(213) 938-2008

STEPHEN RAHN
81 Clementina
San Francisco, California 94105
(415) 495-3556

Representative: Christine Churchill

Clients include: Christian Brothers, Paul
Masson, United Airlines, Koret of California,
Datsun, Itel, Hewlett-Packard, Imsai, Toyota,
Levi Strauss, National Semiconductor,
Philippine Airlines, TRW, Advent, White
Stag Speedo, SBE Linear Systems, Ciga
Hotels, Union Carbide.

Member ASMP.

GEORGE SELLAND
461 Bryant Street
San Francisco, California 94107
(415) 495-3633

George Selland Photography

JAY SILVERMAN STUDIOS
1039 South Fairfax Avenue
Los Angeles, California 90019
(213) 931-1169

Representative: Sharri

Advertising and editorial illustration—fashion, annual reports, still life, beauty and people.

Two superbly equipped studios, with clients like: Max Factor, M.C.A., Playboy Magazine, T.R.W., T.V. Guide, Teak, Security Pacific Bank, Bekins, Capitol Records, Vidal Sassoon, Pentel Pen, Fisher Components, Arrowhead Water, Dataproducts, Kahlua Liquor, Knudsen, American Savings, Brown Jordan, Winchell's Donuts, Redken, Hershey, Mazda, Suzuki, Datsun, & Coca-Cola...

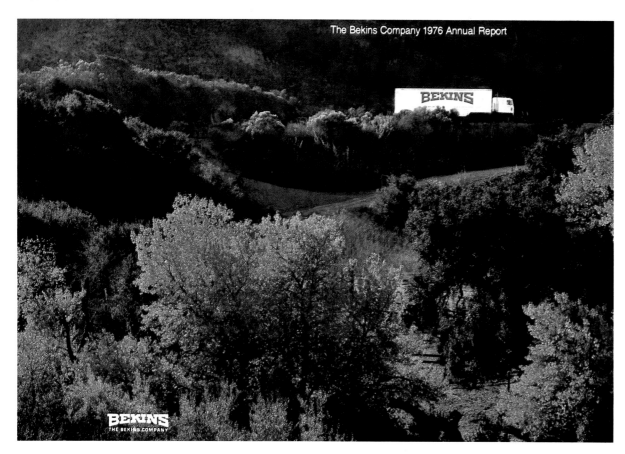

The Bekins Company 1976 Annual Report

SCOTT SLOBODIAN, INC. PHOTOGRAPHY
6630 Santa Monica Boulevard
Hollywood, California 90038
(213) 464-2341

Representative: Barbara Slobodian
(213) 935-6668

A full-service West Coast studio specializing in advertising and annual reports.
The following is a partial list of clients: Interpace, Sanyo Electronics, United California Bank, Knudsen, Fujitsu Stereos, Hughes Aircraft and Helicopters, Starkist, ITT Barton, ITT Cannon, Caesars World, Avery Labels, Litton Industries, Western Pacific Savings and Loan, Squirt, Butte Oil Company, Junior Achiever, Mattel Toys, Logicon, Kelly Tires, Pacific Telephone, First Charter National Bank, WTC Air Freight, Pacific Lighting, Rolls-Royce of Beverly Hills, Globetrotters, Wald Sound, Sahara Tahoe, KPOL, K100 Radio, Biltmore Hotels, Resdel Industries, Utility Trailer, Houdaille, KTTV, Devon Group, TWA Air Freight, JBL Stereos, First National Bank of Nevada, Ampex Speakers, X-tal Stereo, Max Factor, Craig Stereo, Furan Plastics, TreWax, Vivitar, Berkeley Hollander Circe, Albert C. Martin, Architects, Beverly Hills Federal Savings, Cerwin-Vega, Aerojet General, 7 Up, Cox Toys, Warner Brothers, Manufacturers Bank, Bank of America, Leisure Group, Wynn Oil, Lockheed, ACS Air Freight.

San Francisco Studio:
370 Fourth Street
San Francisco, California 94107
(415) 543-2525

Los Angeles Studio:
7207 Melrose Avenue
Los Angeles, California 90046
(213) 934-8214

San Francisco Representative: Ron Sweet
(415) 433-1222

Los Angeles Representation
(213) 934-8214

New York City Representative: Kate Chettle
(212) 752-0273

Advertising agencies that have called for our services include—In New York: William Esty; DKG; Lord Geller Federico; Sacks & Rosen; Tinker Campbell-Ewald; Chicago: JWT; PKG; Marsteller; McCann-Erickson; and Ogilvy & Mather; Atlanta: Tucker Wayne; Kansas City: Brewer Adv.; Los Angeles: DDB; Ayer Jorgensen MacDonald; Erwin Wasey; Benton & Bowles; Chiat/Day; Wells Rich Greene; FCB; D'Arcy-MacManus; Y&R; Honig-Cooper & Harrington; Ogilvy & Mather and Gumpertz/Bentley/Fried; Seattle: McCann-Erickson; San Fran- cisco: JWT; Cunningham & Walsh; Botsford Ketchum; FCB/Honig; McCann-Erickson; Tracy-Locke; Dailey & Associates; Grey Adv.; Hoefer, Dieterich & Brown; Bozell & Jacobs; Wilton, Coombs & Colnett; Allen & Dorward; Vantage Adv.; Steedman, Cooper & Busse; Imaginez; D'Arcy-MacManus; Ayer/Pritikin & Gibbons; Merchan- dising Factory; Brand Year 1; La Perle & Associates; Viacom & Associates and The Studio/Susan Roach.

JOHN TERENCE TURNER
173 37th Avenue East
Seattle, Washington 98112
(206) 325-9073
Frequently located in Sun Valley, Idaho, from
December through April (P.O. Box 1466).

Areas of specialization: sports (skiing, sailing,
tennis, climbing), industrial, fashion.

Clients include: Cummins Engine Co., United Air-
lines, Hughes Airwest, Airborne Freight, K2
Corporation, AMF Head, Sun Valley Company,
Bayliner Corporation, Serac, Dow Pharmaceutical,
Diet Pepsi.

SEATTLE MAGAZINE/VICTORIA, BRITISH COLUMBIA

EDDIE BAUER, INC./ MT. RAINIER

CUMMINS ENGINE CO./ALASKA

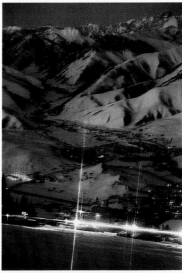

SUN VALLEY COMPANY/SUN VALLEY

SKIING MAGAZINE/SUN VALLEY

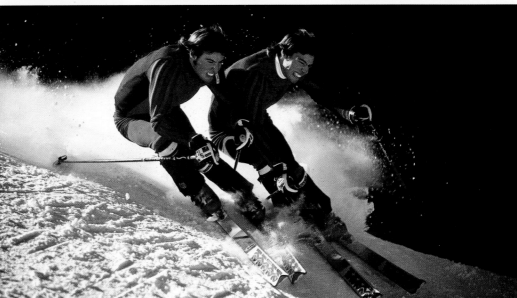

K2 CORPORATION/SUN VALLEY

"I DON'T GET NO RESPECT"

"I don't get no respect." That pathetic plea from comedian, Rodney Dangerfield, has an all too familiar ring. I've heard it throughout my professional career: from my peers, my employers, and my clients. I have heard it from people who work for me. I even say it myself, to my own kids. The "Old Pro" is just history.

Yesterday's Gold Medal and Clio winners are not necessarily today's stars. Brash youth and driving ambition hold no guarantee for respect either. Respect is earned, not given. Consistant heavy hitters win mine.

I respect people who do more than just exhibit superb work, but who also display a sense of humanity and a philosophy within their work. Capitulation does not win my admiration. I'm as unimpressed with the ranting arrogance of the young, as I am with the sour rationales of the old.

Professionalism cannot be sold short. It's more than experience. It's the sum total of beliefs, compromise, humility, ego, energy and the ability to do great work. I respect the pro. I meter out that respect with certain qualifications. I am sometimes fair and sometimes not, but since it's coming from me (and it really doesn't hurt or help anyone), I dish it out as I see fit. The following list states to whom "I don't give no respect," and to whom I do.

Don't Respect

Colossal Egos.

Persistent and annoying reps.

Macho photographers.

Creative people who put down the advertising effort.

People who think the creative process is easy.

Anyone who doesn't respect my time.

"Legislators" of creative work.

Account men who listen but do not hear.

Research exercises.

Putting down the consumer.

Alternate solutions for the sake of having alternate solutions.

Bad ads with good rationales.

Orators who don't articulate.

Mimics who think they are inventors.

Stylists who think they are designers.

Most commercials.

Invisible ads.

Designers who violate good pictures by smothering them with type, over-retouching, bad cropping, etc.

Designers who violate good words by smothering them with pictures.

A work that has no personality.

Do Respect

Confidence with humility.

Guys who know when to lay off.

Open minds, not open shirts.

Creative people who take pride in what they do.

People who try.

My time and anyone else's.

People without rigid rules.

A good listener.

Research that contributes to creative ideas. Research that adds teeth to the problems and more bite in the solutions.

The consumer.

People with objectivity who believe there might be a better way.

Good ads with no reasons.

People who can explain themselves.

The innovator.

People who understand their roles.

The power of video communication.

Ads with energy.

Sensitivity.

Words.

A work that has character and a point of view.

Whether you're an art director, designer, illustrator, photographer, or film director, you know who respects you and who doesn't. You also know who you respect and who you don't. My heroes, my peers, and my apprentices know whether they have it or not.

Respectfully,

IRWIN GOLDBERG
Co-Creative Director
Nadler & Larimer, Inc.
New York City

ROBERT WORTHAM
964 North Vermont Avenue
Hollywood, California 90029
(213) 666-8899

Advertising illustration, editorial,
corporate, fashion, still life, annual
reports.

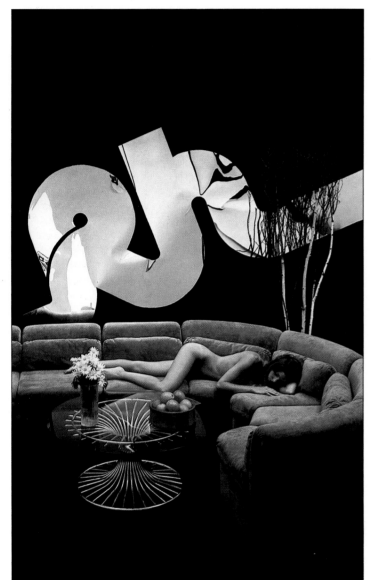

R. HECHTMAN INTERNATIONAL

ATHANA

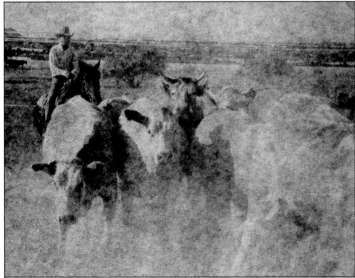

BELL CATTLE FUNDS

FUN

R. HECHTMAN INTERNATIONAL

TOM ZIMBEROFF
P. O. Box 5212
Beverly Hills, California 90210
(213) 271-5900

Corporate image is your concern; corporate imagery is mine.

Experience has trained Zimberoff's eye to discern the exciting, latent, graphic image from the mundane surroundings that often hide it. On location throughout the world, he uses his sense of design and discriminating exploitation of color to complete assignments for travel, editorial, and corporate clients who appreciate that he keeps his cameras and suitcase always packed and at their disposal. Have tripod—will travel.

Existing photography: Contact Press Images
135 Central Park West
New York, New York 10023
(212) 799-9570

TOM ZIMBEROFF
P. O. Box 5212
Beverly Hills, California 90210
(213) 271-5900

A riddle: Do you know what the difference is between a stuntman, a diplomat, a deep sea diver, a race car driver, a desert nomad, an eskimo, a masochist…and a photographer?

Answer: Nothing!

Whether hanging underneath a chopper clutching a camera, or being drenched, blown, frozen, baked, shot at, or simply harangued, Zimberoff has continued to complete assignments under all these conditions and come through ticking like a Timex!

Existing photography: Contact Press Images
135 Central Park West
New York, New York 10023
(212) 799-9570

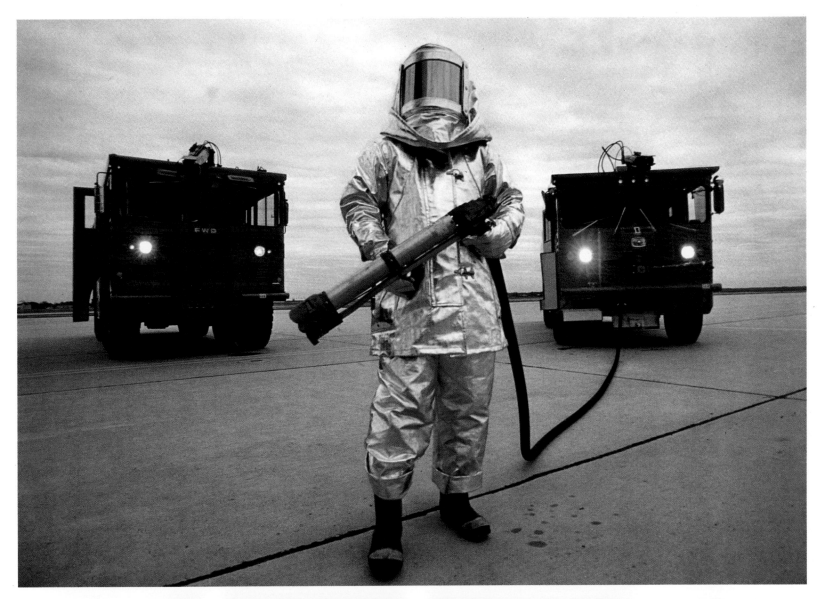

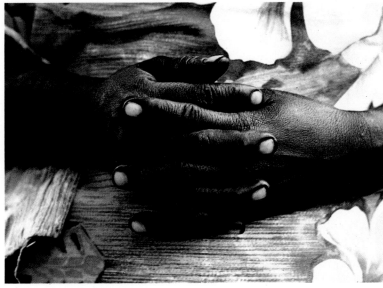

JOHN G. ZIMMERMAN
Girard Studio Group, Ltd.
9135 Hazen Drive
Beverly Hills, California 90210

Representative: Delores Zimmerman
(213) 273-2642

Chicago Representative: Bill Rabin & Associates
(312) 944-6655

Innovative illustrations.
People, action, fashion, travel, sports, etc.

See New York Metropolitan Area,
Page 108.

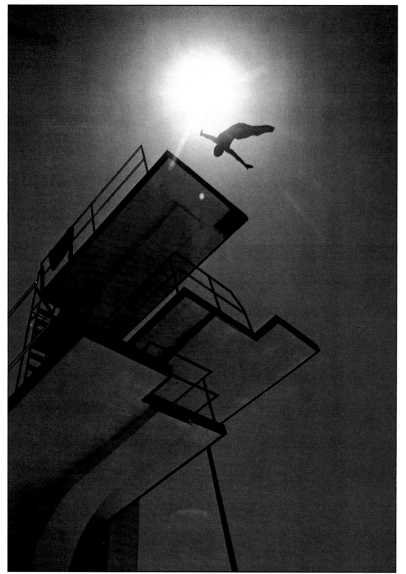

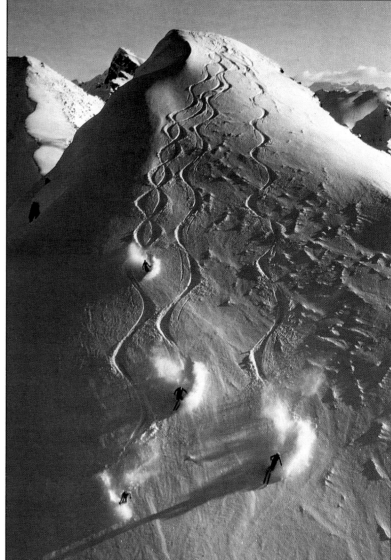

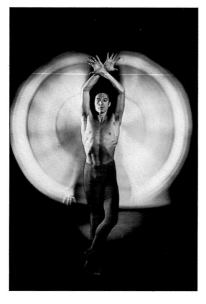

NIKOLAY ZUREK
671 Santa Barbara Road
Berkeley, California 94707
(415) 527-6827

In Europe cable:Nikolay Zurek
426 Bahnhofstrasse
2862 Worpswede
West Germany

San Francisco Representative: Ralph J. Parsons
(415) 986-0107
New York Representative: Ursula G. Kreis
(212) 562-8931

Advertising and editorial illustration, industrial, travel, still-life.

Nikolay brings his own ideas and unique sense of interpretation to each assignment. He has done that successfully with years of international experience for leading agencies, corporations and publishers in the U.S. and Europe. He can solve visual problems with illustrations that communicate the desired mood or message. Portfolio available on request. Stock photography.

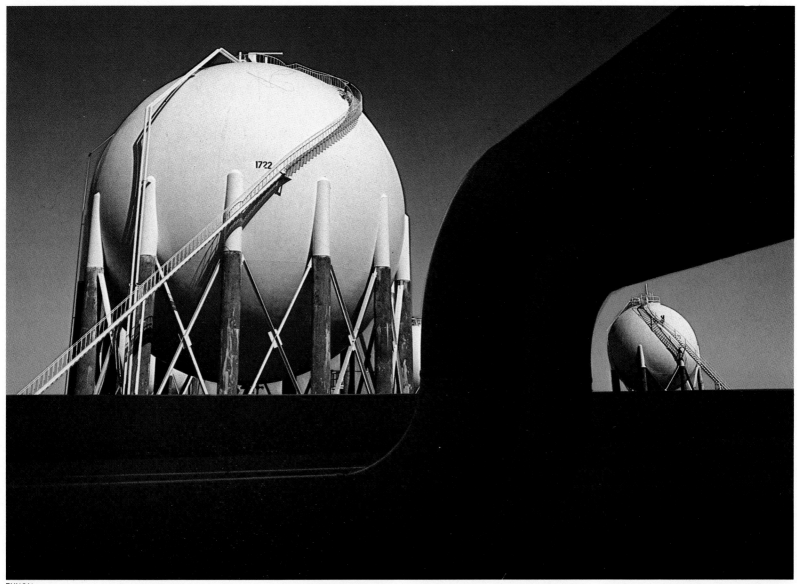

EXXON

KAISER ALUMINUM & CHEMICAL CORPORATION

HEWLETT-PACKARD

BECHTEL

Box 6
Westport, Connecticut 06880
(203) 227-9667

Born January 5, 1946, the refreshing creative instincts of Miggs Burroughs can be traced back to famous illustrator father Bernard Burroughs and Great Great Grandfather Barkham Burroughs, who built a financial empire on royalties earned from his invention of the return address. Miggs has been creating articulate, plain-speaking graphic illustration for the advertising and editorial marketplace since 1971. His work includes a U.S. Commemorative Postage Stamp and several covers for Time magazine, including Spiro Agnew's resignation cover selected in 1978 to hang in a permanent exhibit at The Smithsonian Institution in Washington, D.C., as one of the most significant covers in their history. Miggs resides in Westport, CT, with his attractive, tennis-crazed wife Mimi, and their semi-talented cat Nelson.

CHRISTOPHER COREY
253 Columbus Avenue
San Francisco, California 94133
(415) 421-0637

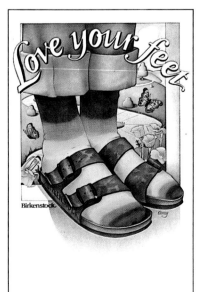

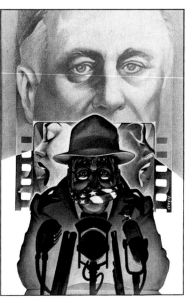

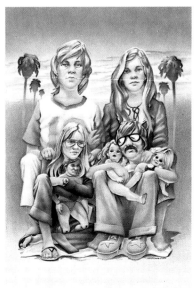

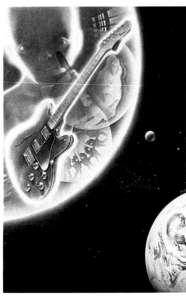

BENTON MAHAN
Box 66
Chesterville, Ohio 43317
(419) 768-2204

From advertising to publishing, my illustrations apply to a great variety of situations, and I've never missed a deadline except once in 1969 when Aunt Millie stepped on my drawing hand. Some of the clients I have done work for include: Sesame Street, Cue, Borden, Inc., Sheraton-Hilton, Good Housekeeping, Hallmark, McGraw-Hill, ITT, Whirlpool, General Electric, Peabody-Galion, J. Walter Thompson, American Airlines and many others.

After working successfully in New York City for several years, I moved back to my hometown of Chesterville, Ohio. Chesterville? You know, 20 miles from Waldo.

I'm looking forward to working with you.

GEOFFREY MOSS
315 East 68th Street
New York, New York 10021
(212) 472-9474

New York Representative: Marion Moskowitz
(212) 472-9474

Chicago Representative: Joel Harlib
(312) 329-1370

Collected works published in: The Art And Politics Of Geoffrey Moss/Introduction by Dan Rather (Gold Medal/Art Directors Club of New York 1978), Graphis, Communication Arts, U&lc, Graphics Today, and People Magazine.

Gold and Silver awards from Art Directors Club of New York, Society of Publication Designers.

Clients include: The Washington Post, The New York Times, CBS, U&lc, Time, Quest 78, The Atlantic Monthly, Young and Rubicam, Fortune, Ogilvy & Mather.

On the faculties of: Parsons School of Design and The Pratt-Phoenix School.

Work exhibited through Rizzoli International.

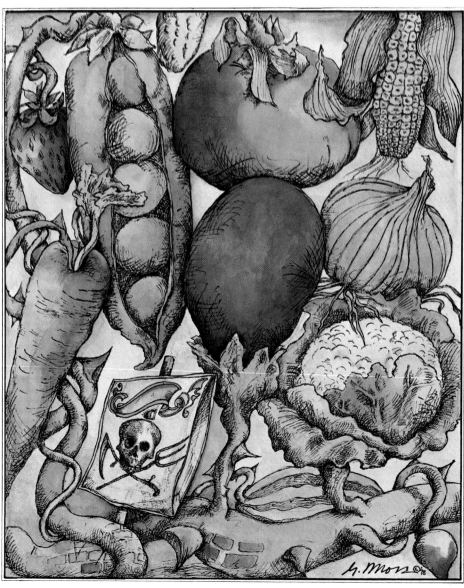

JOHN BRINKMANN DESIGN OFFICES, INC.
3242 West Eighth Street
Los Angeles, California 90005
(213) 382-2339

Efficiency
Function
+ Experience

Effective Design

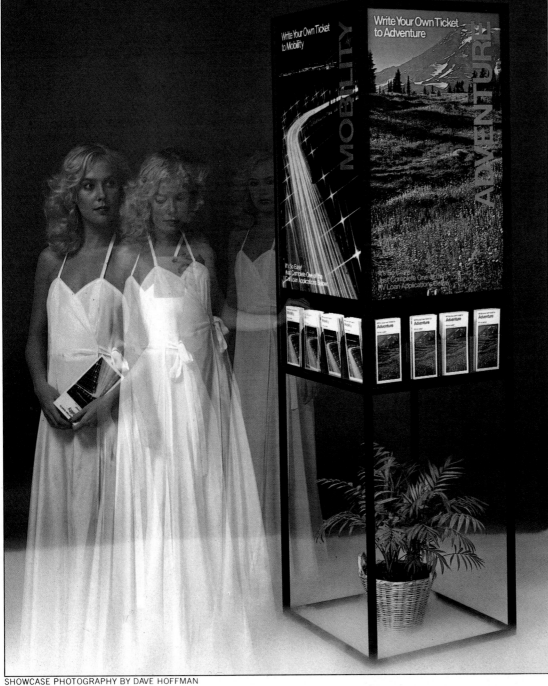

SHOWCASE PHOTOGRAPHY BY DAVE HOFFMAN

41 East 42nd Street
New York, New York 10017
(212) 765-8000

Irene Charles, formerly a principal of Osborn Charles Associates, Inc., has formed a very innovative design group specializing in packaging, new product development, corporate identity and graphics. Twenty years of experience has produced outstanding creative packaging that sells. ICA excells in liquor, soft goods, fashion, cosmetics, retail and consumer goods...

Shown below, the Christmas package for Seagram's White Horse Scotch. The colorful, re-usable, embossed tin box depicts the "Authentic Route" from Edinburgh to Old London Town. On the inside, a replica of the original parchment label. Sales were up 23.7%—much attributed to the package and container.

Among the clients ICA has served: American Can, Avon, Bibb, Chipman Union, Coty, Donahue Sales (Talon), William Grant & Sons, Heublein, National Distillers, J. C. Penney, Revlon, Royal Crown Cola, Saks Fifth Avenue, Seagram, J. P. Stevens, etc.

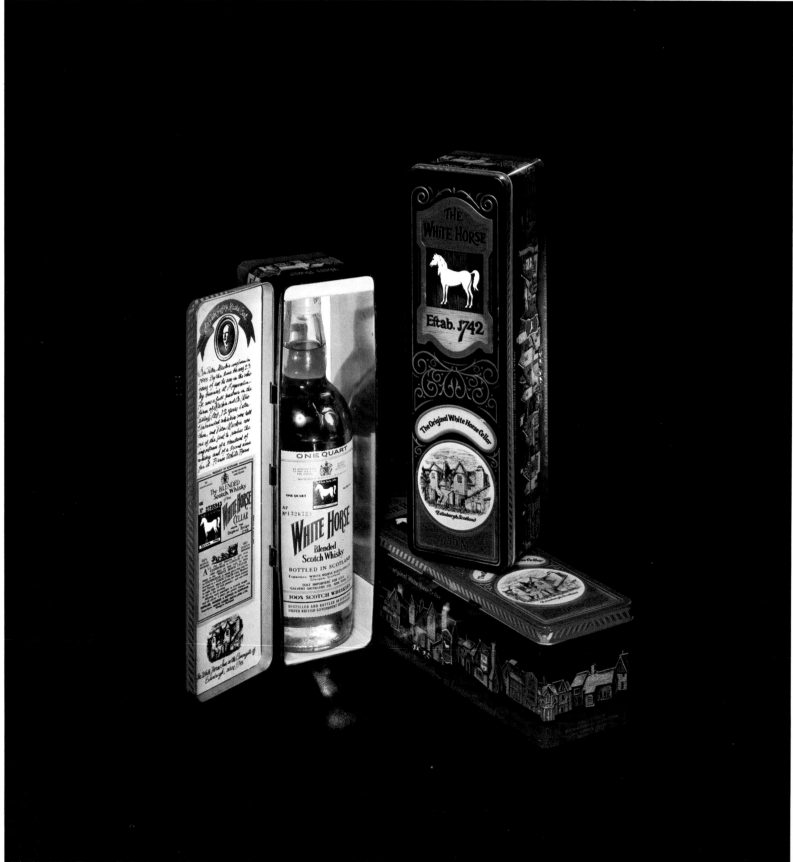

PHOTOGRAPH BY GIL ROSS

CORPORATE ANNUAL REPORTS, INC.
112 East 31st Street
New York, New York 10016
(212) 889-2450

Corporate Annual Reports, Inc. is distinguished by its clientele,
its creative design and its professionalism.

Our clients include many of the nation's largest corporations;
a number of them have been clients for a decade or longer.
We produce excellent design. Our designs vary widely, as each
solution is based on the specific needs of an individual client.
We employ a large staff of experienced professionals. This enables
us to deliver a full range of creative services, control budgets
and insure that no part of a job falls between the cracks.

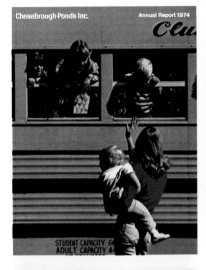
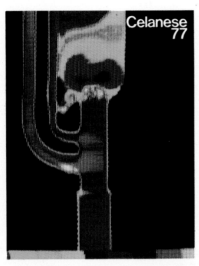
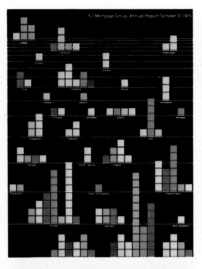
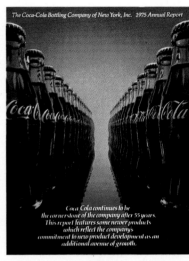

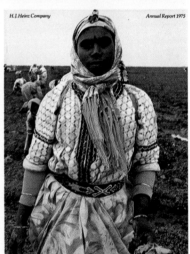
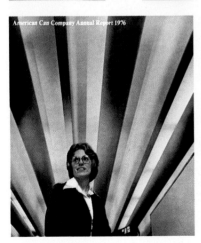

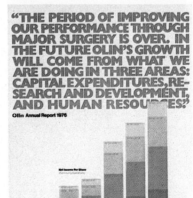

300 Madison Avenue
New York, New York 10017
(212) 682-0040

We believe that designers need not only good eyes but also good ears. We listen to our client's needs…we hear his marketing objectives. Our business is motivating consumers…not satisfying our own egos. Every package on this page was created with this in mind.
Our group functions as a design task force serving corporate packaging needs. In the last ten years we have enjoyed working with the following clients:

American Cyanamid Company
Bohack Supermarkets
Helene Curtis International
International Paper Company
King-Seeley Thermos Company
Milton Bradley Company
Norcliff/Thayer Drugs
Sterling Drug Company
The Stroh Brewery Company
U.S. Tobacco Company
World Tabac Limited

Photographs clockwise
from upper left:

Light beer for Stroh Brewery
Pipe tobacco for World Tabac
Pipe tobacco for U.S. Tobacco
Hair conditioner for Cyanamid
Acne medication for Norcliff/Thayer
Children's lunch kits for Thermos

Photographs by
Conrad-Dell-McCann, New York City

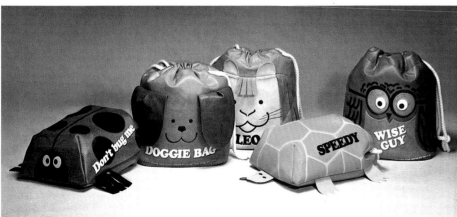

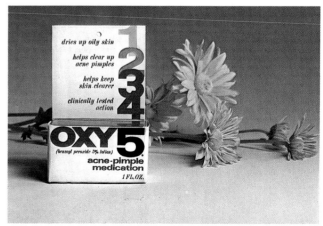

CHILDREN'S LUNCH KITS © 1978 FRED FEUCHT DESIGN GROUP, INC.

Corporate identity systems can maintain a company's overall image, but they often fail to perform well for the corporate divisions, which usually have their own unique marketing communications problems. Many corporations have both consumer and commercial products that require separate and distinct marketing and sales materials.
Fulton + Partners has evolved a special expertise in developing marketing communications programs which integrate into existing corporate communications systems. These programs save considerable time and money while building on the equity of the corporate communications system and guaranteeing a coherent appearance in all literature and marketing materials.

Fulton + Partners is a design/consultant firm which develops integrated marketing communications programs, package design systems, annual reports, logotypes, corporate identity systems, stationery programs and brochures.

Fulton + Partners also provides design services in interior design and space planning, product design, exhibition and display design.

A partial client list includes Koehring Corporation, Owens-Corning Fiberglas, Rival Manufacturing, American Broadcasting Companies, Ohio Citizens Bank, Sperry New Holland, Fujinon and Industrial Design magazine.

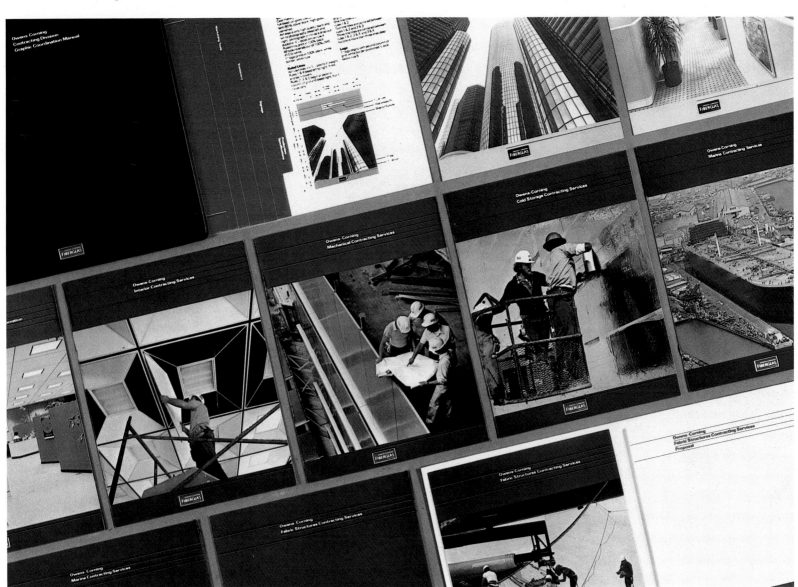

ROBERT P. GERSIN ASSOCIATES INC.
Industrial Design
11 East 22nd Street
New York, New York 10010
(212) 777-9500

No Nonsense
Concept development &
logo, packages & fixtures

New Country
Concept development &
molded cup, logo & graphics

BVD
Upgrading & redesign program,
trademark, packages & fixtures

Gestetner
Showroom in New York City

Viewlex
Portable planetarium for schools

United States of America
US Pavilion at Expo '75 in Japan

Graphics & Corporate Identity	**Packaging**	**Product Development & Design**	**Interiors**	**Architectural Planning & Design**	**Exhibits**
American Health Corp.	Advent Corp.	American Can Co.	American Health Corp.	Brooklyn Hospital	AT & T
AT & T	AT & T	AT & T	AT & T	City of Reston, VA.	Avon Books
Avon Books	Avon Books	BVD	Brooklyn Hospital	Harkness Pavilion, NYC	City of Reston, VA.
BVD	BVD	Colgate-Palmolive	City of Reston, VA.	Lane Bryant	Head Ski
City of Reston, VA.	Galliano	Corning Glass Works	General Instrument	National Fire Protection	HemisFair '68
Head Ski	Head Ski	Head Ski	Gestetner	Association	Houston Lighting &
JC Penney Company	JC Penney Company	Houston Lighting &	Houston Lighting &	National Shirt	Power Company
KLH Corp.	KLH Corp.	Power Company	Power Company	Norfolk Redevelopment &	Houston Medical Museum
Lane Bryant	Lane Bryant	KLH Corp.	Lane Bryant	Housing Authority, VA.	JC Penney Company
National Shirt	Myojo Foods, Japan	Lane Bryant	National Shirt	Pearlridge Mall, Hawaii	KLH Corp.
New Country Yogurt	National Shirt	Narco Avionics	Pearlridge Mall, Hawaii	Sears Roebuck & Co.	Narco Avionics
No Nonsense	New Country Yogurt	New Country Yogurt	St. Francis Hospital, Tulsa	Taubman Company	No Nonsense
St. Francis Hospital, Tulsa	No Nonsense	No Nonsense	Sears Roebuck & Co.	Tenneco Automotive Inc.	Smithsonian
Tenneco Automotive Inc.	Tenneco Automotive Inc.	Timex Corp.	Taubman Company	USA Pavilion, Japan	State of Virginia
Timex Corp.	Timex Corp.	Viewlex Inc.	Tenneco Automotive Inc.		USA Pavilion, Japan
USA Pavilion, Japan	Underberg, West Germany	Xerox Corporation	USA Pavilion, Japan		US Corps of Engineers

TONY GIANTI
12 Piermont Road
Rockleigh, New Jersey 07647
(201) 767-9238

Profit from your appearance.

GRAPHIC DESIGNERS INC.
2975 Wilshire Boulevard
Los Angeles, California 90010
(213) 381-3977

Frank Mediate

George Ivanyi

DON JOHNSON & MILT SIMPSON GRAPHIC DESIGNERS
49 Bleeker Street
Newark, New Jersey 07102
(201) 624-7788

Creative, effective visual communications for a wide
range of corporate clients come out of our town house
on Bleeker Street.

Our closely-knit staff works on corporate projects which
include annual reports, magazines, newspapers,
capabilities brochures, employee benefits packages,
film strips, posters, trademarks, direct mail and
advertising campaigns.

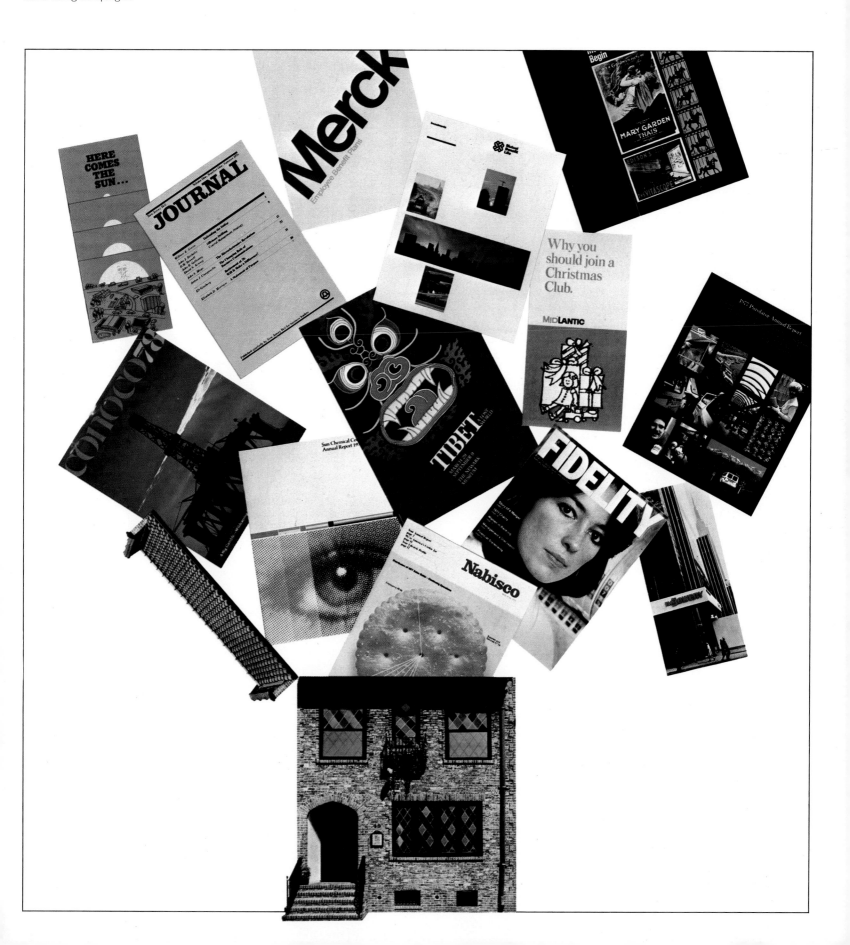

HERB LUBALIN ASSOCIATES, INC.
217 East 28th Street
New York, New York 10016
(212) OR9-2636
Tom Carnase, Tony DiSpigna, Herb Lubalin,
Alan Peckolick, Ernie Smith

Corporate Design

217 East 28th Street
New York, New York 10016
(212) OR9-2636
Tom Carnase, Tony DiSpigna, Herb Lubalin,
Alan Peckolick, Ernie Smith

Packaging

HERB LUBALIN ASSOCIATES, INC.
217 East 28th Street
New York, New York 10016
(212) OR9-2636
Tom Carnase, Tony DiSpigna, Herb Lubalin,
Alan Peckolick, Ernie Smith

Annual Reports

HERB LUBALIN ASSOCIATES, INC.
217 East 28th Street
New York, New York 10016
(212) OR9-2636
Tom Carnase, Tony DiSpigna, Herb Lubalin,
Alan Peckolick, Ernie Smith

Sales Promotion

This fall, in some 400 communities all across our land, the houselights will dim and the curtain rise on a new era in motion pictures. World famous actors, playwrights and directors have joined in an uncommon enterprise: to bring the great plays of Broadway and London on film to men and women everywhere.

MANNING STUDIOS, INC.

2115 Chester Avenue
Cleveland, Ohio 44114
(216) 861-1525

307 East Fourth
Cincinnati, Ohio 45202
(513) 621-6959

348 Washington, N.E.
Warren, Ohio 44483
(216) 399-8725

Manning Studios is an organization of 55 highly skilled professionals who specialize in analyzing and solving your total marketing communications objectives.

Manning is a complete communications and collateral center of amazing versatility and productivity, confidently accepting the creative challenges of design, illustration, photography and multi-media (AV).

Creative Director: Dave Saifman
Design/Illustration Group: Anthony Soppelsa, Frank Potocnik, Bill Marsalko, Steve Horvath, Nick Voglein, Jim Tesso, Dennis Mramor, Fred Yohe, Ed Strong, Glen Becker, Pam Gilliland

Multi-Media Group: John Richards, Mike Shields
Art Production Group: Ron Barrier, Steve Kushner, Tom Hunter, Ed Kiraly, Pat Bock, Marianne Babiak

Photo Group

Photographers: Carl Fowler, Bob Bender, Ladd Trepal, Jiro Miyoshi
Coordinator: Roseanne Strelka
Assistants: Joe Theriot, Keith Berr, Alan Bennington
Lab: Dottie Stevens, Herb Schwartz, Jerry Sansavera

AVERY INTERNATIONAL/SAFETY AND MARKING DIVISION

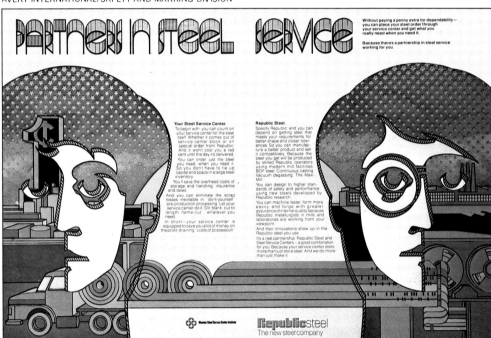

REPUBLIC STEEL/MELDRUM AND FEWSMITH

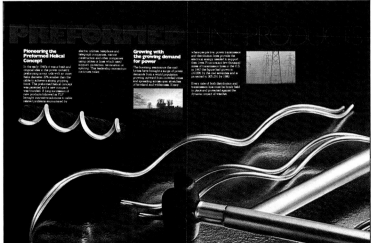

PREFORMED LINE PRODUCTS

FASSON/AN AVERY INTERNATIONAL COMPANY

IRVING D. MILLER, INC.
641 Lexington Avenue
New York, New York 10022
(212) 755-4040

Irving Miller left his post as CBS Art Director in 1958 to open his own studio...now one of New York's most creative shops. His superb design sense and professionalism have been utilized by IBM, American Express, Westvaco, Revlon, Newsweek, Otis Elevator, McCall's, Continental Can, Talon, and a variety of other blue chip corporations.

Miller's unique talents and experience encompass several areas. He excels in the design of logos, corporate identity programs, annual reports, collateral and direct mail campaigns, point of sale, print and TV promotions.

The winner of numerous awards, he has been featured in all the major graphic art publications. His dedication to solving business problems effectively and tastefully has made him a leader in the industry. Small wonder that his roster of discriminating clients grows year after year.

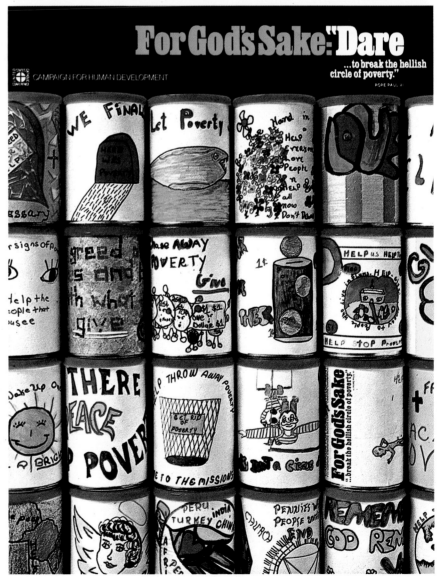

When complex computer technology seems simple, it's
because someone took the time to bridge the gap
between man and machine. With graphics, forms design
and idea conversion. A challenging task. A rewarding
experience for our clients. And, our specialty!
Partial list of clients: Bank of A. Levy, California Federal,
Compass Computer Services, Huerta Design Associates,
LucasFilm Limited, Norand Corporation, Transamerica
Information Services, Unicorn Systems Company,
United California Bank.

Photography: Tom Mareschal

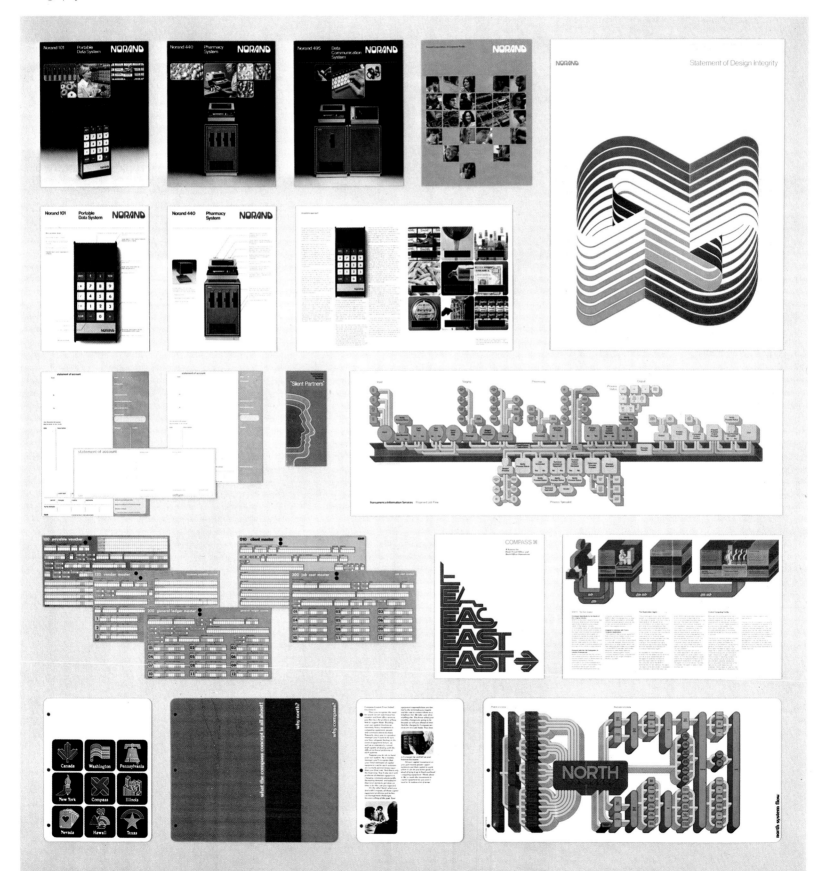

JAMES POTOCKI AND ASSOCIATES
2500 Wilshire Boulevard
Los Angeles, California 90057
(213) 380-7281

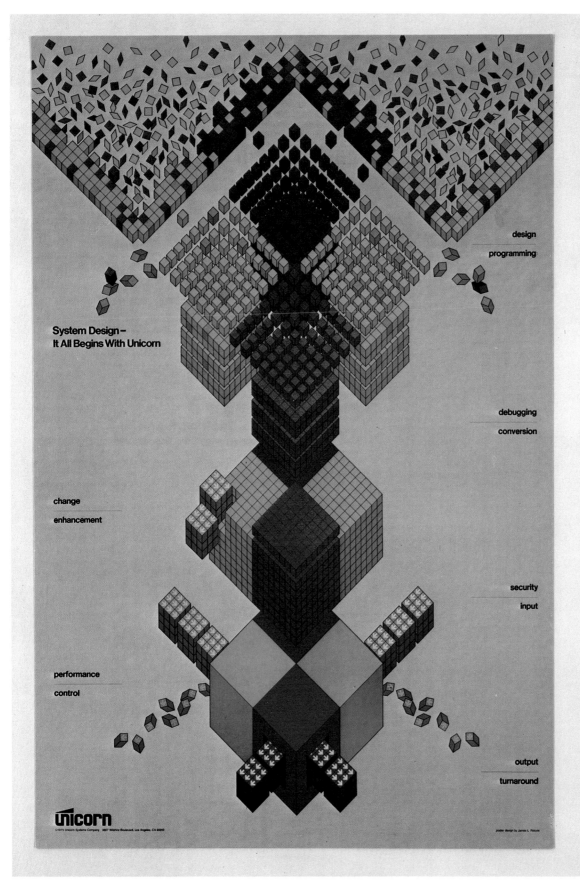

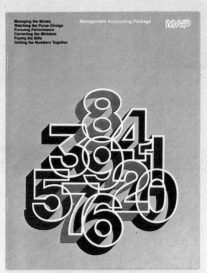

PUSH PIN STUDIOS
207 East 32nd Street
New York, New York 10016
(212) 532-9247

Design, illustration, photography, packaging and film graphics.

"Intelligence, wit, superior imagination and unique perception have made it possible for Push Pin to survive and transcend even their silly name."—Lou Dorfsman

Representative: Phyllis Rich Flood
(212) 532-9247
European Representative: Evelyn Menasce
Ile De La Jatte
6 Blvd. De Courbevoie
Neuilly-sur-Seine, Paris
Tel: 380 39 96

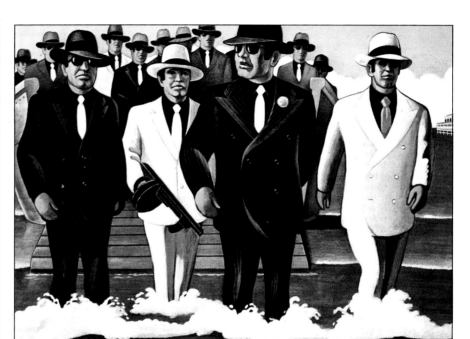

HARUO MIYAUCHI

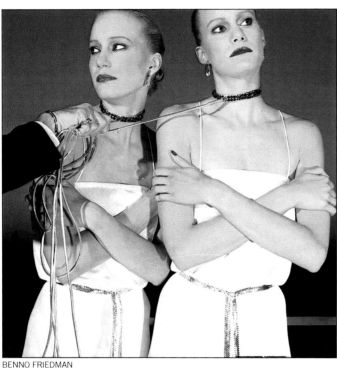

BENNO FRIEDMAN

Separations.

Computerized Quality Separation, Inc.
145 Hudson Street, New York, 10013 (212-925-0554)

RICHARD MANTEL

EMANUEL SCHONGUT

SEYMOUR CHWAST

STANISLAW ZAGORSKI

BERNARD BONHOMME

ARNOLD SAKS DESIGN OFFICE
16 East 79th Street
New York, New York 10021
(212) 861-4300

The graphic design office of Arnold Saks is, essentially, a small and cohesive problem solving group. Their production represents a broad range of graphic design: trademarks, annual reports, corporate booklets, exhibition design and many other forms of design. Among their clients are the major corporations of American industry. The firm has an international reputation and has won major awards for their work in the USA and worldwide.

Shown here are a few samples of their work:

1. Poster for Mobil Oil Corporation
2. Annual report for Chase Manhattan Bank
3. Annual report for Wallace Murray
4. Recruiting and company description kit for Amerada Hess
5. "Rise of an American Architecture" exhibition for the Metropolitan Museum of Art designed in collaboration with architect James Stewart Polshek
6. Symbol for the Export-Import Bank of the United States
7. Trademark for the Louisiana Land and Exploration Company

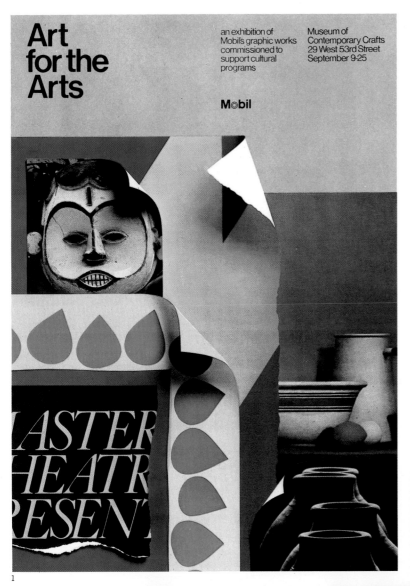

1

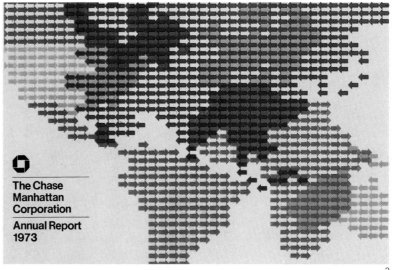

2

4

6

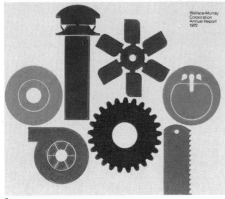

3

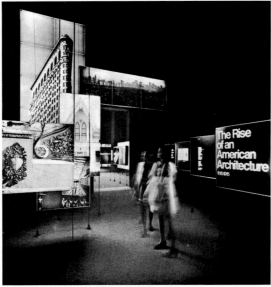

5

7

JOHN WATERS ASSOCIATES
147 East 37th Street
New York, New York 10016
(212) 689-2929

Custom designers of annual reports, publications, identity programs, exhibitions and environmental graphics.

Clients include the following corporations and institutions which are represented below:

American-Maize Products Co., Arrow Electronics, Inc., Florida Capital Corp., General Signal Corp., Gilman Paper Co., Joffrey Ballet, Metropolitan Museum, Museums Collaborative, Inc., Mutual of New York, Olivetti, Touche Ross and Co.

Bernard Hoffman, on his second assignment for Life, was asked to photograph the Budapest String Quartet at Carnegie Hall. He decided to place giant 200-watt, wire-filled flashbulbs near the footlights, facing the audience, and to position his camera behind the Quartet. The flash would illuminate only the spectators, silhouetting the Quartet against the rapt faces.

The musicians were agreeable to the effort, so Bernie set up his equipment, aiming the reflectors at the audience. He carefully placed his 4x5 view camera behind the stage, with the lens poking through the back curtain. A wire synch cord ran from the camera to the flashes. Anxious that this trial assignment for Life succeed, Bernie carefully framed and focused the picture well before the concert started.

The musicians began to play to a full house. Bernie waited until a dramatic moment and fired his first shot. There was a thunderous report as three of the giant bulbs exploded, showering the first few rows with tiny shards of glass. The smoke lifted, and the musicians played on without interruption. Terrified that the exploding bulbs might not have synched with the shutter, Bernie walked around the footlights during the intermission and, in full view of the audience, replaced all the flashbulbs for a second shot. As the musicians began the second part of the concert, Bernie got into position to try for one more shot. He waited again and fired a second time. All the flash units fired without incident. Much relieved, Bernie rushed the two sheets of film back to the Life lab for development.

An hour later, he saw that the explosion hadn't ruined the first shot at all. The audience, beautifully illuminated, was concentrating on the dramatically silhouetted musicians. The second attempt, however, was another story: the same elements were there, but the silhouetted Quartet was shown against an audience of cowering, cringing people, many holding programs over their faces or ducking down behind seats. Life never ran the second picture, but Bernie thought it was by far the best of the take.

GARY GLADSTONE

ROGER ZIMMERMAN
22 East 21st Street
New York, New York 10010
(212) 674-0259

Representative: Civia Snow

Designs that represent a thousand
words…talent that captures the essence
of the subject…accomplishments that reach
beyond book covers to brochures,
promotional materials, catalogs, corporate
symbols. Clients: Gulf Oil, Canadian National
Railway, Mobil, McGraw-Hill, Xerox,
Doubleday, the Federal Reserve Bank and the
White House, to name but a few.

REFERENCE

PHONE LISTINGS OF OVER 5000 PHOTOGRAPHERS ILLUSTRATORS GRAPHIC DESIGNERS REPRESENTATIVES AND STOCK PHOTOGRAPHY COMPANIES

Names in boldface refer to individuals whose work is displayed in Volume Two, followed by the page number, and/or Volume One, with page number in parentheses, e.g. (V1•38).

Those listed who move or change phone numbers are invited to forward up-to-date information to AMERICAN SHOWCASE, Attention: Listings Dept.

NEW YORK METROPOLITAN AREA

Abramowitz, Jerry 212-876-5530
Abramson, Michael 212-691-2601
Ackerman, Matthew 212-564-7544
Ackerson, Thomas 212-524-3238
Acs, Sandor 212-787-0868
Adams, Ansel 212-624-2558
Adams, George G. 212-391-1345
Adelman, Bob 212-982-0230
Adler, Martin 212-477-0478
Aich, Clara 212-686-4220
Aiosa, Vincent 212-249-8883
Alcorn, Richard 212-866-1161
Allen, Casey 212-787-5400
Ambrose, Ken 212-260-4848
Amrine, Jamie 212-243-2178
Ancona, George 212-799-8050
Anderson, Jim 212-873-1723
Anderson, Peter 212-744-3081
Andrews, Bert 212-354-5430
Angelakis, Manos 212-924-3394
Anthes, Ed 212-255-3111
Arky, David 212-777-7309
Arma, Tom 212-532-0764
Arnold, Eve 212-541-7570
Ashe, Bill 1 212-924-5393
Attie, Davie (V1 • 1) 212-228-7750
Avedis Studio/Baghsarian 212-685-5888
Avedon, Richard 212-879-6325
Baehr, Sarah 212-725-8398
Bahrt, Irv 212-869-1750
Bailey, David 212-246-0679
Baker, Joe 212-686-5072
Baldwin, Joel 212-595-8362
Baldwin, Susan 212-243-1967
Baliotti, Dan 212-686-4617
Ballarian, Richard 212-475-7722
Barboza, Tony 212-242-1880
Barclay, Robert (V1 • 2) 212-255-3440
Barkentin, George 212-243-2174
Barnell, Joe 212-687-0696
Barnett, Peggy and Ronald 212-673-0500
Barr, Neal 212-765-5760
Barrett, John E. 212-777-7309
Barret, Ron 212-832-7220
Barton, Paul 212-689-1479
Bartone, Lawrence 212-254-6430
Batlin, Lee 212-685-9492
Baumbach, Daniel 212-255-2262
Bean, John 212-242-8106
Beck, Arthur 212-691-8331
Arnold Beckerman Inc. 212-832-1056
Beckles, Ken 212-691-2641
Bechtold, John 212-679-7630
Bassman, Lillian 212-799-8050
Beard, Peter 212-246-0679
Benedict, William 212-697-4460
Bennett, Philip 2 212-753-0462
Benson, Sam 212-679-7384
Bergman, Barbra 212-689-5886
Bergman, Beth 212-724-1867
Berkwit, Lane 212-371-7523
Bernheim, Marc 212-489-7675
Bernstein, Alan 3 (V1 • 3) 212-221-6631
Bertoli, Umberto 212-684-2480
Betts, Glynne 212-688-4591
Bevilacqua, Joe 212-490-0355
Biggs, Ken 212-752-3930
Bijur, Hilda 212-737-4458
Bisbee, Terry 212-242-4762
Blake, Rebecca 212-695-6438
Bleiweiss, Herb 212-262-3603
Blinkoff, Richard 212-982-5065
Blodgett, Jeremy 212-685-2422
Bodi . 212-947-7883
Bohmark Ltd. 212-889-9670
Bordnick, Barbara 6 212-533-1180
Borea, Raimondo 212-663-4463
Bower, Holly 212-228-3198
Boxer, Tim 212-586-7589
Bracco, Bob 212-753-2857

Brady, Bob 212-736-1253
Brady, Mathew 7 (V1 • 6) 212-982-2700
Brandeis, Ann 212-793-7617
Brathwaite, Kwame 212-586-5163
Breitenbach, Josef 212-799-3019
Jim Breuer Assoc. 212-929-6787
Brisker, Neal 212-355-1316
Britton, Peter 212-737-1664
Brody, Bob 212-736-1253
Bronson, Emerick 212-758-1952
Brooks, Alan 212-751-6811
Brooks, James 212-755-8541
Brosan, Roberto 212-473-1471
Brown, Dave 212-533-1040
Brown, Nancy (V1 • 8) 212-753-2310
Brown, Owen 212-947-9470
Buchenholz, Bruce 212-861-1730
Buckley, Peter 212-744-0658
Budin, Elbert 212-564-9050
Budnik, Dan 212-489-7675
Bullaty, Sonja 212-663-2122
Burnett, David 212-243-1677
Burrell, Fred 212-691-0808
Burri, Rene 212-541-7570
Bushnell, Catharine 212-697-9746
Cadge, William F. (V1 • 9) 212-685-2435
Caffrey, Tom 212-689-1340
Cahill, Bill 212-725-8178
Cailor-Resnick 212-924-3016
Callio, Chris 212-249-4555
Cameola, John J. 212-929-6280
Cannarella, Bud 212-691-1750
Capa, Cornell 212-685-1013
Carroll, Don 212-689-0566
Carter, Bill 212-755-4475
Carter, Dwight 212-924-3855
Cartier-Bresson, Henri 212-541-7570
Cashin, Art 212-475-4184
Castellano, Peter 212-246-4386
Cearley, Guy 212-243-6629
Centner, Ed (V1 • 10) 212-228-3390
Chalkin, Dennis 212-929-1036
Chanteau, Pierre 212-221-5860
Checani, Richard 212-477-5900
Cherry, Larry 212-260-5957
Chin, Mark 212-777-2616
Church, Diana 212-675-5642
Cirone, Bettina 212-753-7159
Clark, Gordon 212-675-5755
Clayman, Andrew 212-674-4906
Clayton, Tom 212-744-1415
Clough, Terry 212-255-3040
Clements, John 212-348-6806
Cobb, Jan 212-889-2257
Cochran, George 12 212-689-9054
Coggin, Roy 212-929-6262
Cohn, Edward 212-935-8646
Colby, Ron 212-684-3084
Cole, Bernard 212-663-1802
Coleman, Bruce 212-683-5227
Collier, Jim 212-832-0295
Collins, Sheldan 212-581-6470
Colmer, Bryan 212-682-3012
Colton, Robert 13 (V1 • 14) 212-831-3953
Compton, Grant 212-988-8194
Conant, Howell 212-532-7255
Connors, William 212-879-2181
Cooke, Jerry 212-288-2045
Cooper, Martha 212-222-5146
Cooper, Steve 212-279-4543
Corman, Bert 212-564-5052
Cornu, Alain 212-683-5777
Corry, Doug 212-736-4080
Cosimo 14 212-563-2730
Cotter, Mimi 212-972-0176
Couzens, Larry 212-684-6585
Covello, Joe 212-691-2656
Cowan, Frank 212-986-7163
Crampton, Nancy 212-254-1135
Creighton, William 518-537-6513
Croner, Ted 212-685-3944
Cross/Francesca Photography 15 212-988-8516

Cserna, George 212-247-5738
Cunningham, Peter 212-475-4866
Dakota, Michael 212-532-4615
Dalsanto, Joseph 212-966-4341
Dantzic, Jerry 212-789-7478
Dauman, Henri 16 212-737-1434
Davidson, Bruce 212-541-7570
Davidson, Darwin K. 17 (V1 • 15) 212-242-0095
Davis, Dick (V1 • 16) 212-751-3276
Davis, Hal 212-831-2791
Davis, Richard 18 212-675-2428
Day, Bob 212-475-7387
DeGeorges, Paul C. 212-686-2980
DeLessio, Len 212-254-4620
DeMenil, Adelaide 212-247-5945
DeMilt, Ronald (V1 • 17) 212-228-5321
Denker, Winnie 212-265-1409
Denner, Manuel (V1 • 18) 212-684-5033
Dennis, Alan 212-986-3282
Dennis, Lisl 212-532-8226
DePra, Nancy 212-288-1740
DeSanto, Thomas 212-989-5622
DeToy, Ted 212-675-6744
Devine, William 212-552-3718
DeVoe, Marcus E. 212-737-9073
Dias, Michael 212-777-9271
Dibue, Robert 212-490-0486
Dixon, Mel 21 212-677-5450
Dolce, Bill and Steve 212-674-4312
Dolgins, Alan 212-532-5083
Dominis, John 212-556-2604
Dorf, Myron Jay 212-255-2020
Dorin, Jay 212-781-7378
Doubilet, David 212-348-5011
Drew, Rue Faris 212-794-8994
Druskis, Laimute 212-768-4326
Dubin, Nancy L. 212-832-0439
Dunand, Frank 212-877-4983
Duncan, Kenn 212-582-7080
Dunning, Hank 212-675-6040
Dunning, Robert and Diane 212-688-0788
Eagan, Timothy 212-777-9210
Eagle, Arnold 212-582-4248
Eagle, Stephen 212-688-6323
Eberstadt, Fred 212-221-7650
Edahl, Edward 212-532-4775
Edelmann, Edward 212-867-5610
Edgeworth, Anthony (V1 • 19) . . 212-679-6031
Ehrenpreis, Dave 212-674-2679
Ehrlich, George 212-243-2687
Eisenberg, Steve 212-594-4530
Ekstrom, Niki 212-744-2972
Elgort, Arthur 212-724-6557
Elkin, Irving 212-686-2980
Elkins, Joel 212-989-4500
Elmer, Jo 212-369-7077
Elness, Jack 212-989-0500
Elson, Paul 212-879-2691
Endress, John 212-736-2670
Englander, Maury 212-982-2800
Erwitt, Elliot 212-799-6767
Estenssoro, Hugo 212-777-2912
Farber, Robert 23 212-752-5271
Farrell, Bill 24 (V1 • 20) 212-683-1425
Farrell, John 212-675-0456
Faulkner, Douglas 212-677-5967
Fay, John Spencer 212-684-2046
Fay, Joyce 212-988-8361
Stephen Fay Studios 212-757-3717
Feinstein, Gary 212-242-3373
Fellerman, Stan 212-243-0027
Ferorelli, Enrico 212-685-8181
Ferrand, Claude 212-799-8050
Fesler, James 212-850-8829
Fetter, Frank 212-355-1316
Ficalora, Toni 212-679-7700
Field, Pat 212-799-8050
Fields, Bruce 212-532-2320
Fine, Peter M. 212-431-9776
Fine, Steven A. 212-532-0350
Finlay, Alastair 212-260-4297
Fischer, Bob 212-755-2131

Fischer, Carl 26 212-794-0400
Jules Fischette Studio 212-246-4551
Fishbein, Chuck 212-532-4452
Fiur, Lola Troy 212-971-1911
Flatow, Herbert Jerome 212-228-1707
Fleming, Peter 212-929-0973
Floret, Evelyn 212-472-3179
Forbert, David J. 212-687-0696
Forbes, Robin 28 212-431-4178
Forman, Harrison 212-697-4165
Forrest, Robert 212-288-4458
Fowler-Gallagher, Susan 212-431-5394
Fox, Jeffrey 212-675-8075
Francekevich, Al 29 212-689-0580
Frank, Dick (V1 • 21) 212-242-4648
Frank, Richard 212-857-5525
Frankian, Paul 212-679-2533
Freedman, Lionel 212-737-8540
Freer, Bonnie 212-866-6307
Freson, Robert 212-246-0679
Fried, Lawrence 212-681-6677
Friedman, Benno 224 212-532-9247
Friedman, Jerry 30 212-533-1960
Frissell, Toni 212-344-4100
Funk, Mitchell 212-988-2886
Funt, David W. (V1 • 22) 212-686-4111
Furones, Claude Emile 212-683-0622
Furuta, Carl 212-753-2857
Fusco, Paul 212-541-7570
Gage, Rob 212-682-2462
Gahr, David 212-789-3365
Gairy, John 212-675-7067
Galate, Jim 212-730-0050
Gallagher, Barrett 212-246-3127
Gallucci, Ed 32 212-532-2720
Gans, Hank 212-683-0622
Gardner, George 212-945-2032
Garetti, John 212-673-8370
Garlanda, Gino 212-685-0358
Gatewood, Charles 212-243-1799
Gatha, Ashvin 212-924-5151
Gee, Elizabeth 212-683-6924
Geiger, Michael 212-686-2323
Giraldi, Frank 212-840-8225
Gescheidt, Alfred 212-889-4023
Giese, Al 33 212-477-3096
Gigli, Ormond 212-758-2860
Gillardin, André 34 (V1 • 23) . . . 212-673-9020
Gilmour, James 212-532-8288
Gladstone, Garry 36 (V1 • 25) . . 212-982-3333
Glanzman, Martin 212-260-7100
Glassman, Carl 212-666-3756
Glaviano, Marco 212-586-0157
Glenn, Gary 212-260-2220
Glinn, Burt 37 (V1 • 26) 212-877-2210
Goff, Lee 212-759-5194
Gold, Bernie 212-677-0310
Gold, Charles 212-697-5252
Goldberg, Irv 212-242-3753
Golden, Caren 212-925-7730
Goldman, A. Bruce 212-666-9143
Goldman, Richard 212-675-3021
Goldsmith, Lynn 212-593-2677
Golob, Stanford 212-532-7166
Gonzales, Manny 212-684-6026
Good, Jay 212-228-2244
Gordon, Joel 212-752-3930
Goro, Fritz 212-556-2342
Gotfryd, Bernard 212-350-2505
Gottheil, Philip 212-686-6391
Gould, Steve 212-686-1690
Gove, Geoffrey 212-260-6051
Gray, Dudley 212-929-3181
Gray, Mitchel 38 212-427-2287
Green, Al 212-486-0725
Green, Alan 212-534-1718
Green, Beth 212-580-1928
Green-Armytage, Stephen 39 (V1 • 28) 212-247-6314
Greenberg, David 212-243-7351
Greenberg, Steven 212-929-8260
Greene, Sue 212-691-1389
Greenfield, Lee 212-832-0130

Nordhausen, George212-767-6658
Nowak, Ed.212-889-8929
Obremski, George.212-475-0090
Oei, Robert212-691-8483
Ogrudek, Robert.212-939-5193
Ohringer, Frederic.212-752-0741
Oliv, Bob.212-533-1220
Olivo, John212-765-8812
Olson, John212-243-5800
O'Neill, Michael.212-677-5440
Oppenheim, David212-475-6442
Oppersdorff, Mathias212-860-4778
O'Reilly, Robert J.212-832-8992
Oringer, Hal.212-564-7544
Orkin, Ruth.212-362-1658
Orling, Alan S.212-473-8363
O'Rourke, J. Barry 68 (V1•64).**212-686-4224**
Orrico, Charles J. 69 (V1•65).**212-490-0980**
Osonitch, Robert212-533-1920
Owens, Sigrid212-686-5190
Ozgen, Nebil212-924-1719
Paccione 70**212-532-2701**
Pakchanian, Kourken212-758-3956
Palladini, David212-879-0233
Palmeri, Michael J.212-273-7945
Panuska, Robert 130 (V1•118).**212-752-3930**
Papadopolous, Peter 72**212-675-8830**
Pappas, Tony.212-532-3634
Parks, Gordon212-246-0679
Pastner, Robert L.212-838-8335
Pateman, Michael212-685-6584
Paz, Peter.212-786-7473
Peck, Joseph L.212-472-1929
Peden, John.212-255-2674
Pederson, Erwin212-677-0044
Pellegrini, Bruno and Frances.212-288-1010
Peltz, Stuart212-532-5083
Pemberton, John.212-532-9285
Pendleton, Bruce 73 (V1•66).**212-986-7381**
Penn, Irving.212-246-0679
Perkell, Jeff.212-580-0988
Perron, Robert.212-661-8796
Perweiler, Gary.212-254-7247
Peterson, Gosta212-876-0560
Pfeffer, Barbara212-877-9913
Pfizenmaier, Edward.212-563-0451
Pfletschinger, Hans212-840-6928
Philiba, Allan A. (V1•67).**212-371-5220**
Phillips, Robert212-757-5190
Pieratt, Edward E.212-989-0500
Pilgreen, John212-243-7516
Pinney, Doris212-683-0637
Pinsley, Jules212-291-2871
Pippin, Wilbur212-675-5514
Platt, Mark212-475-1481
Plotkin, Bruce212-691-6185
Plowden, David212-288-4747
Pobiner, Ted.212-679-5911
Pollens, Linda212-861-7745
Polsky, Herb.212-730-0508
Popper, Andrew212-982-9713
Powers, Bill212-989-7822
Steve Prezanti Studios212-989-5103
Price, Clayton J.212-260-3713
Price, David212-794-9040
Price, William212-222-1098
Priggen, Leslie.212-861-4202
Probst, Kenneth212-929-2031
Pruzan, Michael212-686-5505
Puhlmann, Rico212-246-0679
Raab, Michael212-533-0030
Rainbolt, Joyce.212-686-3514
Rajs, Jake Jason.212-242-2321
Ratkai, George.212-725-2505
Ratzkin, Lawrence212-683-4722
Ray, Bill212-222-7680
Reichenthal, Martin212-686-2408
Reiff, Hal212-533-0699
Reinhardt, Mike212-541-4787
Reinmiller, Mary Ann.212-683-4980
Rentmeester, Co.212-884-0239
Resnick, Stu212-427-8589

Retallack, John212-929-8223
Riboud, Marc.212-541-7570
Ricci, Rocko212-925-0623
Rice, Neil212-924-6096
Ries, Henry 74 (V1•68)**212-689-3794**
Ries, Stan (V1•69).**212-533-1852**
Riley, Frank212-369-1925
Riley, Jon212-532-8326
Ritter, Frank212-427-0965
Rivelli, William 75 (V1•70).**212-254-0990**
Rizzo, Alberto212-935-8646
Rizzuto, Dennis212-359-5555
Robins, Lawrence 76 (V1•72).**212-677-6310**
Rogers, Linda Ferrer212-260-8430
Rooney, Lawrence212-757-4873
Rose, Ben 77**212-691-5270**
Rosenberg, Arnold212-879-8900
Rosenfeld, David212-885-1292
Rosenfeld, Stanley Z.212-989-2404
Rosenthal, Barry212-477-3096
Ross, Ben212-858-4067
Ross, Judy.212-865-8956
Rossum, Cheryl212-628-3173
Roth, Peter212-594-3190
Roth, Stewart 78**212-673-8370**
Rothaus, Ede.212-989-8277
Rothenburg, Judy212-861-7745
Rothstein, Arthur212-953-7566
Rotkin, Charles E.212-757-9255
Rousseau, Will.212-755-5330
Rubin, Daniel212-730-8222
Rubin, Darleen212-243-6973
Rubin, Mary Laurence (V1•73)**212-246-9018**
Rubinstein, Eva212-260-7759
Rudolph, Nancy212-989-0392
Rummler, Tom212-683-8250
Russell, Ted.212-532-4150
Rutledge, Don212-679-3288
Ryan, Bill212-683-1388
Sagarin, Dave212-663-1439
Sahula, Peter.212-982-4340
Salzano, Jim212-242-4820
Samardge, Nick.212-679-2526
Samrock, Carl212-644-0440
Sandbank, Henry (V1•74).**212-674-1151**
Sanford, L. Tobey212-245-2736
Sang, Peter212-473-6162
Santagto, Valerie212-777-3414
Sarapochiello Studio.212-242-0413
Sawyer, Emil212-532-1022
Scavullo, Francesco212-838-2450
Schaff, Peter212-222-2935
Shaffer, Stan212-595-2608
Schaefer, Rick212-254-0936
Schenk, Fred212-677-1250
Schiff, Nancy Rica212-533-1180
Schild, Irving.212-988-0517
Schinz, Marina212-246-0457
Schmidt, Marian212-879-0778
Schneider, Iris212-628-5935
Schorr, Todd.212-689-7324
Schulze, Fred 79**212-242-0930**
Schwartz, Marvin W.212-929-8916
Schwartz, Sing-Si212-228-4466
Schwerin, Ron212-228-0340
Scocozza, Victor (V1•75).**212-675-0700**
Sculnick, Herb 81**212-777-3232**
Seaton, Tom212-989-3550
Secunda, Sheldon (V1•78).**212-477-0241**
Seem, Roy S.212-748-7435
Seghers. Carroll212-679-4582
Seidman, Barry 84 (V1•79).**212-838-3214**
Seitz, Sepp 85 (V1•80).**212-889-9305**
Selby, Richard212-757-9277
Seligman, Paul212-242-5688
Seltzer, Abe212-924-4240
Seltzer, Robert212-475-0314
Shaefer, Richard212-254-0936
Shaffer, Stan212-697-5252
Shaman, Harvey212-793-0434
Shames, Stephen212-989-2004
Sharko, Greg.212-730-8222

Sher, Bob212-245-2416
Sherman, Guy 86.**212-675-4983**
Sherman, Mark212-691-3653
Harry Shiansky Studio212-889-5489
Shiraishi, Carl 88**212-679-5628**
Silano, Bill212-889-0505
Silbert, Layla212-677-0947
Silver, Larry212-684-5242
Silverstone, Marilyn212-541-7570
Simon, Peter Angelo212-473-8340
Singer, Barry212-935-0480
Sirdofsky, Arthur.212-830-0572
Skogsbergh, Ulf (V1•81)**212-255-7536**
Skolnick, Clancy.212-889-2824
Skolnik, Lewis212-758-5662
Skoogfors, Leif.212-489-7675
Skott, Michael (V1•82)**212-686-4807**
Slade, Chuck.212-673-3516
Slade, Paul.212-838-1800
Slavin, Neal212-925-8167
Slovak, Kenneth212-691-0870
Smilow, Stanford212-255-0310
Smith, Camilla212-868-3330
Smith, E. Gordon 89.**212-679-2350**
Smith, J. Frederick (V1•83)**212-683-5173**
Smith, Jeff212-674-8383
Snider, Ed212-673-3652
Snowdon212-246-0679
SO Studio212-475-0090
Sochurek, Howard 90.**212-582-1860**
Solowinski, Ray212-757-7940
Soluri, Michael Robert.212-473-4409
Somoroff, Ben212-679-3125
Somoroff, Michael212-889-6911
Soned, Leonard212-674-2303
Spatz, Eugene212-777-6793
Speiger, Leonard212-595-5480
Spindel, David M.212-989-4984
Spinelli, Frank212-243-8318
Spiro, Edward212-424-7162
Stabin, Victor212-243-7688
Stahman, Robert212-362-7310
Standart, Joe 92**212-532-8268**
Standart, Joseph G.212-289-5198
Stanton, William212-850-9365
Stearns, Philip B.212-751-5406
Steedman, Richard.212-753-2857
Steigman, Steve.212-982-9480
Steinbicker, Houghton.212-889-3920
Steiner, Charles 93**212-777-0813**
Steiner, Christian212-799-4522
Stember, John212-757-0067
Stern, Bob 94**212-354-4916**
Stern, Irene212-777-2616
Stern, Laszlo212-757-5098
Stettner, Bill212-684-4058
Stevens, Roy212-831-3495
Stevenson, Terry212-889-6199
Stewart, Larry212-675-7222
St. John, Lynn (V1•84)**212-688-8884**
Stock, Dennis212-541-7570
Stoecklein, Edmund H.212-850-8472
Stokes, Stephanie212-744-0655
Stoller, Bob212-260-3940
Stone, Bob212-697-5252
Stone, Erika212-737-6435
Storch, Otto.212-532-4932
Strongwater, Peter212-475-4537
Sturgess, Virginia212-532-3437
Sutton, Humphrey212-691-0084
Svenson, Steen212-242-7272
Swedowsky, Ben 95 (V1•85)**212-684-1454**
Swoger, Arthur212-986-9177
Sydlow, Joan212-624-0170
Szasz, Suzanne212-832-9387
Szkodzinsky, Wasyl212-383-2407
Taccone, Frank.212-777-2800
Tanaka, Victor212-675-3445
Tannenbaum, Ken 96**212-947-5065**
Tassi, Dhimitra212-691-4628
Tcherevkoff, Michel 97 (V1•86).**212-228-0540**
Tervanski, Steve212-986-2237

Tesa, J. Rudolph212-533-1220
Thorton's Classic Studios212-685-1725
Tillman, Denny212-674-7160
Tomalin, Norman Owen212-586-3112
Tomono, Yuji212-689-4822
Topple, Edward C.212-623-6192
Tornberg, Ralph212-685-7333
Toshi, Matsuo212-260-2556
Toto, Joe212-260-3377
Trumbo, Keith212-777-5960
Tunison, Ron F.212-335-3166
Tur, Stefan212-475-1699
Turner, Pete 98 (V1•87)**212-799-8572**
Ullmann, John212-753-5668
Umbach, Jonathan212-691-0738
Unangst, Andrew (V1•88).**212-533-1040**
Underhill, Les212-691-9920
Ursuli, Catherine (V1•89).**212-722-9297**
Uzzle, Burk212-541-7570
Vaeth, Peter 100**212-489-1355**
Valentin, Augusto.212-532-7480
Valentinetti, John212-686-4617
Van Glintenkamp, Rik212-924-9210
Van Lindt, Bob.212-752-8770
Varnedoe, Samuel212-986-7862
Venant, Pierre212-624-5099
Vern, Ike212-228-9020
Vicari, Jim 102 (V1•90)**212-675-3745**
Vickers, Camille.212-580-8649
Victor, Thomas.212-582-1882
Vidal, Bernard212-582-3284
Vidol, John212-889-0065
Villegas, Ronald212-683-7897
Villota, Louis212-758-5791
Vine, David212-691-7433
Vlamis, Suzanne212-879-4587
Vogel, Allen.212-675-7550
Von Hassell, Christian212-249-9033
Von Wangenheim, Chris.212-787-8910
Vos, Gene212-685-8384
Wagner, David212-532-4015
Waine, Michael (V1•91).**212-533-4200**
Wallach, Jack212-564-3144
Walsh, Bob212-684-3015
Walz, Barbra212-242-7175
Waltzer, Carl212-929-7844
John Wang Studio Inc.212-982-2765
Warsaw Photographic Assoc.212-725-1888
Watson, Albert M.212-628-7886
Weber, Tommy212-685-5151
Weckler, Chad212-541-4787
Weihs, Tony212-889-5157
Weinberg, Michael212-691-0713
Weinstein, Todd212-673-5855
Weiser, Barry212-674-8457
Weiss, Michael.212-929-4073
West, Charles H.212-242-4894
West, Jerry212-245-2416
White, Anne B.212-289-4556
White, Frank 103.**212-581-8338**
Whitely, Howard.212-490-3111
Wiesehahn, Charles212-679-8342
Williams, Larry (V1•92)**212-925-3087**
Wilson, Mike212-683-3557
Wing Studio212-535-9202
Witlin, Ray212-866-7625
Wolf, Bernard212-427-0220
Wolf, Henry212-472-2500
Wolff, Werner.212-679-3288
Wolfson, Steve212-532-2580
Wollam, Les (V1•93).**212-929-1861**
Wolters, Richard A.212-533-8280
Wood, Susan212-242-2557
Woodward, Herbert 105.**212-685-4385**
Woolfe, Ray212-249-8372
Wormser, Richard L.212-928-0056
Wunderlich, Gabriele212-689-6985
Wynn, Dan212-535-1551
Yaeger, H.212-777-6225
Yamaoka Studio 106**212-736-8292**
Yamashiro, Tad212-473-7177
Yee, Tom212-473-5510

Zack, Patrick212-758-7030
Zacker, Denis212-355-6954
Zager, Howard212-736-1253
Zakarian, Aram212-674-3680
Zanetti, Gerry212-473-4999
Zappa, Tony 107 (V1 • 94)212-532-3476
Zedar, Joseph212-685-5288
Zipkowitz, Harold212-685-6150
Zoiner, John212-972-0357
Zubrzycki, Paul212-242-0634
Zuretti, Charles212-924-9412
Zwiebel, Michael212-847-0778

NORTHEAST

Adams Studio Inc. (V1 • 103)
Washington DC202-785-2188
Adams, Molly/Mendham NJ201-543-4521
Aks, Lee R./Briarcliff Manor NY914-941-3833
Alexander, Jules/Rye NY914-967-8985
Alonso, Manuel/Stamford CT203-359-2838
Anderson, Pete/Hull MA617-925-2358
Anderson, Susanne/Wash DC202-966-7661
Anderton, David/Ridgewood NJ201-652-0632
Anyon, Benjamin/New Rochelle NY914-235-8099
Ballantyne, Thomas C./Concord MA617-369-7599
Balz, Wesley/Hartsdale NY914-949-5962
Barlow, Kurt/Wash. DC202-543-5506
Barnett, Jim/Colesville MD301-384-1266
Baskin, Gerry/Boston MA617-426-7262
Bates, Ray/Newfane VT.802-365-7770
Bell, Chuck III Pittsburgh412-261-2022
Benenate, Joseph/Woburn MA617-933-2575
Bent, John/N. Kingston RI401-783-8538
Berg, Hal/New Rochelle NY914-235-9356
Bernstein, Daniel/Waltham MA617-894-0473
Binzen, Bill/Lakeville CT203-435-2485
Bishop, Edward/Boston MA617-536-7465
Blake, Mike/Boston617-523-3730
Blevins, Burgess 4 (V1 • 4) Baltimore301-685-0740
Blizzard, William C./Beckley WV304-252-4652
Boatner, E.B./Somerville MA.617-354-7035
Bookbinder, Sigmund/Southbury CT203-264-5137
Bragstad, Jeremiah O./Ithaca NY607-273-4039
Breed, John/Cambridge MA617-492-6126
Brignolo, Joseph B./Chester NY914-469-4453
Broderick, Jim 8 Tuxedo Park NY914-351-2725
Brooks, Charlotte/Holmes NY914-878-9376
Burke, John Hamilton/Boston.617-536-4912
Burkhart, Bill/Holyoke MA413-739-9757
Burns, George/Schenectady NY518-393-3633
Burns, Terry/Philadelphia215-242-9022
Camp, Don/Philadelphia.215-382-8655
Caravella, Miriam and Wayne/Wash. DC . . .202-966-0895
Carroll, Hanson/Norwich VT.802-649-1094
Carver, Suzanne/Stonington CT203-535-3521
Case, H. Robert/Wellesley Hills MA617-235-6989
Castello, Maggi/Middleburg VA703-687-6775
Castronovo, John/Montclair NJ.201-746-7731
Chandoha, Walter 10 (V1 • 12)
Annandale NJ201-782-3666
Chapple, Ross/Hume VA202-332-7908
Chwatsky, Ann/Rockville Centre NY516-766-2417
Cleff, Bernie/Philadelphia.215-922-4246
Clemens, Clint/Boston617-261-3005
Clifford, Geoffrey C./Reading VT812-484-5047
Cohen, Henry/Philadelphia215-561-3967
Cole, Helen/Englishtown NJ201-446-4726
Collette, Roger/East Providence RI401-433-2143
Collins, Fred 112 Boston617-426-5731
Conboy, John/Schenectady NY518-346-2346
Condax, John/Philadelphia215-923-7790
Conte, Margot/Hastings-on-Hudson NY . . .914-478-0512
Cosindas, Marie/Boston617-266-9493
Creighton, William/Sag Harbor NY516-725-4320
Cuesta, Mike/Dix Hills NY516-864-8373
Curtis, Bruce/Roslyn Heights NY516-484-2570
Curtis, Jackie/Norwalk CT203-866-6198
Davis, Howard/Baltimore301-288-2133
deCamp, Michael A./Morristown NJ201-538-1693
DeGast, Robert/Annapolis MD301-974-4118
deGeorges, Pam/Claremont NH413-339-4351
Degginger, Edward R./Convent Station NJ. . .201-455-2737

DeVoe, Marcus/Setauket NY516-751-1932
Diamond, Joseph/Ridgewood NJ201-444-7994
Diamondidis, Nick/Philadelphia PA.215-922-1888
Dickstein, Bob/Roslyn Heights NY516-621-2413
Dietz, Donald/Cambridge MA617-547-1619
DiGiacomo, Melchior/Harrington Park NJ . . .201-348-3510
Di Maggio, Joe/Centerpoint NY516-271-6133
DiMarco, Salvatore/Philadelphia215-789-3239
Doherty, William/Waltham MA617-899-9466
Dorot, Didier/Mamaroneck NY914-381-2650
Drake, James A/Philadelphia215-925-8927
Dreyer, Peter H./Boston617-762-8550
Druss, Chuck/Larchmont NY914-834-3912
Dunlap, D. James/Wash. DC.202-526-5008
Dunn, Phoebe 22 New Canaan CT. . . .203-966-9791
Eck, Frank W./Boston617-266-0896
Eckstein, Ed/Philadelphia215-546-8177
Ehrenfeld, Mikki/Lincoln MA617-259-9581
Eisman, Jamie/Philadelphia215-922-7652
Embrey, A. Wilson/Fredericksburg VA. . . .703-373-4023
Endres, Ann/Bernardsville NJ201-766-3215
Eyle, Nicolas/West Edmeston NY.315-824-1780
Ezra, Martin D./Landsdonne PA215-622-7792
Faul, Jan 25/Arlington VA703-522-0150
Faulkner, Douglas/Summit NJ.201-277-2949
Feinberg, Milton/Boston617-267-2000
Feininger, Andreas/New Milford CT203-354-8280
Fernandez, B.J./North Bergen NJ201-865-6997
Ficalora, Salvatore/Arkmonk NY914-273-3990
Fish, Dick/Northampton MA413-584-6500
Fisher, Al/Boston617-536-7126
Fishman, Chuck/Roosevelt NY516-623-6995
Fland, Peter/Deer Park NY516-667-4436
Foote, James A./Old Greenwich CT.203-637-3228
Foster, Frank/Boston.617-523-5508
Foster, Nicholas/Gladstone NJ.201-234-1570
Freeman, Roland L./Wash. DC202-882-7764
Freid, Joel C./Silver Spring MD301-681-7211
Furman, Michael 31 (V1 • 104)
Philadelphia215-925-4233
Gaillet, Helen/Bridgehampton NY516-537-3116
Galvin, Kevin/Hanover MA617-826-4795
Ganton, Brian/Verona NJ201-239-8824
Garfield, Peter/Wash. DC202-333-0168
Gates, Ralph/Short Hills NJ201-379-4456
Germer, Michael/Boston617-262-6980
Gidley, E. Fenton/Darien CT203-838-1767
Gilmour, James R./Dumont NJ201-387-0303
Goell, Jonathan J./Brookline MA617-731-0936
Goldblatt, Steven/Norristown PA215-539-7344
Golden, Robert Francis/Monsey NY914-356-5825
Goldman, Mel/Boston617-536-0539
Goldsmith, Alan/Newton MA617-395-9138
Goldstein, Robert/New Milford NJ201-262-5959
Good, Richard/Philadelphia215-472-7659
Goodwin, John C./Demarest NJ201-768-0777
Gorrill, Robert B./Boston617-328-4012
Grace, Arthur/Wash. DC202-333-6568
Grehan, Farrell/Piermont NY914-359-0404
Griffin, Arthur L./Winchester MA617-729-2690
Griffing, Fred/Upper Grandview NY914-353-0619
The Steve Grohe Studio 113 (V1 • 105)
Boston617-523-6655
Groskinsky, Henry/Port Washington NY . . .516-883-3294
Hall, Judson/Putney VT.802-387-6670
Hall, Sam/Boston617-266-6055
Hamlin, Elizabeth/Cambridge MA.617-547-1619
Hansen, James/Setauket NY516-941-4179
Hansen, Steve (V1 • 106)617-426-6858
Heayn, Mark/Baltimore301-235-1608
Heist, Scott 41 Emmaus PA215-965-5479
Heller, Brian C./East Stroudsburg PA717-421-3175
Henis, Marshall C./Great Neck NY516-466-9098
Hess, Brad/Grandview NY914-358-4060
Hires, Charles E./Malvern PA215-647-3140
Hocker, John W./Cape May NJ609-465-4971
Hobermann, L./Chatham MA617-945-2413
Hoffman, Bernard/Freehold NJ201-780-2578
Holland, James R./Boston MA.617-267-9140
Holt, John 114 Boston617-426-7262
Holt, Walter/Bryn Mawr PA.215-525-8040
Hoops, Jay/Southampton NY516-728-4017

Houser, David/Ridgefield CT203-438-3441
Howard, Carl/Ballston Lake NY.518-877-7615
Hubbell, William/Bedford Hills NY.914-666-5792
Hulings, Peter G./Boston617-426-2565
Hurst, Norman/Cambridge MA617-868-4869
Jackson, Reggie/New Haven CT203-787-5191
Joachim, Bruno/Boston.617-266-7552
Jones, Lou/Boston617-267-3142
Jongen, Antoinette/East Hampton NY516-324-1067
Kalisher, Simpson/Roxbury CT203-354-8893
Kaplan, Carol/Boston.617-353-0525
Katz, Alan/West Orange NJ201-731-8956
Kelly, John J./Springfield PA215-543-1230
King, Ralph 115 (V1 • 107) Boston. . . .617-426-3565
Kligman, Fred/Wash DC202-234-4622
Knapp, Richard/Edgewater NJ201-837-6320
Knapp, Stephen/Worcester MA617-757-2507
Koeniges, Thomas/Islip NY516-581-8163
Kramer, Erwin/Great Neck NY516-466-5582
Laab, Ludwig/Woodstown NJ609-769-3434
Lautman, Robert C./Wash DC202-966-2800
Lee, Carol/Boston617-523-5930
Leipzig, Arthur/Sea Cliff NY516-676-6016
Leney, Julia/Wayland MA617-358-7229
Lensman Photo Ltd./Wash DC202-333-3850
Levart, Herb/Hartsdale NY914-946-2060
Leveille, David 56 Rochester NY716-381-5341
Levy, Rick/Cambridge MA617-864-4298
Lilley, Weaver 116 Philadelphia215-567-2881
Lillibridge, David/Burlington CT203-673-9786
Limont, Alexander/Philadelphia215-438-7259
Linck, Anthony/Fort Lee NJ201-944-5454
Lockwood, Lee/West Newton MA617-965-6343
Lucas, W. Frederick/Nantucket MA617-228-9097
Manheim, Michael Philip/Marblehead MA . .617-631-3560
Maroon, Fred J./Wash DC202-337-0337
Marshall, John/Boston617-536-2988
Martin, Jack/Pennsauken NJ609-663-4971
Massie, Kim/Accord NY.914-687-7744
Masters, Hilary/Ancramdale NY518-329-1522
Matt, Philip/Rochester NY716-461-5977
McCarthy, Margaret/Harrison NY914-835-1587
McConnell, Jack/Hartford CT203-527-7666
McConnell-McNamara/Wethersfield CT . . .203-563-6154
McCoy, Dan J./Housatonic MA.413-274-6211
McKenna, Rollie/Stonington CT203-535-0110
McLaren, Lynn/Boston617-227-7448
Mecca, Pete and Jack/Leonia NJ201-944-3271
Mednick, Seymour/Philadelphia215-735-6100
Meek, Richard/Huntington NY516-271-0072
Miller, Peter M./Waterbury VT802-244-7887
Miller, Roger/Baltimore301-566-1222
Millman, Lester Jay/Rye NY914-967-0486
Minohr, Martha/Wilmington DE.302-762-1250
Mitchell, Mike/Wash DC202-347-3223
Mopsik, Eugene/Philadelphia215-922-3489
Morley, Bob/Boston617-227-3499
Morrow, Christopher W./Boston617-536-7662
Morse, Susan W./Glassboro NJ609-881-3920
Mort, Marvin J./Lafayette Hill PA215-828-7775
Munster, Joseph/Phoenicia NY914-688-5347
Musto, Tom/Wilkes Barre PA.717-822-5798
Nalewajk, Jerome/Stratford CT203-375-0207
Nelder, Oscar/Presque Isle ME207-769-5911
Neubauer, John 117 (V1 • 108) Arlington VA .703-920-5994
Nichols, Don 118 Rochester NY716-275-9666
Nicotera, Doug and Cindi/Harrisburg PA . . .717-939-0702
Nocella, Sam/Willow Grove PA215-659-2171
Nochton, Jack/Bethlehem PA215-691-2223
Northlight Group 119 Newark NJ201-624-3990
Novak, Jack/Alexandria VA.703-836-6464
Olbrys, Anthony/Stamford CT.203-322-9422
O'Mahony, Jack/Boston617-267-2290
Orrico, Charles 69 (V1 • 65) Syosset NY . . .516-364-2257
O'Shaughnessy, Bob/Boston617-523-2525
Palmer, Gabe/Weston CT203-227-1477
Parker, Robert B./Corning NY607-962-4104
Patterson, Roy/Madison CT203-245-1044
Pease, Greg/Baltimore301-235-6798
Perry, Robin L./Waterford CT203-442-3383
Phillips, John/Glen Head NY516-626-1976
Pickerell, John/Bethesda MD301-365-1126

Pierce, Michael/Boston617-262-0785
Pierson, Huntley/Newburyport MA617-267-5823
Pinney, Doris/Greenwich CT203-869-0490
Polansky, Allen/Baltimore301-383-9021
Polumbaum, Ted 120 Lincoln MA617-259-8723
Porcella, Phil (V1 • 109) Boston617-426-3222
Porter, Charles/Poughkeepsie NY.914-454-7033
Profit, Everett R./Boston617-267-5840
Purring, James/Phoenixville PA.215-933-8393
Randolph, Bob/Wash DC202-462-0626
Raycroft, Jim/Boston617-542-7229
Richmond, Jack/Boston617-482-7158
Richman, Mel/Bala-Cynwyd PA215-839-6660
Riley, Laura/Pittstown NJ.201-735-7707
Roseman, Shelly/Philadelphia215-922-1430
Ross, Leonard/Bethlehem PA215-868-8225
Russell, Gail/Darien CT.203-325-0718
Sakmanoff, George/Boston617-262-7227
Salaff, Fred/Tarrytown NY914-592-9293
Salgado, Robert/New Hope PA215-862-2895
Salzbury, Lee/Wash DC202-543-5400
Sanford, Eric/Manchester NH603-624-0122
Schill, William/Haddon Heights NJ609-547-0148
Schlivek, Louis/Ridgewood NJ201-444-6544
Schmitt, Steve (V1 • 110) Boston617-247-3991
Schwartz, Bunny/Fort Lee NJ201-886-0268
Schwartz, Robin/Fort Lee NJ.201-886-0268
Schweikardt, Eric/Westport CT203-227-0371
Seawell, Harry 82 (V1 • 76)
Parkersburg WV304-485-4481
Shames, Martin/CT203-393-0211
Sharpe, David 121 Wash DC202-638-0482
Shelton, Sybil/Englewood NJ201-568-8684
Shroyer, John/Bethlehem PA.215-865-9409
Silk, George/Westport CT.203-227-5757
Simmons, Erik Leigh/East Dennis MA617-394-8763
Simon, Peter R./Gayhead MA617-645-9575
Simpson/Flint (V1 • 111) Baltimore . . .301-837-9923
Siteman, Frank/Winchester MA.617-729-3747
Smith, Hugh R./Fairfield CT203-255-1942
Smith, Paul/Roslyn VA703-522-0150
Smith, Roger B./Avon NY716-245-5516
Smolan, Rick/Philadelphia215-923-0524
Smyth, Kevin/Belmar NJ201-681-2602
Snyder, Clarence/Easton PA215-252-2109
Solomon, Rosalind/Wash DC202-337-0393
Somers, Jo/Boston617-267-4444
Spiegel, Ted/South Salem NY914-763-3668
Spivak, I. Howard/Bass River MA617-394-8334
Stafford, Rick/Allston MA617-495-1595
Stage, John Lewis/New Milford NY914-986-1620
Stecker, Elinor H./Larchmont NY914-937-3800
Stein, Geoffrey R./Boston617-262-0839
Steiner, Lisl/Pound Ridge NY914-764-5538
Steinhard, Walter/Peekskill NY.914-737-3347
Stoller, Ezra/Rye NY914-967-3755
Strongin, James W./Huntington NY516-421-4307
Sweet, Ozzie/Francestown NH.603-547-6611
Synchro Photographics Inc./Mt. Rainier MD .301-699-8142
Tadder, Morton/Baltimore301-837-7427
Tenin, Barry/Westport, CT203-226-9396
Tepper, Alan/Hamilton NY315-824-1000
Tepper, Peter/Fairfield CT.203-367-6172
Tessler, Ted/Great Neck NY516-487-8124
Thomas, Ricardo/Wash DC202-265-6568
Tritsch, Joseph J./Cherry Hill NJ.609-667-0974
Trone, Larry P./Wilmington DE.302-328-7172
Tucker, Bill/Boston617-426-7439
Urban, John/Boston617-426-8644
Vaccaro, Michael A./Chichester NY914-688-5754
Van Arsdale, Nancy/Allendale NJ.201-327-4088
Van Petten, Rob/Boston617-426-8641
Van-Schalkwyk, John/Boston617-542-4825
Vaughan, Vincent D./Philadelphia215-472-7890
Viertel, Janet/Stamford CT.203-322-2561
Von Matthiessen, Maria/Brewster NY914-279-2663
Wachter, Jerry/Baltimore301-484-7277
Wahl, Paul/Bogota NJ201-487-8460
Walch, Robert/Oley PA716-473-7007
Warren, Marion E./Annapolis MS.301-974-0444
Wasco, George R./Philadelphia215-922-4662
Watts, C. Moncrief/Larchmont NY914-834-8079

Weisenfeld, Stanley/Painted Post NY607-962-7314
Weisgrau, Richard/Philadelphia.215-923-3232
Weldon, Mort/North Ardsley NY914-963-1076
Wendler, Hans/Epsom NH603-736-9383
Wexler, Ira/McLean VA.804-241-1776
White, Saul/Chappaqua NY914-769-1933
Wilcox, Elizabeth/Easton CT.203-261-2221
Williams, Lawrence/Upper Darby PA215-528-6460
Williams, Ron/Feasterville PA.215-322-1166
Wittstein, William H./North Haven CT.203-288-3724
Wohosenko, Ihor/Brookline MA617-566-1569
Wood, Richard/Boston617-267-3971
Woujie/Woodstock NY914-679-7094
Wyman, Ira/West Peabody MA617-535-2880
Yamashita, Michael/Montclair NJ201-746-9451
Young, Ellan/Chappaqua NY914-238-4837

SOUTHEAST

The Alderman Co./High Point NC.919-883-6121
Arnold, Harriet/Palm Beach FL305-582-0606
Baldwin, Frederick/Savannah GA912-234-0004
Barley, Bill/Cayce SC803-755-1554
Barton, Paul/Coral Gables FL305-665-0942
Borum, Michael/Nashville TN615-259-9750
Bullington, Thomas/Durham NC919-286-4885
Carlebach, Michael L./Miami305-443-8491
Cerny, Paul/Tampa FL813-839-7710
Coleman, Bob/New Orleans LA504-866-9001
Cook, Jaimie/Atlanta404-892-1393
Cromer, Peggo/Coral Gables FL305-667-3722
David, Alan/Atlanta404-875-5805
deCasseres, Joseph/Atlanta404-892-0769
Diamond, Hindi/Miami305-665-4948
Dinkins, Stephanie/New Orleans LA504-866-3337
Edwards, Jack/New Orleans LA504-529-2147
Faustino 125 Coral Gables FL**305-854-4275**
Fineman, Michael/N. Miami Beach FL305-666-1250
Fisher, Ray/Miami305-665-7659
Forer, Dan/Miami305-751-5752
Fowley, Douglas/Louisville KY.502-245-1100
Freeman, John/Chapel Hill NC919-929-3101
Gefter, Judith/Jacksonville FL904-733-5498
Gelberg, Robert (V1 • 115) Miami**305-374-6601**
Gleasner, Bill/Denver NC704-483-9301
Gould, Allan/Miami305-271-8605
Graham, Fred N./Cocoa Beach FL305-636-1329
Greenberg, Jerry/Miami.305-667-4051
Grimes, Bill/Atlanta404-971-0224
Guravich, Dan/Greenville MS601-335-2444
Hallinan, Dennis/Winter Haven FL.813-293-7942
Hannau, Michael/Hialeah FL305-887-1536
Harris, Christopher/New Orleans LA504-586-0209
Hazzard, Joseph/Charlotte NC704-376-6475
Hines, William (V1 • 116) Sarasota FL**813-371-2738**
Hoflich, Richard/Atlanta404-872-3491
Holland, Ralph (V1 • 117) High Point NC . . .**919-273-5425**
Hunter, Hugh/Birmingham AL205-879-4773
Hyman, Bill 126 Atlanta**404-355-8069**
Jamison, Chipp/Atlanta404-873-3636
Joyner, Louis O./Birmingham AL205-870-4440
Kaplan, Al/N. Miami FL.305-891-7595
Kennedy, Thomas/Gainesville FL.904-373-3097
Kersh, Viron/New Orleans LA504-524-7255
King, J. Brian/Miami305-856-6534
Kohanim, Parish 127 Atlanta**404-892-0099**
Kollar, Robert E./Knoxville TX615-632-2091
Lau, Glenn H./Ocala FL904-237-2129
Leviton, Jay B./Atlanta404-237-7766
Magruder, Mary & Richard/Decatur GA.404-289-8985
Malles, Ed/Birmingham AL205-854-3535
McCarthy, Tom/Miami305-233-1703
McGuire, Jim/Nashville615-385-1045
McNeely, Burton/Land O'Lakes FL.813-996-3025
McQuerter, James/Tampa FL813-872-6383
Medina, Nelson/Tampa FL813-839-6754
Menzel, Peter J./Charlotte TN615-789-4335
Miller, Ardean R./Miami305-661-5688
Miller, Frank J./Hickory NC704-324-8758
Miller, Frank Lotz/New Orleans LA504-899-5688
Miller, Randy 128 Miami**305-667-5765**
Mills, Henry A./Charlotte NC.704-366-3612
Mullen, Edward F./Belair FL313-585-1763

Myers, Fred/Florence AL205-766-4802
Olive, Tim 129 Atlanta**404-872-0500**
Osborne, Mitchel L./New Orleans LA504-522-1871
Parsons, Bill/Little Rock AR501-372-5892
Pelham, Lynn/Miami305-757-3996
Reetz Nick/Atlanta404-874-0822
Roberts, Bruce/Charlotte NC704-375-3748
Rogers, Chuck/Atlanta404-872-0062
Sahuc, Louis/New Orleans LA.504-581-7439
Scheff, Joe/St. Peterburg FL813-822-3599
Schenck, Gordon H./Charlotte NC704-332-4078
Schulke, Flip/Miami305-667-5671
Seitz, Art/Ft. Lauderdale FL305-391-3136
Sherman, Bob/N. Miami Beach FL.305-944-2111
Sherman, Ron/Atlanta404-993-7197
Shrout, Bill/Theodore AL205-973-2417
Siebenthaler, John/Elfers FL813-848-2927
Smeltzer, Robert/Greenville SC803-235-2186
Smith, Charles/Jacksonville FL904-388-6613
Smith, Rick/Greensboro NC919-275-7691
Steinmetz, Joseph J./Sarasota FL813-953-7017
Studio III/Atlanta404-875-0161
Thomas, J. Clark/Nashville TN615-327-1757
Thompson, Thomas L./Atlanta404-874-8247
Touchton, Kenneth M., Jr./Atlanta404-993-6801
Turnau, Jeffrey/Miami305-685-7636
Van Calsem, Bill/New Orleans LA504-522-7346
Vance, David & Assoc./Miami305-685-2433
Phillip Vullo/Atlanta.404-874-0822
Walters, Tom/Charlotte NC.704-333-6294
Weedman, Brent/Nashville TN615-254-1324
Whitman, Alan David/Greenville SC803-271-8238
Williamson, Thomas A./Miami305-757-3996

MIDWEST

Aleksandrowicz, F.J./Cleveland216-696-4566
Alfa Studio/Ed Hoppe/Chicago312-787-2136
Amari, Frank/Chicago312-787-2240
Arndt, David M./Chicago.312-664-2879
Arsenault, Bill/Chicago.312-454-0544
Arteaga Photos Ltd./St. Louis MO314-352-8345
George Ayala & Assoc./Chicago312-644-6025
Azuma/Izui/Chicago312-266-8029
Bachnick, Alex/Chicago312-280-1201
Baer, Gordon/Cincinnati513-579-9214
Bailey, Conrad/Chicago312-337-6951
Bailey, J. Edward/Detroit313-875-5177
B.A.M. Studios/Chicago312-263-1027
Banner & Burns/Chicago312-644-4770
Barlow Photography Inc.
 Richmond Hgts. MO314-721-2385
Basdeka, Peter/Chicago312-782-4568
Bayles, Dal/Milwaukee414-464-8917
Bender, Bob/Cleveland216-861-1525
Bishop, G. Robert/Chesterfield MO314-532-3698
Block, Stuart/Chicago312-944-0427
Bosek, Georg/Chicago312-828-0988
Boyer, Dick/Chicago312-337-7211
Braddy, Jim/Chicago312-337-5664
Braun, Marc/Akron OH216-535-4036
Brimacombe, Gerald/Minneapolis612-941-5860
Broderson, Fred/Chicago312-787-1241
Brody, Jerry/Chicago.312-329-0660
Brown, David/Oak Brook IL312-654-2515
Brown, James F./Cincinnati513-321-8282
Bruton, Jon 133 St. Louis**314-533-6665**
Business Arts/Chicago312-337-4120
Cascarano, John 134 Chicago**312-266-1606**
Chadwick, Taber/Chicago312-454-0855
Chambers, Tom/Chicago312-828-9488
Chin, Ruth/Muncie IN317-284-4582
Clark, Junebug/Detroit313-399-4480
Clarkson, Rich/Topeka KS913-295-1196
C.M.O. Graphics/Chicago312-527-0900
Cowan, Ralph 135 (V1 • 121) Chicago**312-787-1316**
Curtis, Lucky/Chicago312-787-4422
Damien, Paul/Milwaukee414-259-1987
Deahl, David/Chicago312-644-3187
DeBold, Bill/Chicago312-644-3922
DeNatale, Joe/Chicago312-329-0234
DeRussy, Myles/Chicago312-943-3440
Deutsch, Owen/Chicago312-943-7155

Devenny-Wood Ltd./Chicago312-944-7070
DGM Studios/Bloomfield Hills MI313-645-2222
Ditlove, Michel/Chicago312-644-5233
DuBiel, Dennis/Chicago312-266-8559
Dunham, Paul/Chicago.312-649-9554
Eiler, Terry and Lynthia/Athens OH614-592-1280
Elliot, Peter/Chicago312-733-6992
Bob Elmore & Assoc./Chicago312-236-0233
Epperson, Richard 136 Chicago**312-337-2138**
E.T.M. Studios/Chicago312-644-2974
Ewert, Steve/Chicago.312-664-5954
Faverty, Richard/Chicago312-943-2648
Feldkamp-Malloy/Chicago.312-263-0633
Floyd, Bill/Chicago.312-321-1770
Foster, Richard/Chicago312-467-4770
Fotographics/Indianapolis317-353-6259
Friedman, Bernard/Oak Park IL312-666-5400
Gabriel 137 Chicago**312-787-2915**
Gale, Bill/Minneapolis612-827-5858
Getsug-Anderson 138 Minneapolis**612-332-7007**
Gillette, Bill/Ames IA515-233-3337
Grant-Jacoby/Chicago312-664-2055
Gray, Walter/Chicago312-644-2385
Gregory, Gus/Chicago312-787-7443
Gremmler, Paul/Chicago312-871-1250
Griffith, Waite/Omaha402-391-8474
Grippentrag, Dennis/Bloomfield Hills MI313-645-2222
Grubman, Steve/Chicago312-787-2272
Haller, Pam/Chicago312-649-0920
Hamilton, David/Chicago312-861-1775
Hamilton, David W./Chicago312-944-6655
Hammarlund, Vern/Troy MI313-588-5533
Handley, Robert E./Bloomington IL309-828-4661
Harlan, Bruce/South Bend IN219-283-7350
Harper, Hugo/St. Louis MO.314-727-4755
Harris, Bart (V1 • 32, 123) Chicago**312-751-2977**
Hart, Bob/Chicago312-644-3636
Hauser & D'Orio/Chicago.312-787-8276
Hedrich-Blessing/Chicago312-321-1151
Hickson • Bender 140 Waldo OH**614-726-2470**
Hirschfeld, Corson 44 (V1 • 33) Cincinnati . .**513-241-0550**
Izokaitis, Kastytis/Chicago312-321-1388
Johnson, Jim/Chicago.312-943-8864
Jones, Dawson/Dayton OH513-435-1121
Jones, Dick, 142 Chicago**312-642-0242**
Jordano, Dave/Chicago312-929-8660
Joseph, Mark/Chicago312-267-1708
Mel Kaspar 143 (V1 • 124) Chicago**312-528-7711**
Kazu/Chicago. .312-750-5393
Keeler, Chuck/Minneapolis612-339-1429
Keeling, Robert/Chicago312-944-5680
Kelly, Tony/Evanston IL312-864-0488
Kemper, Susan/Bensenville IL312-766-0742
Kilkelly, James (V1 • 126) Minneapolis**612-339-2121**
Kolze, Larry/Chicago312-266-8352
Kouvatsos, Theo/Cincinnati513-241-3000
Krantzen Studios/Chicago.312-922-9200
Kroeger-Zieminski/Chicago.312-822-9600
Krueger, Dick/Chicago312-527-2108
Kulp, Curtis/Chicago312-266-0477
Kuslich, Lawrence J./St. Paul MN612-647-0428
Lane, Jack/Chicago312-337-2326
Lareau, George A./Champaign IL217-351-8144
LaTona, Tony/Kansas City MO816-454-7387
Lee, Jared/Lebanon OH.513-932-2154
Levey, Don/Chicago312-329-9040
Lightfoot, Robert/Des Plaines IL312-297-5447
Lindblade, George R./Sioux City IA712-277-2345
Lowenthal, Jeff/Chicago312-861-1180
Malinowski, Stan/Schaumburg IL.312-397-1157
Manarchy, Dennis (V1 • 127) Chicago**312-828-9117**
Manning Studios Inc. 144 Cleveland**216-861-1525**
Marvy, Jim 145 Hopkins MN**612-935-0307**
Maselli Studios/Chicago312-726-5678
Matz, Fred/Chicago.312-828-9216
McCann, Larry/Chicago.312-329-0370
McMahon, Wm. Franklin/Evanston IL.312-864-2468
McNamara, Norris/Chicago312-944-4477
Miller, Daniel D./Chicago312-761-5552
Miller, Edward L./Chicago312-266-1139
John Mitchell Studios/Elk Grove IL312-956-8230
Mitchell, Rick/Chicago312-829-1700

Morrill, Dan/Chicago312-787-5095
Merle Morris Photographers 146
 Minneapolis .**612-338-7829**
Moss, Jean (V1 • 128) Chicago**312-787-0260**
Moy, Willy/Chicago.312-943-1863
Nano, Ed/Cleveland216-941-3373
Neumer, Koopman/Chicago312-944-3340
Nicholson, Larry B./Raytown MO816-356-4505
Novak, Sam/Chicago312-664-6733
Nygards, Leif-Erik/Evanston IL312-869-1257
Jack O'Grady Studios Inc./Chicago312-726-9833
Olsson, Russ/Chicago.312-329-9358
Jack O'Neal Assoc./Mission KS913-362-4440
O'Rourke, John/Wilmington OH.513-382-3782
Parker, Norm/Chicago312-644-2248
Parks, Jim/Chicago312-321-1193
Pazovski, Kazik/Cincinnati513-721-0133
Perlus & Taxel/Cleveland.216-431-2400
Peterson, Chester N., Jr./Lindsborg KS913-227-3514
Picture Place/Jim Clarke, 147 (V1 • 129)
 St. Louis .**314-872-7506**
Plowden, David/Winnetka IL312-446-2793
Pokempner, Marc/Chicago312-525-4567
Poli, Frank/Chicago312-944-3924
Raczinski, Walter/Chicago312-467-0190
Radland, Bud/Madison WI.608-274-0344
Rampy, Thomas/Ann Arbor MI313-769-4757
Raynor, Dorka/Winnetka IL.312-446-1187
Reichenthal, Martin/Toledo OH419-475-5102
Warren Reynolds & Assoc./Minneapolis612-333-4575
Robinson, David/Chicago312-266-9050
Rocker, Donald/Chicago312-285-5273
Rogers, Bill Arthur/Oak Park IL312-848-3900
Rosmis, Bruce/Chicago.312-787-9046
Sacco, Robert T./Chicago.312-663-9778
Sandy, Dick/Hoffman Estates IL312-359-9580
Saver, Neil/St. Louis MO314-241-9300
Schridde, Charles, 148
 Madison Heights MI**313-589-0111**
Schultz, Tim (V1 • 130) Chicago**312-871-4488**
Scott, Bob/Chicago312-337-4240
Scott, Denis/Chicago312-467-5663
Seed, Suzanne/Chicago312-266-0621
Seymour, Frank/Minneapolis612-338-7829
Seymour, Ronald/Chicago312-642-4030
Shaffer, Mac/Columbus OH614-268-2249
Shay, Arthur/Deerfield IL312-945-4636
Shigeta-Wright Assoc./Chicago312-642-8715
Shotwell, Chuck/Chicago.312-929-0168
Shoulders, Terry/Chicago.312-644-0616
Silker, Glen/Minneapolis612-835-1811
Skrebneski, Victor/Chicago312-944-1339
Sladcik, William/Chicago.312-644-7108
Smetzer, Donald/Chicago312-327-1716
Smith, C.W./Chicago312-337-2087
Snook, Allen/Chicago312-943-7134
Snyder, John/Chicago312-440-1053
Soluri, Tony/Chicago312-243-6580
Sorce, Wayne/Chicago312-583-6510
Stansfield, Stan/Chicago.312-644-2232
Sterling, Joseph/Chicago312-348-4333
Stephens Biondi DeCicco Inc./Chicago312-944-3340
Stierer, Dennis/Ft. Wayne IN219-483-1313
Straus, Jerry/Chicago312-787-2628
Studio Associates/George Anderson
 Chicago .312-372-4013
Studio 400/Ray Mottel/Chicago312-467-5460
Styrkowicz, Tom/Chicago312-528-7114
Tatham, Laird/Chicago312-337-4410
Tenebrini, Paul/Chicago312-642-0904
Thien, Alex/Milwaukee414-964-2249
Thomas, Bill/Nashville IN812-988-7865
Tucker, Bill/Birmingham MI313-626-4745
Tucker, Paul/Dayton OH513-435-9866
Umland, Steve (V1 • 131) Golden Valley, MN .**612-546-6768**
Upitis, Alvis/Minneapolis612-823-7801
Urba, Alexis/Chicago312-644-4466
Vaughan, Jim/Chicago312-663-0369
Visual Innovations/St. Louis MO304-432-4320
Vogue-Wright/Chicago312-664-5600
Vollan, Michael/Chicago.312-644-1792
Von Photography/Chicago312-787-9408

Welzenbach, John 149 Chicago **312-337-3611**
Wenkus, Nugent/Des Plaines IL312-694-4151
West, Stu/Photogenesis 150
Minneapolis612-871-0333
Willett, Mike/Chicago312-527-2360
Woodcock, Richard/Fenton MO314-343-5805
Woodward, Greg/Chicago312-337-5838
Zamiar, Thomas/Chicago312-787-4976
Zann, Arnold/Oak Park !L312-386-2864

SOUTHWEST

Alerdice, Barham/Midlothian TX214-775-3462
Constance Ashley Photographer 153
Dallas214-747-2501
Bagshaw, Cradoc/Tesuque NM505-983-7997
Baker, Bobbe/Dallas214-748-6346
Bates, Al/Houston713-466-4977
Bauer, Erwin A./Teton Village WY307-733-4023
Birnbach, Allen (V1•135) Denver303-455-7800
Bouche, Len/Santa Fe NM505-471-2044
Branner, Phil/Dallas214-522-1230
Brownlee, Michael V./Denver303-753-1653
Bruce, A. Dave, Jr./Houston713-523-6214
Burkhart, John R./Prescott AZ602-778-0334
Bybee, Gerald 154 Salt Lake City UT801-363-1061
Cabluck, Jarrold/Fort Worth TX817-336-1431
Campbell, Tom/Phoenix AZ602-252-9746
Carter, Bob/Dallas214-821-9661
Case, Robert H./Allens Park CO303-747-2289
Chamberlain, Bob/Telluride CO303-728-3525
Chavanell, Joe/San Antonio TX512-344-0385
Chesley, Paul/Aspen CO303-925-2317
Classon, Norm/Aspen CO303-925-4418
Collum, Charles/Dallas214-741-5405
Connolly, Danny F./Houston713-862-8146
Culberson, Jim/Houston713-523-7590
Cupp, David/Denver303-321-3581
Curtsinger, George/Ft. Worth TX214-336-9371
Davis, Dave/Phoenix AZ602-266-9851
DeSciose, Nicholas 19, 155 (V1•136)
Denver.303-455-6315
deVore, Nicholas III/Aspen CO303-925-2317
Eddy, Don/Ft. Collins CO303-484-8144
Elder, Jim/Jackson Hole WY307-733-3555
Fahey, Diane D./Denver303-322-6265
Fish, Vinnie/Park City UT801-649-7373
Forsyth, Mimi/Santa Fe NM505-982-8891
Francisco & Booth/Dallas214-350-4923
Freedman, Sue/El Paso TX915-778-6457
Gomel, Bob/Houston713-772-1763
Griffin, John H./Ft. Worth TX817-543-8666
Hawks, Bob/Tulsa OK918-584-3351
Haynes, Mike/Dallas214-522-1230
Haynsworth, John/Dallas214-748-6346
Hight, George C./Gallup NM505-863-3222
Hiser, C. David/Aspen CO303-925-2317
Hoffman, Harold/Richardson TX214-690-9592
Ivy, Dennis E./Austin TX512-444-3434
Johnsos, Charles/Vail CO.303-476-4900
Jones, C. Bryan/Houston713-524-5594
Jones, Don W./Scottsdale AZ602-948-4591
Katz, John/Houston713-522-0180
Kehrwald, Richard J./Sheridan WY307-674-4679
Kirkley Photography 156 Dallas214-651-9701
Klumpp, Don (V1•137) Houston713-627-1022
Phil Kretchmar Photography/Dallas214-744-2039
Lee, Russell/Austin TX512-452-6174
Lindstrom, Eric/Dallas214-638-1247
Mayer, Elaine Werner/Phoenix AZ602-955-5242
McAllister, Bruce/Denver303-832-7496
McCullough, Bob/Gila NM505-535-4139
McCullough, Thomas E./Sandia Park NM505-281-5734
McKee, Mike/Dallas214-638-1498
McLaughlin, Herb and Dorothy/Phoenix AZ602-258-6551
Meley, David/Long View TX.214-759-6395
Messineo, John/Ft. Collins CO303-482-9349
Mills, Jack R./Oklahoma City OK405-787-7271
Milmoe, James O./Golden CO303-279-4364
Moberley, Connie/Houston713-864-3638
Moore, Terrence/Tucson AZ.602-623-9381
Noble, Dee/Lubbock, TX.806-744-2220
The Photographers Inc./Irving TX214-438-4114

Running, John/Flagstaff AZ602-774-2923
Runyan, Peter F./Vail CO303-476-3142
Russell, John/Aspen CO303-925-2747
Salas, Michael/Plano TX214-423-4396
Salomon/Wahlberg & Friends/Dallas214-823-5851
Schoen, David/Dallas214-826-8808
Scott, Ron/Houston713-529-5868
Jerry Segrest Photography/Dallas214-630-8981
Shaw, Robert (V1•138) Dallas214-528-8868
The Shooting Gallery Inc./Dallas214-742-1668
Short, Glenn/Phoenix AZ602-252-9746
Shupe, John R./Ogden UT801-392-2523
St. Gil, Marc/Houston713-467-4220
Stott, Barry/Vail CO303-476-3334
Tatem, Mike/Littleton CO303-770-6080
Troxell, William H./Flagstaff AZ602-779-3626
Untersee, Chuck/Dallas214-358-2306
Utterback, Michal 157 Salt Lake City UT . . .801-531-7767
Walker, Todd/Tucson AZ602-327-1569
Ward, Sheila/Tucson AZ602-298-3727
Watkins, J.C./Port Arthur TX713-982-3666
Whiting, Dennis/Irving TX214-438-4114
Wilcox, Shorty 158 Breckenridge CO303-453-2511
Witt, Lou/Houston713-944-1603
Wolfhagen, Vilhelm/Houston713-522-2787
Wright, Geri/Aspen CO303-925-2137

WEST

Abecassis, Andree L./Berkeley CA415-526-5099
Ackroyd, Hugh S./Portland OR503-227-5694
Adlen, Joan M./LA213-938-1666
Ahlberg, Holly/LA213-462-0731
Ahrend, Jay/LA213-466-8485
Alexander, David/Hollywood CA.213-464-8690
Alexander, Jesse L./Santa Barbara CA805-969-3916
Alexander, Michael/SF415-982-7980
Amer, Tommy/LA213-469-3305
Anderson, John/Vacaville CA707-448-4926
Aplin, William /Ventura CA805-648-4457
Apton, Bill/SF415-771-9809
Arbogast, Bill/Palo Alto CA415-323-1336
Arnesen, Eric 163 SF415-495-5366
Arteaga Photos Ltd./Seattle206-783-0321
Aurness, Craig/LA213-473-3736
Avery, Sid/LA.213-465-7193
Ayres, Robert Bruce/LA213-876-1477
Baer, Morley/Monterey CA408-624-3530
Bailey, Brent P./Costa Mesa CA714-548-9683
Ballis, George/Fresno CA.209-237-6516
Barnes, David 164 Seattle206-525-1965
Bartone, Tom/LA213-876-5510
Bartruff, Dave (V1•141) San Anselmo CA . . .415-457-1482
Bauer, Karel M./Mill Valley Ca.415-863-5155
Bays, Pete/Davis CA.916-756-3640
Becker Bishop Studios (V1•142)
Santa Clara CA408-244-8484
Beebe, Morton P./SF415-362-3530
Belknap, Bill/Boulder City NV.702-293-1406
Bergman, Alan/LA213-935-2744
Berman, Steve/LA213-933-9185
Bernstein, Cal/LA213-461-3737
Betz, Rn. Ted/SF415-488-0407
Bez, Frank/Los Osos CA.805-528-5500
Biggs, Ken/LA.213-462-7739
Blakeley, Jim 165 (V1•143)
SF415-495-5100
Blakeman, Bob/LA.213-479-4327
Blaustein, John/Berkeley CA415-845-2525
Blodget, Lee (V1•144) SF415-495-3995
Bodnar, Joe/LA213-838-6587
Bourdet, Al/Olympic Valley CA916-583-3959
Bourret, Tom/SF.415-777-1736
Braasch, Gary (V1•145) Vancouver WA206-695-3844
Bradley, Leverett/Santa Monica CA213-394-0908
Bragstad, Jeremiah O./SF415-864-2668
Brascia, Sondra Scott/Beverly Hills CA.213-274-1911
Braun, Ernest/San Anselmo CA415-454-2791
Brawer, Sid/Beverly Hills CA.213-278-6821
Brenneis, Jon/Berkeley CA415-845-3377
Britt, Jim/LA.213-845-3832
Brooks, David B./Nipomo-Mesa CA213-737-4358

Brown, Delores McCutcheon
Canyon Country CA805-251-2416
Bryan, J.Y./Riverside CA714-684-8266
Bryson, John/LA.213-478-1011
Buchanan, Craig/SF.415-343-5566
Buckman, Rollin/Saratoga CA408-867-9203
Buelteman, Robert L., Jr./SF.415-566-7670
Burden, S.C./Beverly Hills CA213-271-7008
Bush, Charles/LA213-937-8248
Cahoon, John/LA213-930-1144
Camozzi, Teresa/SF415-421-8898
Capps, Alan/LA.213-276-3724
Carroll, Tom/Malibu CA213-454-1319
Caulfield, Patricia/Las Vegas NV702-735-3533
Ralph Chandler Studio, Inc. 167 LA213-469-6205
Chester, Mark (V1•146) SF415-922-7512
Clark, William F./LA213-486-2564
Claxton, William/Beverly Hills CA213-276-4228
Clemenz, Bob/Manhattan Beach CA213-329-0797
Cobb, Vincent/Beverly Hills CA213-277-5554
Cofrin, John P./Mill Valley CA415-435-2605
Cogan, Bill/SF213-391-1350
Coleberd, Frances/Menlo Park CA415-325-4731
Collison, James/Sherman Oaks CA213-784-4916
Colmano, Marino/SF.415-388-4104
Considine, Tim/Beverly Hills CA213-464-0101
Cornfield, Jim/LA213-937-5810
Costa, Tony/LA213-934-3933
Crawford, Del O./Santa Cruz CA408-475-7511
Crouch, Steve/Carmel CA408-624-2030
Cummins, Jim/Seattle206-623-6206
Dain, Martin/Carmel Valley CA408-659-3259
Dandridge, Frank D./LA213-233-7304
Daniels, Josephus/Pebble Beach CA408-372-8812
de Gennaro, George 169 (V1•162) LA. . . .213-935-5179
deLancie/Mayer/SF415-546-1232
deLespinasse, Hank/Las Vegas702-361-6628
della Grotta, Vivienne/Carpinteria CA805-684-1339
den Dekker, John/Alhambra CA213-570-9144
Denman, Frank B./Seattle206-623-1062
Rick Der Photography/SF415-433-2055
Derr, Steve/SF415-641-0550
Desanges, St. Jivago/Westwood CA213-938-0151
Diaz, Armando/SF415-495-3552
Doll, Glen L./LA213-413-2600
Donchin, Chic/LA.213-462-6567
Dondero, Donald/Reno NV702-825-7348
Dow, Larry/LA213-483-7970
Dubler, Douglas (V1•164) Malibu CA213-340-3034
Dugas, Albert/LA.213-876-7116
Dull, Ed/Portland OR503-224-3754
Dumont, Michael P./SF415-563-1561
Dunbar, Clark M./Los Altos CA408-732-8403
Dunbar, Theodore H./LA213-465-0175
Elich, George/Sacramento CA916-481-5021
Emberly, Gordon/SF415-621-9714
Embree, Glen/LA213-938-2349
Emanuel, Manny/Hollywood213-465-0259
England, Jim/LA213-413-2575
Engler, Tom 170 Hollywood213-666-4640
Esgro, Dan/LA.213-655-4012
Evans, Marty/LA213-466-7279
Eymann, William Charles/Palo Alto CA.415-494-0281
Feldman, Marc 171 LA213-463-4829
Felt, Jim/Portland OR503-238-1748
Fenton, Reed/LA213-651-4646
Fischer, Curt/SF.
Fish, Richard/LA213-986-5190
Fisher, Arthur Vining/SF415-626-5483
Fousie, Michael Shea/Boise ID208-345-8635
Fox, Paul/Palm Springs CA.714-325-0386
Freed, Jack/LA.213-931-1015
Freis, Jay/Sausalito CA415-332-6709
Fries, Janet/SF415-648-4719
Fruchtman, Jerry/Hollywood CA.213-465-4032
Richard Yutaka Fukuhara 172
Signal Hill CA213-597-4497
Furuta, Carl/LA213-655-1911
Fusco, Paul/SF415-388-8940
Gage, Rob/Laguna Beach CA714-494-7265
Gardner, Robert 173 LA213-931-1108
William Garnet Photography/LA213-931-0367

Garretson, James/Corte Madera CA415-924-4533
Garrison, Ron/San Diego CA.714-231-1515
Gascon, Enrique (V1•165) LA213-383-9157
Gatley, David/Granada Hills CA213-363-3494
Gechtman, Neal/Beverly Hills CA213-875-2550
Genter, Ralph/LA213-655-8724
Gersten, Paul Ben (V1•166) LA213-652-6111
Giobbe, Enzo/North Hollywood CA213-547-4361
Glaubinger, David/San Anselmo CA.415-453-5902
Going, Michael/LA213-465-6853
Goldstein, Arthur 174 (V1•167) LA.213-874-6322
Goldstein, Ed/LA.213-663-5800
Gordon, Charles M./Seattle206-365-2132
Gordon, Larry Dale 175 (V1•168) LA213-874-6318
Gornick, Alan/LA.213-223-8914
Gottlieb, Mark/Palo Alto CA.415-321-8761
Graham, Ellen/Beverly Hills CA.213-275-6195
Gray, Dennis (V1•147) SF415-546-6536
Greene, Herb/SF415-543-4829
Grimm, Tom/Laguna Beach CA.714-494-1336
Gross, Richard/SF415-922-6270
Gustafson, Egill (V1•149) Hansville WA . . .206-638-2478
Hailey, Jason/LA213-653-7710
Hamilton, John R./Gardena CA213-321-9992
Hampton, Ralph/Manhattan Beach CA213-429-9678
Harlow, Bruce 176 Seattle206-622-4843
Harris, Ron/Hollywood CA213-461-4496
Harrison, Howard E./SF.415-826-0252
Henman, Graham/LA213-934-1815
Herron, Matt/Sausalito CA.415-332-7388
Hewett, Richard/LA213-254-4577
Hicks, John and Regina/Carmel CA.408-624-7573
Higgins, Donald/Santa Monica CA213-393-8858
Hishi, James/LA213-658-8267
Hixson, Richard (V1•150) SF415-495-0558
Hollenbeck, Cliff/Seattle206-824-7700
Holz, William/LA213-656-4061
Hooper, H. Lee (V1•169) Malibu CA213-457-3363
Hooper, R. Scott/Las Vegas NV702-870-8653
Hopkins, Phil/San Diego CA714-287-1196
Hough, John David/SF.415-495-5769
Houle, Sue/LA213-273-1863
Huff, Susan/Tahoe City CA916-583-3735
Hungerford, Lauren/LA213-476-8896
Hyman, Milt/LA.213-938-3666
Iri, Carl/LA213-388-5737
Isaacs, Robert/Sunnyvale CA408-245-1690
Jacobs, Lou/Studio City CA213-872-1677
Jensen, John/SF.415-982-0962
Johnson, Lee Baker/LA213-849-6321
Johnson, Payne B./Del Mar CA714-755-2531
Jolitz, William R./SF.415-781-8421
Jones, Douglas/Sherman Oaks CA213-783-1456
Jorgensen, Hans/Seattle206-622-4269
Kahana, Yoram/Hollywood CA213-876-8208
Kauffman, Mark/Santa Rosa CA707-528-9466
Kearney, Irene/LA.213-472-2704
Kelley, Tom/LA.213-657-1780
Kemper, Charles 177 SF415-495-6468
Kirkland, Douglas/LA.213-659-9604
Krawczyk, John J./LA.213-463-2503
Kredenser, Peter/Beverly Hills CA.213-278-6356
Krosnick, Alan 178 SF415-957-1520
Kuhn, Chuck (V1•151) Seattle.206-624-4706
Kuhn, Robert/LA.213-461-3656
Kwong, Sam/LA.213-931-9393
Lamb & Hall Photography/LA.213-931-1775
Lang, G. Erwin/LA.213-455-1526
Laurance, Mike/Hollywood213-383-4748
Laxer, Jack (V1•170) Pacific Palisades CA . . .213-459-1213
Leatart, Brian/LA.213-386-3003
Lefferts, Marshall/LA213-469-6316
Lee, Larry/Newhall CA.805-259-1226
Lee, C. Robert/Idyllwild CA714-659-3325
Legname, Rudy (V1•152) SF415-777-9569
Lenk, Kurt/Malibu CA213-457-2621
Lewin, Elyse/LA.213-788-1601
Lewine, Rob/LA213-654-0830
Lichtner, Marvin/LA213-454-9355
Liles, Harry/LA213-466-1612
Linden, Seymour/Santa Monica213-393-5817
Livzey, John/LA213-469-2992

ILLUSTRATION

NEW YORK METROPOLITAN AREA

Accornero, Franco.212-697-8525
Accurso, Tony.212-435-1323
Adato, Jacqueline.212-777-3770
Air Stream212-682-1490
Albano, Chuck212-472-9474
Alcorn, John212-421-0050
Alcorn, Bob212-867-4640
Allegro Studio212-986-8161
Allen, Mary212-689-3902
Almquist, Don212-682-2462
Altemus, Robert (V1 • 183)**212-861-5080**
Ameijide, Raymond212-832-3214
Amsel, Richard (V1 • 184)**212-628-5960**
Anderson, Dick212-986-3282
Ansado, John212-929-0487
Antonio212-787-8910
Aplin, Jim212-855-3817
Applebaum & Curtis212-752-0679
Aristovulos, Nick212-725-2454
Art Pro Studio212-532-6844
Aruego, Jose212-988-5463
Arwin, Melanie Gaines212-924-2020
Asch, Howard212-352-0256
Ashmead, Hal212-686-3514
BJB Graphics Inc.212-535-5065
Baldus, Fred212-757-6300
Barkley, James212-682-1490
Barr, Ken212-697-8525
Barrett, Ron212-832-7220
Barry, Ron212-686-3514
Bauer, Carla212-873-4634
Bazzel, Deborah212-867-4640
Becker, Ron212-689-3902
Beecham, Tom212-697-8525
Bego, Dolores212-697-6170
Bek-gran, Phyllis212-689-3902
Bell, Barbara212-752-0190
Bergman, Barbra212-679-4562
Berkey, John212-355-0910
Billout, Guy212-255-2023
Blackwell, Garie212-752-8490
Blake, Quentin212-355-2763
Blechman, Bob212-869-1630
Blumrich, Christoph212-475-0440
Bonhomme, Bernard 224**212-532-9247**
Bossert, Jill212-752-7657
Bottner, Barbara212-889-3216
Bozzo, Frank212-535-9182
Brainin, Max212-953-2044
Brautigam, Don212-777-3770
Bridy, Dan212-682-2462
Brofsky, Miriam212-595-8094
Brooks, A.212-777-3770
Brundage, Dick212-689-3902
Byrd, David Edward212-255-5435
Byrd, Robert212-682-2462
Calogero, Gene212-873-3297
Cantarella, Virginia Hoyt212-622-2061
Cardi, Nick212-688-1080
Cason, Merrill212-860-2607
Catalano, Sal212-682-1490
Caulos, Luiz212-799-8050
Cayard, Bruce212-697-6170
Charmatz, Bill212-595-3907
Chen, Tony212-699-4813
Chester, Harry212-752-0570
Chorao, Kay212-749-8256
Christensen, David212-777-3770
Chwast, Seymour 224 (V1 • 187)**212-532-9247**
Ciardiello, Joseph212-351-2289
Clark, Jane212-867-4640
Clarke, Bob212-581-4045
Cober, Alan E.212-758-8490
CoConis, Ted212-288-4128
Coe, Sue212-734-6698
Collier, John212-421-0050
Colton, Keita212-686-3514
Continuity Assoc.212-751-5140
Cooley, D. Gary212-249-7231
Cooper, Robert212-758-2222

Crair, Mel212-697-8525
Cramer, D.L.212-799-7138
Crawford, Margery212-686-6883
Cross, Peter212-687-2272
Crosthwaite, C. Royd.212-355-0910
Cruz, Ray212-475-0440
Cuevas, Robert212-661-7149
Cunningham, Robert M.212-675-1731
Dacey, Bob212-686-3514
Dale, Robert212-758-2222
Daly, Sean212-490-0673
Davidson, Everett212-682-1490
Davis, Jack212-751-4656
DeCamps, Craig212-564-2691
Deigan, Jim212-682-2462
Delessert, Etienne212-421-0050
Deschamps, Bob212-751-4656
Descombes, Roland212-355-0910
Devlin, Bill (V1 • 188)**212-935-9436**
Dewey, Kenneth F.212-755-4945
Diamond, Donna212-362-3717
Dietz, Jim212-686-3514
Dillon, Diane212-624-0023
Dillon, Leo.212-624-0023
Dinnerstein, Harvey212-783-6879
Domingo, Ray212-751-4656
Doret, Michael212-889-0490
Drakides & Assoc.212-490-0658
Drovetto212-787-8910
Drucker, Mort212-755-4945
Echevarria, Abe212-679-4562
Egielski, Richard212-255-9328
Ellis, Dean212-254-7590
Ellis, Kathy212-868-3330
Ely, Richard.212-688-7232
Emmett, Bruce and Lisa212-751-6459
Endewelt, Jack.212-877-0575
Engelman, Julie212-355-1316
Enik, Ted.212-683-0560
Esteves, Jan212-682-2462
Eutemey, Loring212-249-8883
Evans, Tom212-686-3514
Farina, Michael212-355-1316
Farmakis, Andrea212-758-5280
Fasolino, Teresa212-799-8050
Federico, Helen212-661-0850
Fennimore, Linda212-866-0279
Fernandes, Stanislaw (V1 • 189).**212-533-2648**
Fery, Guy212-682-2462
Fitzgerald, Frank212-722-6793
Forbes, Bart212-686-3514
Francis, Judy212-866-7204
Fraser, Betty212-247-1937
Freas, John212-682-2462
Friedland, Lew212-359-3420
Froom, Georgia212-751-7970
Fulgoni, Louis212-243-2959
G & T Studio212-687-1684
Gaadt, George212-682-2462
Gadino, Victor212-686-3514
Gaetano, Nicholas212-755-4945
Gahan, Nancy Lou212-674-2644
Gallardo, Gervasio212-355-0910
Garland, Michael212-535-3044
Garnett, Joe212-688-1080
Gehm, Charles212-697-8525
Giglio, Richard212-675-7642
Geller, Martin212-237-1733
Genova, Joe212-682-1490
Gentile, John and Anthony212-757-1966
George, Andrew212-758-2222
Gersten, Gerry212-928-7957
Geyer, Jackie212-682-2462
Gill, Richard212-532-4566
Gillott, Carol212-243-6448
Giovanopoulos, Paul212-661-0850
Giuliani, Vin212-832-7300
Giusti, Robert212-421-0050
Graber, Norman212-682-7932
Graham, Mariah212-580-8061
Gray, John212-758-2222
Gray, Susan.212-787-5400

Green, Norman.212-679-4562
Grinder, Rainbow212-682-2462
Gross, Steve212-697-8525
Grossman, Robert212-925-1965
Grote, Rich212-867-4640
Hall, Joan212-989-4734
Hann, Jacquie212-255-4595
Harkins, George212-758-2222
Harris-Perrot, Catherine212-794-0922
Harrison, Hugh212-858-9034
Harrison, Sean212-369-3831
Heiner, Joe212-475-0440
Henderson, Alan.212-758-2222
Hering, Al212-986-3282
Hermann, Al212-752-8490
Hess, Mark (V1 • 191)**212-421-0050**
Hirschfeld, Al212-534-6172
Hodges, Mike.212-794-0922
Hofmann, Ginnie212-751-4656
Holt, Katheryn212-243-5139
Hooks, Mitchell212-737-1853
Hortens, Walter212-838-0014
Hour Hands.212-490-1835
Huens, Jean-Leon.212-355-0910
Huffaker, Sandy212-477-1867
Huffman, Tom212-347-4028
Hull, Cathy212-683-8559
Hunt, Jim212-758-2222
Hunter, Stan212-355-0910
Hunyady, Brooke.212-522-7335
Huyssen, Roger212-472-1812
Inouye, Carol212-787-8535
Jampel, Judith212-873-5234
Jezierski, Chet212-355-0910
Johnson, Doug212-989-7473
Johnson, Hedda (V1 • 193).**212-737-3236**
Jorg, Elizabeth212-687-2272
Juckes, Geoff212-569-0729
Juggernaut (V1 • 194)**212-691-8181**
Just, Hal212-697-6170
Kalish, Lionel212-751-4656
Kanelous, George212-688-1080
Kappes, Werner212-861-1748
Karchin, Steve212-249-1566
Karlin, Bernie212-687-7636
Karlin, Eugene212-457-5086
Karp, Steve212-697-8525
Katz, Les (V1 • 195)**212-625-4741**
Kendrick, Dennis212-924-3085
Kibbee, Gordon212-989-7074
King, Jean.212-866-8488
Klapper, Rhonda212-490-0673
Kliros, Thea212-355-1316
Knettell, Sharon212-751-4656
Knight, Jacob212-661-0850
Korda, Leslie212-595-3711
Krakovitz, Harlan212-689-3902
Kramer, Carveth212-661-0850
Kranz, Kathy212-754-1600
Krieger, Salem212-682-2462
Kubinyi, Laszlo212-855-4945
Lackow, Andy212-867-4640
LaGrone, Roy212-773-3091
Landis, Joan212-989-7074
Lang, Gary212-697-8525
Lanza, Barbara212-625-3685
Lapsley, Robert212-689-3902
Laslo, Larry212-687-2272
Laurence, Karen.212-661-0850
Leake, Don212-877-8405
Leffel, David212-575-7914
Lesser, Ron212-697-8525
Levin, Arnie212-472-9474
Levine, David212-624-4879
Levine, Ned212-691-7950
Levirne, Joel (V1 • 196)**212-869-8370**
Lewis, Tim212-475-0440
Lieberman, Ron212-947-0653
Lilly, Charles (V1 • 197)**212-873-3608**
Lindlof, Ed212-682-2462
Line, Lemuel212-355-0910
Linn, Warren212-758-2222

Lloyd, Peter212-355-1316
Lodigensky, Ted212-355-1316
Lohne, Garrett212-362-3257
Lopez, Antonio212-924-2060
Lubey, Dick212-686-3514
Lyall, Dennis212-682-2462
Lyons, Ellen212-794-0922
Maas, Julie212-988-6359
Mack, Stan212-855-4945
Maddalone, John212-751-1108
Mager, Janet212-661-0850
Mahoney, Ron212-682-2462
Maldeau, Michele.212-387-1287
Manos, Jim212-986-3282
Mantel, Richard 224**212-532-9247**
Marchesi, Stephen212-777-3770
Mardon, Allan212-751-4656
Marich, Felix212-758-2222
Martin, David212-243-2750
Mattelson, Marvin212-684-2974
Maxwell, Brookie212-799-8050
McAfee, Mara212-348-9284
McClelland, John212-682-2462
McConnell, Gerald212-475-5466
McCoy, Steve212-794-0922
McCrady, Lady212-532-6317
McDaniel, Jerry212-697-6170
McLean, Wilson212-752-8490
McMullan, James212-683-8530
McNamara Assoc.212-682-2462
McVicker, Charles212-697-4451
Mehlman, Elwyn212-751-4656
Melendez, Robert212-355-1316
Metcalf, Roger212-688-1080
Meyerowitz, Rick212-989-7074
Michal, Marie212-751-4656
Michaels, Bob212-752-1185
Mihaesco, Eugene212-867-9683
Minor, Wendell212-421-0050
Mitsuhashi, Yoko212-686-6631
Miyamoto, Lance R.212-427-9701
Miyauchi, Haruo 224**212-532-9247**
Morgan, Barry212-850-0904
Morgan, Jacqui212-421-0766
Morrison, Don212-697-6170
Moseley, Marshall.212-499-7045
Moss, Geoffrey 206**212-472-9474**
Murray, Steve212-679-6529
Myers, Lou212-751-4656
Nagel, Pat.212-682-2462
Neff, Leland212-246-3737
Neibart, Wally212-682-2462
Newcomb, John212-986-3282
Nessim, Barbara212-677-8888
Newsom, Tom212-682-2462
Noonan, Julia212-879-5916
Nuñez, Carlos212-935-5942
Oakes, Bill212-687-2272
Ochagavia, Carlos212-355-0910
Odom, Mel212-724-9320
Oelbaum, Frances212-924-7198
Oksenherdler, Marcos212-625-6175
Olson, Maribeth212-689-3902
Orloff, Denis212-982-8341
Ormai, Stella212-753-5146
Overacre, Gary212-751-4656
Palladini, David212-689-3902
Pan, Richard212-683-6435
Paslavsky, Ivan212-759-3985
Pepper, Bob.212-355-1316
Pepper, Brenda212-875-3236
Petragnani, Vincent212-758-2222
Pfeiffer, Fred212-753-1425
Pimsler, Alvin J.212-787-4967
Pinkney, Jerry212-751-4656
Podwil, Jerry212-255-9464
Pohl, Dennis212-255-8540
Pomerance, Joseph212-622-6669
Porter, Ray.212-799-8050
Primavera, Elise212-689-3902
Punchatz, Don Ivan.212-989-7074
Quartuccio, Dom212-661-1173

Quay, Mary Jo.212-249-5288
Quon, Mike212-226-6024
Radigan, Bob212-682-2462
Rane, Walter212-988-6149
Raphael & Bolognese212-228-5219
Reingold, Alan212-697-6170
Renfro, Ed.212-682-2462
Rennie, John Alun.212-490-0673
Rixford, Ellen.212-697-6170
Robinette, John212-687-2272
Rosenblum, Richard212-682-2462
Rosenthal, Doug212-475-9422
Ross, Barry212-663-7386
Ross, Betsy212-777-2616
Ross, Larry212-986-3282
Ruffins, Reynold212-526-4291
Ryan, Terrance J.212-688-1080
Sandler, Barbara212-691-2342
Santore, Charles212-751-4656
Saris, Anthony212-831-6353
Sauber, Rob.212-777-3770
Schmelzer, John212-794-0922
Schmidt, Chuck212-758-2222
Schorr, Todd.212-682-2462
Schongut, Emanuel 224**212-532-9247**
Schulz, Robert212-355-0910
Schwartz, Frank212-689-3902
Scribner, Joanne L.212-686-4520
Seaver, Jeffrey212-255-8299
Seltzer, Isadore212-666-1561
Shendroff, Kaaren212-687-2272
Shap, Sandra212-758-2222
Shea, Mary Anne212-239-1076
Shields, Charles.212-755-4945
Shilstone, Arthur212-682-2462
Siegel, Anita212-697-6170
Silverman, Burt212-799-3399
Singer, Gloria.212-339-7832
Siracusa, Catherine212-580-8084
The Sketch Pad Studio.212-989-7074
Skibinski, Ray212-752-6132
Slackman, Charles212-758-8233
Slagter, Philip212-755-4945
Slock, Catherine.212-988-6112
Smith, Cornelia212-689-3902
Smith, Elwood H.212-982-4882
Soileau, Hodges212-355-1316
Sorel, Ed.212-421-0050
Spollen, Chris212-984-7475
Sposato, John212-477-3909
Stabin, Victor212-243-7688
Stahl, Nancy212-475-0440
Staico, Kathy.212-758-2222
Stamaty, Mark Alan212-475-1626
Star Studios212-475-0440
Steadman, Barbara212-689-3902
Sternglass, Arno212-989-7074
Sterrett, Jane.212-929-2566
Stipelman, Steven212-689-3902
Barnard Stone Assoc.212-687-6940
Stone, Gilbert212-421-0050
Strimban, Robert (V1•202).**212-243-6965**
Taback, Simms212-421-0050
Taylor, Doug.212-674-6346
Taylor, Stan212-685-4741
Thompson, Arthur212-867-4640
Thornton, Richard212-689-3902
Tidy, Marsha212-752-6132
Topazio, Vincent212-355-1316
Travis, Kathy212-697-6170
Trossman, Michael212-691-2312
Trull, John.212-535-5383
Trusilo, Jim212-682-2462
Tunstull, Glen212-355-1316
Ungerer, Tomi.212-421-0050
Van Hamersveld, John212-799-8050
Ventilla, Istvan212-799-8050
Victor, Joan B.212-988-2773
Vitsky, Sally.212-799-8050
Viviano, Sam.212-242-1471
Vizbar, Milda212-582-8800
Wald, Carol212-431-4216

Waldrep, Richard212-935-9522
Walker, Bob.212-682-2462
Warhol, Andy.212-475-5550
Waxberg, Larry.212-889-2025
Weaver, Robert.212-254-4289
Weisberg, Glen.212-988-7955
Welkis, Allen212-686-3514
Weller, Don212-755-4945
Wells, Skip212-697-8525
Whistl'n Dixie212-935-9522
Whitesides, Kim (V1•204).**212-799-4789**
Wilcox, David.212-421-0050
Wilkinson, Bill212-697-6170
Wilkinson, Chuck212-682-1490
Willardson, Dave212-475-0440
Willoughby, Ann212-799-8050
Wilson, Rowland (V1•205)**212-371-1850**
Wohlberg, Ben212-254-9663
Wolin, Ron212-682-2462
Wood, Page212-867-4640
Woodend, James212-697-8525
Word-Wise212-246-0430
Young, Bruce.212-688-1080
Zagorski, Stanislaw 224**212-532-9247**
Zick, Brian212-475-0440
Ziering, Bob.212-873-0034

NORTHEAST

Abel, Roy/Scarsdale NY.914-725-1899
Acuna, Ed/Westport CT.203-227-4090
Amicosante, Vincent/Edgewater NJ.201-224-8195
Andersen, Roy/Ridgefield CT203-438-6354
Anthony, Carol/Greenwich CT.203-531-7345
Bang, Molly Garrett/Woods Hole MA. . . .617-548-7135
Bangham, Richard (V1•185)
 Takoma Park MD.**301-270-6986**
Bass, Marilyn/Carmel NY914-225-8611
Berger, Vivian/Yonkers NY914-237-5914
Boehm, Linda/Weston CT203-226-7674
Bonner, Lee/Baltimore301-377-2869
Booth, Carl H./Providence RI401-274-3919
Bridy, Dan/Pittsburgh.412-343-5549
Brown, Judith Gwyn/Weston CT. . . .203-226-7674
Brown, Michael David/Rockville MD . . .301-762-4474
Burroughs, Miggs 203 (V1•186)
 Westport CT.**203-227-9667**
Bill Burrows & Assoc./Baltimore. . . .301-752-4615
Butcher, Jim/Baltimore301-879-6380
Calvin, James/Weston CT203-226-7674
Carruthers, Roy/Old Greenwich CT203-637-2957
Cavanagh, Tom/Closter NJ.201-768-2526
Cayea, John/Cornwall-on-Hudson NY914-534-2942
Chandler, Jean/Wyckoff NJ.201-891-2381
Close, Alan/Greenwich CT203-869-6440
Cober, Alan/Ossining NY914-941-8696
Cohen, Gil/Philadelphia215-247-9007
Colby, Sas/Weston CT.203-226-7674
Collins, Pat/Weston CT203-226-7674
Colonna, Bernie/Weston CT.203-226-7674
Condak, Cliff/Cold Spring NY914-265-9420
Corson, Richard/Watchung NJ.201-755-4438
Craft, Kinuko/Weston CT.203-226-7674
Creative Image/Goshen NY914-294-6743
Cummins, Jim/Weston CT203-226-7674
Cushman, Doug/Weston CT203-226-7674
David, Cyril/East Hampton NY516-324-2802
Davis, Allen/Weston CT.203-226-7674
Davis, Paul/Sag Harbor NY516-725-2503
Dawson, Diane/Weston CT203-226-7674
Deigen, Jim/Pittsburgh.412-391-1698
de Kiefte, Kees/Weston CT203-226-7674
Demarest, Robert/Glen Rock NJ201-445-4943
Dior, Jerry/Edison NJ201-561-6536
Downey, William/Red Bank NJ201-842-5965
Eagle, Mike/Old Saybrook CT203-388-5654
Ebersole, Patricia/Fishkill NY914-454-1665
Edwards, William/Waterbury CT. . . .203-754-1298
Einsel, Naiad and Walter/Westport CT . . .203-226-0709
Ely, Creston/Weston CT203-226-7674
Enos, Randall/Weston CT203-227-4785
Epstein, Dave/Irvington-on-Hudson NY . . .914-591-7470
Etter, Beverly/Poughkeepsie NY. . . .914-471-5126

Eucalyptus Tree Studio/Baltimore. . . .301-243-0211
Farris, Jo/Westport CT.203-227-7806
Felix, Louisa/Hoboken, NJ.201-653-4833
Ford, Pam/Westport CT203-226-3233
Frazetta, Frank/East Stroudsberg PA . . .717-424-2945
Frost, Ralph/Wilkes Barre PA717-472-3600
Fuchs, Bernard/Westport CT.203-227-4644
Garland, Michael/Weston CT203-226-7674
Gist, Linda E./Ft. Washington PA215-643-3757
Glanzman, Louis S./Sayville NY516-589-2613
Glessner, Marc/Somerset NJ.201-249-5038
Michael Gnatek Assoc./Wash DC. . . .202-872-8989
Gnidziejko, Alex/Madison NJ.201-377-2664
Goldman, Marvin/Carmel NY914-225-8611
Grashow, James/West Redding CT. . . .203-938-9195
Handville, Robert T./Pleasantville NY. . .914-969-3582
Hardy, Neil O./Westport CT.203-226-4446
Harris, Sidney/Great Neck NY516-466-6143
Harsh, Fred/Weston CT203-226-7674
Harvey, Richard/Ridgefield CT203-438-0553
Hathaway, Margaret/Weston CT203-226-7674
Heindel, Robert/Fairfield CT203-261-4270
Henderson, David/Verona NJ201-783-5791
Herrick, George W./Hartford CT.203-527-1940
Hess, Richard (V1•191) Roxbury CT. . . .**203-354-2921**
Hildebrandt, Greg/West Orange NJ . . .201-736-1364
Hildebrandt, Tim/Gladstone NJ.201-234-2149
Huehnergarth, John/Princeton NJ . . .609-921-3211
Hunt, Stan/Westport CT203-227-7806
Hunter, Allan B./Abington PA215-657-4614
Jarvis, David (V1•192) Greenwich CT . . .**203-531-8339**
Jean, Carole/Roslyn NY516-484-4144
Johnson, David A./New Canaan CT . . .203-966-0245
Jones, George/Wilton CT203-762-7242
Kalback, Jerry/Glenwood NY716-592-7767
Kidder, Harvey/Pleasantville NY914-769-6298
Koslow, Howard/East Norwich NY . . .516-922-7427
Kossin, Sanford/Port Washington NY . . .516-883-3038
Kuhn, Bob/Roxbury CT203-354-7607
Lambert, Saul/Princeton NJ609-924-6518
Lavin, Robert/Huntington NY516-427-3733
Lazarevich, Mila/Weston CT.203-226-7674
Lee, Robert J./Carmel NY.914-225-4934
Lieberman, Warren/Weston CT203-226-7674
Lisberger Studios Inc/Boston.617-426-7070
Lonette, Reisie/Weston CT203-226-7674
Lorenz, Al/Weston CT203-226-7674
Lorenz, Lee/Westport CT203-227-7806
Luber, Mal/Weston CT203-226-7674
Luzak, Dennis/West Redding CT203-938-3278
Lynch, Don/Upper Nyack NY.914-358-3939
Mackay, Donald A./Ossining NY914-941-5036
Maffia, Daniel/Englewood NJ201-871-0435
Magee, Alan/Camden ME.207-236-2985
Mambach, Alex/Jersey City NJ.201-795-4775
Mardon, Allan/Danbury CT203-744-5369
Mariano, Mike/Weston CT203-226-7674
Mariuzza, Pete/Briarcliff Manor NY . . .914-769-3310
Martinot, Claude/Weston CT203-226-7674
McCaffery, Janet/Weston CT.203-226-7674
McCollum, Rick/Westport CT203-255-2275
McGinnis, Robert/Old Greenwich CT. . .203-537-1259
McIntosh, Jon C./Weston CT203-226-7674
McQueen, Lucinda Emily/Lyme CT. . . .203-434-8189
Meltzoff, Stanley/Fair Haven NJ.201-747-4415
Mitchell, Ken/Newtown CT203-426-0388
Modell, Frank/Westport CT.203-227-7806
Moon, Elizia/Weston CT.203-226-7674
Morgaard, Bente/Boston MA617-426-3565
Myers, Lou/Peekskill NY.914-737-2307
Nelson, Bill (V1•199) Richmond VA**804-358-9637**
Norman, Marty/Glen Head NY516-671-4482
Oni/Yorktown Heights NY.914-245-5862
O'Sullivan, Tom/Weston CT.203-226-7674
Otnes, Fred/West Redding CT.203-938-2829
Palulian, Dick/Rowayton CT.203-866-3734
Partch, Virgil/Westport CT203-227-7806
Passalacqua, David/Sayville NY.516-589-1663
Peak, Bob/Greenwich CT.203-869-4404
Pisano, Al/Upper Saddle River NJ . . .201-327-6716
Pitt Studios (V1•200) Pittsburgh.**412-261-0460**
Plotkin, Barnett/Great Neck NY.516-487-7457

Porter, George/West Chester PA.215-692-6618
Provensen, Alice/Staatsburg NY.914-266-3245
Provensen, Martin/Staatsburg NY. . . .914-266-3245
Rabinowitz, Sandy/Weston CT203-226-7674
Radigan, Bob/Pittsburgh412-281-9387
Ramus, Michael/Princeton NJ609-924-4266
Raymo, Anne/West Saugerties NY . . .914-246-6088
Richter, Mische/Westport CT203-227-7806
Rogers, Howard/Weston Ct203-227-2273
Roth, Ferdinand L./Livingston NJ201-992-1030
Rothacker, George H./Media PA.215-566-8058
Ruggero, Pat/Hicksville NY516-935-8902
Saldutti, Denise/Colonia NJ.201-381-1931
Sanderson, Ruth/Weston CT203-226-7674
Santa, Monica/Weston CT203-226-7674
Saxon, Charles/Westport CT.203-227-7806
Scalera, Ron/Orange NJ201-674-6266
Schaare, Harry J./Westbury NY516-333-1526
Schleinkofer, David/Levittown PA215-946-3464
Schottland, M./Weston CT203-226-7674
Scrofani, Joseph/Fort Lee NJ201-461-5123
Seidler, Ned/Wash DC.202-362-2667
Sharpe, Jim/Westport CT.203-226-9984
Sickles, Noel/Stamford CT.203-323-1770
Singer, Arthur/Jericho NY516-938-8228
Smath, Jerry/Weston CT203-226-7674
Smith, Douglas/Larchmont NY.914-834-3997
Smith, Joseph/New Fairview CT203-746-1858
Smith, N.J./Weston CT203-226-7674
Smith, Phil/Weston CT.203-226-7674
Smollin, Mike/Redding Ridge CT.203-938-9154
Sorel, Ed/Carmel NY.914-225-8086
Sottung, George/Ridgefield CT203-438-4124
Soyka, Edward/Irvington NY914-591-7486
Spanfeller, Jim/Katonah NY.914-232-3546
Sparkman, Gene/N. Salem NY914-669-9443
Sparks, Richard/Norwalk CT203-866-2002
Spitzmiller, Walter/West Redding CT. . .203-938-3551
Springer, Sally/Weston CT203-226-7674
Stahl, Benjamin F./Litchfield Ct203-567-8005
Stasiak, Krystyna/Weston CT203-226-7674
Steig, William/Westport CT203-227-7806
Steinberg, Herb/Roosevelt NJ609-448-4724
Stevenson, James/Westport CT.203-227-7806
Stirnweis, Shannon/Wilton CT203-762-7058
Sundgaard, Erik/Weston CT203-226-7674
Swan, Susan/Westport CT203-226-9104
Syverson, Henry/Westport CT203-227-7806
Taktakajian, Asdur/N. Tarrytown NY. . .914-631-5553
Tarantal, Stephen/Philadelphia215-925-2584
Tauss, Herb/Garrison NY914-424-3765
Tinkelman, Murray/Peekskill NY914-737-5960
Toulmin-Rothe, Ann/Westport CT203-226-3505
Troiani, Don/Pound Ridge NY914-764-5514
Tsui, George/Bellmore NY516-781-3506
Ulrich, George/Weston CT203-226-7674
Upshur, Tom/Roslyn Heights NY516-484-4688
Valla, Victor/Gladstone NJ.201-234-0438
Veno, Joe/Weston CT.203-226-7674
Viskupic, Gary/Center Port NY516-757-9021
Wallner, John C./Ossining NY914-762-5451
Walters, Candace/Weston CT203-226-7674
Weber, Robert/Westport CT.203-227-7806
Wilson, Gahan/Westport CT203-227-7806

SOUTHEAST

Boatright, John/Memphis TN901-683-1856
Berry, Jim/Atlanta404-262-7424
Boyd, Bob/Atlanta.404-262-7424
Carey, Wayne/Atlanta404-262-7424
Faure, Renee/Neptune Beach FL904-246-2781
Gaadt, David M./Atlanta404-252-7500
Gantt, Carlton/Atlanta404-262-7424
Graphics Group/Atlanta404-261-5146
Hamilton, Marcus/Charlotte NC704-545-3121
Hinojosa, Albino/Ruston LA318-255-2820
Nunn, J.B./Atlanta404-262-7424
Overacre, Gary/Marietta GA404-973-8878
Robinette, John/Memphis TN901-324-0510
Saffold, Joe/Atlanta404-231-2168
Turner, Pete/Cary NC919-467-8466
Wende, Phillip/Atlanta414-926-6355

Wiley, Ray/Jacksonville FL	.904-398-0079
Wilkes, Jean/Atlanta	.404-876-1950
Wilson, Meredith/Atlanta	.404-262-7424
Wilson, Reagan/Atlanta	.404-262-7424
The Workshop/Atlanta	.404-575-0141

MIDWEST

Alcorn, John/Chicago	.312-944-6655
Altschuler, Franz/Chicago	.312-787-8834
Anderson, Bill and Judy/Chicago	.312-332-5168
Art Graphics/Chicago	.312-236-4955
Biderbost, Bill/Evanston IL	.312-787-8834
Billout, Guy/Chicago	.312-944-6655
Blechman, R.O./Chicago	.312-944-6655
Blick, Al/Chicago	.312-332-5168
Bordelon, Melinda/Chicago	.312-944-6655
Bridy, Dan/Chicago	.312-856-0030
C.M.O. Graphics/Chicago	.312-527-0900
Carruthers, Roy/Chicago	.312-944-6655
Carugati, Eraldo/Chicago	.312-944-3340
Centaur Studios/St. Louis MO	.314-421-6485
Clay, Stephen/Chicago	.312-664-5954
Cochran, Bobbye/Chicago	.312-332-6041
Collins, Koehr, Lund Studios/Clayton MO	.314-725-0344
Conahan, Jim/Chicago	.312-822-0560
Craft, Kinuko/Chicago	.312-372-1616
Crane, Gary/Chicago	.312-332-5168
Creative Source/Chicago	.312-649-9777
Davis, Paul/Chicago	.312-944-6655
Deigen, Jim/Chicago	.312-856-0030
DiCianna, Ron/Chicago	.312-332-5168
Duggan, Lee/Chicago	.312-726-4966
Dyess, John/Fenton MO	.314-225-4000
Dypold, Pat/Chicago	.312-787-9408
Eaton & Iwen/Chicago	.312-332-3256
English, Mark/Fairway KS	.913-677-2858
Farrell, Richard/Waterloo IA	.319-233-4303
Feldkamp-Malloy/Chicago	.312-263-0633
Foley, Mike/Fenton MO	.314-225-4000
Fox, James/Chicago	.312-856-0030
George, Harry/Cleveland	.216-241-5355
Geyer, Jackie/Chicago	.312-944-6655
Giancarlo, Jennifer/Chicago	.312-822-0560
Giovanopoulous, Paul/Chicago	.312-944-6655
Giusti, Robert/Chicago	.312-944-6655
Gohman, Lynn/Cincinnati	.513-841-6600
Green, Peter/Chicago	.312-772-2292
Hagio, Kunio/Chicago	.312-664-9012
Handelan-Pederson/Chicago	.312-782-6833
Hayes, Phil/Chicago	.312-944-6655
Hess, Mark (V1 • 191) Chicago	**.312-944-6655**
Hess, Richard (V1 • 191) Chicago	**.312-944-6655**
Hoover & Kern Studios/Chicago	.312-337-7214
Howe, Robert Charles/Chicago	.312-532-7411
Tom Hoyne/Creative Source/Chicago	.312-649-9777
Hsi, Kai/Chicago	.312-642-9853
Huyssen, Roger/Chicago	.312-782-2703
Isom, Joe/Overland Park KS	.913-381-1325
Jacobsen, Bill/Chicago	.312-321-9558
Johnson, Hedda (V1 • 193) Chicago	**.312-944-6655**
Johnson, Indura/Chicago	.312-664-5954
Jones, Jan/Chicago	.312-751-0033
Kauffman, George/Kansas City MO	.816-523-0223
Kelley, Gary/Waterloo IA	.319-234-7055
Knight, Jacob/Chicago	.312-944-6655
Kock, Carl/Chicago	.312-871-1242
Koenig, Rainer/Kansas City MO	.816-531-8053
Koopman Neumer/Chicago	.312-726-3508
Langeneckert, Donald/St. Louis	.314-421-2484
Lee, Jared D./Lebanon OH	.513-932-2154
Linoff, Ed/Chicago	.312-944-6655
Maffia, Daniel/Chicago	.312-944-6655
Magdich, Dennis/Chicago	.312-664-4235
Magee, Allen/Chicago	.312-944-6655
Mahan, Benton 205 Chesterville OH	**.419-768-2204**
Mahoney, Ron/Chicago	.312-856-0030
Mark, Roger Leyon/Chicago	.312-787-8834
McMahon, Mike/Chicago	.312-332-5168
Morgan, Mike/Chicago	.312-944-6655
Mull, Christy Sheets/Chicago	.312-332-6041
Murawski, Alex/Chicago	.312-782-2703
Nelson, Fred/Chicago	.312-787-8834

Nitti, Chuck/Chicago	.312-664-7715
Noonan, Julia/Chicago	.312-944-6655
Jack O'Grady Graphics Inc./Chicago	.312-726-9833
Parker, Hank/Chicago	.312-944-6655
Pigalle Studios Inc./St. Louis MO	.314-241-4398
Pitt Studios (V1 • 200) Cleveland	**.216-241-6720**
Hal Poth Studio/Clayton MO	.314-721-7525
Povilaitis, David/Chicago	.312-751-1470
Radigan, Bob/Chicago	.312-856-0030
Raglin, Kim/Chicago	.312-332-5168
Rodriguez, Robert/Chicago	.312-944-6655
Rudnak, Theo/Chicago	.312-332-5168
Ruffins, Reynold/Chicago	.312-944-6655
Saffold, Joe/Chicago	.312-332-6041
Sandford, John/Chicago	.312-332-5168
Sauber, Rob/Chicago	.312-649-9332
Harlan Scheffler/Handelan-Pederson Chicago	.312-782-6833
Schmelzer, J.P./Madison WI	.608-244-1937
Schwab, Mike/Chicago	.312-944-6655
Sheldon, Steve/Glendale MO	.314-961-0713
Simmons, Bob/Chicago	.312-787-8834
Simon, William/St. Louis MO	.314-421-5544
Sorel, Ed/Chicago	.312-944-6655
Star Studios/Chicago	.312-944-6655
Stephens Biondi DeCicco Inc./Chicago	.312-944-3340
Strosser, Ruth Brunner/Chicago	.312-856-0030
Sullivan, Mary Ann/Cincinnat.	.513-731-6768
Sumichrast, Jozef/Deerfield IL	.312-945-6353
Taback, Simms/Chicago	.312-944-6655
Taylor, Doug/Chicago	.312-664-9012
Thiewes, Sam/Chicago	.312-726-5579
Trossman, Michael/Chicago	.312-787-8834
Vaccarello, Paul/Chicago	.312-822-0560
Bill Vann Studio/St. Louis MO	.314-231-2322
Vuksanovich, Bill/Chicago	.312-283-2138
Weiss, Barbara/Southfield MI	.313-357-5985
Wende, Phillip/Chicago	.312-332-5168
Wilcox, David/Chicago	.312-944-6655
Wilkes, Jean/Chicago	.312-332-5168
Willson Graphics/Chicago	.312-642-5328
Wolf, Leslie/Chicago	.312-856-0300
Wright, Janie Case/Chicago	.312-332-6041
Zingarelli, Louise/Chicago	.312-787-8834

SOUTHWEST

Anderson, Jon/Logan UT	.801-752-8936
Christensen, James C./American Fork UT	.801-224-6237
Durbin, Mike/Houston	.713-667-8129
Early, Sean/Arlington TX	.817-469-8151
Eubanks, Tony /Grapevine TX	.817-481-3792
Forbes, Bart/Dallas	.214-526-1430
Goodell, Jon/Tuttle OK	.405-348-4183
Katona, Robert/Golden CO	.303-279-1302
Lewis, Maurice/Houston	.713-664-1807
Lindlof, Ed/Austin TX	.512-472-0195
Loveless, Frank/Dallas	.214-692-5157
McEntire, Larry/Houston	.713-529-9771
Parker, Hank/Frisco CO	.303-468-5833
Punchatz, Don Ivan/Arlington TX.	.817-460-7680
Reynolds, James/Sedona AZ	.602-282-7011
Ricks, Thom/San Antonio TX	.512-824-7387
Robins, Mike/Houston	.713-933-8043
Schorre, Charles/Houston	.713-522-8628
Smith, Dennis/Alpine UT	.801-756-3635
Strand, David/Dallas	.214-745-1210
Toliver, Dale/Austin TX	.512-926-2199
Unruh, Jack/Dallas	.214-661-5118

WEST

Abrams, Edward/Hermosa Beach CA	.213-372-6266
Abrams, Jodell Davidow/Hermosa Beach CA	.213-372-6266
Akimoto, George/Monterey Park CA	.213-573-3930
Allison, Gene/LA	.213-382-6281
Alt, Tim/Beverly Hills CA	.213-550-7619
Alvin, John/LA	.213-279-1775
Anderson, Terry/LA	.213-645-8469
Ansley, Frank/SF	.415-781-6681
Anson, Susan/Beverly Hills CA	.213-550-7619
Armstrong, Betty/LA	.213-660-6251
Baine, Vernon/Walnut Creek CA	.415-933-5973
Barbee, Joel/San Clemente CA	.714-498-0067

Barrett, Bill/LA	.213-822-4999
Barry, Ron/Hollywood CA	.213-469-8767
Bausch, Robert/SF	.415-752-6400
Beach, Lou/Hollywood CA	.213-874-1661
Beersworth, Roger/LA	.213-392-4877
Bellinger, Cathy/LA	.213-938-5177
Bennett, Chuck/LA	.213-659-2406
Bernstein, Saul/Hollywood CA	.213-467-6832
Berrett, Randy/SF	.415-752-4977
Billout, Guy/LA	.213-392-7792
Blair, Nancy D./Brentwood CA	.213-826-7331
Boisvert, Nick/LA	.213-256-0502
Boyle, Neil/LA	.213-381-1387
Bradbury, Jack/Sonoma CA	.707-938-2975
Bradley, Barbara/Berkeley CA	.415-525-5496
Brenon, Helen/LA	.213-462-3513
Broad, David/SF	.415-421-2017
Burchard, Michelle/LA	.213-933-2249
Butte, Annie/Jacksonville OR	.503-899-1750
Camozzi, Teresa/SF	.415-421-8898
Candioty, David/LA	.213-386-7312
Carbojal, Edward/LA	.213-221-4878
Carpenter, Mia/LA	.213-651-3015
Carroll, Justin/Hollywood CA	.213-874-1661
Carver, Steve/Beverly Hills CA	.213-274-9859
Cavenaugh, Joey/LA	.213-467-8200
Chewning, Randy/Huntington Beach CA	.714-968-1533
Christensen, David/Long Beach CA	.213-439-8947
Cleary, Joe/Orinda CA	.415-254-8330
Cole, Dick/Palo Alto CA	.415-322-2007
Conner, Dick/LA	.213-382-9834
Coppock, Chuck/LA	.213-382-6281
Corey, Christopher 204 SF	**.415-421-0637**
Coro, Margaret/Beverly Hills CA	.213-550-7619
Costelloe, Richard/Sherman Oaks CA	.213-995-1035
Criss, Keith/Oakland CA	.415-444-4550
Critz, Carl/LA	.213-382-6281
Curtis, Art/LA	.213-392-4877
Dalton, Patricia/Tustin CA	.714-644-0462
Dann, Stan/Oakland CA	.415-835-3571
Dean, Donald/Oakland CA	.415-451-8330
De Anda, Ruben/LA	.213-938-5177
Dearstyne, John/LA	.213-789-0743
Deasy, Rosemary/LA	.213-874-4552
Dietz, James/Seattle WA	.206-325-2857
Diffenderfer Ed/Lafayette CA	.415-254-8235
Dodig, Lynn/LA	.213-651-2878
Drake, Bob/LA	.213-931-8690
Drayton, Richard/Woodland Hills CA	.213-347-2227
Durfee, Tom/SF	.415-781-0527
Duffus, Bill/Pasadena CA	.213-799-5839
Eichenberger, Dave/LA	.213-651-2878
Elgaard, Greta/LA	.213-651-3015
Ellefson, Dennis/LA	.213-279-1775
Ellenberger, Jack/LA	.213-382-6281
Ellescas, Richard/Hollywood CA	.213-467-6832
Endicott, Jim/Santa Monica CA	.213-828-9653
Evans, Jim/Santa Monica CA	.213-395-8267
Fedak, Malcom/Alameda CA	.415-865-3684
Fell, L. Don/Beverly Hills CA	.213-273-8412
Ferrero, Felix/SF	.415-981-1164
Fuchs, Bernie/LA	.213-651-3015
Gaetano, Nicholas/LA	.213-784-5814
Galli, Stan/Kentfield CA	.415-461-5847
Gallon, Dale B./Newport Beach CA	.714-646-5550
Galloway, Nixon/LA	.213-937-4472
Garnett, Joe/Hollywood CA	.213-469-8767
Garris, Philip/Santa Monica CA	.213-395-8267
Germain, Frank/LA	.213-482-4472
Gerrie, Dean/Newport Beach Ca	.714-759-9491
Glad, Deanna/Santa Monica CA	.213-396-1861
Gleason, Bob/Santa Monica CA	.213-828-9653
Goldstein, Howard/Van Nuys CA	.213-987-2837
Gomez, Ignacio/LA	.213-930-1144
Gorman, Stan/LA	.213-937-4472
Graca, Jim/North Hollywood CA	.213-980-3284
Green, Peter/LA	.213-990-8084
Grim, Elgas/LA	.213-382-6281
Group West/LA	.213-937-4472
Grove, David (V1 • 190) SF	**.415-433-2100**
Guidice, Rick/Los Gatos CA	.415-354-7787
Gurvin, Abe/LA	.213-826-6879

Hansen, Donald/Tacoma WA	.206-582-3208
Hardiman, Miles/Auburn CA	.916-823-2653
Harris, Diane Teske/Hollywood CA	.213-467-6797
Hashimoto, Allan/LA	.213-273-6768
Hatzer, Fred/LA	.213-937-4472
Heidrich, Tim/Redondo Beach CA	.213-535-0405
Heimann, Jim/Santa Monica CA	.213-828-9653
Heiner, Joe/LA	.213-467-8200
Hendricks, Donald/Riverside CA	.714-684-7046
Herrero, Lowell/SF	.415-543-6400
Hickson, Ron/LA	.213-461-9141
Hinton, Hank/LA	.213-279-1775
Hoburg, Maryanne Regal/SF	.415-731-1870
Hodges, Ken/Los Alamitos CA	.213-431-4343
Holman, Carol/LA	.213-256-0502
Holmstrom, Gralyn/LA	.213-937-4472
Hood, Holly/LA	.213-652-4183
Hoover, Gary/Pasadena CA	.213-681-0516
Hope, Frederic/LA	.213-937-4472
Hubbard, Roger/LA	.213-938-5177
Hutkin, Elliot/LA	.213-938-5177
Hyatt, John/Hollywood CA	.213-469-8767
Hyde, Bill/Foster City CA	.415-345-6955
Ikkanda, Richard/LA	.213-938-5177
Imhoff, Bill/LA	.213-383-5125
Ingalls, Betty/Orinda CA	.415-254-5036
Ingalls, Ed/Orinda CA	.415-254-5036
Ivanyi, George/LA	.213-381-3977
Jenott, John/Mill Valley CA	.415-383-2330
Johnson, Jack/LA	.213-467-8200
Juhlin, Don/SF.	.415-621-1488
Kaufman, Van/LA	.213-651-3015
Keeler, Jack/San Leandro CA	.415-352-3640
Kelley & Mouse/Santa Monica CA	.213-395-8267
Kenyon, Chris/Walnut Creek CA	.415-934-5844
Kerr, Ken/Glendale CA	.213-240-9430
Kincaid, Aron/Hollywood CA	.213-874-1661
King, Dale W./LA	.213-462-4532
King, Heather/Berkeley CA	.415-845-2782
Kinyon, Robert/Orange CA	.714-485-5362
Klein, Norman/LA	.213-652-4183
Kosh, John/LA	.213-461-9141
Krieger, E. Salem/Hollywood CA	.213-874-1661
Kriss, Ron/LA	.213-651-2878
Krogle, Bob/Santa Monica CA	.213-828-9653
Labadie, Ed/Glendale CA	.213-240-0802
Larreco, John/Mill Valley CA	.415-982-7771
Laycock, Dick/Woodland Hills CA	.213-703-6498
Lee, Warren/Corte Madera CA	.415-924-0261
Leedy, Jeff/Mill Valley CA	.415-332-9100
Lewis, John/Oakland CA	.415-535-1548
Lichtenwalner, John/Medford OR	.503-535-4537
Lieppman, Jeff/Pasadena CA	.213-441-9129
Lillard, Jill/Pasadena CA	.213-792-5921
Lipking, Ron/Woodland Hills CA	.213-703-6498
Lipney, Stephanie Joy/LA	.213-388-7611
Lloyd, Peter/LA	.213-392-7792
Locke, Margo/Los Altos CA	.415-948-3434
Locke, Vance/Los Altos CA	.415-948-3434
Loeb, Katherine/Hollywood CA	.213-874-1661
Lozano, Henry Jr./LA	.213-593-7741
Lum, Darell/Monterey Park CA	.213-289-1214
Lyman, Kenvin/Hollywood CA	.213-874-1661
Lytle, John/Oakland CA	.415-530-0770
Machat, Mike/Long Beach CA	.213-433-6221
Madrid, Bill/LA	.213-380-7223
Manzelman, Judy/Larkspur CA	.415-461-9685
Marsh, Cynthia/Hollywood CA	.213-654-4505
Mattelson, Marvin/LA	.213-273-6768
Mazur, Ruby/LA	.213-273-6768
McAdams, Larry/Orange CA	.714-639-6149
McConnell, Jim/Oakland CA	.415-569-0852
McKee, Ron/LA	.213-937-4472
McCarthy, Errol/Woodland Hills CA	.213-347-2227
Meagher, Terrence (V1 • 198) Palo Alto CA	**.415-326-5170**
Mediate, Frank/LA	.213-381-3977
Medoff, Jack/LA	.213-784-5814
Merritt, Norman/LA	.213-937-4472
Metcalf, Jim/Baldwin Park CA	.213-338-9949
Mikkelson, Linda S./LA	.213-937-8360
Mikkelson, R.J./LA	.213-463-3171
Miller, Jim/LA	.213-388-5043

NEW YORK METROPOLITAN AREA

AD Assoc. Inc. 212-730-1660
AKM Assoc. 212-687-7636
Abramson Studio 212-682-1271
Accorsi, William. 212-473-8346
Gaylord Adams Design 212-684-4625
Album Graphics Inc. 212-489-0793
The Alderman Co. 212-751-6606
Allied Graphic Arts 212-730-1414
Amabile Assoc. 212-840-0766
Anagraphics Inc. 212-245-3315
Ancona Design Atelier. 212-947-8287
Anspach Grossman Portugal 212-421-4950
Bob Antler Graphics 212-751-2031
Antupit, Samuel N. 212-832-2680
Appelbaum & Curtis 212-752-0679
Apteryx Ltd. 212-759-1707
The Art Board Inc. 212-752-3888
Art Department 212-391-1826
The Art Farm Inc. 212-688-4555
Art Plus Studio 212-564-8258
BJB Graphics 212-683-5065
BN Assoc. 212-684-7210
Bain, S. Milo 212-279-0442
Barnett/Goslin/Barnett 212-924-7010
Barton-Gillet Co. 212-535-8782
James Bell Graphic Design Inc. . 212-683-3280
Berger, Neckamkin & Assoc. 212-867-9760
Besalel, Ely. 212-759-7820
Bessen & Tully. 212-838-6400
Betty Binns Graphic Design 212-371-4324
Charles Biondo Design Assoc. .. 212-867-0760
Boker Group 212-758-2479
Boulanger Assoc. Inc. 212-661-4546
Bradford, Peter 212-354-0034
Braswell, Lynn 212-222-8761
Brodsky Graphics 212-684-2600
Alastair Brown Assoc. 212-221-3166
Buckley Designs Inc. 212-759-2447
Caravello Studios 212-221-7663
Joseph Catalano Studios 212-682-1579
Cetta, Al. 212-677-2707
Chang, Ivan 212-777-6102
Irene Charles Assoc. 208 **212-765-8000**
Chermayeff & Geismar Assoc. ... 212-759-9433
Gregory Chislovsky Design Inc. . 212-532-3206
Andrew Christie Studio 212-879-5791
Chwast, Seymour 224 (V1•187) . **212-532-9247**
Coleman, LiPuma & Maslow. 212-421-9030
Corchia, Al 212-682-0720
Corporate Annual Reports Inc. 209 . **212-889-2450**
Corporate Graphics Inc. 212-683-3161
Corporate Images. 212-686-5221
Cosgrove Assoc. 212-867-3318
Sheldon Cotler Inc. 212-765-5990
Morison S. Cousins & Assoc. Inc. . 212-751-3390
Creative Freelancers 212-371-8030
Cruz, Ray 212-986-1783
Csoka/Benato/Fleurant Inc. 212-686-6741
Curtis Design Inc. 212-685-0670
Lawrence Daniels & Friends Inc. . 212-889-0071
Danne & Blackburn Inc. 212-371-3250
Davis-Delaney-Arrow Inc. 212-686-2500
DeCamps, Craig. 212-564-2691
DeFiglio, Rosemary. 212-777-1815
Rudolph de Harak Inc. 212-929-5445
Delphan Co. 212-371-6700
Design Alliance 212-490-2460
Designlab 212-751-9219
Design Organization 212-838-1045
Design Refinery 212-673-0417
The Designing Woman 212-864-0909
Designers 3 Inc. 212-986-5454
Diamond Art Studio Ltd. 212-355-5444
Charles DiComo & Assoc. 212-564-1428
DiFranza-Williamson Inc. 212-832-2343
Doret, Michael 212-889-0490
Duffy, William R. 212-682-6755
Dwyer, Tom 212-986-7108
Edleman Studios Inc. 212-255-7250
Eisaman, Johns & Laws Inc. 212-486-2200

Eisenman & Enock 212-541-5570
Ellis, Dean 212-254-7590
Erickson Assoc. 212-688-0048
FIR Assoc. 212-682-6992
Richard Falkins Advertising Design . 212-661-4145
Fred Feucht Design 210 **212-682-0040**
Figliola, Vince 212-288-4513
Filicori, Mauro 212-677-0065
Fine Design 212-826-1077
Friedlander, Ira 212-734-3178
Fulton & Partners 211 **212-593-0910**
GL&C Advertising Design Inc. .. 212-683-5811
Robert A. Gale Inc. 212-935-0300
Norman Gorbaty Design. 212-684-1665
Beau Gardner Assoc. 212-832-2426
Gentile Studio 212-986-7743
George, Hershell. 212-925-2505
Robert Gersin & Assoc. 212 ... **212-777-9500**
Gerstman & Meyers Inc. 212-586-2535
Gianninoto Assoc. Inc. 212-759-5757
Giovanni Design Assoc. 212-725-8536
Gips Inc. 212-421-5940
Gladych, Marianne 212-925-9712
Glaser, Milton 212-889-3161
Glusker, Irwin 212-757-4438
Goetz, Myron 212-679-4250
Bill Gold Advertising 212-686-8665
Goodkin, Lynn 212-472-1957
W. Chris Gorman Assoc. 212-697-1931
Goslin/Barnett 212-924-7010
The Graphic Expression Inc. ... 212-759-7788
Graphic Workshop 212-759-4524
RC Graphics 212-755-1383
Graphics by Nostradamus 212-751-0745
Graphics Institute 212-840-6585
Graphics 60 Inc. 212-687-1292
Graphics to Go 212-889-9337
Gray, George 212-873-3607
H.G. Assoc. Inc. 212-221-3070
Betti Haft/Graphics 212-288-4766
John Haines Design 212-254-2326
John Heiney & Assoc. 212-686-1121
Charles Heston Assoc. 212-889-6400
Hopkins, Will 212-580-9800
Horvath & Assoc. Studios Ltd. . 212-679-7384
Isip Rey Design Assoc. 212-246-9053
Image Communications 212-838-0713
Israel, Marvin 212-254-4674
Jarrin Design Inc. 212-879-3767
Johnston, Shaun and Susan. 212-663-4686
Jonson, Pedersen, Hinrichs & Shakery. 212-889-9611
Kaeser & Wilson Design 212-725-0690
Kallir Phillips Ross Inc. 212-371-4800
Karlin, Bernie and Mati 212-687-7636
Kass, Milton 212-874-0418
Warren A. Kass Graphics Inc. .. 212-355-4411
Marjorie L. Katz Graphic Design . 212-685-8416
Kleb Assoc. 212-246-2847
Irv Koons Assoc. 212-752-4130
Krackehl, Gene. 212-794-8817
Kraftsow & Milliken, Inc. 212-753-0277
Landi-Handler Design, Inc. 212-661-3630
Laslo, Larry 212-687-2272
Robert Lassen Graphic Arts 212-929-0017
Lee & Young Communications 212-751-6480
Lefkowith Inc. 212-758-8550
Levine, Gerald 212-751-3645
William V. Levine & Assoc. 212-751-1880
Al Lichtenberg Graphic Art 212-679-5350
Lieberman, Ron 212-947-0653
Liebert Studios 212-686-4520
Lika Assoc. 212-490-3660
Lind Brothers Inc. 212-889-8720
Lopez Salpeter Inc. 212-687-7090
Serge Loukin Inc. 212-685-6473
Loscalzo/Michaelson & Assoc. .. 212-490-1620
Herb Lubalin Assoc. 216 **212-679-2636**
Lynch, Sheila. 212-255-3222
Neil MacDonald Assoc. 212-661-5142
Maddalone, John 212-751-1108
Mantel, Richard 224 **212-532-9247**
Fred Marcellino Studio 212-532-0150

Marciuliano Inc. 212-697-0740
Mayo-Infurna Design 212-757-3136
Gerald McConnell Inc. 212-475-5466
McDaniel, Jerry 212-697-6170
McFarlane, John 212-935-4676
McGhie Assoc. Inc. 212-661-2990
Abby Merrill Studio Inc. 212-753-6179
Miho Inc. 212-288-2070
Miller Art Studio 212-986-9731
Irving D. Miller Inc. 221 **212-755-4040**
Modular Marketing Inc. 212-581-4690
John Morning Design. 212-688-0088
Mossberg, Stuart 212-689-3105
Harry Moshier & Assoc. 212-986-3727
Moskoff & Assoc. 212-765-4810
The Mouse That Roared 212-697-8746
Murtha Desola Finsilver Fiore . 212-832-4770
George Nelson & Co. 212-777-4300
Robert Nemser Assoc. 212-832-9595
New American Graphics 212-221-7662
New Studio Inc. 212-752-8686
Newley Assoc. 212-661-6770
R.L. Newport & Co. 212-953-1630
Noneman & Noneman Design 212-260-0770
Norman Affiliates 212-686-9119
Charles W. North Studio. 212-686-5740
Ong & Assoc. 212-355-4343
Robert O'Reilly Graphic Studio . 212-832-8992
Orlov, Christian 212-873-2381
Page, Arbitrio, Resen Ltd. 212-421-8190
Palladino, Tony. 212-751-0068
Paragraphics Inc. 212-421-3978
CA Parshall Inc. 212-685-6370
Pencil Box Studio 212-724-6445
Pencils Portfolio Inc. 212-832-6890
Penpoint Studio Inc. 212-243-5435
Performing Dogs 212-989-7473
Pellegrini & Kaestle 212-686-4481
Richard Perlman Design 212-752-7229
Stan Peters Assoc. Inc. 212-684-0315
Podob, Al 212-486-0024
J.W. Prendergast & Assoc. Inc. . 212-697-2720
Mark Prigoff Graphics 212-724-1055
Production Studio for Graphic Arts . 212-753-3350
Profile Press Inc. 212-675-4188
Progressive Designers 212-532-3693
Push Pin Studios 224 **212-532-9247**
Quadra Promotions 212-840-0288
Quarry Enterprise 212-679-2559
Mike Quon Graphic Design 212-226-6024
R.D. Graphics 212-682-6734
Rapecis Assoc. Inc. 212-697-1760
Ratzkin, Lawrence 212-683-4722
Regene, Califano 212-682-6110
Johannes Regn Inc. 212-758-4724
Richard Rogers Inc. 212-685-3666
Romanoff Design Inc. 212-689-3029
Rosebud Studio 212-752-1144
Ross Advertising Art 212-688-8242
Ross/Pento Inc. 212-371-5220
Randee Rubin Design 212-490-1036
Anthony Russell Inc. 212-255-0650
Robert Sadler Design 212-838-7259
St. Vincent, Milone & McConnells . 212-661-0945
Saks, Arnold 225 **212-861-4300**
Salisbury & Salisbury Inc. 212-575-0770
Sant'Andrea, Jim 212-557-0070
Savarese, Carlos 212-794-0198
Saville Design 212-689-8580
Saxton Communications Group ... 212-953-1300
Schechter & Luth Inc. 212-752-4400
Schneider Graphics 212-889-5333
Schrenk, Tisa & Gerry 212-457-3472
Vincent Scotti Assoc. 212-724-3999
Sheldon Seidler Inc. 212-472-2924
Ellen Shapiro Graphic Design Inc. . 212-221-2625
Shareholders Reports 212-686-9099
Siegel & Gale Inc. 212-759-5246
Sochynsky, Ilona 212-686-1275
Richard Solay & Assoc. 212-868-4270
Stonehill Studio 212-689-7074
Stuart, Gunn & Furuta 212-695-7770

Studio 42 212-354-7298
Sukon Art Studios Inc. 212-593-8600
Sullivan Keithley Inc. 212-679-5317
Tapa-Graphics. 212-243-0176
Tauss, Jack George 212-279-1658
Taylor & Ives 212-682-3860
Theoharides Inc. 212-838-7760
Think Group 212-730-1919
Tobias, William 212-628-9810
Tower Graphic Arts Corp. 212-421-0850
Jay Tribich Design Assoc. 212-986-5215
George Tscherny Inc. 212-734-3277
Ultra Arts Inc. 212-679-7493
Viewpoint Graphics 212-685-0560
Vignelli Assoc. 212-593-1416
Visible Studio Inc. 212-683-8530
Vollbracht, Michael. 212-751-9219
Wajdowicz, Jurek 212-689-1158
Wallace Church Assoc. 212-755-2903
N.B. Ward Assoc. Inc. 212-684-8074
Wardell-Berger Design 212-398-9355
John Waters Assoc. Inc. 226 .. **212-689-2929**
Eunice Weed Assoc. Inc. 212-725-4933
The Weekend Studio 212-260-8479
Whistl'n Dixie 212-935-9522
Bruce Withers Graphic Design .. 212-755-1161
Rudi Wolff Inc. 212-873-5800
Wood, Alan 212-846-8061
Yasumura & Assoc. 212-953-2094
Young Goldman Young Inc. 212-371-5030
Yule, Susan Hunt 212-226-0439
Zagorski, Stanislaw 224 **212-532-9247**
Zahor Design Inc. 212-532-7475
Zeitsoff, Elaine 212-580-1282
Zimmerman, Roger 228 **212-674-0259**

NORTHEAST

Adler Schwartz Graphics Inc./Baltimore. ... 301-433-4400
Amato, John/Wantagh NY 516-785-1521
Milton Anderson Co./Murray Hill NJ . 201-464-9040
Aries Graphics/Londonderry NH . 603-668-0811
Aron & Falcone/Chatham NJ 201-635-2900
Art Services/Pittsburgh. 412-781-1022
The Artery/Baltimore 301-752-2979
Ashton, Worthington/Baltimore . 301-837-4434
BKB Productions Inc./Boston ... 617-267-2667
Barton-Gillet/Baltimore 301-685-5411
Baskin & Assoc./Wash DC 202-331-1098
Jack Bevridge & Assoc. Inc./Wash DC . 202-223-4010
William E. Beyer Assoc./Boston . 617-266-4001
Bogus Assoc./Melrose MA 617-662-0114
Bookmakers/Westport CT 203-226-4293
Brauer Industrial Design/Bronxville NY . 914-337-7660
Bridy, Dan/Pittsburgh. 412-288-9362
Brown, Michael David/Rockeville MD . 301-762-4474
Bruno-Mease/Philadelphia 215-732-4800
Bill Buckett Assoc./Rochester NY . 716-546-6580
CASE/Wash DC 212-659-3820
Cabot Corp./Boston 617-423-6000
Harold Cabot & Co. Inc./Boston . 617-426-7600
Captain Graphics/Boston 617-262-7575
Carmel, Abraham/Peekskill NY .. 914-737-1439
Colopy Dale Inc./Pittsburgh ... 412-471-0522
Centrum Corp./Wash DC 202-293-7750
Comite Plus/Boston 617-247-2268
Connecticut Graphics/Stamford CT . 203-359-3316
Contis Studios/Boston 617-542-9666
Cook & Shanofsky Assoc./Princeton NJ . 609-921-0200
Creative Communication Center
 Pennsauken NJ. 609-665-2058
The Creative Group/Baltimore .. 301-547-1404
Dakota Design/Philadelphia 215-265-1255
D'Art Studio/Natick MA 617-653-2900
Dawson Designers Assoc./Boston . 617-266-5747
Stephen Daye Associates
 Everett MA 617-389-1570
Jim Deigin Assoc./Pittsburgh .. 412-391-1698
DeMartin-Marona-Cranstoun-Downes
 Wilmington DE. 302-654-5277
Design Research/Braintree MA .. 617-848-5210
Design Assoc./Wash DC 202-467-5550
Design Center Inc./Boston 617-536-6846

Design Group of Boston/Boston617-261-2170
The Design Solution/Wash DC202-837-6663
DiFiore Assoc./Pittsburgh412-471-0608
Allan Downing/Advertising Design
 Needham MA617-449-4784
Duffy & Assoc./Wash DC202-955-2216
Edigraph Inc./Katonah NY914-232-3725
Epstein, Len/Philadelphia215-664-4700
Eucalyptus Tree Studio/Baltimore301-243-0211
Evans Garber & Paige/Utica NY315-733-2313
Fader, Jones & Zarkades/Boston617-267-7779
Fannell Studio/Boston617-267-0895
Fletcher-Walker-Gessell Inc.
 Midland Park NJ201-652-7200
Ford/Byrne/Philadelphia215-564-0500
Gregory Fossella Assoc./Boston617-267-4940
Froelich Advertising Services/Mahwah NJ . . .201-529-1737
Gaadt, George S./Pittsburgh412-741-5161
Gasser, Gene/Chatham NJ201-635-6020
Gateway Studios/Pittsburgh412-361-7500
Geyer, Jackie/Pittsburgh412-261-1111
Gianti, Tony 213 Rockleigh NJ**201-767-9238**
Gilliam, Williams & Assoc. Inc./Wash DC . . .202-857-0331
Frank Glickman Inc./Cambridge MA617-354-2700
Peter Good Graphic Design/Chester CT203-526-9857
Graphic Design/North Babylon NY516-242-2817
Graphic Studio Inc./Pittsburgh412-281-5354
Graphic Supermarket/Boston617-482-1717
Grinder, Rainbow/Pittsburgh412-261-1444
Graphics for Industry/Englewood NJ201-871-3186
Gunn Assoc./Boston617-267-0618
Robert Hain Assoc./Scotch Plains NJ201-322-1717
Hallock, Robert/Newtown CT203-426-4757
Harrington-Jackson/Boston617-536-6164
Harrison Assoc./Port Washington NY516-883-3897
Hellmuth, James/Wash DC202-244-0465
Herbick & Held/Pittsburgh412-321-7400
Herman & Lees/Cambridge MA617-867-6463
Jack Hough Inc./Stamford CT203-357-7077
Image Consultants/Burlington MA617-273-1010
Jensen, R.S./Baltimore301-225-7900
Johnson & Simpson Graphic Designers 215
 Newark NJ**201-624-7788**
Dick Jones Design Inc./Bridgeport CT203-334-6912
Just Frank Advertising/Hauppauge NY516-231-3216
KBH Graphics/Baltimore301-539-7916
Henry J. Kaufman & Assoc. Inc./Wash DC . .202-333-0700
King-Casey Inc./New Canaan CT203-966-3581
Matt Klim & Assoc./Avon CT203-678-1222
Howard Kjeldsen Assoc. Inc./Atlanta404-266-1897
Harry Knox & Assoc./Wash DC202-833-2305
Kramer/Miller/Lomden/Glossman
 Philadelphia215-545-7077
Krone Art Service/Lemoine PA717-236-9329
David Lausch Graphics/Baltimore301-235-7453
The Layout Pad Inc./Pittsburgh412-355-0280
Lebowitz, Mo/North Bellmore NY516-221-8376
Judith K. Leeds Studio/West Caldwell NJ . . .201-226-3552
Hal Lewis Design/Philadelphia215-563-4461
Lion Hill Studio/Baltimore301-728-8571
Matt Lizak Graphic Design
 North Smithfield RI401-766-8885
Kenneth MacKellar Inc./Boston617-542-7728
The Magnificent Art Machine/Milford NJ603-673-5253
Mahoney, Ron/Pittsburgh412-261-3824
Major Assoc./Baltimore301-752-6174
Mandala/Philadelphia215-923-6020
Marcello Studio/Pittsburgh412-281-9307
Mariuzza, Pete/Briarcliff Manor NY914-769-3310
Marini, Climes & Guip/Pittsburgh412-281-9387
Martucci Studio/Boston617-266-6960
Donya Melanson Assoc./Boston617-482-0421
Mills, Clark/Philadelphia215-732-3739
Mueller/Wister/Philadelphia215-568-7260
Peter Muller-Munk Assoc./Pittsburgh412-261-5161
Munce, Howard/Westport CT203-227-7362
Gene Myers Assoc./Pittsburgh412-661-6314
Nason Design Assoc./Boston617-266-7286
Navratil Art Studio/Pittsburgh412-471-4322
Nimek, Fran Gazze/New Brunswick NJ201-821-8741
Nolan & Assoc./Chevy Chase MD301-652-8600

North Charles Street Design Org./Baltimore . .301-539-4040
Novum Inc./Boston617-523-8060
Oei Enterprises Ltd./Rowayton CT203-866-2470
Omni Assoc./Baltimore301-889-1793
Omnigraphics/Cambridge MA617-354-7444
Otnes, Fred/West Redding CT203-938-2829
Ed Parker Assoc./Boston617-261-2726
Parks Inc./Wash. DC202-452-0096
Paterno Design/Massapequa Park NY516-541-5839
Paulhus Design Inc./Providence RI401-331-8591
Petco Design/Stamford CT.203-348-3734
Philadelphia Creative Workshop
 Philadelphia215-563-3330
Phillips Associates/Natick MA617-429-1050
The Pilot House/Boston617-523-2200
Pitt Studios (V1 • 200) Pittsburgh**412-261-0460**
Paul Planert Design Assoc./Pittsburgh412-621-1275
Plataz, George/Pittsburgh412-322-3177
Plimsoll Productions/Wiscasset MA207-882-7286
Plus Two Design Assoc./Nesconset NY516-265-6441
RSV/Boston617-262-9450
Rainbow Arts Inc./Fitchburg MA617-342-8642
Paul Rand Inc./Weston CT203-227-5375
Reinelt-Sundin-Valenti Assoc./Boston617-262-9450
Ridgeway, Zaklin & Assoc./Westwood NJ . . .201-664-4543
Rieb, Robert/Westport CT203-227-0061
Leonard Lee Ringel Graphic Design
 Kendall Park NJ201-297-9084
Roston, Arnold/Great Neck NY516-487-8735
Sanders & Noe Inc./Wash DC202-657-3700
Schoenfeld, Cal/Parsippany NJ201-334-6257
Schneider, Ed/Wash DC202-293-7750
Schneider Design/Baltimore301-467-2611
James L. Selak Design/Fairport NY716-223-0150
Selame Design Assoc.
 Newton Lower Falls MA617-969-6690
Smith, Doug/Larchmont NY914-834-3997
Tyler Smith Art Direction/Providence RI401-751-1220
Sparkman & Bartholomew/Wash DC202-785-2414
Stano/Sweeny Design/New Rochelle NY914-576-1652
Takjian, Asdur/North Tarrytown NY914-631-5553
Taylor Assoc./Stratford CT203-378-3090
Tetrad Inc./Annapolis MD301-268-8680
Telesis/Baltimore301-235-2000
Thompson, Bradbury/Riverside CT203-637-3614
Thompson, George L./Reading MA617-944-6256
Torode, Barbara/Philadelphia215-665-0265
Fred Troller Assoc. Inc./Rye NY914-698-1405
Van Dine, Horton, McNamara Inc./Pittsburgh . .412-261-4280
Victoria Assoc./Natick MA617-235-2003
Louisa Viladas Graphics & Design
 Greenwich CT203-661-0053
Visual Research & Design Corp./Boston617-536-2111
Wasserman, Myron/Philadelphia215-922-4545
Weitzman & Assoc./Bethesda MD301-652-7035
Weymouth Design/Boston617-542-2647
Gene Whalen Assoc./Pittsburgh412-391-7518
White, E. James/Springfield VA202-256-7900
Wickham & Assoc. Inc./Wash DC202-296-4860
Williams Assoc./Lynn MA617-599-1818
Wills/Grant/Philadelphia215-985-9079
The Workshop/Atlanta GA404-875-0141
World Wide Agency/Baltimore301-385-0800
Kent M. Wright Assoc. Inc./Sudbury MA617-237-9140
Zeb Graphix/Wash DC202-293-1687

SOUTHEAST

Ace Art/New Orleans504-861-2222
The Alderman Company/High Point NC919-883-6121
Richard Allyn Studio/Miami305-945-1702
Amberger, Michael/Miami305-643-6976
And Ink/Sunrise FL305-731-0551
Art Services/Atlanta404-892-2105
Artra Inc./Hollywood FL305-963-5070
Aurelio & Friends Inc./Miami305-661-5369
Barrett & Gaby/Miami305-661-5369
William S. Bodenhamer Inc./Miami305-371-6791
Bonner Advertising Art/New Orleans504-895-7938
Bornstein Piatti/Coral Gables FL.305-445-0553
Brothers Bogushy/Miami.305-373-0665
Rick Cooper Graphics/Miami305-358-3170

Corporate Graphics/Ft. Lauderdale FL305-776-4060
Creative Design Assoc./Palm Beach FL305-659-7676
Creative Services Unlimited/Naples FL813-262-0201
Design Workshop Inc./N. Miami FL305-893-2820
Designers Stewart & Winner/Louisville KY . . .502-636-1423
Erickson Graphics/Largo FL813-595-9644
First Impressions/Tampa FL.813-224-0454
Kim A. Foster Graphic Design/Miami305-665-3620
Gerbino Advertising Inc./Ft. Lauderdale FL . . .305-776-5050
Graphics 4/Ft. Lauderdale FL.305-764-1470
Graphics Group/Atlanta404-261-5146
Graphicstudio/N. Miami FL305-893-1015
Bill Gregg Advertising Design/Miami.305-854-7657
Hall, Stephen/Miami305-374-5043
Michael Hannau Enterprises Inc./Hialeah FL. . .305-887-1536
James N. Hansen Designer Inc./Orlando FL. . .305-896-4240
Hauser Sydney/Sarasota FL813-388-3021
Idea Factory/Winter Haven FL813-299-8472
Images/Miami305-374-5043
Implement Ltd./Louisville KY502-459-0804
International Graphics/Hollywood FL305-945-3441
Kelly & Co. Design Group/St. Petersburg FL . .813-346-2226
Howard Kjeldsen Assoc. Inc./Atlanta404-266-1897
(Kre • a'tiv)/Miami305-595-2320
Bruce Lashley Super Graphics/Tampa FL813-876-6497
Layne & Messina/S. Miami FL305-661-0682
Leisuregraphics Inc./Miami.305-620-5525
Leonard Graphics/St. Petersburg FL813-576-6723
Ross Lewis/Miami305-443-3620
Lippman, Mogull Advertising
 Consultants Inc./N. Miami FL305-893-1175
Shelley Lowell Design/Atlanta404-634-2070
Martin Studio/Miami305-635-1816
Hugh Miller & Group/Orlando FL305-293-8220
Morgan-Burchette Assoc./Alexandria VA703-548-5106
Bill Mosher Graphics/Clearwater FL813-447-4996
Multifact Inc./Orlando FL305-293-1300
Murray Advertising & PR Inc./Lakeland FL . . .813-688-1693
PL&P Advertising Studio/Ft. Lauderdale FL. . .305-771-7722
Don Platt Advertising Art/Hialeah FL305-888-3296
Point 6/Ft. Lauderdale FL305-563-6939
Arthur Polizos Assoc./Norfolk VA804-622-7035
John Portman & Assoc./Atlanta404-522-8811
Positively Main St. Graphics/Sarasota FL813-866-4959
Promotion Graphics Inc./W. Miami FL305-891-3941
Rodriguez, Emilio Jr./Miami305-235-4700
Ronjo Graphics/Miami305-446-2006
Sager Assoc. Inc./Sarasota FL813-366-4192
Schulwolf, Frank/Coral Gables FL305-665-2129
Specified Designs/Miami305-573-4550
Still, Benjamin/Ft. Lauderdale FL305-462-6184
Swearingen Graphics/Louisville KY502-459-9960
Dana Thayer: Industrial Design/Monroe VA. . . .804-846-6359
Don Trousdell Design/Atlanta.404-885-1457
Unigraphics Inc./Ft. Lauderdale FL305-566-9887
Varisco, Tom/New Orleans504-581-7086
Visual Graphic Design/Tampa FL813-877-3804
The Workshop/Atlanta404-875-0141

MIDWEST

Aarons, Alan/Northfield IL312-441-5050
Adams, Frank S./Chicago312-227-1943
Leonard Ades Graphic Design/Northfield IL. . .312-441-6737
Album Graphics/Melrose Park IL312-344-9100
Altschuler, Franz /Chicago312-664-4876
Ampersand Design /Chicago312-944-4880
S. Frederick Anderson Studios /Chicago312-876-0670
Anderson, I.K. /Chicago312-664-4536
Architectural Graphics Systems /Chicago312-871-0100
Architectural Signing Inc. /Chicago312-871-0100
The Art Group /Cincinnati513-721-1270
Azure Blue /Cleveland Heights OH216-368-1100
Babcock & Schmid Assoc. /Bath OH216-666-8826
Bal Graphics Inc. /Chicago312-337-0325
Terry Barich Graphic Design /Chicago312-935-3934
Len Beach Assoc. /Toledo419-535-3151
Burton E. Benjamin Assoc. /Chicago312-332-0246
Bruce Beck Design Assoc. /Evanston IL.312-869-7100
Belden Liska Design /Chicago312-787-7095
Hayward Blake & Co. /Evanston IL.312-869-7100
Blau-Bishop & Assoc. /Chicago312-321-1420

Boller-Coates-Robert /Chicago312-787-2783
Bradford-Cout Graphic Design /Skokie IL312-539-5557
Burke, J. /Chicago312-648-0566
Busch, Lonnie /Fenton MO314-343-1330
Center for Advanced Research in Design
 Chicago312-786-5570
Centaur Studios Inc. /St. Louis314-421-6485
Dave Chapman Design /Chicago312-782-4050
Chestnut House /Chicago312-822-9090
Sheila Chin Design /Minneapolis612-338-3000
Communications Design Group /Evanston IL .312-864-0440
Creative Directions Inc. /Milwaukee414-466-3910
DeGoede & Others /Chicago312-828-0056
Design Associates /Indianapolis317-636-8053
Design Center /Minneapolis612-835-5999
Design Consultants /Chicago312-372-4670
Design Group Three /Chicago312-337-0277
Design North /Racine WI414-762-1320
Design Partnership Inc. /Evanston IL.312-869-7100
The Design Partnership /Minneapolis612-338-8889
Design Planning Group /Chicago312-427-3585
Design Two Ltd. /Chicago.312-642-9888
Dickens Design Group /Chicago312-222-1850
David Doty Design /Chicago312-348-1200
William Drendel Designs /Chicago.312-944-5411
John Dresser Design /Libertyville IL312-362-4222
Epstein & Szilagyi /Cleveland.216-421-1600
Robert Falk Design Group /St. Louis314-367-5552
Feldkamp-Malloy /Chicago312-263-0633
Ficho & Corley Inc. /Chicago.312-787-1011
Frank /James Productions /Clayton MO314-726-4600
Frager, Hob /Cleveland216-771-2868
Glenbard Graphics Inc. /Wheaton IL.312-653-4550
Goldsholl Assoc. /Northfield IL312-446-8300
Goldsmith Yamasaki Specht Inc. /Chicago . . .312-565-1170
M. Gournoe Ltd. /Chicago.312-787-5157
Grant-Jacoby /Chicago312-664-2055
Graphic Corporation /Des Moines515-247-8500
Graphic Design Studio /St. Louis314-991-1820
Graphics Group /Chicago.312-341-9550
John Greiner & Assoc. /Chicago312-644-2973
The Hanley Partnership /St. Louis314-621-1400
Hans Design /Northbrook IL312-272-7890
David Hirsch Design Group /Chicago312-267-6777
Grant Hoekstra Graphics /Chicago.312-641-6940
Impact Division of FCB/Chicago.312-467-9200
Indiana Design Consortium /Lafayette IN317-742-5083
Victor Ing Design /Morton Grove IL312-965-3459
Interdesign /Minneapolis612-871-7979
Interface Design Group/Milwaukee414-276-6688
Intermedia /Cincinnati513-721-1270
Richmond Jones Graphics /Chicago312-935-6500
Juenger, Richard /St. Louis314-231-4069
Kansas City's Best /Kansas City MO816-931-4771
Kaulfuss Design /Chicago312-943-2161
Marilyn Katz, Creative Consultant /Chicago. . .312-321-0908
Kaleidoscope Art Inc. /Cleveland Heights OH .216-932-4454
Ronald Kovach Assoc. /Evanston IL312-864-8898
Krudo Design /Chicago312-764-7669
Merlin Krupp Studios /Minneapolis612-871-6611
Kuester, Kevin M. /Eden Prairie MN.612-941-3326
Laughing Graphics /Minneapolis.612-929-6400
David Lawrence Design /Chicago312-944-6620
Kathy Lay Design /Downers Grove IL.312-960-1028
Gerald Lehrfield/Bert Ray Studio /Chicago . . .312-944-0651
Lesniewicz /Navarre /Toledo OH419-243-7131
Lawrence Levy Design /Evanston IL312-869-4410
Lipson-Jacob & Assoc. /Chicago312-861-0048
Lloydesign /Chicago312-944-7886
Mabrey Design /Northfield IL312-446-9595
Charles MacMurray Design Inc. /Chicago312-822-9636
Manning Studios Inc. 220,144 Cleveland. . .**216-861-1525**
Lynn Martin Design /Chicago312-737-3717
Massey, John /Chicago312-786-5500
Mid-America Graphics /Omaha NE402-554-1416
McMurray, Charles /Chicago312-664-5885
McNamara Assoc. /Detroit312-961-9188
Media Loft /Minneapolis612-831-0226
Meyer Seltzer Design /Illustration /Chicago . . .312-327-7789
Hal Miller Design /Elgin IL312-697-5522
Moonink Inc. /Chicago.312-565-0400

Lawrence Muesing Design/Northfield IL . . .312-446-8326
Multigraphics/Clearwater KS.316-584-6962
Murrie White Drummond Leinhart & Assoc.
 Chicago .312-943-5995
Carol Naughton & Assoc./Chicago312-782-7589
Newcomb House Inc./St. Louis314-569-3750
The Nimi Design Group/Chicago.312-644-8700
Nottingham-Spirk Design Inc./Cleveland . .216-231-7830
Obata Design Inc./St. Louis314-241-1710
Jack O'Grady Graphics/Chicago312-726-9833
Omnigroup/Chicago.312-944-6050
Osborne-Tuttle/Chicago.312-828-9280
Overlock Howe & Co./St. Louis314-241-8640
P.S. Graphic Design/Des Moines515-243-3056
Palmer Design Assoc./Chicago.312-263-1268
Perception Inc./Chicago.312-782-5019
Perman, Norman/Chicago312-642-1348
Herbert Pinzke Design/Chicago.312-644-7671
Pitt Studios (V1 • 200) Cleveland **216-241-6720**
Point 6 Advertising Art/Cleveland216-523-1827
Porter, Allen E./Chicago.312-236-5479
Push Pin Studios 224 Chicago**312-944-6655**
R.V.I. Corporation/Chicago312-787-2220
Barbara & Patrick Redmond Design
 Minneapolis612-341-3910
Michael Reid Design/Chicago312-337-0556
Robertz Design Company/Chicago312-861-0060
Rotelli Design/Chicago.312-527-9870
Roth, Randall/Chicago.312-467-0140
Rudnak, Theo/Chicago312-332-5168
Samata Design Group Ltd./Barrington IL . .312-381-9090
Savlin Assoc./Evanston IL312-328-3366
Richard Schlatter Design/Battle Creek MI. .616-964-0898
E.F. Schmidt Co./Merromine Falls WI . . .312-263-0995
Ron Schultz Design/Chicago312-528-1853
Schumaker Design Inc./Grand Rapids, MI . .616-456-5431
The Shipley Assoc./Elmhurst IL.312-279-1212
Skolnick, Jerome/Chicago312-944-4586
Vito Simanis Design/St. Charles IL312-584-1683
Barry Slavin Design/Chicago.312-944-2920
The Glen Smith Co./Minneapolis612-871-1616
H.B. Smith & Assoc./Chicago.312-787-8920
Stepan Design/Chicago.312-332-3776
Gordon H. Stromberg Visual/Chicago. . . .312-275-9449
Studio One Inc./Minneapolis612-831-6313
Gladys Swanson Graphics/Chicago312-726-3381
Swoger Grafik/Chicago312-935-0755
Synthesis/Chicago.312-787-1201
TCI Advertising/St. Louis.314-966-6675
Tarpey, Gene/Chicago312-427-0575
George Tassian Org./Cincinnati513-721-5566
Peter Teubner & Assoc./Chicago312-467-0021
Thumbnails Inc./Minneapolis612-333-6539
Titel Design/Chicago312-477-4667
Underwood, Muriel/Chicago.312-236-8472
Unimark International Corp./Chicago312-782-5850
Frederick Vallarta Assoc. Inc./Chicago. . .312-944-7300
Bill Vann Studio/St. Louis314-231-2322
Venture Graphics/Chicago.312-644-0616
Vista Three Design/Minneapolis612-920-5311
Visual Design Center/Chicago312-329-1230
Harry B. Voight Graphic Design/Oak Park IL. .312-848-0388
Wallner Graphics/Chicago.312-787-6787
Jack Weiss Assoc./Evanston IL312-869-7100
Wenzel Studio/Chicago.312-321-0758
Wilkes, Jean/Chicago312-332-5168
M. Wilson Graphic Design/Columbus OH . .614-239-9449
Winbush Design/Chicago312-527-4478
Wise, Guinotte/Independence MO816-836-1362

SOUTHWEST

Ad Directors/Dallas214-634-7337
Advence Design Center/Dallas214-526-1420
Baxter & Korge/Houston713-781-5110
Benton, Patrick/Dallas214-526-1181
CRS/Houston713-621-9600
Creative Communications/Denver303-399-4390
Larry Darnell Design/Dallas.214-748-0114
Demlow/Durand Advertising Art/Dallas . . .214-521-8780
Design & Image Associates/Denver303-572-0498
Designers & Partners/Dallas214-630-7504
Eisenberg & Pannell/Dallas.214-528-5990

Envision Art & Design Studio/Houston713-932-0251
Genesis Inc./Denver303-825-1230
Freshman, Shelley/Denver.303-759-3541
Graffiti Studio/Boulder CO.303-442-5396
Hendel, Richard/Austin TX.512-345-2578
Herring Design/Houston713-526-1250
Konig Design Group/San Antonio TX512-824-7387
Le Vrier, Philip/Welesco TX512-968-4626
Lidji/Dallas214-528-3501
Lively/McPhail Studio/Dallas214-741-5126
Loucks Atelier/Houston713-528-2945
Lueck, Bob/Dallas214-521-4291
Morales, Frank/Dallas214-827-2101
Pierce, Donald/Houston713-526-8429
Reed, Melnichek, Gentry/Dallas214-634-7337
Lee Reedy Designer/Denver303-832-1489
The Richards Group/Dallas214-233-2101
Roseburg, Pam/Dallas214-826-0616
Rowley Kahler Assoc./Denver303-573-6073
Salesvertising Inc./Denver303-837-1096
The Sketch Pad/Arlington TX817-469-8151
Sloves Products/Albuquerque NM505-255-8661
Smitherman Graphics/Austin TX512-459-3379
Robert Taylor Design/Denver303-837-1070
Unit 1/Denver303-744-1033
Ed Zahra Design/Dallas214-521-3030

WEST

Adpro/ SF .415-434-1650
Adspectrum Inc./Vineland CA213-988-9484
Advertising Designers/LA213-463-8143
Albers, Hans/Pacific Palisades CA213-454-6726
Album Graphics Inc./LA213-462-0823
Primo Angeli Graphics/SF415-989-1830
John Anselmo Design Assoc.
 Santa Monica CA213-393-9411
Artworks/SF415-434-3754
Carl Ballay & Others/SF415-421-7278
Banuelos Design/Orange CA714-997-2823
Saul Bass & Assoc. Inc./LA213-466-9701
Paul Benemelis Graphics/Oakland CA . . .415-645-6156
Chuck Bennett/LA213-659-2406
Jerry Berman & Assoc./SF415-673-7807
The Big Apple/LA213-466-3306
Big Orange Graphics/Pasadena CA213-577-1840
John Birdsall Inc./LA213-933-7501
Jeff Bisch Design/LA213-545-5688
Bruce Bishop Designs/LA213-384-9764
Blair, Nancy D./Brentwood CA.213-826-7331
Bradford Boston Graphic Design/LA213-294-4202
Bright & Agate Inc./LA213-652-5920
John Brinkmann Design Offices Inc. 207 LA.213-382-2339
The Brubaker Group/LA.213-277-6251
Joseph A. Burchard Designer
 N. Hollywood CA213-762-8775
Carra, Flynn & Shimokochi/LA213-483-8210
Casado Design/SF415-421-5032
Ralph Chapek Inc./Pasadena CA213-795-4371
Pelly Charles Designworks/Vineland CA . . .213-781-4488
Jann Church Graphic Design
 Newport Beach CA714-640-6224
John Cleveland Design/LA.213-826-0948
Colls Design/LA.213-385-6644
The Committee/LA213-659-2406
Copolla Creative Concepts/SF415-546-6050
Cornerstone/Palo Alto CA.415-322-6261
Corporate Graphics/SF415-433-1231
Richard Costelloe/Sherman Oaks CA . . .213-995-1035
James Cross Design Office Inc./LA213-484-2525
Crow-Quill Studios/SF415-989-3334
Don Crum Graphic Design/LA.213-221-1688
Danziger, Louis/LA.213-935-1251
Designall Group/LA213-466-7218
Designwise/LA213-936-5276
Design Council/Portland OR.503-226-4781
Design Office/SF415-543-4760
Design West/Newport CA.714-833-3500
The Design Works/LA213-556-2021
Larry Deutsch Design/LA.213-937-3521
Dimensional Design/N. Hollywood CA . . .213-769-5694
Tom Dittman Graphic Design
 Beverly Hills CA213-273-2197

Bob Drake Studio/LA213-931-8690
Dubow & Hutkin/LA213-938-5177
Duffus, Bill/LA213-661-8273
Dunbar, Randy/LA213-256-0502
Rod Dyer Inc./LA213-654-6486
Emerson-Johnson-MacKay Inc.
 N. Hollywood CA213-763-6641
Rudy Enjaian Design/SF415-781-8388
Evenson, Stan/Beverly Hills CA213-274-9859
Fifth Street Design Assoc./Berkeley CA. . . .415-526-0852
Fine Lines/LA213-822-4999
Finlay, Kaiser & Ballard Inc./LA213-272-2741
John Follis & Assoc./LA213-735-1283
Franks, Bill/LA213-382-6281
Jon Fredrik & Assoc./Portland OR503-224-0687
Friends of Design/SF415-433-0378
The Gnu Group/Sausalito CA415-332-9010
Howard Goldstein Design/Van Nuys CA . . .213-987-2837
Gonzalez, Bebett/SF.415-433-0378
Ken Goodell & Assoc./Beverly Hills CA . . .213-274-9095
Gorilla Graphics/SF415-285-4841
Gorman, Stan/LA.213-937-4472
Gouger Sparks Silva/SF415-441-0303
Jerome Gould & Assoc./W. LA213-477-5587
Grafx/LA .213-674-5911
Graphic Arts/Long Beach CA213-598-7525
Graphic Communications Center/SF415-989-4444
Graphic Design Assoc./LA.213-413-5300
Graphic Design West/LA213-346-8139
Graphic Designers Inc. 214/LA**213-381-3977**
Graphicus/N. Hollywood CA213-769-5694
Gribbet/LA213-462-7362
Group West Inc./LA213-937-4472
Gurvin, Abe/LA213-279-1775
Gwin Graphics/SF415-495-3680
Haines Art Studio/LA213-387-2197
Hanson & Boelter Design Offices
 Sherman Oaks CA213-990-6141
Eugene Hassold Design Assoc./SF.415-981-2553
Herb Hayakawa & Assoc./LA213-879-4477
Heckler Assoc./Seattle WA206-622-3737
Hildreth & Assoc./N. Hollywood CA213-836-1843
Hinche-Kay Design/LA213-387-2111
Hobco Arts/LA213-477-3051
Holm, Laura/SF415-495-5616
Richard Holmes Design/Laguna Beach CA . .714-494-5818
Hood, Holly/LA213-652-4183
Hope, Frederic/LA213-937-4472
Hubbard, Roger/LA.213-938-5177
Huerta Design/LA.213-381-6641
Lauren Hungerford Design/LA213-476-8896
Wayne Hunt Graphic Design/LA213-687-7422
Hutkin, Elliot/LA213-938-5177
Ikkanda, Richard/LA213-938-5177
The Image Factory/Hollywood CA.213-462-2207
The Image Machine/Canoga Park CA213-346-1272
Innovations/SF415-922-7799
Ivanyi, George 214 LA**213-381-3977**
Steve Jacobs Design Inc./Palo Alto CA . . .415-328-4669
Alvin Joe & Assoc./SF415-392-3577
Jonson Pedersen Hinrichs Sharkey/SF . . .415-981-6612
Dennis S. Juett & Assoc./LA213-385-4373
Kaiser Design Group/LA213-478-3858
Charlotte Kay Graphics/SF415-391-6108
Kate & Neil Keating Design/SF415-421-3350
Craig Keck Assoc./S. Pasadena CA213-799-1159
Klein, Norman/LA213-652-4183
Kortebein, Bruce/SF415-543-4760
Krogstad/N. Hollywood CA.213-765-0866
Lancaster, Rob/Seattle WA.206-285-3214
Walter Landor & Assoc./SF.415-955-1310
LaPerle Assoc./SF415-989-4444
Larry Le Mone Advertising Design
 Pasadena CA213-794-1446
Leprovost & Leprovost/Malibu CA213-457-3742
Darryl Lloyd Assoc./Encino CA213-872-2338
Logan, Carey & Rehag/SF415-543-7080
Ron Loosen Assoc./SF213-258-6500
Darell Lum & Assoc./Monterey Park CA . . .213-289-1214
Wilford Low & Assoc./SF415-397-8233
MAB Design Inc./Santa Monica CA213-399-4767
Manahan, Leo/LA213-392-4877

Manwaring, Michael/SF415-421-3595
Will Martin Design/LA.213-272-3417
Mechanical Marvel/SF415-788-5965
Max McDonald Design Office/LA.213-461-8241
McGarvin Graphics/Pasadena CA213-796-1260
McGowan, Mark/SF415-647-2107
McNail, John /Pasadena CA213-796-0495
Mediate, Frank 214 LA**213-381-3977**
Medoff, Jack/LA213-876-4716
Metamorphic Design/Portland OR.503-227-2276
Charles E. Mize Advertising Art/SF415-421-1548
NFLP Creative Services/LA.213-475-0571
Gene Nedder Industrial Design/Rosedale CA.213-345-4101
Neibauer, Lance/LA213-382-6281
Nethery, Susan/LA213-392-4877
Neumarket Design Assoc./LA.213-651-5044
Abbey Norman Graphic Design
 Pasadena CA213-681-6763
Oregon Rainbow/Portland OR.503-223-4882
Ortega-Orr Assoc. Inc./LA213-874-3755
Pacific Design Center/W. Hollywood CA . . .213-657-0800
Page, Frank/LA213-279-1775
Joseph R. Palsa & Assoc./SF415-986-2022
Parkhurst, Ken/LA213-653-4301
Philbrook, Bill/LA.213-937-4472
James Potocki & Assoc. 222 LA**213-380-7281**
Quilez, Jose/LA213-652-4183
Philip J. Quinn Design/Redwood City CA. . .415-366-6516
RA Graphics/Beverly Hills CA213-276-8240
Ramey Communications/SF213-665-4144
J. Richard Reed Design/SF.415-621-1389
Charles Reilly Co./Pasadena CA213-796-7168
Gerald Reis & Co./SF415-543-1344
Richter & Carr Communications/LA213-276-4133
Rios, Gil/LA213-651-3015
Susan Roach & Assoc./SF415-928-4400
Herb Rosenthal Assoc. Inc./LA213-655-0214
Ross Design/SF415-928-1144
Ross, Deborah/Hollywood CA213-874-1661
Runyan + Rice/Playa del Rey CA213-871-2230
Richard Runyan Design/LA213-478-7966
Sachs-Oehler Studio/N. Hollywood CA . . .213-769-6656
San Francisco Design & Type Studio/SF . .415-495-6280
David Schwartz Communication Designs
 Santa Monica CA213-393-0860
Selby Inc./Portland OR503-234-2822
Selve Bond Steward & Romberger
 S. Pasadena CA213-682-3914
Sheppard Design Assoc./Pasadena CA. . . .213-793-0936
Sheridan/Solan & Assoc./LA213-931-1089
Shimano Ishimaru Cary Shimano Inc.
 W. Hollywood CA.213-999-2511
Art Shipman & Assoc./Pasadena CA213-795-9725
Shook & Co./Glendale CA213-240-7083
Mamoru Shimokochi/LA213-461-2097
Sidjakov, Nicolas/SF.415-673-7814
Sims, Norine/LA213-256-0502
Sam Smidt Assoc./Palo Alto CA415-494-1260
Lauren Smith Design Group
 Mountain View CA415-343-6642
Smith, Terry/LA213-937-4472
Soo Hoo, Patrick/LA213-385-1743
Specht, Will/LA213-651-3015
Spiegelman, Marjorie/SF.415-398-3432
Steinberg, Bruce/SF415-648-0925
Steinhelber & Deutsch Assoc./SF415-362-6113
Steinle, Robert L./LA213-272-0651
David Strong Design Group/Seattle WA . . .206-285-3620
The Studio/SF415-928-4400
Studio Artists/LA213-382-6281
Studio Space/Long Beach CA213-439-0859
The Sunshine Group/Orange CA213-639-2674
Tartak/Libera Design/LA213-477-3571
Taylor, Gerry W./LA213-659-2406
Thompkins, Bob/LA213-937-4472
Team Three/LA213-478-3501
Roger Tierney Assoc./LA213-381-5155
Tri-Arts Inc./LA213-461-4891
Ulven, Melvin/Portland OR503-227-3916
Unigraphics/SF415-398-8232
Van Dyke McCarthy/Seattle WA.206-282-8070
Van Hamersveld Design/LA213-656-3815

Van Noy & Co./LA.213-386-7312
Vanderbyl, Michael/SF415-397-4583
Vigon-Nahas-Vigon/LA.213-990-8084
Visual Communications/LA.213-469-9381
Volquartz, Per/LA.213-474-7911
Dennis Voss Graphic Design/SF415-986-7961
The Weller Institute/LA213-225-1349
Welter, Warren/Mill Valley CA415-383-6245
Joseph Weston Graphic Design/LA213-385-7910
Martin Will Design Assoc./LA.213-272-3417
John Williams Design/SF.415-362-7155
Wolin, Ron/LA. .213-930-1144
Steve Wong & Assoc./SF415-391-1358
Wong & Ritola/SF415-391-2340
Woodward Design Assoc./Hollywood CA . . . 213-461-4141
Wright, Stevens/Long Beach CA213-593-7741
Yamada, Tony/Sherman Oaks CA213-990-5692
Mourice Yanez & Assoc./LA213-387-2197
Donald Young Design/LA.213-938-7138
Zamparelli Design/Encino CA213-981-6644

REPRESENTATIVES

NEW YORK METROPOLITAN AREA

Ken Abbey & Assoc.212-758-5259
American Artists/R. Mendelsohn Assoc.212-682-2462
Amos, Lisa212-838-6520
Andrews, Jim212-689-9054
Andrews, Margery E.212-777-3770
Anton, Jerry212-679-4562
Arnold, Peter212-840-6928
Artists Assoc.212-755-1365
Arton Assoc.212-661-0850
Backer, Vic212-535-9202
Bahm, Darwin M.212-989-7074
Barclay, R. Francis212-255-3440
Basile, Ron212-986-6710
Becker, Noel212-757-8987
Berenis & Jones212-243-8843
Blatt, Abby212-924-7010
Blum, Felice S.212-243-3942
Boghosian, Marty212-371-4961
Booth, Tom212-243-2750
Boyle, Janet M.212-475-0440
Brackman, Selma.212-777-4210
Brindle, Carolyn212-249-8883
Broderick, William212-242-0930
Brody, Sam212-758-0640
Brown, Doug212-288-6630
Pema & Perry Browne Ltd.212-369-1925
Bush, Nan.212-751-0996
Cafiero, Charles.212-777-2616
Cahill, Joe.212-751-0529
Camera 5212-989-2804
Carp, Stanley212-759-8880
Caruso, Frank212-260-7203
Chello, Renee212-689-1982
Cherpitel, Latifah.212-243-1318
Chettle, Kate212-752-0273
Chie212-685-6854
Chislovsky, Carol212-758-2222
Clements, John212-348-6806
Collins, Chuck212-765-8812
Collins, Patrick M.212-688-3228
Crabb, Wendy212-734-4391
Daniels, Camille212-947-5065
Davies, Nora212-840-2866
Denner, Ann.212-684-5033
Deverin, Daniele212-755-4945
DiBartolo, Joseph212-254-6327
Di Martino, Joseph212-935-9522
Du Bane, Jean-Jacques212-697-6860
Dubner, Logan212-533-2970
Dunley, Joyce212-242-4283
Epstein, Ellen212-289-2172
Erica212-777-3232
Feld, Robin212-249-7231
Feldon, Leah212-725-1325
Ficalora, Michael212-679-7700
Flah, Linda212-472-2500
Flock & Lombardi Assoc. Ltd.212-689-3902
Flood, Phyllis Rich212-532-9247
Fonyo, Andrea212-582-3284
Forsyth, Alfred212-752-3930
Foster, Peter.212-593-0793
Frattolillo, Rinaldo212-486-1901
Fried, Robin212-564-9050
Furst, Franz212-753-3148
Galler, Margot212-989-9825
Jack Garten Representatives Inc.212-787-8910
Gazebo Productions212-489-7423
Giordano, Maria212-982-2700
Giraldi, Tina212-840-8225
Goldman, Larry212-246-3737
Goldstein, Michael L.212-873-4634
Goldstein, Russell M.212-986-1783
Goldstein, Suzanne.212-758-3420
Goodwin, Phyllis A.212-753-2857
Gordon, Barbara212-686-3514
Gordon, Elliott212-686-3514
Gould, Linda212-684-2974
Gould, Stephen Jay212-686-1690
Grayson, Jay212-689-1468
Green, Anita212-532-5083

Greenblatt, Eunice N.212-628-3842
Grey, Barbara L212-851-0332
Grien, Anita.212-697-6170
Grinell, Kate212-684-3084
Groves, Michael212-532-2074
Grunell, Kate212-684-3084
Henry, John212-686-6883
Hollyman, Audrey212-867-2383
Holt, Rita212-777-3910
Hottelet, Mary212-477-3573
Hovde, Nob & Laurence212-753-0462
Jedell, Joan212-861-7861
Johnson, Evelyne212-532-0928
Kahn, Harvey212-752-8490
Kammler, Fred212-249-4446
Barney Kane Inc.212-355-1316
Keating, Peggy.212-691-4654
Kim212-679-5628
Kirchoff-Wohlberg Inc.212-753-5146
Klein, Ellen.212-243-0027
Klein, Leslie D.212-832-7220
Kleiner, Goldie212-799-8050
Kochan, Joan S.212-684-4058
Kopel, Shelly212-986-3282
Krausman, Robert212-686-1897
Kreis, Ursula G.212-562-8931
Lammeck, Denys212-582-5572
Lane, Judy.212-861-7225
Jane Lander Assoc.212-679-1358
Larkin, Mary212-688-8884
Lavaty, Frank & Jeff212-355-0910
Lee, Alan212-861-1748
Leff, Jerry212-697-8525
Leinberger, Cliff212-473-4999
Lento, Julia212-233-8989
Leonian, Edith212-989-7670
Lerman, Gary212-683-5777
Luppi, Judith212-677-1910
Mace, Zelda212-765-3889
Madris, Stephen.212-744-6668
Mandel, Bette212-737-5062
Mann, Ken212-245-3192
Mann, William Thompson212-595-6260
Marino, Frank212-563-2730
Marino, Louise212-677-6310
Martin, Bruce212-679-1358
Mautner, Jane212-777-9024
Melsky, Barney212-532-3311
Mendelsohn, Richard212-682-2462
Mendola, Joseph212-986-5680
Mercier, Lou.212-972-1701
Mersel, Constance V.212-787-4816
Messeroff, Claire212-255-8250
Messing, Patricia F.212-724-1627
Michalski, Ben.212-683-4025
Milsop, Frances212-794-0922
Moretz, Eileen P.212-254-3766
Morgan, Vicki212-475-0440
Morrill, Dick212-421-5833
Mosel, Sue212-288-9204
Moskowitz, Marion212-472-9474
Moubrie, Gabrielle212-265-5301
Mullen, Ron M.212-751-0529
Mulvey Assoc.212-246-3660
Nayer, Jack212-989-6650
Nelson, George L.212-679-7538
Newborn, Milton.212-421-0050
Opticalusions212-688-1080
Palevitz, Bob212-684-6026
Pasqua, Dominique212-661-0850
Patterson, Sylvia212-675-2805
Penny, Barbara212-867-4640
Photo Artists212-246-3737
Photo Researchers212-758-3420
Popper, Serge212-682-1527
Quercia, Mat212-477-4491
Gerald & Cullen Rapp Inc.212-751-4656
Ray, Marlys212-222-7680
Kay Reese & Assoc.212-924-5151
Remler, Gladys.212-244-4270
Renard, Marc212-736-3266
Richards, Gary.212-691-7950

Riley, Ted212-355-2763
Rivelli, Cynthia212-254-0990
Rosenberg, Arlene212-982-7376
Rothenberg, Judith A.212-861-7745
Rubin, Mel212-582-0404
Rudoff, Stanley212-679-8780
Russo, Karen212-243-6778
Sacramone, Dario D.212-929-0487
Sander, Vicki212-674-8161
Saunders, Marvin212-661-4710
Saunders, Michele212-580-3845
Scanlon, Henry R.212-989-0500
Scerra, Peter212-490-1610
Schickler, Paul212-355-1044
Schifrin, Joan I.212-686-0907
Schneider, Amy B.212-490-0673
Schon, Herb212-249-3236
Schub, Peter & Robert Bear212-246-0679
Shamilzadeh, Sol212-691-5270
Shepherd, Judith212-838-3214
Shostal Assoc.212-687-0696
Silver, Susan212-674-1151
Sims, Jennifer212-532-4010
Slesinger, Simon212-475-2916
Smith, James Forrest.212-674-5566
Snow, Civia212-674-0259
Sokolsky, Stanley212-686-5000
Stermer, Carol Lee212-867-4640
Stiefel, Frank.212-879-6200
Stockland, Bill212-242-7693
Stogo & Bernstein Assoc. Inc.212-697-5252
Stogo, Bernstein & Andriulli212-682-1490
Studer, Lillian212-687-2272
Sun, Edward212-674-7288
Susse, Ed212-472-0674
Tannenbaum, Dennis212-279-2838
Terrero, Robert212-881-7146
Tyson, David212-686-0761
Umlas, Barbara212-249-4555
Valdetaire, Anne212-685-5753
Van Arnam, Lewis.212-541-4787
Wasserman, Ted.212-867-5360
Wayne, Tony.212-757-5398
Wein, Gita212-759-2763
Woodfin Camp & Assoc.212-355-1855
Yellen, Bert212-889-4701
York, Jim.212-688-7232
Youngs, Maralee212-679-8124
Zarember, Sam212-765-8928

NORTHEAST & SOUTHEAST

Alter, Don G./Warren VT802-496-3574
Bancroft, Carol/Weston CT.203-226-7674
Benke, Jill/Boston617-542-4825
Ben Bonart & Assoc. Inc./Wash. DC202-965-2218
Chandoha, Sam/Annandale NJ.201-782-3666
Creative Services/Atlanta404-262-7424
Darrow, Whitney/Westport CT203-227-7806
Grace, Dede/Weston CT.203-226-7674
First National Productions/New Orleans504-897-1592
Groskinsky, Alma/Port Washington NY516-883-3294
Hall, Shari/Wash DC.202-244-7823
Holloway, Tom/Port Washington NY516-883-3408
Kenny, Ella/Boston.617-426-3565
Landsman, Gary/Wash. DC202-223-1590
Lensman Photo Ltd./Wash. DC202-333-3850
Mariucci, Marie/Marlboro NJ201-594-4950
Murphy, Michael/Pittsburgh.412-261-2022
Nichols, Eva/Rochester NY716-275-9666
Olive, Bobbi/Atlanta404-872-0500
Pastore, J. Daniel/Southport CT203-255-2487
Savadow, Rick/Baltimore301-685-5423
Silver, Peter-Image 4 Productions
 Port Chester NY914-937-3339
Taylor, Cory/Baltimore.301-385-1716
Taylor, John/Hopewell NJ609-466-3151
Valen Assoc./Westport CT203-227-7806
Woodfin Camp Inc./Wash. DC202-466-3830

MIDWEST

Aiko/Chicago312-869-7081
Asad, Susan/Chicago312-266-7540
Ashley, Susan/Chicago312-348-5393
Ball, John/Chicago.312-332-6041
Berk, Ida/Chicago312-944-1339
Bernsten, Jim/Chicago312-822-0560
Bowman, Ann/Chicago312-337-5664
Brawar, Wendy/Chicago312-266-1606
Brenner, Harriett/Chicago312-751-1470
Burch, Ralph/Chicago312-751-2977
Chambers, Ron/Chicago312-642-8715
Christell, Jim/Chicago312-236-2396
Claussen, Bo/Chicago312-871-1242
Crawford, Cathy/Chicago312-787-2915
DeGrado, James/Chicago312-663-9778
Dorman, Paul/Detroit313-645-2222
Draheim, Jim/Chicago312-828-9216
Drewel, Judie/St. Louis314-533-6665
DuBiel, Karen/Chicago312-266-8559
Dwyer, Debbie/Chicago312-644-5233
Eakin, Dana/Chicago312-782-2703
Engh, Rohn/Osceola WI.715-248-3800
Erdos, Kitty/Chicago312-787-4976
Ferreri, Rosemary/Chicago.312-644-3187
Hammond, Pamela/Chicago312-726-5678
Harlib, Joel/Chicago312-329-1370
Harwood, Tim/Chicago312-828-9117
Myrna Hogan & Assoc./Chicago312-372-1616
Howze, Walter/Chicago312-332-5700
Johnson, Ginger Todd/Chicago312-772-2292
Kamin, Vince/Chicago312-787-8834
Kapes, Jack/Chicago312-664-8282
Kelly, Nick/Chicago312-280-8212
Kezelis, Elena/Chicago312-644-7108
Kulfan, Cynthia/Chicago.312-944-5680
Lasko, Pat/Chicago312-787-1316
McMasters, Deborah/Chicago312-467-4770
McNaughton, Toni/Chicago312-929-2505
Miles, Thomas/Minneapolis612-871-0333
Miller, Richard/Chicago312-271-6644
Moore, Connie/Chicago.312-787-4422
Moravick, Don/Chicago.312-664-9012
Mosier-Maloney/Chicago.312-943-1668
O'Brien, Jim/Chicago312-856-0007
O'Brien/DeSantiago/Chicago.312-856-0300
Parker, Tom/Chicago312-266-2891
Potts, Carolyn/Chicago312-935-1707
Pride, Max/Chicago312-337-2138
Pulver, Owen/Chicago.312-332-5325
Putnam, Barbara/Chicago.312-266-8352
Quick, Sue/Chicago312-644-7557
Rabin, Bill/Chicago312-944-6655
Schuck, John/Minneapolis.612-338-7829
Schwartz/McCarthy/Chicago.312-236-4135
Sell, Dan/Chicago312-332-5168
Sharrard, Chuck/Chicago312-642-8715
Skillicorn, Roy/Chicago.312-787-9408
Thiele, Elizabeth/Chicago312-944-4477
Clay Timon & Assoc./Chicago.312-641-0934
Tracy, Cathleen/Chicago312-944-7070
Tuke, Joni/Chicago.312-664-4235
West, Karen/Chicago312-664-5954
Wilde, Nancy/Chicago312-528-7711
Witmer, Bob/Chicago312-642-0242
Wood, Chuck/Chicago312-944-7070
Zimmerman, Amy/Chicago312-642-4426

WEST & SOUTHWEST

Aline, France /LA213-392-7792
Antonioli, Gina /LA213-930-1144
Azzara, Marilyn /LA213-876-2551
Barton, Stephanie /Dallas214-647-4133
Bishop, Michael /Inglewood CA213-674-5911
Bonar, Ellen /LA .213-474-7911
Ashley Bowler & Assoc. /LA213-467-8200
Bright, Sandy /W. LA213-479-5853
Brown, Dianne /LA213-386-3414
Brown, George /SF415-495-7175
Bunce, Judy /SF .415-421-2778
Burke, Donna /LA213-655-4012
Campagna, Debra /SF415-546-6536
Campbell, John /LA213-385-1938
Marilyn Caplan & Assoc. /LA213-459-3301
Carson, Valerie /LA213-273-6768
Chan, Arlo /LA .213-659-7647
Churchill, Christine /SF415-495-3556
Collamer, Carol /DSF415-383-5093
Cooley, Chris /LA213-465-7193
Cormany, Paul /Santa Monica CA213-828-9653
Creative Assoc. /N. Hollywood CA213-760-1787
Dale, Julie /LA .213-487-0270
Diskin, Donnell /LA213-383-9157
Drayton, Sherryl /Woodland Hills CA213-347-2227
DuBow & Hutkin /LA213-938-5177
DuCane, Alex /Hollywood CA213-654-4505
Earl, Al /LA .213-462-7432
Eisenrauch & Fink /LA213-652-4183
Elias, Annika /LA213-655-3527
Fellows, Kathleen /LA213-851-5051
Fenton, Irv /LA .213-937-4472
Fields, Mary /LA .213-874-2798
Fleming, Laird Tyler /LA213-784-5814
Friedman, Todd & Lewis Portnoy
 Beverly Hills CA213-550-7005
Gardner, Gail /LA213-931-1108
Garvin George /Santa Monica CA213-395-8267
Tom Gilbert & Assoc. /Hollywood CA213-469-8767
Glesby, Ellen /LA213-477-4648
Globe Photos /LA213-654-3350
Richard Goldstone Productions /LA213-931-1305
Graphic Arts Agency /LA213-820-3791
Graff, Lisa /Hollywood CA213-461-4969
Hallowell, Wayne /N. Hollywood CA213-769-5694
Hamik, Peggy /SF415-421-3422
Hammond, Roger /LA213-937-4472
Happe, Michele /LA213-933-2249
Hart, Ginger /LA .213-931-9393
Haugen Assoc. /LA213-822-4999
Hayes, Annie /Malibu CA213-457-7670
Hedge, Joanne /Hollywood Ca213-874-1661
Henry Assoc. Inc. /Denver303-756-4811
Herman, Donna /LA213-466-9940
Hewson, Janie /LA213-655-3772
Hyatt, Nadine /SF415-563-5679
Iwataki, Sandy /LA213-457-7406
Jay, Bonnie /LA .213-826-1100
Kaiser, Ruth /LA .213-380-5908
Knable, Ellen /LA213-990-8084
Kowal, Tad /LA .213-653-2940
Kowalenko, Zina /LA213-463-1129
Lagerson, Kitty /LA213-936-6861
Lancaster, Corelli /Hollywood CA213-876-2552
Lawson, Karen /LA213-464-3364
Laycock, Louise /Woodland Hills CA213-703-6498
Joan Lesser Etc. /Beverly Hills CA213-550-7619
List, Gloria /LA .213-651-3015
Lombardi, Pie /LA213-931-5942
London, Valerie /LA213-655-4214
Lovejoy, Pamela /LA213-936-1616
Luna, Tony /Pasadena CA213-684-0460
MacArthur, Jim /LA213-660-1321
Marcuse, Sy /LA .213-487-3860
Marshall, J.P. /SF415-543-0190
Martin, Steve /LA213-936-3131
Maslansky, Marysa /LA213-934-1384
Matson, Coleen /LA213-462-3513
Mattei, Michele /LA.213-656-7407
McCullough, Don & Gavin /LA213-382-6281

Morico, Mike /LA.213-382-6281
Nichols, Pam /Hollywood CA213-467-6797
Parsons, Ralph /SF415-986-0107
Pentecost, Harry /Hollywood CA213-467-6832
Pepper, Don /LA .213-382-6281
Philbrook, Bill /LA213-937-4472
Photo Artists /LA213-463-7717
Pierceall, Kelly /LA213-559-4327
Putnam & Brookhouse /LA213-256-0502
Reed, Dick /LA .213-650-6304
Rezos, Andre /Pacific Palisades CA213-454-6726
Richards, Marilyn /LA213-457-2897
Roybal, Alec /LA .213-258-6500
Runyon, Kathleen /LA213-384-9952
Sakai, Steve /Temple City CA213-283-9940
Salisbury, Sharon /SF415-285-4770
Sauers, Joan /Beverly Hills CA213-274-9859
Schiff, Anthony /LA213-556-3033
Scott, Lexy /LA .213-657-8707
Sebree, Sandie /LA213-874-6322
Skow, Carol /LA .213-938-6287
Slobodian, Barbara /LA213-464-2341
Smith, Linda /Dallas.214-651-9701
Souza, Sandy /LA213-462-4532
Spellman, Martha /W. LA213-479-4329
Spradling, David /LA.213-475-7794
Stein, Greg /Torrence CA.213-373-6789
Steinberg, John /LA.213-279-1775
Sullivan, Diane /SF.415-673-4044
Sweet, Ron /SF. .415-433-1222
Terry, Gloria /Pasadena CA213-681-4115
Truax, Sharon /Venice CA213-396-3162
Vandamme, Vicki /SF415-433-5480
Wagoner, Joe /LA213-392-4877
Walton, Al /LA .213-661-8273
Wielage, M.B. /LA213-651-2878
Wood, Joan /LA. .213-276-5984
Zimmerman, Delores H. /Beverly Hills CA . . .213-273-2642

STOCK PHOTOGRAPHY

NEW YORK METROPOLITAN AREA

Alpha Photo Assoc.	212-777-4216
American Library Color Slide Co.	212-255-5356
Animals Animals	212-580-9595
Peter Arnold Inc. (V1•97)	**212-840-6928**
Authenticated News Inc.	212-243-6995
Bettmann Archive Inc.	212-758-0362
Black Star Publishing Co.	212-679-3288
Camera Clix Inc.	212-684-3526
Camera 5	212-989-2804
Bruce Coleman Inc.	212-683-5227
Consolidated Poster Service	212-581-3105
Culver Pictures Inc.	212-684-5054
DPI NYC	212-752-3930
DeVaney, George A.	212-682-1017
de Wys, Leo 20	**212-986-3190**
Dunningan, John V.	212-889-7594
Eastern Photo Service Inc.	212-986-3190
Editorial Photocolor Archives	212-697-1136
European Art Color Slides	212-877-9654
Focus on Sports	212-661-6860
Four By Five Inc.	212-355-2323
Freelance Photographer's Guild	212-777-4210
Globe Photos Inc.	212-689-1340
The Granger Collection	212-586-0971
Lee Gross Assoc. Inc.	212-682-5240
Group 4	212-249-4446
Heyman, Ken	212-421-4512
Image Bank	212-371-3636
Keystone Press Agency Inc.	212-924-8123
Kramer, Joan	212-224-1758
Harold M. Lambert Studios	212-685-0122
Lewis, Frederick	212-685-0122
Long, Joe	212-249-4446
Magnum Photos Inc.	212-541-7570
Maisel, Jay	212-431-5013
Mayflower Photo Library Inc.	212-753-3125
Memory Shop Inc.	212-473-2404
Mercier, Louis	212-972-1701
Monkmeyer Press Photo Agency	212-755-1715
Movie Star News	212-982-8364
Nancy Palmer Photo Agency	212-683-9309
Penguin Photo	212-758-7328
People and Places Int'l. Inc.	212-986-6131
Photo Researchers Inc.	212-758-3420
Photo Trends	212-279-2995
Photo World Inc.	212-777-4214
Photofile Ltd.	212-989-0500
Photography for Industry	212-757-9255
Plessner Int'l.	212-686-2444
Roberts, H. Armstrong	212-682-6626
Seidman, Sy	212-982-4318
Shostal Assoc.	212-687-0696
Sports Illustrated 91 (V1•98)	**212-841-3663**
Stock Photos Unlimited Inc.	212-421-8980
Stock Shop	212-436-0601
Sygma Photo News	212-595-0077
Taurus Photos	212-683-4025
Three Lions Inc.	212-691-8640
Time-Life Picture Agency	212-586-1212
Underwood & Underwood	212-586-5910
United Press Int'l. News Pictures	212-682-0400
Wide World Photos Inc.	212-262-6300
Woodfin Camp & Assoc. 104 (V1•99)	**212-355-1855**

NORTHEAST & SOUTHEAST

Boston Stock Photographs/Boston	617-266-2573
Chandoha, Walter	
10 (V1•12) Annandale NJ	**201-782-3666**
Lensman Photos Ltd./Wash. DC	202-333-3850
Phelps & Thompson Inc./Atlanta	404-881-1925
Roberts, H. Armstrong/Phila.	215-386-6300
Symmes, Ed/Atlanta	404-873-5721
Wide World Photos Inc./Boston	617-357-8104
Woodfin Camp & Assoc. 104 (V1•99)	**202-466-3830**

MIDWEST

Artstreet/Chicago	312-664-3049
Brandt & Assoc./Barrington Hills IL	312-428-6363
Campbell Stock Photo Service/Detroit	313-559-6870
Candida Photos Inc./Chicago	312-736-5544
Collectors Series/Chicago	312-427-5311
Gress-Rupert/Chicago	312-642-1188
Hedrich-Blessing/Chicago	312-321-1151
Historical Picture Services/Chicago	312-346-0599
Ibid Inc./Chicago	312-644-0515
Image Bank/Chicago	312-944-0424
Lambert, Harold M./Chicago	312-332-5350
Redman, Lee F./Chicago	312-973-3441
Piles & Files of Photos/Chicago	312-642-7110
Van Cleve Stock Photography Inc./Chicago	312-764-2440
Webb Photos/St. Paul MN	612-647-7317
Zehrt, Jack/St. Louis MO	314-773-2298

SOUTHWEST & WEST

After Image/LA	213-663-8211
American Stock Photos/LA.	213-469-3908
Morton Beebe & Assoc./SF	415-362-3530
Image Bank West/SF	415-398-2242
McLaughlin, Herb & Dorothy/Phoenix AZ.	602-258-6551
Running Productions/Flagstaff, AZ	602-774-2923
Visual Media Inc./Reno, NV	702-322-8868
Weckler's World/SF	415-982-1750

SPECIALTIES

These charts are intended to simplify using AMERICAN SHOWCASE. Individuals whose work is displayed in Volume Two and/or Volume One are listed alphabetically; photographers are also listed by geographic region. Almost every artist will accept assignments outside their regions. Some photographers requested their pages be included in the New York Metropolitan section, regardless of where they actually live and are listed in this chart.

Page numbers refer to Volume Two; those in parentheses refer to Volume One.

To the right of each name are columns identifying common specialties, with dots indicating which ones apply to each individual. Many artists or firms are generalists and have indicated most of the specialties, or none of the specialties. Others have noted just two or three of particular interest or expertise and assumed clients will realize they can handle assignments in additional specialties as well.

Some individuals have less common specialties. These are identified in the miscellaneous column by numbers that refer to the legends at the end of each chart.

PHOTOGRAPHY

NEW YORK METROPOLITAN AREA

Name	Advertising	Corporate/Annual report	Editorial	Still life	Photo Illustration	Food	Fashion/Beauty	Other	
Peter Arnold Inc. (V1•97)	●	●	●				●	2,7,9 12,13	
Bill Ashe 1	●	●		●	●				
David Attie (V1•1)							●		
Robert Barclay (V1•2)					●		●	●	
Philip Bennett 2	●	●	●				●	●	
Alan Bernstein 3 (V1•3)	●		●				●		
Barbara Bordnick 6	●	●	●				●	●	8
Mathew Brady 7 (V1•6)	●		●	●	●				
James Broderick 8	●		●					5	
Nancy Brown (V1•8)	●		●				●	●	
Bill Cadge (V1•9)	●		●				●		
Ed Centner (V1•10)	●						●	8	
Walter Chandoha 10 (V1•12)	●		●					2, 7	
George Cochran 12	●	●		●	●				
Robert Colton 13 (V1•14)	●	●	●						
Cosimo 14	●		●	●	●	●			
Cross/Francesca 15							●		
Henri Dauman 16	●	●	●				●	1,6, 8,13	
Darwin Davidson 17 (V1•15)								6	
Dick Davis (V1•16)	●	●	●				●	13	
Richard Davis 18	●		●				●	●	
Ronald DeMilt (V1•17)				●			●	●	8, 13
Manuel Denner (V1•18)				●	●	●		2	
Leo deWys Inc. 20	●	●	●	●	●	●	●	12	
Mel Dixon 21	●		●				●		
Phoebe Dunn 22	●	●	●				●	4, 7	
Anthony Edgeworth (V1•19)	●	●	●				●	●	
Robert Farber 23							●	●	7
Bill Farrell 24 (V1•20)	●	●					●	●	
Carl Fischer 26									
Robin Forbes 28		●	●				●	4	
Al Francekevich 29		●		●	●		●		
Dick Frank (V1•21)	●	●	●	●					
Jerry Friedman 30		●			●				
David Funt (V1•22)						●	●		

Name	Advertising	Corporate/Annual report	Editorial	Still life	Photo Illustration	Food	Fashion/Beauty	Other
Ed Gallucci 32	●		●	●	●		●	11
Al Giese 33	●	●					●	13
André Gillardin 34 (V1•23)	●	●	●	●	●			
Gary Gladstone 36 (V1•25)		●						
Burt Glinn 37 (V1•26)	●	●	●				●	13
Mitchel Gray 38							●	
Stephen Green-Armytage 39 (V1•28)	●		●		●			3, 4, 12,13
Hank Gropper (V1•29)			●	●			●	
George Haling (V1•30)	●	●	●				●	7
Haviland Photography 40	●		●				●	●
Bill Helms 42								
Ryszard Horowitz 45 (V1•34)	●		●	●			●	11
Ted Horowitz 46 (V1•35)	●	●	●					
Rosemary Howard 48	●		●				●	●
Bob Huntzinger 49	●		●				●	●
Shig Ikeda 50	●		●	●	●			
Marty Jacobs 51	●			●	●	●	●	
Janeart Ltd. (V1•36)	●	●						
Richard Jeffery (V1•37)								
Armen Kachaturian (V1•39)							●	6, 8
Art Kane 52 (V1•40)	●	●	●				●	●
Alan Kaplan (V1•42)							●	
James Karales (V1•43)			●	●				
Malcolm Kirk (V1•44)	●	●	●					
Palma Kolansky 53 (V1•45)	●						●	
Mark Kozlowski 54	●		●				●	
Whitney Lane (V1•46)	●	●	●				●	
David Langley (V1•47)							●	
Gilles Larrain 55 (V1•48)	●		●				●	3,13
Phillip Leonian (V1•50)	●		●				●	11
Allen Lieberman 57	●	●	●	●	●			
Christopher Little 58	●		●				●	
Klaus Lucka 59	●		●				●	●
Dick Luria 60 (V1•52)	●	●						
Phil Marco 63 (V1•54)	●		●			●		
John Marmaras 64 (V1•55)		●	●				●	13

Name	Advertising	Corporate/Annual report	Editorial	Still life	Photo Illustration	Food	Fashion/Beauty	Other
Masca (V1•57)				•			•	
Tosh Matsumoto 65	•			•	•			
Susan McCartney 66	•		•					13
John Chang McCurdy (V1•58)	•	•				•		
Lowell McFarland (V1•59)	•		•			•		
Louis Mervar 67 (V1•60)	•			•	•	•		
Robert Monroe (V1•61)	•		•	•		•	•	
Gordon Munro (V1•62)	•		•			•		
J. Barry O'Rourke 68 (V1•64)	•		•					
Charles Orrico 69 (V1•65)	•	•	•					
Paccione 70	•	•	•	•		•	•	
Peter Papadopolous 72	•					•		
Bruce Pendleton 73 (V1•66)	•	•		•				
Allan Philiba (V1•67)	•	•	•			•		13
Henry Ries 74 (V1•68)				•		•		
Stan Ries (V1•69)		•		•				3, 6
William Rivelli 75 (V1•70)	•	•				•		
Lawrence Robins 76 (V1•72)	•					•		8
Ben Rose 77						•		11
Stewart Roth 78	•			•				
Mary-Laurence Rubin (V1•73)						•		7
Henry Sandbank (V1•74)				•				
Fred Schulze 79								
Victor Scocozza (V1•75)	•			•	•			
Herb Sculnick 81								
Sheldon Secunda (V1•78)	•		•			•		
Barry Seidman 84 (V1•79)	•							
Sepp Seitz 85 (V1•80)			•					
Guy Sherman 86	•		•	•	•		•	
Carl Shiraishi 88	•		•	•	•		•	•
Ulf Skogsbergh (V1•81)	•			•				
Michael Skott (V1•82)	•			•				
Gordon E. Smith 89				•	•	•		
J. Frederick Smith (V1•83)							•	•
Howard Sochurek 90	•	•	•					
Sports Illustrated 91 (V1•98)	•		•					12
Joe Standart 92		•	•			•		13
Charles Steiner 93	•	•						
Lynn St. John (V1•84)	•	•	•	•				
Bob Stern 94	•	•		•			•	8, 11
Ben Swedowsky 95 (V1•85)				•	•			
Ken Tannenbaum 96	•			•	•	•	•	•
Michel Tcherevkoff 97 (V1•86)	•			•				
Pete Turner 98 (V1•87)	•			•	•		•	
Andrew Unangst (V1•88)				•			•	
Catherine Ursillo (V1•89)			•	•				
Peter Vaeth 100	•			•				
James Vicari 102 (V1•90)	•					•		
Michael Waine (V1•91)	•					•		
Frank White 103	•			•				
Larry Williams (V1•92)				•		•	•	
Les Wollam (V1•93)			•				•	
Woodfin Camp Inc. 104 (V1•99)	•	•	•					7, 8, 13
Herbert Woodward 105	•			•	•	•		
Mike Yamaoka 106	•	•	•	•	•	•	•	
Tony Zappa 107 (V1•94)	•							

NORTHEAST

Name	Advertising	Corporate/Annual report	Editorial	Still life	Photo Illustration	Food	Fashion/Beauty	Other
Adams Studio (V1•103) Washington DC						•	•	•
Chuck Bell 111 Pittsburgh	•	•	•	•	•	•	•	
Burgess Blevins 4 (V1•4) Baltimore			•				•	•
Fred Collins 112 Boston								
Jan Faul 25 Arlington VA	•	•	•				•	
Michael Furman 31 (V1•104) Philadelphia	•					•	•	
Steve Grohe 113 (V1•105) Boston	•	•						
Steve Hansen (V1•106) Boston	•	•	•				•	1
H. Scott Heist 41 Emmaus PA	•	•		•				
John Holt 114 Boston	•	•	•	•	•	•		
Ralph King 115 (V1•107) Boston	•	•	•	•	•		•	
David Leveille 56 Rochester NY								
Weaver Lilley 116 Philadelphia				•			•	
John Neubauer 117 (V1•108) Arlington VA	•	•	•	•	•	•	•	3, 6, 8, 13
Don Nichols 118 Rochester NY	•	•		•	•	•		

	Advertising	Corporate/Annual report	Editorial	Still life	Photo illustration	Food	Fashion/Beauty	Other
Northlight Group 119 Newark NJ	●	●	●	○		●		
Ted Polumbaum 120 Lincoln MA	●	●	●			○		
Philip Porcella (V1•109) Boston	●							
Steve Schmitt (V1•110) Boston	●	●	●					
Harry Seawell 82 (V1•76) Parkersburg WV	●	●	●	○		○		1,3,8, 10,13
David Sharpe 121 Washington DC	●	●		○	○		○	6
Simpson/Flint (V1•111) Baltimore	●							
SOUTHEAST								
Faustino 125 Coral Gables FL	●	●					○	13
Bob Gelberg (V1•115) Miami	●	●						1
William Hines (V1•116) Sarasota FL	●	●				○		
Ralph Holland (V1•117) High Point NC	●	●		○		○	○	
Bill Hyman 126 Atlanta	●	●	●	○	○	○	○	
Parish Kohanim 127 Atlanta								
Randy Miller 128 Miami								
Tim Olive 129 Atlanta								
Robert T. Panuska 130 (V1•118) Miami	●			○		○		
MIDWEST								
Jon Bruton 133 St. Louis MO								
John Cascarano 134 Chicago						○		
Ralph Cowan 135 (V1•121) Chicago	●	●		○	○	○		
Richard Epperson 136 Chicago	●			○	○	○		11
Gabriel 137 Chicago								
Getsug/Anderson 138 Minneapolis								
Bart Harris (V1•32, 123) Chicago	●					○		
Hickson-Bender Photography 140 Waldo OH	●	●	●	○		○		
Corson Hirschfeld 44 (V1•33) Cincinnati OH	●	●	●			○	○	
Dick Jones 142 Chicago	●	●	●	○	○	○	○	
Mel Kaspar 143 (V1•124) Chicago			●	○		○		
James Kilkelly (V1•126) Minneapolis		●		○		○		
Dennis Manarchy (V1•127) Chicago				○				
Manning Studios 144 Cleveland	●	●		○	○	○	○	5
Jim Marvy 145 Hopkins MN	●		●	○	○	○		
Merle Morris 146 Minneapolis	●	●	●	○	○	○		5
Jean Moss (V1•128) Chicago						○	○	8
Picture Place 147 (V1•129) St. Louis MO	●	●	●	○	○	○		
Charles Schridde 148 Madison Heights MI	●		●			○		○
Tim Schultz (V1•130) Chicago				○		○		
Steve Umland (V1•131) Golden Valley MN	●			○		○	○	
John Welzenbach 149 Chicago								
Stu West 150 Minneapolis								
SOUTHWEST								
Constance Ashley 153 Dallas	●		●			○	○	
Allen Birnbach (V1•135) Denver	●		●					
Gerald Bybee 154 Salt Lake City UT	●	●		○		○	○	
Nicholas De Sciose 19, 155 (V1•136) Denver			●				○	
Kirkley Photography 156 Dallas	●	●	●	○	○	○	○	
Don Klumpp (V1•137) Houston			●			○	○	
Bob Shaw (V1•138) Dallas	●	●	●	○			○	
Michal Utterback 157 Ogden UT								
Shorty Wilcox 158 Breckenridge CO	●	●	●					12
WEST COAST								
Erik Arnesen 163 SF	●	●	●			○		
David Barnes 164 Seattle	●	●	●					
Dave Bartruff (V1•141) San Anselmo CA		●				○		
Becker Bishop Studios (V1•142) Santa Clara CA	●			○				
Jim Blakeley 165 (V1•143) SF	●			○	○	○		
Lee Blodget (V1•144) SF	●			○		○		
Gary Braasch (V1•145) Vancouver WA		●						7, 13
Ralph Chandler 167 LA								
Mark Chester (V1•146) SF			●					
George de Gennaro 169 (V1•162) LA	●			○		○		
Douglas Dubler (V1•164) Malibu CA	●			○			○	○
Tom Engler 170 Hollywood CA	●		●	○		○	○	
Marc Feldman 171 Hollywood CA	●		●	○		○		
Richard Yutaka Fukuhara 172 Signal Hill CA								
Robert Gardner 173 LA								
Enrique Gascon (V1•165) LA							○	○
Paul Ben Gersten (V1•166) LA	●			○		○		6
Artie Goldstein 174 (V1•167) LA	●							
Larry Dale Gordon 175 (V1•168) LA								
Dennis Gray (V1•147) SF	●	●		○				

	Advertising	Corporate/Annual report	Editorial	Still life	Photo Illustration	Food	Fashion/Beauty	Other
Bruce Harlow 176 Seattle								
Richard Hixson (V1•150) SF				●		●		
H. Lee Hooper (V1•169) Malibu CA	●	●						
Charles Kemper 177 SF								
Alan Krosnick 178 SF	●			●	●			
Chuck Kuhn (V1•151) Seattle						●	●	
Jack Laxer (V1•170) Pacific Palisades CA	●	●		●	●	●		3, 9, 10
Rudy Legname (V1•152) SF	●	●		●		●	●	
Jack Luxon (V1•153) Portland OR							●	
Marv Lyons 179 (V1•171) LA	●	●	●			●	●	
Maddocks/Allan 180 LA	●	●		●		●		
George Meinzinger 182 LA								
Grant Mudford 184 LA	●	●	●				●	
David Muench 185 Santa Barbara CA	●	●	●			●	●	
Suzanne Nyerges 186 LA						●	●	
Tomas O'Brien 187 LA	●			●	●			
Steve Rahn 188 SF								

	Advertising	Corporate/Annual report	Editorial	Still life	Photo Illustration	Food	Fashion/Beauty	Other
Ken Rogers (V1•172) Beverly Hills CA	●	●	●				●	
David Scharf (V1•173) LA								9, 10
George Selland 189 SF	●							
Jay Silverman 190 (V1•175) LA	●	●	●	●		●	●	
Craig Simpson (V1•154) SF	●					●		
Scott Slobodian 191 LA	●	●						
Walter Swarthout 192 (V1•156) SF				●	●	●	●	
Stanley Tretick (V1•112) Studio City CA	●	●	●					
John Terence Turner 193 Seattle								
Michelle Vignes (V1•158) SF		●	●					
James Wood (V1•176) LA							●	
Robert Wortham 195 LA	●	●		●		●	●	
Tom Zimberoff 196 Beverly Hills CA								
Dick Zimmerman (V1•179) LA	●		●			●	●	
John Zimmerman 108, 198 (V1•180) Beverly Hills CA	●	●	●			●	●	
Nikolay Zurek 199 Berkeley CA	●	●	●	●	●			

LEGEND

1 Aerial
2 Animals
3 Architecture
4 Children
5 Film/Audio visual
6 interiors
7 Nature
8 People
9 Photomicrography
10 Scientific/Medical
11 Special effects
12 Sport
13 Travel

ILLUSTRATION

Name	Advertising	Editorial	Corporate/Annual report	Other
Robert Altemus (V1•183) NYC			●	●
Richard Amsel (V1•184) NYC	●	●		
Richard Bangham (V1•185) Takoma Park MD	●	●	●	
Miggs Burroughs 203 (V1•186) Westport CT	●	●		
Seymour Chwast (V1•187) NYC	●	●		3, 4
Christopher Corey 204 SF	●	●		3, 4, 5
Bill Devlin (V1•188) NYC	●	●		
Stanislaw Fernandes (V1•189) NYC	●	●		
David Grove (V1•190) SF	●	●	●	
Mark Hess (V1•191) Greenwich CT	●	●	●	3
Richard Hess (V1•191) Roxbury CT	●	●	●	3
David Jarvis (V1•192) Greenwich CT	●	●	●	
Hedda Johnson (V1•193) NYC	●	●	●	
Juggernaut (V1•194) NYC	●	●	●	3
Les Katz (V1•195) NYC				
Joel Levirne (V1•196) NYC	●		●	
Charles Lilly (V1•197) NYC	●	●		2
Benton Mahan 205 Chesterville OH	●	●		
Terrence Meagher (V1•198) Palo Alto CA		●		2
Geoffrey Moss 206 NYC				
Bill Nelson (V1•199) Richmond VA	●	●	●	
Pitt Studios (V1•200) Cleveland, Pittsburgh	●	●	●	3
John Rutherford (V1•201) Mill Valley CA	●			
Robert Strimban (V1•202) NYC	●	●		6
Robert Tanenbaum (V1•203) Tarzana CA	●	●		5
Kim Whitesides (V1•204) NYC	●	●		5
Rowland Wilson (V1•205) NYC	●	●		1

LEGEND

1 Animation Design
2 Books
3 Design
4 Lettering
5 Portraits
6 Sculpture

GRAPHIC DESIGN

Name	Annual reports	Corporate literature	Corporate identity	Packaging	Advertising	Editorial design	Other
John Brinkmann Design 207 LA	●	●	●	●	●		3
Irene Charles Assoc. 208 NYC		●	●	●			
Corporate Annual Reports 209 NYC	●	●					
Fred Feucht Design 210 NYC			●				
Fulton & Partners 211 NYC			●				
Robert Gersin & Assoc. 212 NYC	●	●	●	●			1, 3
Tony Gianti 213 Rockleigh NJ			●	●	●		
Graphic Designers Inc. 214 LA	●	●	●	●	●	●	4
Johnson & Simpson 215 Newark NJ	●	●	●	●			
Herb Lubalin Assoc. 216 NYC	●	●	●	●	●	●	
Manning Studios 220 Cleveland	●	●	●	●	●		1
Irving Miller 221 NYC	●	●	●	●	●		
James Potocki & Assoc. 222 LA		●	●				2
Push Pin Studios 224 NYC	●	●	●	●	●	●	4
Arnold Saks Design 225 NYC	●	●	●				
John Waters Assoc. 226 NYC	●	●	●			●	
Roger Zimmerman 228 NYC	●	●	●	●	●	●	

LEGEND

1 Audio Visual
2 Computer effects
3 Displays
4 Illustration

INDEX/DIRECTORY

Page numbers following the names
refer to Volume Two, except those in
parentheses which refer to Volume One.

THIS BOOK WAS SET BY BAUMWELL

because superior design requires the typographic craftsmanship that understands and appreciates it ...at prices that keep it a very affordable "luxury."

Robert Gardner 173
800 South Citrus Avenue
Los Angeles, California 90036
(213) 931-1108

Enrique Gascon (V1•165)
143 South Edgemont
Los Angeles, California 90004
(213) 383-9157

Bob Gelberg (V1•115)
1465 South Miami Avenue
Miami, Florida 33130,
(305) 374-6601

Paul Gersten (V1•166)
428½ South San Vicente Boulevard
Los Angeles, California 90048
(213) 652-6111

Getsug/Anderson 138
127 North Seventh Street
Minneapolis, Minnesota 55403
(612) 332-7007

Al Giese 33
119 Fifth Avenue
New York, New York 10003
(212) 477-3096

André Gillardin 34 (V1•23)
5 East 19th Street
New York, New York 10003
(212) 673-9020

Gary Gladstone 36 (V1•25)
237 East 20th Street
New York, New York 10003
(212) 982-3333

Burt Glinn 37 (V1•26)
41 Central Park West
New York, New York 10023
(212) 877-2210

Artie Goldstein 174 (V1•167)
1021½ North La Brea
Los Angeles, California 90038
(213) 874-6322

Larry Dale Gordon 175 (V1•168)
2047 Castilian Drive
Los Angeles, California 90068
(213) 874-6318

Dennis Gray (V1•147)
185 Berry Street
Room 2860
San Francisco, California 94107
(415) 546-6536

Mitchel Gray 38
169 East 86th Street
New York, New York 10028
(212) 427-2287

Stephen Green-Armytage 39 (V1•28)
171 West 57th Street
New York, New York 10019
(212) 247-6314

Steve Grohe 113 (V1•105)
186 South Street
Boston, Massachusetts 02111
(617) 523-6655

Hank Gropper (V1•29)
156 Fifth Avenue
New York, New York 10010
(212) 243-5413

George Haling (V1•30)
105 East 28th Street
New York, New York 10016
(212) 683-2558

Steve Hansen (V1•106)
84 Berkeley Street
Boston, Massachusetts 02116
(617) 426-6858

Bruce Harlow 176
2214 Second Avenue
Seattle, Washington 98121
(206) 622-4843

Bart Harris (V1•32, 123)
70 West Hubbard Street
Chicago, Illinois 60610
(312) 751-2977

Haviland Photography 40
34 East 23rd Street
New York, New York 10010
(212) 260-3670

H. Scott Heist 41
242 Main Street
Emmaus, Pennsylvania 18049
(215) 965-5479

Bill Helms 42
1175 York Avenue
New York, New York 10021
(212) 759-2079

Hickson-Bender 140
Box 201, 281 Klingel Road
Waldo, Ohio 43356
(614) 726-2470

William Hines (V1•116)
P.O. Box 2763
Sarasota, Florida 33578
(813) 371-2738

Corson Hirschfeld 44 (V1•33)
316 West Fourth Street
Cincinnati, Ohio 45202
(513) 241-0550

Richard Hixson (V1•150)
333 Fifth Street
San Francisco, California 94107
(415) 495-0558

Ralph Holland (V1•117)
500 East Farriss Avenue
High Point, North Carolina 27262
(919) 273-5425
(919) 882-0057

John Holt 114
129 South Street
Boston, Massachusetts 02111
(617) 426-7262

H. Lee Hooper (V1•169)
P.O. Box 515
Malibu, California 90265
(213) 457-3363

Ryszard Horowitz 45 (V1•34)
103 Fifth Avenue
New York, New York 10003
(212) 243-6440

Ted Horowitz 46 (V1•35)
8 West 75th Street
New York, New York 10023
(212) 595-0040

Rosemary Howard 48
902 Broadway
New York, New York 10010
(212) 473-5552

Robert Huntzinger 49
3 West 18th Street
New York, New York 10011
(212) 675-1710

Bill Hyman 126
689 Antone Street, N.W.
Atlanta, Georgia 30318
(404) 355-8069

Shig Ikeda 50
119 West 22nd Street
New York, New York 10011
(212) 924-4744

Marty Jacobs 51
34 East 23rd Street
New York, New York 10010
(212) 475-1160

Janeart Ltd. (V1•36)
154 West 57th Street
New York, New York 10019
(212) 765-1121

Richard Jeffery (V1•37)
119 West 22nd Street
New York, New York 10011
(212) 255-2330

Dick Jones 142
325 West Huron Street
Chicago, Illinois 60610
(312) 642-0242

Armen Kachaturian (V1•39)
10 East 23rd Street
New York, New York 10010
(212) 533-3550

Art Kane 52 (V1•40)
1181 Broadway
New York, New York 10001
(212) 679-2016

Alan Kaplan (V1•42)
7 East 20th Street
New York, New York 10003
(212) 982-9500

James Karales (V1•43)
147 West 79th Street
New York, New York 10024
(212) 799-2483

Mel Kaspar 143 (V1•124)
2033 North Orleans
Chicago, Illinois 60614
(312) 528-7711

Charles Kemper 177
74 Tehama Street
San Francisco, California 94105
(415) 495-6468

James Kilkelly (V1•126)
528 Hennepin Avenue
Fifth Floor
Minneapolis, Minnesota 55403
(612) 339-2121
(612) 871-6682

Ralph King 115 (V1•107)
103 Broad Street
Boston, Massachusetts 02110
(617) 426-3565

Malcolm Kirk (V1•44)
37 West 53rd Street
New York, New York 10019
(212) 541-7999

Kirkley Photography 156
1112 Ross Avenue
Dallas, Texas 75202
(214) 651-9701

Don Klumpp (V1•137)
2619 Joanel
Houston, Texas 77027
(713) 627-1022

Parish Kohanim 127
10 Biltmore Place, N.W.
Atlanta, Georgia 30308
(404) 892-0099

Palma Kolansky 53 (V1•45)
24 East 21st Street
New York, New York 10010
(212) 673-3553

Mark Kozlowski 54
24 East 21st Street
New York, New York 10010
(212) 475-7133

Alan Krosnick 178
215 Second Street
San Francisco, California 94105
(415) 957-1520

Chuck Kuhn (V1•151)
206 Third Avenue South
Seattle, Washington 98104
(206) 624-4706

Whitney Lane (V1•46)
210 East 47th Street
New York, New York 10017
(212) 838-6520
(914) 762-5335

David Langley (V1•47)
536 West 50th Street
New York, New York 10019
(212) 581-3930

Gilles Larrain 55 (V1•48)
95 Grand Street
New York, New York 10013
(212) 925-8494

Jack Laxer (V1•170)
16952 Dulce Ynez Lane
Pacific Palisades, California 90272
(213) 459-1213

Rudy Legname (V1•152)
389 Clementina Street
San Francisco, California 94103
(415) 777-9569

Phillip Leonian (V1•50)
170 Fifth Avenue
New York, New York 10010
(212) 989-7670

David J. Leveille 56
Northlight Studios
671 Panorama Trail West
Rochester, New York 14625
(716) 381-5341

Allen H. Lieberman 57
126 West 22nd Street
New York, New York 10011
(212) AL5-4646

Weaver Lilley 116
125 South 18th Street
Philadelphia, Pennsylvania 19103
(215) 567-2881

Christopher Little 58
New York, New York
(212) 691-1024

Klaus Lucka 59
35 West 31st Street
New York, New York 10001
(212) 594-5910

Dick Luria 60 (V1•52)
5 East 16th Street
New York, New York 10003
(212) 929-7575

Jack Luxon (V1•153)
107 Northwest Fifth, #213
Portland, Oregon 97209
(503) 227-0929

Marv Lyons 179 (V1•171)
7900 Woodrow Wilson Drive
Los Angeles, California 90046
(213) 650-8100

Maddocks/Allan 180
4766 Melrose Avenue
Los Angeles, California 90029
(213) 660-1321

Dennis Manarchy (V1•127)
125 West Hubbard
Chicago, Illinois 60610
(312) 828-9117

Manning Studios 144,220
2115 Chester Avenue
Cleveland, Ohio 44114
(216) 861-1525
(216) 399-8725
(513) 621-6959

Phil Marco 63 (V1•54)
104 Fifth Avenue
New York, New York 10011
(212) 929-8082

John Marmaras 64 (V1•55)
235 Seventh Avenue
New York, New York 10011
(212) 741-0212

Jim Marvy 145
41 12th Avenue North
Hopkins, Minnesota 55343
(612) 935-0307

Masca (V1•57)
100 Fifth Avenue
New York, New York 10011
(212) 675-2580

Tosh Matsumoto 65
30 East 23rd Street
New York, New York 10010
(212) 673-8100

Susan McCartney 66
902 Broadway, #1608
New York, New York 10010
(212) 868-3330

John Chang McCurdy (V1•58)
156 Fifth Avenue
New York, New York 10010
(212) 243-6949

Lowell McFarland (V1•59)
13 East 22nd Street
New York, New York 10010
(212) 674-5566

George Meinzinger 182
968 North Vermont
Los Angeles, California 90029
(213) 666-4640

Louis Mervar 67 (V1•60)
29 West 38th Street, 16th Floor
New York, New York 10018
(212) 354-8024

Randy Miller 128
6100 Southwest 92nd Street
Miami, Florida 33156
(305) 667-5765

Robert Monroe (V1•61)
255 West 90th Street
New York, New York 10024
(212) 879-2550

Merle Morris 146
614 Fifth Avenue South
Minneapolis, Minnesota 55415
(612) 338-7829

Jean Moss (V1•128)
222 West Ontario
Chicago, Illinois 60610
(312) 787-0260

Grant Mudford 184
5619 West 4th Street, #2
Los Angeles, California 90036
(213) 936-9145

David Muench 185
P.O. Box 30500
Santa Barbara, California 93105
(805) 967-4488

Gordon Munro (V1•62)
381 Park Avenue South
New York, New York 10016
(212) 889-1610

John Neubauer 117 (V1•108)
1525 South Arlington Ridge Road
Arlington, Virginia 22202
(703) 920-5994

Don Nichols 118
1241 University Avenue
Rochester, New York 14607
(716) 275-9666

Northlight Group 119
45 Academy Street
Newark, New Jersey 07102
(201) 624-3990

Suzanne Nyerges 186
413 South Fairfax Avenue
Los Angeles, California 90036
(213) 938-0151

Tomas O'Brien 187
450 South La Brea
Los Angeles, California 90036
(213) 933-2249
(213) 938-2008

Tim Olive 129
Atlanta
(404) 872-0500

J. Barry O'Rourke 68 (V1•64)
1181 Broadway
New York, New York 10001
(212) 686-4224

Charles J. Orrico 69 (V1•65)
72 Barry Lane
Syosset, New York 11791
(516) 364-2257
(212) 490-0980

Paccione 70
115 East 36th Street
New York, New York 10016
(212) 532-2701

Robert T. Panuska 130 (V1•118)
c/o Al Forsyth
521 Madison Avenue
New York, New York 10022
(212) 752-3930

Peter Papadopolous 72
78 Fifth Avenue
New York, New York 10011
(212) 675-8830

Bruce Pendleton 73 (V1•66)
485 Fifth Avenue
New York, New York 10017
(212) 986-7381

Allan Philiba (V1•67)
3408 Bertha Drive
Baldwin, New York 11510
(212) 371-5220
(516) 623-7841

The Picture Place 147 (V1•129)
689 Craig Road
St. Louis, Missouri 63141
(314) 872-7506
Jim Clarke

Ted Polumbaum 120
Laurel Drive
Lincoln, Massachusetts 01773
(617) 259-8723

Philip Porcella (V1•109)
109 Broad Street
Boston, Massachusetts 02110
(617) 426-3222

Stephen Rahn 188
81 Clementina
San Francisco, California 94105
(415) 495-3556

Henry Ries 74 (V1•68)
204 East 35th Street
New York, New York 10016
(212) 689-3794

Stan Ries (V1•69)
48 Great Jones Street
New York, New York 10012
(212) 533-1852

William Rivelli 75 (V1•70)
24 East 21st Street
New York, New York 10010
(212) 254-0990

Lawrence Robins 76 (V1•72)
5 East 19th Street
New York, New York 10003
(212) 677-6310

Ken Rogers (V1•172)
P.O. Box 3187
Beverly Hills, California 90212
(213) 553-5532

Ben Rose 77
91 Fifth Avenue
New York, New York 10003
(212) 691-5270

Stewart Roth 78
23 East 21st Street
New York, New York 10010
(212) 673-8370

Mary-Laurence Rubin (V1•73)
65 West 55th Street
New York, New York 10019
(212) 246-9018

Henry Sandbank (V1•74)
105 East 16th Street
New York, New York 10003
(212) 674-1151

David Scharf (V1•173)
2100 Loma Vista Place
Los Angeles, California 90039
(213) 666-8657

Steve Schmitt (V1•110)
29 Newbury Street
Boston, Massachusetts 02116
(617) 247-3991

Charles Schridde 148
600 Ajax Drive
Madison Heights, Michigan 48071
(313) 589-0111

Tim Schultz (V1•130)
2000 North Clifton
Chicago, Illinois 60614
(312) 871-4488

Fred Schulze 79
163 West 23rd Street
New York, New York 10011
(212) 242-0930
(212) 242-0480

Victor Scocozza (V1•75)
117 East 30th Street
New York, New York 10016
(212) 675-0700

Herb Sculnick 81
133 Fifth Avenue
New York, New York 10003
(212) 777-3232

Harry Seawell 82 (V1•76)
Suite 3, 215 Eleventh Street
Parkersburg, West Virginia 26101
(304) 485-4481

Sheldon Secunda (V1•78)
112 Fourth Avenue
New York, New York 10003
(212) 477-0241

Barry Seidman 84 (V1•79)
119 Fifth Avenue
New York, New York 10003
(212) 838-3214

Sepp Seitz 85 (V1•80)
381 Park Avenue South, #1216
New York, New York 10016
(212) 683-5588
(516) 367-9675

STOCK PHOTOGRAPHY

Peter Arnold, Inc. (V1•97)
1500 Broadway
New York, New York 10036
(212) 840-6928

Leo de Wys, Inc. 20
60 East 42nd Street
New York, New York 10017
(212) 986-3190

Sports Illustrated 91 (V1•98)
Room 1919
Time & Life Building
New York, New York 10020
(212) 841-3663
(212) 841-2803
(212) 841-2898

Woodfin Camp & Associates 104 (V1•99)
415 Madison Avenue
New York, New York 10017
(212) 355-1855
(202) 466-3830

ILLUSTRATORS

Robert Altemus (V1•183)
401 East 64th Street
New York, New York 10021
(212) 861-5080

Richard Amsel (V1•184)
353 East 83rd Street
New York, New York 10028
(212) 628-5960

Richard Bangham (V1•185)
7115 Sycamore Avenue
Takoma Park, Maryland 20012
(301) 270-6986

Miggs Burroughs 203 (V1•186)
Box 6
Westport, Connecticut 06880
(203) 227-9667

Seymour Chwast 224 (V1•187)
Push Pin Studios
207 East 32nd Street
New York, New York 10016
(212) 532-9247

Christopher Corey 204
253 Columbus Avenue
San Francisco, California 94133
(415) 421-0637

Bill Devlin (V1•188)
301 East 47th Street
New York, New York 10017
(212) 935-9436

Stanislaw Fernandes (V1•189)
35 East 12th Street
New York, New York 10003
(212) 533-2648

David Grove (V1•190)
382 Union Street
San Francisco, California 94133
(415) 433-2100

Mark Hess (V1•191)
121 East Middle Patent Road
Greenwich, Connecticut 06830
(212) 421-0050

Richard Hess (V1•191)
Southover Farm
Roxbury, Connecticut 06783
(203) 354-2921

David Jarvis (V1•192)
33 Windy Knolls
Greenwich, Connecticut 06830
(203) 531-8339

Hedda Johnson (V1•193)
2 Fifth Avenue
New York, New York 10011
(212) 737-3236

Juggernaut (V1•194)
265 East 78th Street, #1E
New York, New York 10021
(212) 691-8181
(212) 988-9049

Les Katz (V1•195)
367 Sackett Street
Brooklyn, New York 11231
(212) 625-4741

Joel Levirne (V1•196)
Graphic Images, Ltd.
151 West 46th Street
New York, New York 10036
(212) 869-8370

Charles Lilly (V1•197)
56 West 82nd Street, #15
New York, New York 10024
(212) 873-3608

Benton Mahan 205
P.O. Box 66
Chesterville, Ohio 43317
(419) 768-2204

Terrence Meagher (V1•198)
212 High Street
Palo Alto, California 94301
(415) 326-5170

Geoffrey Moss 206
315 East 68th Street
New York, New York 10021
(212) 472-9474

Bill Nelson (V1•199)
1402 Wilmington Avenue
Richmond, Virginia 23227
(804) 358-9637

Pitt Studios (V1•200)
1370 Ontario Street
Cleveland, Ohio 44113
(216) 241-6720
(412) 261-0460

John Rutherford (V1•201)
55 Alvarado Avenue
Mill Valley, California 94941
(415) 383-1788

Robert Strimban (V1•202)
349 West 20th Street
New York, New York 10011
(212) 243-6965

Robert Tanenbaum (V1•203)
5505 Corbin Avenue
Tarzana, California 91356
(213) 345-6741

Kim Whitesides (V1•204)
1 West 85th Street
New York, New York 10024
(212) 799-4789

Rowland Wilson (V1•205)
c/o Phil Kimmelman Associates
65 East 55th Street
New York, New York 10022
(212) 371-1850

GRAPHIC DESIGNERS

John Brinkmann Design 207
3242 West Eighth Street
Los Angeles, California 90005
(213) 382-2339

Irene Charles Associates 208
41 East 42nd Street
New York, New York 10017
(212) 765-8000

Corporate Annual Reports 209
112 East 31st Street
New York, New York 10016
(212) 889-2450

Fred Feucht Design 210
300 Madison Avenue
New York, New York 10017
(212) 682-0040

Fulton & Partners 211
717 Fifth Avenue
New York, New York 10022
(212) 593-0910

Robert Gersin & Associates 212
11 East 22nd Street
New York, New York 10010
(212) 777-9500

Tony Gianti 213
12 Piermont Road
Rockleigh, New Jersey 07647
(201) 767-9238

Graphic Designers, Inc. 214
2975 Wilshire Boulevard
Los Angeles, California 90010
(213) 381-3977

Johnson & Simpson 215
49 Bleeker Street
Newark, New Jersey 07102
(201) 624-7788

Herb Lubalin Associates 216
217 East 28th Street
New York, New York 10016
(212) OR 9-2636

Manning Studios 220, 144
2115 Chester Avenue
Cleveland, Ohio 44114
(216) 861-1525
(216) 399-8725
(513) 621-6959

Irving D. Miller 221
641 Lexington Avenue
New York, New York 10022
(212) 755-4040

James Potocki & Associates 222
2500 Wilshire Boulevard, #900
Los Angeles, California 90057
(213) 380-7281

Push Pin Studios 224
207 East 32nd Street
New York, New York 10016
(212) 532-9247

Arnold Saks Design 225
16 East 79th Street
New York, New York 10021
(212) 861-4300

John Waters Associates 226
147 East 37th Street
New York, New York 10016
(212) 689-2929

Roger Zimmerman 228
22 East 21st Street
New York, New York 10010
(212) 674-0259

footnote:

Art directors who spend reasonable amounts of time working with color separations know that the test of a good color separation house lies in two things: their ability to interpret what it is that the art director is trying to get out of a piece of color art; and the talent that exists within that organization to deliver on the interpretation.

Many good separation houses sport sophisticated machinery and everyone will tell you that their machinery can do many things automatically at the push of a button. In reality, however, when push comes to shove the final result is a combination of the talent they have on hand and their willingness to extend themselves in order to deliver what is necessary for the project.

What you have seen in this publication can only give you an idea of finished product. What you cannot see on the printed page is the amount of service, effort and cooperation that goes into getting that image on the page. This footnote is written in testimony to those people at O.S.C. with whom I have worked for years and who to my mind exemplify a dedication to a craft tradition which I am happy to see still exists in this business.

Whether it has been for large and complicated projects, many of which I have been involved in as Art Director of Time-Life Books or more modest ones which they have undertaken with me now as President of my own design firm, my confidence in them has not changed.

What you have seen in the pages of this publication is not the result of button pushing and dial setting but ultimately is the result of intelligent understanding and responsible execution of problems.

OFFSET SEPARATIONS CORPORATION 437 MADISON AVENUE, NEW YORK 10022

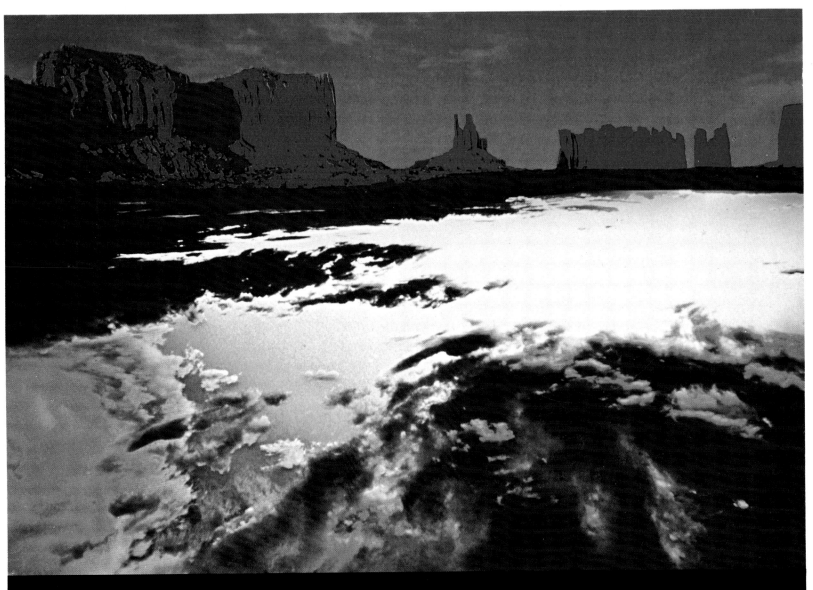

Have you ever dreamed of turning the world on end...expressing your visions with new depth and impact...transforming the conventional into exciting adventures in color, texture, mood?

The Nikon F2A is designed to help you realize your creative capabilities. As it does daily, for an overwhelming majority of 35mm professionals. And for reasons that are anything but abstract.

Take the fascinating world of multi-image photography. The matchless accuracy of the Nikon F2A viewfinder lets you compose with absolute confidence, aided by the reliability of Nikon center-weighted exposure control. And, the precise F2A registration assures each image appears exactly where you planned.

This confidence is yours with any of 6 interchangeable viewfinders. With any of 21 finder screens. With 2 high-performance motor drives: the new, lower-cost MD-3 that puts single shots and continuous sequences at up to 4 frames per second at your command, and the legendary MD-2 with power rewind and 5 fps speed. Even with bulk-film and large-format camera backs.

And, for the most dramatic perspectives in 35mm photography, every F2A accepts the nearly 60 Nikkor lenses from 6mm through 2000mm. Optics unrivalled in quality and variety — calculated to inspire your imagination as no others can.

There are countless reasons why creative photography acquires new meaning with the Nikon F2A. Your Nikon dealer will help you find them. Look for him in the Yellow Pages. And, be sure to inquire about the traveling Nikon School of Photography. Or write to Dept. N-38, Nikon Inc., Garden City, New York 11530. Subsidiary of Ehrenreich Photo-Optical Industries, Inc. EPi (In Canada: Nikon Division, Anglophoto, Ltd., P.Q.)

© Nikon Inc. 1978

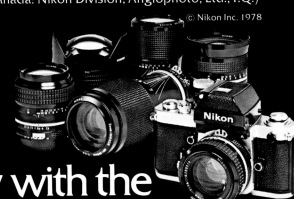

Abstract photography with the Confidence of Nikon